AN INTIMATE DISTANCE

How have women artists taken possession of the female body? What is the relationship between looking and embodiment in art made by women? In a series of original readings of the work of artists from Käthe Kollwitz and Georgia O'Keeffe to Helen Chadwick and Laura Godfrey-Isaacs, Rosemary Betterton explores how women artists have addressed the changing relationship between women, the body and its representation in art. In detailed critical essays that range from the analysis of maternal imagery in the work of German artists at the turn of the century to the unrepresented body in contemporary abstract painting, Betterton argues that women's art practices offer new ways of engaging with our fascinations with and fears about the female body.

Reflecting the shift within feminist art over the last decade, *An Intimate Distance* sets the reinscription of the body within women's art practice in the context of current debates on the body, including reproductive science, maternal subjectivity and the concept of 'body horror' in relation to food, ageing and sex. Drawing on recent theories of embodiment developed within feminist philosophy and psychoanalytic theory, the essays reveal how the permeable boundaries between nature and culture, the female body and technology are being crossed in the work of women artists.

Rosemary Betterton teaches art history and critical studies at Sheffield Hallam University. She is the author of *Looking On: Images of Femininity in the Visual Arts and Media*, and has written widely in the areas of feminist art history and theory.

AN INTIMATE DISTANCE

WOMEN, ARTISTS AND THE BODY

Rosemary Betterton

London and New York

First published 1996
by Routledge
11 New Fetter Lane, London EC4P 4EE

Simultaneously published in the USA and Canada
by Routledge
29 West 35th Street, New York, NY 10001

Routledge is an International Thomson Publishing company

© 1996 Rosemary Betterton

Typeset in Times by
Florencetype Ltd, Stoodleigh, Devon

Printed and bound in Great Britain by
Biddles Ltd, Guildford and Kings Lynn

British Library Cataloguing in Publication Data
A catalogue record for this book is available from
the British Library

Library of Congress Cataloging in Publication Data
A catalogue record for this book has been requested

ISBN 0–415–11084–X (hbk)
ISBN 0–415–11085–8 (pbk)

for Caitilín and Kathleen

CONTENTS

PLATES

PLATES

PLATES

Every effort has been made to seek permission to reproduce copyright material before the book went to press. If any proper acknowledgement has not been made, we would invite copyright holders to inform us of the oversight.

ACKNOWLEDGEMENTS

This book has arisen from dialogue with other people and also with other writings. Over the two and half years of its production, and in previous years, many people have offered me support and encouragement. I particularly want to thank the friends and colleagues who have taken the time and trouble to read drafts at various stages of production. I hope I have taken both their critical comments and helpful suggestions on board. They are Jill Le Bihan, Lucy Bland, Jan Carder, Rebecca Fortnum, Van Gore, Lily Markiewicz, Angela Martin, Carola Muysers, Elizabeth Norman, Griselda Pollock and Heidi Reitmaier. My thanks also to Sylvia Harvey and Chris Goldie with whom I have shared some of the pains of writing. I am particularly grateful to the artists who have generously given me access to their work and taken time to discuss it with me. They include Rebecca Fortnum, Leslie Hakim-Dowek, Laura Godfrey-Isaacs, Deborah Law, Rosa Lee, Lily Markiewicz, Lesley Sanderson and Pam Skelton. Many of the chapters were first presented as papers and I am grateful to the organizers who invited me to speak as well as to all those who responded to them. I also want to thank the students with whom I have come into contact over past years and from whom I continue to learn a lot.

For practical support, I want to thank the School of Cultural Studies, Sheffield Hallam University, and Chas Critcher at the Centre for Communications, Media and Communities Research for providing me with study leave and administrative support to begin the book in 1993 and to finish it in 1995. My thanks to Lynne Colton for her invaluable help in picture research and to John Baxendale for processing my discs (as well as his arcane knowledge of 60s pop music). I want to thank Sue Bragg for her unfailing calm in producing the final manuscript and her patience with my last minute panics. Finally, I am grateful to my editor at Routledge, Rebecca Barden, for seeing the project through from beginning to end. Last of all, my thanks go to family, friends and colleagues for all their support, encouragement and tolerance, especially Eoín Nelson and Caiti Betterton.

ACKNOWLEDGEMENTS

The author and the publishers wish to thank the following copyright holders for their permission to reproduce the illustrations appearing in this book:

Since this book was completed the artist, Helen Chadwick, tragically died in March 1996. I wish to pay tribute to her work which has been an important and continuing source of inspiration.

Plate 1 by permission of Cliché Galerie Gilbert & Paul Pétridès and SPADEM, Paris; Plate 2 by permission of the Kunstammlungen Böttcherstrasse; Plate 3 © British Museum; Plate 4 by permission of Graphische Sammlung, Staatsgalerie Stuttgart; Plate 5 by permission of the Kunstammlungen Böttcherstrasse; Plate 6 reproduced by permission; Plate 7 by permission of the Fawcett Collection; Plate 8 by permission of the Museum of London; Plate 9 by permission of the British Library; Plate 10 by permission of the Tate Gallery; Plate 11 by permission of the National Museum of Labour History; Plate 12 by permission of the Fawcett Collection; Plate 13 by permission of the British Library; Plate 14 by permission of the Museum of London; Plate 15 by permission of the National Museum of Labour History; Plate 16 by permission of the Alfred Stieglitz Collection, Metropolitan Museum of Art, New York; Plate 17 by permission of *Vogue*; Plate 18 by permission of the artist; Plate 19 by permission of the artist; Plate 20 by permission of the artist; Plate 21 by permission of the artist; Plate 22 by permission of the artist; Plate 23 by permission of Wrangler Ltd; Plate 24 by permission of Benetton, photograph by Oliviero Toscani; Plate 25 by permission of the Australian Broadcasting Corporation; Plates 26a and b by permission of the artist; Plates 27a and b by permission of the artist; Plate 28 by permission of the artist; Plate 29 by permission of Metro Pictures, New York; Plate 30 by permission of the artist; Plate 31 by permission of the artist; Plate 32 by permission of the artist; Plates 33 and 34 by permission of the artist; Plates 35, 36 and 37 by permission of the artist; Plate 38 by permission of the artist; Plates 39, 40 and 41 by permission of the artist, photographs by Neil Conroy; Plates 42, 43 and 44 by permission of the artist; Plate 45 by permission of the artist; Plates 46, 47 and 48 by permission of the artist; Plates 49 and 50 by permission of the artist.

1

INTRODUCTION

> Gathering and re-using takes time, measurable in hours during the day certainly but also a sense of time having passed before, a sense of history and most importantly a sense of future, a knowledge of survival. A quilt made from gathered pieces of cloth takes time to plan, design and make.
>
> (Himid 1988: 8)

The writing of this book can be summed up in Lubaina Himid's telling phrase describing black women's creativity as a form of 'gathering and re-using'. In such a process, many insights and voices, both acknowledged and unconsciously absorbed, have gone into shaping the ideas it contains. The idea of 'gathering and re-using' carries with it the implication of women's work and daily lives. It reminds me that, as a child round about eleven or twelve years old, I had a passion for making patchwork. Taught by a friend of my mother, I at once decided on the most difficult pattern of stars and octagons which required precise cutting of templates and careful handstitching if the pieces were not to fall apart. From initial pleasure, it gradually became an obligation which I could never fulfil. I carried the unfinished patchwork, measuring roughly three feet by four, around with me for years – took it with me to university, through various moves to different flats and houses and eventually mislaid it – although it may still turn up one day. It carried with it a sense of feminine identity, experienced as a mixture of satisfaction and frustration, achievement and failure, attachment and loss. In other words, a kind of uncompleted project of femininity which somehow characterized my own contradictory and unresolved relationship to the feminine.

This hardly suggests a very positive model for writing a book, but it does describe something of the process involved that has been one of 'gathering and re-using' ideas, some of which I've carried about with me for years, others more newly discovered – and shaping them into new patterns of my own making. My aim is not to dissolve their various differences, but to let them stand against each other in what is sometimes a

1

clash of contradictory materials. At one level, the idea of gathering and re-using stands for an approach to making art and, at another, for the kind of critical framework which informs it. No single theory or set of explanations will accommodate the richness and diversity of women's art practices nor can a new interpretation supplant or displace existing readings of the work. New meanings are not there to be discovered, but are produced by a community of readers in creative dialogue with texts, producers and each other. It describes a process of layering and uncovering a series of different positions in which the traditional model of 'mastering' the text with an authoritative interpretation is no longer the goal. It also suggests something of the continuous and open-ended nature of this book. There can be no last word, no definitive statement about the complex and changing relationships between women, their bodies and their representation. For that reason, I've chosen to structure the book in the form of essays, born out of different impulses and demands over the last few years, but with common and interweaving themes.

The initial idea for the book was a simple one. It was to bring together various articles, reviews and papers I had published over ten years on the theme of women artists, representation and the body. In the event, this has turned out to be a somewhat more lengthy and complicated process. All the original pieces have been substantially revised and new chapters have been developed. But the original intention still stands. The book is both a review and a culmination of my own developing ideas around gender, representation and artistic practice over the past decade. However, it is not a book *about* theory. Its focus is rather on the application of theoretical perspectives to the textual analysis of visual images mainly, but not exclusively, made by women. Inevitably, any selection also means exclusion. The choice of artists discussed here reflects my own interests, but also a certain bias towards work which has not already received substantive critical attention. There are therefore notable omissions where I have felt artists' work has been thoroughly and fruitfully explored elsewhere.[1] In other cases it has been my own lack of knowledge or insight which has failed to make the right connections. I have selected a relatively limited number of images from the visual arts, film and media, in order to explore a number of discrete, but related themes.

Chapter 1 offers a short overview of some developing theoretical debates around the body in representation within feminist theory and cultural practice since the 1970s. In the ten years since I wrote an article called 'How Do Women Look?' on the work of Suzanne Valadon, I am aware how much visual theory has moved on. In that essay, I was concerned with questions of gender and spectatorship, particularly with how a woman's viewpoint might be theorized in relation to the visual image, an issue which was then barely addressed within the visual arts. Ideas about the body have changed, partly due to the absorption of

increasingly sophisticated psychoanalytic perspectives and partly, perhaps, as a consequence of postmodernism. Katy Deepwell has suggested that, within certain forms of postmodern debate, feminism 'appears as a homogeneous noun – old fashioned and *passé* – never defined or expanded, only invoked to be dismissed' (Deepwell 1995: 5). I want to hold on here – in what sometimes feels like a quaintly old-fashioned way – to a central project of re-framing and re-fashioning the body within a feminist politics of sexual difference.[2] At the same time, I recognize a change that has taken place in my own thinking from a preoccupation with the cultural construction of gender in representation towards an interest in what might be termed an 'embodied subjectivity', with how the body itself is experienced discursively and psychically.

Between about 1890 and 1914, a reconfiguration occurred, both politically and artistically, in female embodiment. As women sought political representation, conflicts over the political and sexual body, the status of motherhood and the role of women as artists became the subject of intense debate.

For how are we to understand the complex shifts which enabled women artists to take possession of the body in representation without grasping its political dimensions? It was the struggle to open up professional art training to both sexes which enabled women artists to move with some confidence into the masculine terrain of the nude at the turn of the century. For the first time in European art history, women artists were enabled to study the naked male and female body directly from life, albeit still hedged around with restrictions.[4] When Käthe Kollwitz attended the Drawing and Painting School of the Verein der Berliner Künstlerinnen in 1885, she followed a course of drawing from plaster casts of the female nude and live semi-clothed male models, but drawing from the naked female body was deemed unsuitable. By the time Paula Modersohn-Becker arrived at the School in 1896, a wider course of study included drawing from the naked female model. The real problem for women who wanted to make a serious career in art, however, was that such limitations marked off their education as second rate. This inhibited the self-confidence needed to become professional artists and was a source of later insecurity to both Modersohn-Becker and Kollwitz. They were not only disadvantaged by their education, but also by prevailing ideologies of gender and art. In Chapter 2, I argue that the maternal body became a central metaphor through which Modersohn-Becker and Kollwitz addressed their own relationship as artists to the process of making images. In their representations of 'nude mothers' from the 1900s, we can see an attempt to resolve the contradictions between an ideological imperative of motherhood as women's primary vocation in Germany, and their own identities as women artists.

It was a period in which contradictions between nineteenth-century ideals of femininity and new and emergent representations of women

came to the fore. In Chapter 3 I explore some of the issues around suffrage and its representation by examining the 'political body' of feminism. In the early 1970s, I had watched *Shoulder to Shoulder* (Midge Mackenzie, BBC, 1974), a fictionalized documentary television series about the struggle for the vote, with fascination, but with little sense of connection. Watching the series again in 1993 (on the sixty-fifth anniversary of women's attainment of the vote) I realized it was the physical embodiment of the suffragettes as much as their words which left a lasting impression – the contradiction between the respectability of their dress and their often brave, sometimes violent actions. This representation of a representation suggests something of the partial and layered memories through which the suffrage movement has come down to us.

As Liz Stanley and others have argued, while frequently represented as a campaign for the vote alone, the suffrage movement addressed much broader concerns which included issues of sweated labour and low pay, women's and children's health and rights, female friendships and sexuality.[3] Within this agenda, the struggle over the representation of women's bodies was an implicit rather than explicitly acknowledged part of the suffrage campaigns. Yet during this period, the relations between women and men, women and women, and of women to their own bodies and persons were transformed.

In recent years a debate has emerged in the feminist press which has centred once again on the issue of women and painting – what kinds of painting are appropriate for women to do and indeed, should women practice painting at all? In many ways this is an odd debate since women have continued to paint throughout this century. At its heart, however, is the identification of painting with modernism and, in particular, with the figure of the modernist male artist with, as Griselda Pollock puts it succinctly, 'the right to enjoy *being the body* of the painter in the studio – the creative self in the private domain' (Pollock 1992: 140). Chapter 4 explores the specific issue of non-representational painting and embodiment in order to examine the potential for reclaiming a female authorship for abstraction. If modern painting is engaged in a set of interactions between the body of the painter and the body of the work, is it possible to challenge the modernist critical paradigm which persistently devalues the female body? Within the rich rhetorical repertoire of painting, the body has always been the reference point for a series of metaphorical and direct equivalences between the surface of flesh and the painted 'skin' of the canvas, in the physical dimensions of the picture attuned to human scale and in the mark of the brush as trace of individual artistic presence. Since Romanticism, artists have claimed that truth lies in the ability 'to transpose *yourself* into your subject' (Fuseli 1971: 94). The creative process has come to be understood as a register of direct psychic expression translated through the physical acts of an embodied subject. Within modern

art, a rhetoric of the body has developed in which the painting process has been identified with direct bodily gesture and expression. But, if the physical body is the touchstone of aesthetic truth in modern art, then it is the specifically gendered body which has provided its central metaphors. Shaped within and conditioned by ideologies of sexual difference, the body of the woman artist has been marginalized or rendered absent from the canon.

Chapter 5 explores a very different bodily landscape, that of reproductive technology and the contradictory imperatives that are producing new representations of maternal identity. It examines some of the ways in which these representations have entered into the domain of popular media and culture. For women, the decision to have or not to have children, whether by choice, circumstance, or reason of infertility, is inevitably shaped by representations of what motherhood means in our culture. Childbearing and childlessness are intimately connected with a sense of identity and self worth for women. The issues are complex and, in the cultural sphere, we can see represented the contradictions, ambivalences and dilemmas in an area which is so deeply entwined with our innermost fears and desires. Given its very recent development, it is not surprising that few artists have as yet begun to address the implications of reproductive technologies for women's bodies. While motherhood in all its diverse and contradictory forms has been a recurrent theme in art by women, the experiences of childlessness and infertility have not been similarly explored. The representation of reproductive technologies can be seen as one 'site of struggle', a space in which women's identities as maternal and non-maternal subjects are currently being redefined.

New treatments for infertility clearly represent one area where the permeable boundaries between the female body and technology, nature and culture, are being crossed. As Rosi Braidotti suggests, 'the new reproductive technologies, by normalizing the dismemberment of the body, transform the body into a mosaic of detachable pieces' (Braidotti 1991: 139). Art in the 1990s has embraced bodily transgression in work of various 'bad girls' (and boys), but what precisely is being transgressed? Is it the boundaries of masculine culture or a particular definition of *feminist* art which is in question? A shift away from the theoretical purity of feminist art in the 1980s has undoubtedly released an explosion of transgressive pleasures and desires. Chapter 6 explores 'Body Horror' through themes of food, sexuality and ageing. Fear and loathing of the female body which eats, excretes and reproduces, has a long and well founded tradition in European culture up to today's horror film. This chapter argues that the female body and its appetites can be represented in terms other than the psychic horrors of the 'monstrous feminine'. Current art work by women which deals with food – from chocolate to oysters – with sex,

and with the maternal body, offers a way of addressing our ambivalent fears of and fascinations with our desiring, corporeal being.

In 1989 I watched the performance *Altered Tracks* by the Irish artist, Anne Tallentire, in which she traced a path with stones laid on a projected map of Ireland. As she walked along the lines, she described how Irish placenames had been translated under English occupation and lost the significance of their original naming. The work dealt with destiny and choice, with the power to change as well as to follow the lines of history and from it I understood, for the first time, something about the experience of dis-location, what the dual loss of language and place might mean. The crossing of borders, both internal and external, has become a powerful image of alienation at the end of the twentieth century. Chapter 7 explores the cultural politics of location and exile through the work of individual Asian, Jewish and Arab artists living in Britain. In very different ways, their work addresses important questions about the relationship between language, culture and territory. Recovery of the past, located both in history and in place, and its meaning for the individual is a common thread running through the work as, too, is their use of the medium of installation as a dual intervention in time and place. While each artist works in a different way, all share the notion of a mother tongue or a maternal home as the site of desire and loss.

Only now, looking back over these essays I discover the ghost of another, unwritten, book behind them. Running through them is a speculation about how much art practices by women reveal about maternal relationships, both of mothers to their children and of daughters to their own mothers. The emergence of this preoccupation in my own writing coincided with the birth of my first and only daughter when I was forty, and in the same year as the death of my father. As Mary Kelly has shown, middle age provokes a questioning of how feminine identity may be located in the female body, a period of reflection on the 'interim', the time – or place – in between: 'In the gentle ebb and flow of departure to return, separation to union, from daughter to mother ..., history and culture might happily admit to being feminised' (Chadwick n.d.: 76).

1

AN INTIMATE DISTANCE
Women, artists and the body

In 1931, at the age of sixty-six, Suzanne Valadon painted a *Self Portrait* (Plate 1). In it, she shows herself unclothed but for a necklace, her face made up and hair cropped short in the style of a twenties flapper. Refusing to compromise with age, Valadon confronts her body without embarrassment or pity. This *Self Portrait* is one of many in which Valadon rigorously interrogated her own self image during her long working life.[1] Valadon was not unique as an artist in confronting the onset of old age so directly – one can think of examples from Rembrandt to Picasso – but what is striking is the clarity with which Valadon negotiates the relationship to her *feminine* body. The act of painting herself naked is both intimate, connected to her sense of self, and at the same time, places her body at a distance as the object of representation. Reflected as in a mirror, she stares dispassionately at the feminine body she inhabits. Valadon's look at herself opens up the third term in the creation of meaning: the viewer completes a circuit which leaps the gap between self and Other. It is this 'intimate distance' which this book sets out to explore.

In this chapter, I want to examine a shift from questions about representation – how the female body should be represented – to the question of subjectivity – what it means to inhabit that body: from the problem of *looking* (distance) to the problem of *embodiment* (touch). One of the themes that recurs through these essays is what such metaphors of 'distance' and 'touch' mean within a visual art practice by women. Western systems of representation in art and science have placed the act of looking at the centre of their enquiry, predicating a certain distance between the viewer and what is seen – between the subject and the object of vision.[2] But within recent feminist theory, logocentric vision has been questioned as a basis for women's art practice. This is concerned with ways of 'speaking' differently about women's bodies, both in the sense of contesting existing representations *and* of exploring differently embodied perspectives.

Why do questions of representation and symbolization of the female body by women matter? Michèle Barrett has suggested that within modern

7

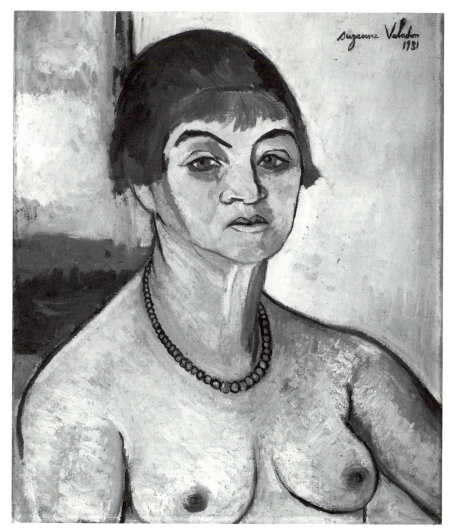

Plate 1 Suzanne Valadon, *Self Portrait*, 1931, oil on canvas.

feminism, the 'contestation of cultural meaning has been every bit as important as other feminist projects' (Barrett 1992: 211). Claiming the right of women to represent themselves has been central to a feminist agenda since the struggle for the vote began over a century ago. From the late 1960s, various kinds of feminist politics have centred on women's bodies in campaigns around reproduction and health, for the right of women to control their bodies against sexual abuse and violence, and against the exploitation of women's bodies in pornography and in the

mass media. The title of the first anthology of writings from the British women's movement, *The Body Politic*, edited by Michelene Wandor in 1972, signified the importance, both literally and metaphorically, of the body within feminist thinking. And yet, it would be true to say that, from the start, feminism has had trouble with the body. In particular, this has been with the question of how to theorize the body as the border-line between the biological and the social, the natural and the cultural, a problem to which I shall return shortly.

Twenty-five years later, issues around representation, the body and gender difference have become ever more complicated. Feminist politics have mutated and diversified, both as the result of pressures from within and in response to external conditions. Questions of the body and its status within culture and language have been at the heart of recent theo-retical debates. Feminist appropriations and revisions of poststructuralist and psychoanalytic theory, especially the work of Michel Foucault on sexuality and of Jacques Lacan on the formation of the individual, have produced new theoretical insights which radically question the notion of a coherent female subject. Profound changes in technology and its rela-tion to the body in the late twentieth century – most recently in gene therapy, new technologies of reproduction and emerging forms of inter-action with computers – have also, in diverse ways, started to shift long held assumptions about the integrity of the body. Thus political, theoret-ical and technological changes intersect to produce new knowledges and understandings.

These political theoretical and technological shifts have challenged the fixed polarities of sexual difference which underpinned much early femi-nist art practice in the 1970s. But women's art has also begun to reconstruct our conception of what female bodies might mean in our culture. One of the key arguments of this book is that cultural production is itself a form of knowledge that can offer access to and understandings of the body which are unavailable through purely cognitive means. Women's painting, sculpture, writing, dance, performance, installation, video or film all offer us ways in which the female body has been re-imagined.

RE-IMAGINING THE BODY

In an early issue of the journal *Art History*, Lisa Tickner reviewed ways in which existing images of sexuality in art were being challenged by the work of women artists in the 1970s. As Tickner (1978) argued persua-sively, the body was a crucial site for feminist intervention in art practice because it represented all that was perceived to be degrading in the erotic tradition of western art and yet, at the same time, it offered a means of articulating a specifically female experience. As Mary Kelly claimed subse-quently, 'the specific contribution of feminists ... has been to pose the

9

question of sexual difference across the discourse of the body in a way which focuses on the construction, not of the individual, but of the sexed subject' (Kelly 1981: 54). But, if feminist body art of the 1970s posed the question of identity in terms of sexual difference located in the body, from the beginning there was a contradiction between the demand for a rigorous critique of existing codes of the erotic and the desire to produce new and more productive representations for women. As Janice Winship asked, 'is it possible to create new erotic codes – and I assume that is what feminism is striving for – without in some way re-using the old?' (Winship 1985: 25/28). Pleasure, or rather – whose pleasure? – had become a problematic issue.

Discussions about how the female body should be represented in feminist art were affected by parallel and very public debates about pornography in Britain and in the United States. Eroticized, objectified, fragmented and sometimes abused, pornography to many feminists seemed to be the paradigm for all male representations of the female body. One central objection to pornography, then as now, is that it reduces women's bodies to the status of purely sexual objects and sexuality to penetration. Metonymically, the female genitals are made to stand in for the whole female body: 'The project of the soft core pinup is to construct sexual difference in representation by defining it in terms of, even reducing it to, bodily parts marked culturally ... as feminine' (Kuhn 1985: 38). Yet ironically, feminist body art in some ways mirrored the focus on the sexual body in pornography. As Donna Haraway commented in another context, 'feminists here reduced women's bodies to the area revealed by the tools of gynaecology' (Haraway 1987: 72). The intense anger fuelled by pornography debates in the late 1970s and 1980s made it a particularly difficult climate for women to work on issues of the body and sexuality. Making images of the female body became a risky business.[3]

The question of aesthetics was also subject to intense debate within feminist cultural theory in the late 1970s and 1980s. The project of a feminist cultural practice, some argued, should be to deconstruct existing representations of women and to problematize the pleasures that they offered. In film and the visual arts, such practices rejected narrative, figuration and illusion, in favour of textual strategies which refused any straightforward identification between viewer and image. For rather different reasons, but with similar aesthetic intent, painting as a medium was rejected in favour of photo-text, performance and 'scripto-visual' media.[4] Destruction of the viewer's pleasure was to be a radical weapon and new kinds of engagement were offered which avoided any direct figuration of the female body. Probably the best known example of this type of work was Mary Kelly's *Post Partum Document*, 1973–9. Kelly brilliantly described the positioning of the maternal body at the edges of culture and on the boundaries of the unrepresentable. As she later argued

when the work was published in book form, 'to use the body of a woman, her image or person is not impossible, but problematic for feminism' (Kelly 1985: xvii).[5]

'Negative aesthetics' offered a powerful critique of existing forms of representation and initiated a desire for change but, as Laura Mulvey later pointed out, 'the great problem then is how to move to "something new", from creative confrontation to creativity' (Mulvey 1989: 161). While sometimes negative in its effects, deconstruction provided a crucial weapon in exposing the relationship between cultural forms and women's oppression. But, if women were to be represented as active desiring agents, then a return to their bodies – whether figuratively or metaphorically – seemed a necessity. The question then was how to represent the sexual body in ways which could not be framed within a 'male gaze'.

A REPERTOIRE OF IMAGES

You are the only one who can never see yourself except as an image; you never see your eyes unless they are dulled by the gaze they rest upon the mirror or the lens. ... even and especially for your own body, you are condemned to the repertoire of its images.

(Barthes 1977b: 31)

We cannot remain pure reflections, nor two dimensional flesh/bodies. Privileging the flat mirror, a technical object exterior to us, and the images which it gives back to us, can only generate for us, give us a false body, a surplus two dimensional body.

(Irigaray 1994: 12)

Roland Barthes described a passive model of our relationship to self image in which the body can only be grasped through the mirror of the reflected gaze. In contrast, Luce Irigaray rejects the metaphor of the mirror in which woman merely re-duplicates the male gaze, replacing it with the speculum whose curved surface reflects the female interior. These two accounts of the relationship between looking and embodiment offer different aspects of a debate which has occupied feminist visual theory over the last decade.

Until recently, it has been the first model which has been central to most feminist accounts of women's relationship to the body and its representation. Since the 1970s, according to John Berger's classic formulation, 'men looked' and 'women appeared' – in theory at least. Laura Mulvey's appropriation of Freudian concepts of voyeurism and fetishism gave further cogency to a binary split between women as passive objects of the look, and men as active subjects of their own desires. The theory of the 'male gaze' provided a powerful explanatory framework for the deep-seated and enduring resistance to change of certain representations of the

female body in art and cinema.[6] Indeed, although subject to substantial revision and critique, it continued to exert a hold over feminist visual theory through the 1980s, as the representation of women in visual culture came to be viewed with deep suspicion. And, while the question of women's spectatorship did come on to the agenda – through concepts of visual transvestism, masquerade and lesbian spectatorship – a theoretical account of women as the active *agents* of their own desires remained largely absent in Anglo-American writing.[7] As feminist cultural theory and practice increasingly drew on psychoanalytic theory for an explanatory framework, Lacan's influential model of the 'mirror stage' further privileged *sight* as the means through which an individual subject gained his or her sense of imaginary bodily unity. This seemed, for the time being, to preclude any further discussion of the materiality of women's bodies without raising what Nancy Miller has tartly described as, 'the feminist bugaboo about essentialism' (Miller 1986: 115).

However, theories of the gaze did not exhaust the possibilities of women's relationships to the female body and its representation. Barthes' suggestion that we are forever condemned to see our own body through 'the repertoire of its images' seemed unduly pessimistic in implying that experiences of the body are only available through existing cultural codes. At one level, of course, this cannot be denied; since the female body has more commonly borne the gaze of others, it is inevitably mediated through many other images and representations. Even the most intimate experience can be shown to be coded and made visible through discourse. But historical examples also show otherwise. In the late nineteenth century, when women who loved other women had no public language through which to name themselves, they could still express their desires for each other, romantically and physically, but these expressions were not culturally coded *as* lesbian.[8] Images and representations may frame but not entirely exclude possibilities of the body which exceed contemporary discourse.

Despite his fascination with the visual, Barthes himself offered another way of approaching the body in representation.[9] In his 1972 essay, 'The Grain of the Voice', Barthes suggested that the relation between representation and embodiment might be fruitfully understood at a material level:

> The 'grain' is the body in the voice as it sings, the hand as it writes, the limb as it performs. If I perceive the 'grain' in a piece of music and accord this 'grain' a theoretical value ..., I inevitably set up a new scheme of evaluation which will certainly be individual – I am determined to listen to my relation with the body of the man or woman singing or playing and that relation is erotic – but in no way 'subjective' ... I shall not judge a performance according to the rules

12

of interpretation, the constraints of style ... but according to the image of the body (the figure) given me.

(Barthes 1977a: 188)

Barthes develops a different model of the cultural text here which addresses the ways in which the body is felt, as well as, sometimes, seen. This shift between the 'image repertoire' and the ' "grain" in the voice' suggests a slippage between a relationship based on looking and one based on other senses.

The French psychoanalyst and philosopher, Luce Irigaray, has provided the most powerful critique of the primacy of vision as a model for comprehending the female body. Irigaray argues that the look has been privileged over the other senses – touch, taste, smell, and hearing – with a resultant impoverishment of bodily relations in western thought. In *Speculum of the Other Woman* (1985a), Irigaray proposed that the model of the 'mirror' through which our bodies are re-presented to us from without in idealized form, is one seen as though through men's eyes. Flattened and distorting, this mirror lacks the volume necessary to the representation of the female body for, according to Irigaray, 'we are creatures of volume, meeting volumes, procreating and creating volumes' (Irigaray 1994: 12).[10] A woman needs to recreate herself in forms which will more properly represent her material body: 'Otherwise she is in danger of using or reusing that to which man has already given form(s) particularly of her self/selves, working what has already been worked and losing herself in this labyrinth' (Irigaray 1994: 12).

The work of Irigaray, and that of other French writers including Julia Kristeva, Hélène Cixous and Catherine Clément, has undoubtedly been influential in the development of feminist aesthetics in the 1980s and the 1990s, offering a way of exploring how the feminine body exceeds its discursive limits. But a problem remains. What is the status of this 'body' in feminist discourse – and what are the implications of these debates for a visual art practice by women?

SOCIAL BODIES

If it is a social object, the body can be redefined, its forms and functions can be contested and its place in culture re-evaluated and transformed.

(Grosz 1987: 3)

In western traditions of religion, culture and science, women have always been aligned with nature, a position of inferiority shared with other marginalized groups whose difference from the norms of white, bourgeois, male rationality is signified by the division between body and mind. Within this dichotomy, the power to change, transform, progress within history

13

is assigned to those inhabiting the sphere of culture against which the body has come to signify the realm of the timeless and essential. In addressing the body as a site of sexual difference, a feminist politics therefore confronts a whole tradition in which the female body is positioned as a binary term of difference. And yet, to speak 'as a woman' and not simply 'like a woman', necessarily involves the question of female embodiment. Being a man or being a woman is more than an effect of discourse, it is 'connected to a social position in the world, to embodiment and the social effects of embodiment' (Whitford 1991a: 129). This clearly remains a central contradiction for feminism. But it can be a productive tension if it forces us to recognize that categories of difference based in the body are not fixed, but constantly being remade anew.

Two main responses to this positioning of the body have emerged within modern feminism. The first claims an equal stake in rationality by drawing on the post-Enlightenment liberal discourse of equal rights. As Donna Haraway argues, the 'body' in liberal theory was neutral, sexed but not gendered; it could thus provide a means of attacking gender hierarchy:

> Liberal theory was a resource for feminists, but only at the price of renouncing anything specific about women's voice and position, and carefully avoiding the problem of difference, for example, race, among women. The 'neutral' body was always unmarked, white and masculine.
>
> (Haraway 1990: 148)

The second argument embraces sexual difference and seeks to reverse what is constituted as a sign of inferiority, women's closeness to nature, as a positive value to be celebrated. This is a powerful and attractive strand within contemporary feminist thought and has generated some of the best known and most popular texts which have shaped the forms of women's politics.[11] The arguments against them have been equally well rehearsed: essentialist, they fail to recognize material differences of class, race and power between women, and they appear to abandon any claim to (male) rationality.

One stumbling block in reconceptualizing the body and its representation has been the way in which feminist theory itself has described the division between the biological and the social. Underpinning feminist thinking in sociology, psychology and cultural theory in the 1970s had been the central distinction between 'sex' and 'gender': ' "Sex" is a biological term: "gender" a psychological and cultural one' (Oakley 1972: 158). This analytical separation allowed feminists to argue that definitions of masculinity and femininity were imposed on the male and female body according to socially and culturally prescribed norms. They could thus resist accounts which collapsed a socially constructed femininity into an irreducible biological essence. But, this sex/gender distinction does not fit well with more recent attempts to theorize the fluid boundaries of gender

and sexual identity.[12] It is difficult to imagine a clear mapping of sex and gender differences after a decade in which transexual and transgender desires have been acknowledged and queer identity reclaimed. Feminist scientists too have begun to rethink the categories of sex and gender, or more precisely, to look critically at the biological definition of the body. As Rosalind Pollack Petchesky comments:

> A true biological perspective does not lead us to determinism but rather to infinite *variation*, which is to say it is historical. . . . Particular lives are lived in particular bodies – not only 'women's bodies', but just as relevantly, ageing, ill, disabled or infertile ones.
>
> (Petchesky 1987: 76)

Feminist literature of science has taken the deconstruction of sexual difference one stage further by applying it to the ways in which female bodies are themselves constituted by culture as well as within nature. One concrete example of an interaction between the biological and the cultural is the changing age at which girls begin to menstruate, which has steadily dropped through this century. Determined primarily by the ratio of body weight to size, this reflects broader historical changes in eating habits and health which are historically and culturally specific: the body has a history.[13] Feminists drawing on psychoanalytic and discourse theory within a range of disciplines have argued that *how* we inhabit our bodies psychically is also culturally and socially constructed. The body itself becomes the site of social and political inscription rather than a given biological truth.

According to Luce Irigaray, the imaginary and symbolic form of the male body underlies western thought and it is this, she argues, that determines the concept of self in humanism; the model of the thinking subject is derived from the imaginary male body.[14] Irigaray's argument is not concerned so much with reversal – thinking with the female body – as with deconstructing the terms of binary difference which secure the female body as the absent term in culture. It offers another explanation for a limited 'repertoire of images' available to women and why these are so resistant to change. More positively, Irigaray's argument is also about the possibility of that change and how it might be effected. Margaret Whitford uses the term 'poetics of the body' (Whitford 1991: 173) to describe the strategy Irigaray employs to counter the logic and language of the male symbolic order. The female body offers a means both of contesting women's place in the existing social order and of creating other terms in which to discuss it, for:

> to seek to rediscover a possible imaginary for women through the movement of two lips re-touching . . . does not mean a regressive recourse to anatomy or to a concept of 'nature' nor recall a genital order – women have more than one pair of lips! Rather it means

to open up the autological and tautological circles of systems of representation and their discourse so that women may speak (of) their sex [*parler leur sexe*].

(Irigaray quoted in Whitford 1991a: 173)

The difference between those critics of Irigaray who have argued that she is idealist and essentialist, and those who argue for a more nuanced understanding of her ideas, turns on the question of whether or not her use of the body is taken to be *strategic*. In other words, whether she advocates a return to the body as a 'solution' for women, or as a strategic move to counter male myths and concepts about women's bodies and psyches. Margaret Whitford's comment that, 'what interests me is what Irigaray makes it possible for us to think' (Whitford 1991a: 4) seems entirely apposite here. The kind of imaginative insights and intellectual leaps she offers are both fascinating because they offer an account of women's subjectivity which is not bound within the parameters of male experience, and frustrating in their constant ellipses and contradictions. While her writing does not offer a prescription for a feminine aesthetic, it can help us to think about the conditions and process of representing female difference in new terms.[15] Crucially for Irigaray this involves representing that which is repressed within psychoanalytic theory, the mother–daughter relationship:

We must also find, find anew, invent the words, the sentences, that speak the most archaic and the most contemporary relationship with the body of the mother, with our bodies, the sentences which translate the bond between her body, ours and that of our daughters. We have to discover a language (*langage*) which does not replace the bodily encounter – as patriarchal language (*langue*) attempts to do, but which can go along with it, words which do not bar the corporeal, but which speak corporeal.

(Irigaray 1991: 43)

Like Julia Kristeva, Irigaray sees the repressed maternal relationship and the pre-Oedipal state of infancy as central within the formation of gendered subjectivity. Unlike Kristeva, however, for whom the pre-Oedipal is non-gendered and therefore has semiotic potential for both sexes, Irigaray connects the 'bodily encounter' specifically to women's experience of the maternal relationship as daughters and as mothers.

In this sense feminist representations may function as fragments, the partial workings out of different ways to 'speak the corporeal', rather than as descriptions or prescriptions of a future language. Such a practice in art might be seen as working towards different conceptions and symbolizations of the relationship between the biological and the imaginary body which is socially and culturally produced. The advantage of this formulation is that it brings us back from questions of the system of knowledge

16

(*langage*) to the position of the speaking subject (*langue*).[16] It is in relation to this question of creating a place from which women can speak *as women*, that Irigaray offers most. But this implies developing a strategy not simply for speaking (finding the right words), but also of creating the conditions under which women can speak (represent themselves).

Precisely where Irigaray can be and has been criticized is that, while she addresses women's exclusion from discourse, she does not deal with questions of power, with how to achieve changes in social existence and in material conditions. A valid criticism made forcefully in an early essay on the concept of *écriture feminine* by Ann Rosalind Jones is that its proponents pay little attention to the history and practices of women's actual cultural production or to the material conditions which make this possible. As she perceptively remarks, it is the 'body' of earlier women's writing and cultural practices which enables women to create in the present and not only, or even, through recourse to their own bodies (Showalter 1986: 373).

EMBODIED PERSPECTIVES

In her introduction to *The Pirate's Fiancée*, Meaghan Morris discusses the problem of representation that 'in its untransformed state, leaves a woman no place from which to speak and nothing to say' (Morris 1988: 3). She argues that the process of re-writing and re-presentation in the context of feminist critique is one of the enabling conditions of securing a feminist politics. It is in this light that the exploration of the desiring and maternal body in current visual practices by women can be understood as part of a broader attempt to 're-imagine' the body within feminist politics. Concepts of the body, its pleasure, pain and desire remain central to feminist cultural practice. But there can be a productive tension between critique and 're-vision'; between the project of dismantling an oppressive past and present and of envisioning present and future alternatives. What is made can also be unmade – or made differently. The production of a 'feminist' body in representation can intervene in such inscription to offer new meanings and pleasures. As Elizabeth Grosz suggests:

> Women's specificities, their corporeality and subjectivities, are not inherently resistant to representation or depiction. They may be unrepresentable in a culture in which the masculine can represent others only as versions of itself, where the masculine relies on the subordination of the feminine. But this is not logically or biologically fixed. It can be contested and changed. It can be redefined, reconceived, reinscribed in ways entirely different from those that mark it today.
>
> (Grosz 1987: 15)

We have moved along a trajectory from the body as mediated through the mirror of the two dimensional image to the social body as experienced corporeally and physically; from Suzanne Valadon's *Self Portrait*, surveying her feminine self from outside, to Laura Godfrey-Isaacs' *Pink Surface*, 1992, (see Plate 19) and *Pink Skin*, 1992, in which we are absorbed under the skin of femininity. The term 'embodied perspective' which Moira Gatens uses to characterize feminist writers on the female body, seems a particularly useful way of describing the work of certain women artists, from the late nineteenth century to the present day, whose work engages with female embodiment (Gatens 1992: 134).

A number of critics have drawn parallels between our own epoch and the situation in Britain at the end of the nineteenth century.[17] Elaine Showalter has argued that the fears of 'sexual anarchy' were linked to social disorder at home and imperialism abroad in Britain in the 1890s (Showalter 1991: 3). She points out that a resurgence of sexual repression, calls for social purity, and anxieties over sexual difference accompanied the syphilis panic in the 1880s and 1890s and 'deviant' social groups were likewise targeted for social control. The resurgence of nationalism, eugenics and racist rhetoric in this period was accompanied by a desire to 'cleanse' the social *and* the sexual body. In certain respects, late nineteenth-century feminism shared in this response, particularly in relation to the social purity campaigns. As Lucy Bland shows, 'banning the beast' of sexuality was intimately connected with fears of racial difference at a time of social disruption and Imperial anxiety in Britain (Bland 1995: xiii).

The parallels with the end of the nineteenth century are seductive, yet dangerous for, if the prevailing response of turn-of-the-century feminism was to reject the body, a more contradictory set of responses has emerged at the end of the twentieth. The nervousness about the body in feminist art of the 1980s has been replaced by its full-blooded embrace – sometimes literally, as sexually explicit and transgressive art practices run riot. The shift away from a totalizing view of pornography as sexual exploitation has been paralleled by a move towards the exploration of a range of sexualities.[18] References to the body are everywhere, from a new tactility in women's painting to the exploration of the virtual body in cyberspace. What is striking about the current glut of bodies is their very heterogeneity in which no particular medium or content is either forbidden or privileged.

If one of the overarching projects of modernity in this century has been one of the increasing rationalization of the social body – economically, politically, socially and sexually – then its corollary may be seen in the *disembodiment* of modernist art practices, particularly in the postwar period. The re-inscription of the female body in art in ways which transgress its boundaries, may be seen as part of an attempt to visualize the

repressed, corporeal and unregulated aspects of ourselves. Acknowledging and recognizing that part of the social, sexual and psychic body which has been excluded, is not only to celebrate it, but to demythologize its fearful power. In the end we have no choice but to re-invent the project of modernity and to re-inhabit its social body with, among others, the absent bodies of women.

2

MOTHER FIGURES

The maternal nude in the work of Käthe Kollwitz and Paula Modersohn-Becker[1]

Paula Modersohn-Becker's *Reclining Mother and Child*, 1906 (Plate 2) and Käthe Kollwitz's *Woman with Dead Child*, 1903 (Plate 3) are striking in their representation of motherhood. They depict the maternal state as one of physical absorption and psychic possession in a way that disturbs our preconceptions. Nearly a century after they were produced, the images still have the power to disconcert us by the directness of their vision. Both images stand outside the western cultural tradition of spiritual and dematerialized motherhood symbolized by the immaculate conception and virgin birth.[2] The two female figures remind us, in the solidity of their flesh and the strength of their enfolding arms, that it is through the body of the mother that the unique and irreplaceable intensity of birth is experienced. And yet the two images are very different, for while Modersohn-Becker represents the blissful intimacy of the maternal relationship, Kollwitz shows us the unspeakable pain of maternal loss.

Unusually, both artists have chosen to combine two separate genres of visual representation, the figure of the mother and the figure of the nude. In so doing, Modersohn-Becker and Kollwitz have brought together two poles of femininity which are traditionally held apart, the representation of the female body as erotic and sexually available and as reproductive and private.[3]

In this chapter I will explore the links between these two works and their location within contemporary discursive constructions of motherhood. I will suggest that the previously unremarked configuration of the 'maternal nude' in their work is a central metaphor through which Kollwitz and Modersohn-Becker were able to explore the contradictions for women artists between maternal and artistic identity.

Three types of material are used to frame the arguments here: biographical sources drawing primarily on the artists' own published letters and journals; debates about the role of women and the status of motherhood in Germany before 1914; and psychoanalytic accounts of the formation of maternal subjectivity. The extent to which these materials

Plate 2 Paula Modersohn-Becker, *Reclining Mother and Child*, 1906, oil on canvas, 124.7cm × 82cm.

Plate 3 Käthe Kollwitz, *Woman with Dead Child*, 1903, etching with engraving overprinted with a gold tone plate, 47.6cm × 41.9cm.

can offer critical insights into reading the images themselves is one of the questions which the chapter seeks to address.

REPRESENTATIONS OF MOTHERHOOD

The two artists, Käthe Kollwitz and Paula Modersohn-Becker had much in common. They were born (in 1867 and 1876 respectively) within a decade of each other in the northern German cities of Königsberg and Dresden, in the former state of Prussia. They were brought up within liberal bourgeois families and received their training at women's art schools in Berlin and Munich, each achieving some measure of professional independence by the turn of the century. They moved in similar progressive circles, for example, both knew the brothers Hauptmann: Gerhart, whose radical play *The Weavers* (1892) was the basis for Kollwitz's first graphic cycle, and Carl, playwright and novelist, in whose house Paula Modersohn-Becker spent her honeymoon in 1901. There is, however, no evidence that they ever met or even knew of each other's work.[4] In spite of their similarities they have been more often described in feminist literature in terms of their differences. In such comparisons, Modersohn-Becker is seen to embody the individualist figure of the avant-garde artist, while Kollwitz represents the very model of proletarian, feminist activism.[5] This is nowhere more evident than in the discussion of their representations of motherhood.

This view was stated most succinctly by Linda Nochlin in her original analysis of the iconography of motherhood in the two artists' work. Arguing that Modersohn-Becker's images of motherhood derive from a nineteenth-century pictorial tradition in which the peasant mother becomes the 'very embodiment of fatalistic conservatism', Nochlin compared these with the political activism of Kollwitz's revolutionary heroine, Black Anna, in the graphic cycle, *The Peasants' Revolt* 1902–8 (Sutherland Harris and Nochlin, 1978: 67). Nochlin interpreted Kollwitz's representations of motherhood, in contrast to those of Modersohn-Becker, as social documents connected to specific feminist and socialist perspectives. It has been her public persona as an artist of strong political sympathies which has, until recently, been the primary focus of Kollwitz's interest for feminist critics. Through the lens of social criticism, Kollwitz's depictions of women as heroic mothers and resisting workers have received much serious critical attention. This construction of Kollwitz as first and foremost a political artist places emphasis on a crucial aspect of her work and beliefs, but at the expense of exploring some of the contradictions and ambivalences towards art and politics revealed in her journal and letters. In a recent reappraisal of Kollwitz's work, Elizabeth Prelinger has argued that a more considered approach to Kollwitz's artistic and political beliefs is needed and has suggested that she lacked a 'clearly defined approach

to political matters' (Prelinger 1992: 78). Prelinger also pays welcome attention to the study of the female nude in Kollwitz's work, an area hitherto neglected in feminist criticism. The nude made up a significant proportion of Kollwitz's figure studies before 1910, particularly during the period when she was employed as a teacher at the Berlin School for Women Artists. And, although the nude does not constitute a central subject in Kollwitz's later work, when it appears it is frequently linked to the figure of the mother. Instead of representing a political ideology which can be simply read off the image, Kollwitz's 'maternal nudes', like much else of her work, suggest a complex and contradictory process of negotiation between the different meanings attached to motherhood.

The image of the mother, often breastfeeding her child, appears throughout Paula Modersohn-Becker's mature work from her first entry into the artistic colony of Worpswede in 1897 until her premature death, three weeks after the birth of her own daughter, in 1907. While her early studies of peasant mothers were initially influenced by the genre style of Fritz Mackensen, her teacher at Worpswede, she developed an independent approach culminating in the large naked mother figures of her late works. In her monograph on Modersohn-Becker, Gillian Perry suggested that: 'These anonymous monumental mothers are themselves symbols of a mysterious life-giving process. In their detachment they seem to reflect some of Paula's own ambiguous attitude to motherhood' (Perry 1979: 59). Modersohn-Becker's images have often been interpreted with reference to contemporary ideologies of primitivism.[6] In a number of self portraits, for example, her *Self Portrait with an Amber Necklace*, 1906, Modersohn-Becker did indeed represent her sexual identity in metaphors of nature, making visual connections between her own body and the flowers and foliage as symbols of fertility which surround her. While such paintings may reinforce a traditional encoding of the female body with nature, Modersohn-Becker was employing one of the few tropes available to a woman of her class at a time when the representation of female sexuality was problematic for a bourgeois woman artist. We may see her work not so much as an instinctive response to nature, but as a strategy with which to address the *absence* of a visual language of the body available to women artists in the 1900s.

The contrast that is drawn between the two artists in terms of their respective iconography of motherhood does not adequately address the complex political coding of maternal discourses in Germany at the turn of the century. Moreover, it disguises the real conflict which *both* artists faced in addressing the representation of motherhood within the context of prevailing cultural attitudes to femininity and to art. For Modersohn-Becker, as indeed for Kollwitz, ambivalence in the representation of motherhood could not simply be a personal matter. It was the product of a profound cultural rupture between the role of the artist and the role

of the mother in the period. This conflict can be seen to operate through a number of parallel and related dualities in both artists' work: between the self-portrait and the nude; the nude and the mother, and between visual representation and maternal origin.

THE BODY OF THE ARTIST AND THE BODY OF THE NUDE

By taking account of a specific set of configurations around gender, artistic identity and motherhood in Germany at the turn of the century it is possible to open up different readings of the maternal body in the work of Kollwitz and Modersohn-Becker. Both artists produced images which were informed by contemporary debates about women and sexuality in German political and cultural circles. For an artist who was also a woman to paint the nude and, moreover, the nude body of the mother, was to confront directly the contemporary inscription of gender difference on the body. Study of the nude was of crucial interest to women artists in the early modernist period because it was the point of intersection for contemporary discourses on gender and art. Mastery of the female nude was central to the construction of artistic identity in the nineteenth century and the site of a specifically gendered relationship between the male artist and female model. Its elements had come to represent a fundamental metaphor for creativity in modern European art: the artist as master of the gaze and of the natural world, signified through the naked body of a woman.[7]

By the 1900s, the relationship between the male painter and the female model was firmly entrenched as a central image by which to define artistic identity in both popular myth and painterly imagination. In a work by the German painter, Lovis Corinth, *Self Portrait with Model*, the artist placed himself high in the canvas facing squarely out of the frame, his gaze and his body commanding the pictorial space. He looks over the head of the model whose back is turned towards us, her face hidden against his shoulder and one hand laid on his breast. His arms frame her body but, rather than returning her embrace, he holds a brush in his left hand, a palette and brushes erect in his right. Corinth's bravura signature and the date and place of execution – 1903 Berlin – appear to either side of the artist's head, as though confirming his ownership of the image *and* its occupants.

The model here is his wife, Charlotte Berend. In painting himself with his wife, Corinth referred to a type of artist's self-portrait established by Rubens in the seventeenth century. But the painting also recalls more recent precedents in nineteenth-century images of the ideal bourgeois couple, where the wife is shown as support and helpmeet to her husband, the man looking outwards to the world, the woman turning to him for her protection.[8] Corinth thus proclaimed his own status as a successful

artist in command of the language and traditions of art. In so doing, he legitimated his position culturally through accepted norms, constructing an image which conflated two kinds of gender relationships, that of male artist and female nude and that of husband and wife. The portrait can thus be seen to authorize an expected – and gendered – reading. At one and the same time, *Self Portrait with Model* affirms the prescribed relationship between husband and wife, and effaces Charlotte Berend's professional identity as an artist practising in her own right.[9] In the face of such phallic mastery, how was it possible for a woman artist to assert her own identity and to engage with such a deeply gendered terrain as the nude?[10] Those images by women which combine self-portraiture with the nude articulate the problem of representing this psychic split between feminine and artistic subjectivity.

A self-portrait, like the act of writing a journal or a letter, constructs the self as other, making available to others a particular representation of the subject which the author has selected. The autobiographical is thus not an unmediated expression of inner being, but the production of a fictive self which functions as a form of self 're-presentation'. For a male artist like Lovis Corinth, this process could legitimate an existing and accepted public identity, but for a woman it was far more problematic, involving a conflict between the 'public' and 'private' self.[11] It is in this light that we may understand the significance of the repeated self-portraits which Modersohn-Becker and Kollwitz produced throughout their lives in terms of a need to produce the self both as artist and as woman.

In an early work by Käthe Kollwitz, *Self Portrait and Nude Studies*, 1900 (Plate 4), the juxtaposition of the artist's head and the nude body is striking. This preparatory study was one of a series for an etching, *Life*, in which Kollwitz superimposed her portrait head on a group of standing nudes that appear on the left-hand side of a symbolic triptych. In this drawing, the artist's vertical profile is marked off from the reclining nude torso by an area of intense shaded black which throws the face into harshly lit relief. In contrast, the female body is drawn frontally, the strongest accent of shadow marked by a brown brushstroke directing attention between the legs, a focus which appears to correspond to the artist's line of sight. The fragmenting and severing of the female sexual body in a way which both emphasizes the genitals and their exposure to the viewer, is more familiar today in relation to the pornographic gaze. It is with a sense of shock that we see it here. The image seems to suggest something of the sexual objectification implicit in the artist's controlling look but, by placing her own profile head in the place where the missing head of the nude would be, Kollwitz reveals that she too is the object of the gaze – she is looked at as well as looking.

At the time when Modersohn-Becker, Kollwitz and Corinth were producing their self-portraits in the 1900s, questions of gender and

Plate 4 Käthe Kollwitz, *Self Portrait and Nude Studies*, 1900, graphite, pen and black ink, 280cm x 445cm.

creativity and women's dual role as biological and as intellectual producers were being fiercely debated in Germany. The identities of 'woman' and 'artist' were considered by many to be mutually exclusive. These issues had become a matter of public debate as a result of the emergent feminist movement in Germany in the last decade of the nineteenth century, a debate which centred on motherhood as a primary concern. Given the conservative bias of the official art world in Berlin, it is not surprising to find the art historian, Karl Scheffler, arguing in *Die Frau und die Kunst*, 1908, that women lacked the will and the talent to become creative artists, being better suited by nature to the performing arts.[12] But anti-feminists and feminists alike showed a surprising consensus in their attitudes towards women as creative artists. For example, the Swedish writer, Ellen Key, whose ideas on motherhood became so influential on the German women's movement at the end of the 1890s, also believed that women's talent was for 'receptive' rather than 'creative' genius and that, lacking true originality, they were more suited to acting and singing. Even a radical feminist like Lily Braun argued in *Die Frauenfrage*, 1901, that women were more capable in interpretative roles than in the creative arts.[13]

Such views simultaneously reinforced women's traditionally exhibitionist role and prohibited them from entry into the sphere of cultural production on equal terms with men. Margaret Whitford has suggested that: 'In the traditional repartition of roles, women *represent* the body for men. The resulting split between intelligible and sensible then becomes difficult to shift, because it appears to be the basis of all thought' (Whitford 1991a: 62).

The normative pairing of male artist and female model reproduces that fundamental gendered division between the 'intelligible and sensible', mind and body, in western thought. In this division of roles, the artist may look at, but not inhabit the body of the woman. As Jane Gallop has argued, 'if we think physically rather than metaphysically, of the mind–body split *through the body*, it becomes an image of shocking violence' (Gallop 1988: 1).[14]

Kollwitz's image suggests something of the violence that this split in subjectivity might engender for the woman artist. Her inability to resolve the separation between the self-portrait head and the nude body reveals the division between the artist who has the right to look and the female body as object of the gaze. In a violent splitting of head from body, she places herself at one and the same time in the masculine and feminine position, at once subject and object, a division which she was as yet unable to resolve within the terms of contemporary discussion of women and art.[15]

In feminist writings on science, the concept of detachment or objectivity has been connected to a specifically masculine subjectivity, the desire

for a separation between an observer and the thing known, the subject and object of knowledge. This has been linked to the denial of maternal origin and the fantasy of self-generation, of being father or mother to oneself.[16] The fantasy of a self freed from connection to the mother is necessary, according to psychoanalytic accounts, for socialization into the symbolic order and the correct assumption of sexual difference. This psychic splitting between subject and object may suggest another level on which the dislocating effect of Kollwitz's *Self Portrait and Nude Studies* can be explained. Unlike the male artist, Kollwitz cannot simply occupy the position of detached observer, since to do so would be to negate her own body. Through the act of representing the female body as object, the male artist is able to re-enact an Oedipal separation of the child from its mother. But for a woman artist to represent the female body is to confront the question of likeness as well as difference, of proximity to, as well as distance from the maternal body. The body of the artist and the body of the nude – what is at stake here is the separation of the two. If the body of the artist was permitted to women, it was only in so far as their own bodies, and specifically their bodies *as* mothers were denied.

THE BODY OF THE MOTHER

Combining commitment to their work as serious professionals with responsibilities for children was a source of tension and anxiety for many women artists of the period. A reading of Modersohn-Becker's and Kollwitz's letters and journals reveals a continual process of negotiation between their professional commitment to work and personal expectations of marriage and motherhood. The struggle to define their artistic identities against the claims of family, friends and social convention was hard won. Käthe Kollwitz's sister students at the Munich School of Women's Art in the 1880s had believed that marriage and an artistic career were incompatible, demanding celibacy as the ideal state for a woman artist. She herself later recorded the tensions between motherhood and work in her diaries, emotionally committed to her two sons but resentful of time taken up when she was unable to work.

For Paula Becker, marriage to Otto Modersohn in 1901 had offered the opportunity of continuing to work in the relative freedom of the artistic colony of Worpswede, the support and encouragement of an older, more established artist, and a degree of economic independence from her own family. But she began to feel constricted by the narrow artistic outlook of Worpswede and the expectations of a shared married life, which included taking on the maternal responsibility for Modersohn's daughter from a previous marriage. She sought escape in Paris, where she worked during 1903 and 1905, finally returning to Paris in 1906 after breaking with Otto Modersohn.

Earlier, 1901–2 had marked a turning point in her work and, in a number of letters and journal entries written at the end of 1901 and in the following year, she linked her experiences of marriage with statements on the development of her work. Significantly, she used imagery of birth and fertility to describe the progress of her painting: 'There have been three young wives in Worpswede for some time now. And the babies are due around Christmas. I'm still not ready. I must wait awhile so that I will bear magnificent fruit' (22.10.1901) and:

> There are times when this feeling of devotion and dependence lies dormant. . . . Then all at once this feeling awakes and surges and roars, as if the container would nearly burst. There's no room for anything else. My Mother. Dawn is within me and I feel the approaching day. I am becoming something (6.7.1902).
>
> (Modersohn-Becker 1980: 201–11)

Becker's growing self-confidence in her abilities as a painter recurs as a theme in her letters and journal entries of these years. But the intellectual atmosphere in which she was working in the 1900s made it especially difficult to resolve the conflict between her identity as a woman and that as an artist. The reiteration of her desire and will to paint must be read against the failure to recognize her independent status as a painter on the part of her fellow artists at Worpswede and of her family.[17] She appeared to need to represent herself as an artist, both to herself and to others, in her private writings and in a series of self-portraits from these years.

In letters written home and diary entries during her fourth and final visit to Paris in 1906, Modersohn-Becker makes a number of references to her own sexuality and potential pregnancy. Her comments suggest an ambivalence in which the attraction of and desire for motherhood is mixed with an increasing sense of the failure of her own marriage. Having left Otto Modersohn behind in Worpswede, she felt herself to be standing between her old life and a new identity as an independent artist. In a letter to her mother dated 8 May 1906, she wrote: 'Now I am beginning a new life. Don't interfere, just let me be. It's so very beautiful. This last week I've been living as if in ecstasy. I feel I've accomplished something good' (Modersohn-Becker 1980: 286).

It was in May 1906 that she painted *Self Portrait on Her Sixth Wedding Day* in which she depicted herself pregnant, naked from the hips up, her arms gently encircling her swollen belly (Plate 5). Unusually, Becker signed and inscribed the canvas 'I painted this at the age of thirty on my sixth wedding day. P.B.', the date marking the fifth anniversary of her marriage on 25 May 1901. She thus deliberately chose to represent herself as pregnant at the precise moment in her life when she had decisively rejected the identity of wife and mother. This *Self Portrait* is often referred to as anticipating her actual pregnancy by some mysterious and intuitive process,

Plate 5 Paula Modersohn-Becker, *Self Portrait on Her Sixth Wedding Day*, 1906, oil on board, 101.5cm × 70.2cm.

an interpretation which confirms the prevalent critical view of Modersohn-Becker as a 'primitive' artist. Her premature death as a consequence of childbirth in the following year after she had returned, under pressure, to her marriage, has overdetermined this view of her work.[18]

A different reading of *Self Portrait on Her Sixth Wedding Day* would suggest that, here at least, Becker is not representing motherhood as a natural state but as a metaphor, not least in the unusual combination of pregnancy with a nude self-portrait. Becker confronts her own image as pregnant Other – that which she both desires and has refused – in order to maintain her separate identity as an 'artist'. According to Lacan's account of the acquisition of sexed identity, the mirror image reflects the self as coherent, but this image of coherence is a fantasy; a necessary construct through which the human subject is able to enter into possession of language and make sense of the social world. In Becker's *Self Portrait*, the image of motherhood is just such a fantasy, a temporary moment of coherence, and this may explain how the painting can hold together disparate elements with such apparent ease. It is at one and the same time an individual portrait and an emblematic pregnant body, a private reference to her marriage and the public statement of a nude. These subjective contradictions are suggested in the formal contrast between the strong modelling of her head and right hand and the paler tonalities of the body and the left arm which cradles her belly. These latter are painted so that the form of the body merges into the grey patterned wall behind, suggesting an insubstantiality of the flesh itself.[19]

In her essay 'Stabat Mater', Julia Kristeva explores the implications of the cult of the Virgin Mary for the construction of femininity and motherhood. Within a psychoanalytic framework deriving from Lacan, Kristeva addresses the question of maternal subjectivity, examining the relationship between the patriarchal ideal and the lived, non-symbolic aspects of giving birth. She defines the maternal as: 'the ambivalent principle that is bound to the species on the one hand, and on the other stems from an identity catastrophe that causes the Name to topple over into the unnameable that one imagines as femininity, non-language or body' (Kristeva 1986a: 163). Kristeva's definition of the maternal as 'bound to the species' recalls debates in Germany at the turn of the century in which the concept of motherhood was closely linked to eugenics. That it also represents a crisis of identity in which the 'unnameable' feminine body is made present, suggests something of the conflicts underlying the repeated image of the body of the naked mother in Paula Modersohn-Becker's work. For, according to Kristeva's analysis of the maternal, it entails a separation and loss of self:

> So, to imagine a mother as the subject of gestation . . . is simultaneously to admit the risk of a loss of identity and to disavow it. It

is to acknowledge that we are shaken by biology, by the unsymbol-
ised drives and that this escapes social exchange, escapes
representation of the given object, escapes the contract of desire.
(Kristeva 1981: 158–9)[20]

By imagining herself as pregnant, Becker is able to give a symbolic form
to the maternal state of lost identity and, simultaneously, to 'disavow' it.
It is significant that she chose the visual prototype of the sacred womb,
the *Madonna del Parto*, in which the Virgin Mary is represented in preg-
nancy.[21] For in such images, the Madonna's body becomes symbol of the
'virginal maternal', the impossible duality of inviolable and fertile body
which is at the heart of the Christian ideal of womanhood. In represen-
tations of the Virgin Mother, the female body appears as a sealed vessel.
As Lynda Nead has argued, one of the principal functions of the female
nude in western art has been the containment and regulation of the
female sexual body:

> The forms, conventions, and poses of art have worked metaphori-
> cally to shore up the female body – to seal orifices and to prevent
> marginal matter from transgressing the boundary dividing the inside
> of the body and the outside, the self from the space of the other.
> (Nead 1992: 6)

But if, as Nead suggests, the function of the nude is to make 'safe' the
permeable borderline between nature and culture, the maternal body
potentially disrupts that boundary. For the maternal body points to the
impossibility of closure, to a liminal state where the boundaries of the
body are fluid. In the act of giving birth, as well as during pregnancy and
breastfeeding, the body of the mother is the subject of a constant exchange
with that of the child. Whereas the nude is seamless, the pregnant body
signifies the state in which the boundaries of inside and outside, self and
other, dissolve. In Kristeva's words, the maternal body is 'a thoroughfare,
a threshold where "nature" confronts "culture"' (Kristeva 1980: 238).

In this respect, the figuration of the maternal nude is a contradiction in
terms: a profound rupture in representation. But, as Kristeva argues, in
the Christian image of the Madonna the potential threat of the maternal
body is contained within the imaginary construct of the virgin birth:
the body inviolate. Such an inaccessible ideal of femininity cannot be
achieved except by the sacrifice of sexuality or by, 'if she is married,
one who leads a life that would remove from the "earthly" condition
and dedicate her to the highest sublimation alien to her body. A bonus,
however: the promised *jouissance*' (Kristeva: 1986a: 182).

Paula Becker had removed herself from the 'earthly' condition of her
marriage, to which she referred in the inscription on the self-portrait. The
jouissance which she chose at this moment over biological motherhood

was the 'ecstasy' of creativity which she described in her letter of 8 May. Her desire for a child could be sublimated through symbolic representation. The 'immaculate conception' of the *Self Portrait* was achieved in the production of the maternal body as *representation*, without the loss of identity which Kristeva argues is entailed in actual motherhood. The redoubling of the image of containment signified in the figuration of the nude and the virgin mother is also suggested by the self-possession of the figure herself. The inviolability of the pregnant body, protected gently by her enfolding arms, is held at a distance from the spectator by the artist's direct yet inscrutable gaze. It indicates a condition of temporary suspension between subject and object, between the virginal and maternal, and between the identity of artist as the maker of images and mother as the maker of flesh.

MATERNAL DISCOURSES

Both Modersohn-Becker and Kollwitz were producing their images in the context of fierce debates about the role of women, sexuality and motherhood. The terms of these debates are particularly revealing for a reading of their representations of the maternal nude. In a period when attitudes to women's roles and to female sexuality were being reassessed, the debate about motherhood came to be a central strand of reformist as well as of reactionary politics. The difficulty of disentangling progressive from conservative thinking on the subject indicates something of the ideological and personal tensions women artists experienced between the desire for autonomy and the desire for children. This was reinforced by a prevailing biological determinism in scientific and popular discourses which was often shared by those who supported women's rights to social and sexual equality.

In Germany, as in Britain and France, between 1890 and 1914 considerable political and social anxieties were being voiced about the decline both in numbers and 'quality' of the population, concerns which focused especially on the role and responsibilities of mothers as nurturers, homemakers and educators.[22] By the 1900s, the 'good' mother had become the focus of widespread concern about women's function in the family and in the perpetuation of the race. While the rising concern about motherhood was expressly linked to the eugenic demands of the Wilhelmine state for improvement in the Imperial race, similar views were also voiced by feminists and socialists at the turn of the century. Social Darwinism and scientific socialism, anthropology and religion, were all contributory elements within a discourse which placed motherhood at the centre of social and sexual reform. As Felicia Gordon has pointed out, in debates on reproductive rights, positions 'operated in sometimes surprising relation to one another producing intriguing alliances and conflicts within

left/right, feminist/anti-feminist, imperialist/anti-imperialist, pro-natalist/ neo-Malthusian groupings' (Gordon 1992: 388).

Becker's and Kollwitz's different representations of motherhood have often been linked respectively to the theories of two influential nine-teenth-century male writers, Johannes J. Bachofen and August Bebel. In *Myth, Religion and Mother Right* (1861), Bachofen had argued that the most primitive stage of human development was represented by a matri-archal society which had the relationship between mother and child at its heart:

> The relationship which stands at the origin of all culture, of every virtue, of every nobler aspect of existence, is that between mother and child. . . . Woman at this stage is the repository of all culture, of all benevolence, of all devotion, of all concern for the living and grief for the dead.
>
> (Bachofen 1967: 79)

Bachofen's theories of evolution, in which a universal matriarchal stage was superseded by an intellectually and technologically superior patriar-chal society, were based on a reading of myth and symbol. Although his methods were largely discredited in empirical anthropology by 1900, his model of matriarchal culture continued to exert an influence into the twentieth century.[23] His ideas were certainly known in the Worpswede circle, for example, where Rainer Maria Rilke read his work, and his theories held an appeal to the poetic imagination long after he ceased to affect scientific thought.

The view that motherhood was an essential female function also connected a socialist thinker like August Bebel with the earlier anthro-pological theories of Bachofen. For example, three chapters of Bebel's influential book *Women under Socialism* (1879) were devoted to ques-tions of marriage, population and eugenics. His book, which was discussed by Käthe Kollwitz, her brother and friends in the early 1880s, presented powerful arguments on behalf of women's political and legal equality. Arguing against women's restriction to the domestic sphere, Bebel never-theless maintained that motherhood was woman's 'natural' role, although this should not be used to exclude women from economic and political rights. Rather than opposing Bachofen, Bebel's ideas were influenced in crucial respects by prevailing maternal ideology, and both writers were influential in German progressive circles by the turn of the century. What otherwise very different political and theoretical positions held in common was the view that woman's role in modern society was still bound up with her *biological* function as mother.

While the writings of both men were clearly significant, a close con-nection can also be traced between Modersohn-Becker's and Kollwitz's maternal imagery and debates in contemporary German feminist

circles, where pro-natalism had a more profound effect on the women's movement than in Britain or the United States.[24] It is the emphasis on motherhood as essential to *all* women which also provided the ground for contemporary debates among German feminists. One of the most influential figures in this respect was the Swedish writer, Ellen Key, whose ideas had considerable impact after the publication of her essay *Missbrauchte Frauenkraft* (Women's Misused Energy) in Germany in 1898. Opposing the emphasis on equal rights within bourgeois feminism, Key argued that women's entry into male professions was a misuse of their energies which would be better spent on their innate talent for mothering, which she saw as women's 'highest cultural task'. Women, she argued, could not both achieve in the public sphere and successfully continue to mother. By competing with men they would lose their primary role and thus endanger the species. Key's writings emphasized a positive evaluation of sexual difference in which women's role as mothers should be highly valued and freed from economic dependence and domestic drudgery through social and legal reforms. She also, controversially for the time, supported the right of every woman to choose to bear children whether married or not, and was attacked for this stance by anti-feminists. In her later writing, Key explicitly linked sexual reform with eugenics:

> Motherliness must be cultivated by the acquisition of the principles of heredity, of race hygiene, child hygiene, child psychology. Motherliness must revolt against giving the race too few, too many, or degenerate children. Motherliness must exact all the legal rights without which woman cannot, in the fullest sense of the word, be either child-mother or social-mother.
>
> (Key 1983: 175)[25]

Phrases like 'race hygiene' seem profoundly shocking in an era of ethnic cleansing, but reveal the extent to which sexual reform and eugenics were linked in progressive feminist and socialist circles in the early twentieth century. Key's views helped to define the terms of debates about motherhood in the 1900s and were taken up by many German feminists. These included Helene Lange, editor of *Die Frau*, and Gertrude Baumer, leader of the bourgeois women's movement, who argued that women had a cultural mission to restore personal values and 'soul' to the German people. While Lange and Baumer represent a conservative strand within the women's movement, the argument that women's role should be to extend domestic values and a female viewpoint into the public sphere, linked certain feminist positions to the critique of capitalism and materialism also to be found at the turn of the century in progressive artistic circles, such as that at Worpswede. The attack on the over-civilization of contemporary life and a desire to restore essential German

Volk values, can be seen to share contemporary avant-garde preoccupations with primitivism and its association with directness of expression in art.[26]

Paula Becker's membership of the Worpswede colony put her in touch with progressive and reformist tendencies at the turn of the century. Her own attitude to feminism was ambivalent, but she was certainly aware of current feminist ideas, attending a feminist lecture in Berlin in 1897. Writing of a visit to Heinrich Hart's 'New Community' in Berlin in 1901, Becker dismissed the women she saw there with the comment 'Too much vanity, long hair, powder and too few corsets', clearly lacking sympathy with urban New Life socialists and feminists (Modersohn-Becker 1980: 178). She did identify very strongly with other women, however, both in an intensely felt relationship with the sculptor, Clara Westhoff, and in frequent letters to her mother, her aunt and her two sisters, Milly and Herma.[27] But it seems likely that her provincial bourgeois background and her youthful identification with the naturalism of Worpswede predisposed her against the progressive 'equal rights' feminism she came across in Berlin. The emphasis on women's unique mission to restore personal values in a materialist society suggests a more likely sympathy with the cultural theories of Ellen Key's German followers.

The characteristics of Modersohn-Becker's late nudes are usually ascribed to the formal influences of archaic and modern art that she saw in Paris, for example, the antique heads in the Louvre from which she made drawings in 1903, and contemporary artists' work she admired, particularly Rodin and Cézanne. Viewed within the context of contemporary maternalist debates, these late nudes can be seen to form a link between French avant-garde aesthetics and the positive evaluation of motherhood and female sexuality in the writings of Ellen Key. This seems to be especially the case in the series of mother and child paintings of 1906–7 such as *Kneeling Mother with Child at the Breast*, 1907. Here, the monumental figure of the mother towers again a background of formalized fruit and foliage. As Lisa Tickner has described, these are 'images which glorify a protective, naked, fecund maternity' (Tickner 1980: 34). In this painting, the mother is shown in an exalted state of 'nature', in a symbiotic harmony with the child at the breast. It seems close in feeling to a passage from Ellen Key's essay, 'The Renaissance of Motherhood', written in 1914:

> In every strong maternal feeling there is also a strong sensuous feeling of pleasure . . . which thrills the mother with blissful emotion when she puts the child to her breast; and at the same moment motherliness attains its most sublime spiritual state, sinks into the depths of eternity, which no ecstatic words – only tears – can express.
>
> (Key 1983: 173)

This elevation of motherhood with its mysticism and biological essentialism was questioned by those German feminists committed to equality in the public spheres of politics, education and work. But, it is significant that even socialists like Clara Zetkin, leader of the proletarian women's movement in the Social Democratic Party (SPD), were affected by pro-natalist arguments. While Zetkin rejected the biological basis of women's 'cultural mission', and argued for the rights of working women to political and economic independence, she nevertheless supported the view that women's participation in public life benefited them *as* mothers, and was critical of the 'New Woman' in British and American feminist movements:

> The woman who, as a fully developed person, is at home outside the home will achieve the highest. She will bring her children a powerfully developed humanity and progressive strength. The goal of the women's movement is not the manly woman.
>
> (Zetkin, *Mannweib*, 1902,
> quoted in Goodman 1986: 120)

Zetkin's position was that woman's full humanity would only be achieved when she participated fully both as mother and worker. But while she and other socialists did not subscribe to the essentialism of Key's maternalist views, nor did they fundamentally challenge the sexual status quo and the prevailing ideology of motherhood within monogamous marriage on which it rested.[28]

The Bund für Mutterschutz (League for the Protection of Mothers) was the organization which united radical, socialist and conservative strands of the German feminist movement around issues concerning the improvements to maternity rights and benefits. The Bund was set up under the influence of Ellen Key, who spoke at its founding meeting in 1905. Like Key, the Bund argued for women's freedom to choose motherhood irrespective of their sexual status. Arguments on behalf of motherhood were thus linked to greater sexual freedom for women and, under the leadership of Helene Stoecker, the Bund became associated with the sexual reform movement in Germany before 1914. The Bund also presented eugenic arguments concerning the fitness of the race alongside demands for women's rights in its campaigns on behalf of working-class women. In a petition to the Reichstag in 1907, the Bund called for comprehensive maternity insurance to be included in health insurance for working women both on the grounds of the health of mothers and children and the needs of the state for healthy citizens and soldiers.[29] Such a close connection between feminist demands for women's social rights and the elevation of the mother as guardian of racial identity seems incompatible to modern thinking. Yet it is in this context that different readings of Käthe Kollwitz's recurrent images of motherhood can be made. Kollwitz's maternal iconography

registers shifts between the different values and meanings attached to motherhood within German feminism. Her political sympathies were primarily with the socialist women's movement in the SPD although she never became a member of the party. But she also had direct links with the Bund für Mutterschutz, having donated two drawings to the Bund in Leipzig in 1909, including one of a mother and child. It is easy to see a similar commitment to improving the conditions of urban working-class women in her images of exploitation, poverty and homelessness, for example, the series of drawings, *Portraits of Misery*, which she produced for the Munich satirical journal *Simplizissimus* in 1909. Kollwitz may also have known of a play by Ida Strauss published in 1905 which was largely based on Ellen Key's ideas.[30] The play's theme of the death of a son as the result of his working-class mother's poor health and working conditions is very close to the social themes of Kollwitz's work of this period. Certainly, Key's concept of 'social motherliness' as a moral force within a society gripped by poverty, exploitation and war has strong resonances in Kollwitz's representations of urban and industrial life from 1908–9.

What has generally escaped critical discussion is the extent to which the social and historical specificity of a series like the *Portraits of Misery* is counterposed by a strong tendency to universalize motherhood throughout Kollwitz's work.[31] This is particularly marked in those images where the figure of the nude and the mother are combined. Thus, in a later work like *The Sacrifice*, from the woodcut series *War*, 1922–3, Kollwitz seems closer to Modersohn-Becker in choosing to strip the figure of specific social reference. Indeed, the naked mother and child are enveloped in a dark womb-like shape which recalls the natural forms of a leaf or flower. In dealing with the elemental relationships of birth and death both artists' work is shaped by contemporary discourses which represent the maternal as 'a threshold where "nature" confronts "culture"' (Kristeva 1980: 238) between the biological and the social.

TWO MATERNAL NUDES

In *Reclining Mother and Child*, 1906 (Plate 2), Modersohn-Becker paints the mother and child as though they exist outside social discourse. The setting is minimal, a white sheet and pillow against a midnight blue ground, and the woman's body is removed from any context which might define her individual history. Unlike her many paintings of peasant mothers, this is not a secular Madonna surrounded by symbolic flowers and fruits, but a figure whose only identity is literally *embodied*. In a number of preliminary studies for the painting, the artist explored various relationships between the mother and still unsexed child which differ in the ways in which the figures are shown, being either separated or linked by their different poses. In one drawing the child sits upright against its mother's

thighs while she lies slumped, seemingly exhausted and unaware, her breasts and arms slack. In another study, which prefigures the final painting, the body of the mother and child mirror one another in complete physical unity, the child's head is pressed against the mother's face. Like the moment after birth when a new born baby is placed on the mother's belly, the image signifies a connection between internal and external space. It is as though the child, lying embraced in a fetal position, were still a part of the mother's own body.

In psychoanalytic terms, this represents the state of primary narcissism when the infant does not yet perceive itself to be separated from the mother. Modersohn-Becker returns constantly in her representations of motherhood to this pre-Oedipal moment when mother and child are shown as one, either in the act of breastfeeding or, as here, in the intimate reciprocity of their two bodies. This intense physical relationship of the mother and child provides one means of access to the experience of the maternal body. As viewers we are returned to the possibility of primal pleasure, to the buried memory of the maternal object. In representing the state before separation from the mother, before awareness of sexual difference occurs, Modersohn-Becker here 'escapes' the spectacle of the erotic. Pleasure in the power of sight – the voyeurism implicit in the nude – is replaced by the pleasures of touch. The physicality of the maternal experience and its psychic grounding in the body is suggested by the pervading sensation of weight in the painting itself; the paint is dense and flat, a dark line anchors the body to the ground.

Julia Kristeva describes this state before the child acquires language as the semiotic, anterior to the symbolic order of patriarchal structures and meanings and necessarily repressed on the child's acquisition of an independent social identity. She suggests that it is, among other things, through the creative process that the experience of the semiotic can be recalled in adulthood.[32] The connection that Kristeva makes between the conditions of artistic creation and the maternal state is clearly relevant to the representation of the maternal nude, and yet her account of the semiotic presents a paradox for the woman artist. In her essay 'Motherhood According to Giovanni Bellini' Kristeva likens the position of the artist to that of the mother but argues that, although analogous, the two are incompatible:

> The speaker reaches this limit, this requisite of sociality, only by virtue of a particular, discursive practice called 'art'. A woman also attains it (and in our society, especially) through the strange form of split symbolisation (threshold of language and instinctual drive, of the 'symbolic' and the 'semiotic') of which the act of giving birth consists.
>
> (Kristeva 1980: 240)

Here, Kristeva suggests that the relationship to the semiotic that is achieved through the making of art can be paralleled with that of giving birth. The 'artist' and the 'mother' represent two points of entry into the same experience, but while the artist may represent the maternal state, the mother may not 'represent' herself: 'the artist speaks from a place where she is not, where she knows not. He delineates what, in her, is a body rejoicing *(jouissant)*. The very existence of aesthetic practice makes clear that the Mother as subject is a delusion' (Kristeva 1980: 242). The problem here is not so much with Kristeva's assumption that the artist is male, as her assertion that birth is a process *without a subject*. The 'artist' and the 'mother' represent two opposite poles in which, on the one hand, the artistic intellect can interpret the maternal experience and, on the other, the maternal body merely enacts it. In separating artistic production from the subjectless, 'biological' experience of maternity in this way, Kristeva appears to reproduce the gendered mind/body split which is central to western systems of thought. Indeed, her formulation returns us precisely to the terms of those debates in Germany at the turn of the century in which artistic production and motherhood were defined as mutually incompatible. Kristeva's account of the semiotic then offers a means of thinking about how maternal origin might be represented, but only at the cost of denying subjectivity to the mother. But, what happens when the artist is a woman *and* a mother?

In Reclining Mother and Child, Modersohn-Becker describes a subjective space in which self and Other are inextricably linked. One way in which we can see this is in the unusual spatial construction evident in the painting as well as in some of the preliminary studies. The viewpoint is high, we look down upon the mother's body from above and yet, at the same time, it appears to tilt towards us in the upper part of the picture plane, curving around the foreground space. As viewers, we are thus placed both at a distance from *and* enfolded into the maternal body. The binary division between artist and mother in Kristeva's account, between the exterior and interior of the mother's body, is suspended. In its place, the 'maternal nude' simultaneously affirms artistic identity and opens up the possibility of representing the mother's body from a woman's point of view, in terms of likeness as well as of difference, of proximity as well as of separation. And yet, within Modersohn-Becker's painting, such maternal subjectivity can only exist in a space which is stripped of all social or symbolic reference. It is as though the dissolution of binary opposites can be represented only as taking place in a utopian space outside the realm of the social.

I want to argue that the same problem in representing the maternal subject is also present in Käthe Kollwitz's images of motherhood. Like Modersohn-Becker, Kollwitz deals with the mother–child relationship, but if the former represents a pre-Oedipal state of unity, then Kollwitz is

41

preoccupied with maternal loss. As most critics have noted, the death of a child is a repeated theme in Kollwitz's many images of mothers and children throughout her long career. Her choice of subject has frequently been linked both to the death of her younger son Peter, who was killed in 1914 at the outset of the First World War, and to the experiences of the working-class women whom Kollwitz knew from her husband Karl's surgery, for whom the death of a child was a frequent occurrence. But, while this biographical context is undoubtedly important, it cannot explain the frequent repetition of images of the death of children which occur even in her earliest work, for example, in *Poverty* (1893–4) from the graphic cycle, *A Weavers' Rebellion*. The psychoanalyst, Alice Miller, has located this obsession with a child's death in the repressed experiences of Kollwitz's own mother who lost her first two babies in infancy.[33] In a fascinating reading of Kollwitz's childhood memories drawn from her diaries, Miller argues that it is the shadow of her dead siblings and her own mother's loss which haunts Kollwitz's work. Kollwitz's images take on a psychotherapeutic function, but in Miller's interpretation, are still located within an essentially biographical framework and, moreover, one which does not acknowledge the complex articulation of the relationship between mother and artist in Kollwitz's own adult life.

This fundamental preoccupation with maternal loss can be seen at its most powerful in *Woman with Dead Child*, 1903 (Plate 3), where the naked body of the mother grips and enfolds the body of her dead son. Kollwitz used herself and her seven-year-old son, Peter, as models for the etching, although there is nothing specific in the image to suggest a self-portrait.[34] In a similar treatment of the theme, *Pietà*, 1903, for which she made numerous studies, Kollwitz drew directly on the Christian icon of the Virgin Mary mourning her dead son in her lap, and in this image the mother's face laid on the body of the child expresses an entirely human experience of grief and tenderness.[35] In the final version of *Woman with Dead Child*, the glowing gold ground recalls its medieval and Renaissance prototypes, but the mother is rendered anonymous by the pain which convulses her. Her massive size and strength suggest a non-human quality and, as in Modersohn-Becker's *Reclining Mother and Child*, the figure exists outside any specific social space. In contrast to that blissful unity of mother and child, Kollwitz's mother bespeaks a terrible loss: the splitting of the maternal body. In *Woman with Dead Child* we see the violence of separation of the child from the mother in the process of gaining independent identity. In a reversal of the passage of birth, the mother absorbs the child into her own body; she possesses and is possessed by it. The intensity with which the mother's face is pressed to her son's throat and chest suggests she is trying to ingest his body, to reincorporate it back into her own, as well as to breathe life into it. Kollwitz's friend, Beate Bonus Jeep, described her initial reaction to the image in perceptive terms:

'A mother, animal-like, naked, the light coloured corpse of her dead child between her thigh bones and arms, seeks with her eyes, with her lips, with her breath, to swallow back into herself the disappearing life that once belonged to her womb' (quoted in Prelinger 1992: 42). The devouring mother is a familiar figure in representations from the Greek myth of Medea to the modern horror film, *Alien*.[36] Psychoanalysis offers us an account of this monstrous oral mother in terms of the infant's fears of engulfment in the maternal body. In the theories of Melanie Klein, the mother's body functions simultaneously as an idealized love object and source of threat and object of hate.[37] But, in *Woman with Dead Child*, it is the mother's pain of separation rather than the child's which we are forced to confront. In a recent analysis of Kollwitz's treatment of the figure of the mourning mother, Angela Moorjani draws on Kleinian theory to argue that the dual themes of generation and sacrifice are central to her images:

> At the same time projections of the dangerous oral mother fantasy and their denial, these images stage the maternal passion to preserve and absorb. The web of lines linking mother and child and the circular womblike compositions, containing life and death struggles, keep these images suspended between the destructive and reparative conceptions.
>
> (Moorjani 1992: 113)

Moorjani concludes that Kollwitz's imagery is caught in an impasse in which the maternal can only be represented in terms of primal fantasies of the archaic mother as either generative or destructive.

The duality of representation which implies both the loss and the threat of the mother, is repeated in a later series of images which reinforce the connection Kollwitz made between creativity, female generation and death. In an unusually explicit image, *Liebesszene I* (Love scene I), belonging to the series of *Sekreta* drawings made around 1910 during the period of her affair with the Viennese publisher, Hugo Heller, Kollwitz represents the act of sexual intercourse in an extraordinarily direct way. These drawings were never exhibited, and such a powerfully erotic image with the suggestion of women's sexual passion would have been unimaginable as a public statement by a woman artist, although there are some parallels in women's private writings of the period.[38] This drawing can be closely related to a series of symbolic etchings on the theme of death, woman and a child, also dating from 1910. In one etching, *Death and Woman* (Plate 6), the same pose for the woman in *Liebesszene I* is used in reverse. Here, however, it is not a lover but Death which embraces her, while her child clings passionately to her body. The representation of the sexual act and death, like the birth and death of a child, have become mirror images for each other. Each represents a moment of

engulfment and obliteration of individual identity, a passage of transition in which the fear of the loss of self is made present. It is not too far-fetched to suggest that the image of a child's death stood in this context for Kollwitz's continuing fear of loss of her own creative identity, in a transference in which she equated the maternal state with artistic productivity. In her diaries, Kollwitz recorded frequent periods of creative block when she could hardly work for months at a time. In an entry dated April 1910, following a repeated dream in which she again had a small baby, she wrote:

> No longer diverted by other emotions, I work the way a cow grazes, but Heller once said that such calm is death. Perhaps in reality I accomplish little more. The hands work and work and the head imagines it is producing God knows what. Yet formerly in my so

Plate 6 Käthe Kollwitz, *Death and Woman*, 1910, etching and sandpaper aquatint, 44.7cm × 44.6cm.

wretchedly limited working time, I was more productive because I was more sensual: I lived as a human being must live, passionately interested in everything.

(Kollwitz 1955: 53)

Maternal subjectivity is represented here by Kollwitz as the *condition* of artistic production rather than, as contemporary discourses insisted, its very antithesis.

Both Kollwitz and Modersohn-Becker can be seen to exemplify the difficult project of 'theorising and enacting [maternal] subjectivity and of finding adequate forms of representation for it' (to paraphrase Braidotti, 1991: 137). But the problem for the woman artist still remained: how to represent the mother as subject within a culture which provided no language or discursive framework for her creative expression. The nude lay at the point of intersection between discourses of femininity and sexuality on the one hand, and the construction of artistic identity on the other. While the nude was readily available as an image through which to affirm male artistic identity, women had to find their own ways of reworking its meanings. For both artists, the 'maternal nude' was one means by which they could address issues of their own sexual and creative identity at a time when the roles of artist and mother were viewed as irreconcilable. The figure of the maternal nude enabled Kollwitz and Modersohn-Becker to develop an iconography which avoided the conventional voyeurism of the nude and could offer a metaphor for a specifically female model of creativity. It provided a means of exploring their conflicting desires to inhabit the body of the artist and of the mother by linking two opposing terms of sexual difference. But the repeated figuration of the mother in their work also alludes to psychic conflicts involved in making the 'unnameable' female body present in representation. For Modersohn-Becker, the maternal body as a site of plenitude could only be represented as existing outside of social relationships. In Kollwitz's depictions of motherhood, the recurrent imagery of the dead child points to the fear of loss of her own identity as an artist. The artistic process could only mirror, but not resolve, the profound contradiction for women in a period when, to be a mother meant the loss of an individual and social self.

3

'A PERFECT WOMAN'
The political body of suffrage

'A perfect Woman, nobly planned,
To warn, to comfort, and command.'

These lines from Wordsworth's *Poems of the Imagination* conclude with a description of the half woman, half angel who occupies his waking dreams:

And yet a Spirit still, and bright
With something of angelic light.[1]

Wordsworth's poem represents an early version of the literary and visual ideal of femininity which was later to be more famously incarnated in Coventry Patmore's poem *The Angel in the House* (1854–62), and became the model for domesticated middle-class femininity in the latter half of the nineteenth-century. The same couplet was used to accompany an anti-suffrage cartoon designed by John Hassall for the National League for Opposing Women's Suffrage in 1912 (Plate 7). Open eyed, screaming and waving a placard demanding 'I Want a Vote', the figure epitomized the 'Punch version of a Suffragette', under whose disguise Constance Lytton had been arrested in 1910. For the popular press and sections of the public at the time, this image perfectly embodied the stereotype of the militant suffrage supporter. But what is at first sight merely a grotesque caricature articulates some of the key elements in the struggle for the vote: the right of women to express demands in their own voices and persons; the modernization of women's roles – signified here in the figure's contemporary dress – and the enactment of women's emancipation through their bodily presence in public and political space. To be sure, the cartoon mobilizes only negative connotations – loss of self-control, hysteria and a masculinized sexual identity – but the deliberate contrast between the image and the verse draws very precisely on the confrontation between the 'modern woman' embodied in suffrage and previous conceptions of an idealized femininity which prevailed until the First World War.

46

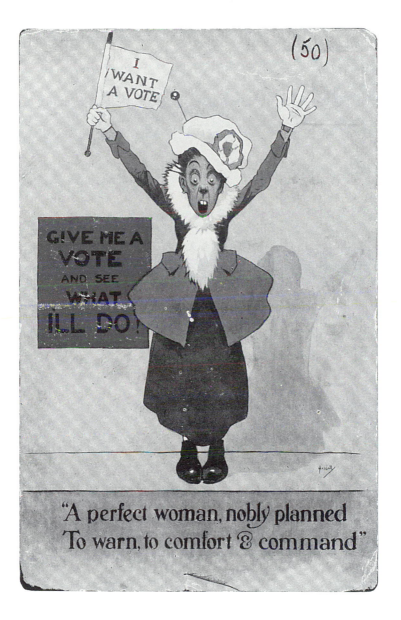

Plate 7 John Hassall, *A Perfect Woman*, 1912, anti-suffragette postcard.

In the following year, the same phrase was used to describe Joan of Arc as 'not only perfect patriot but perfect woman' in the *Suffragette*, the newspaper of the Women's Social and Political Union (WSPU) (9 May 1913). Joan of Arc had become a favourite embodiment of female heroism within the suffrage campaigns, having particular currency as a result of the campaign for her beatification, achieved in 1909, and subsequent canonization in 1920.[2] Her banner had been carried in the historic 1908 demonstration organized by the National Union of Women's Suffrage Societies (NUWSS) when 30,000 suffrage supporters marched through the streets and opened a new phase of mass suffrage campaigns. Figures dressed as Joan of Arc frequently appeared at the head of suffrage processions, for example, in the Women's Coronation Procession in 1911 (Plate 8). And, on 3 June 1913, Emily Wilding Davison, on the evening before she fell under the King's horse on Derby Day and was fatally injured, went to salute the statue of Joan of Arc at the suffrage 'All in a Garden Fair'.[3]

This particular conjuncture of poetic text and visual images suggests the focus of the intense debate between the suffrage movement and its opponents concerning the politics of sexual difference. The campaign for women's suffrage sharpened political anxieties around the nature of femininity which had already been raised by the spectre of the 'New Woman' in the 1890s. The representation of women, in terms both of the vote and of visual and verbal imagery, was crucial to each side in the debate. Both claimed to represent the 'perfect woman', but what each meant by perfect womanhood took on radically opposed meanings within different political constituencies and factions. In the visual images we are presented with a paradox. On the one hand, Hassall's anti-suffrage cartoon portrays, in stereotypical form, the image of a modern Edwardian woman. On the other, a real suffrage supporter represents herself in the guise of a part mythical, medieval hero. Within this paradox lie complex questions about the relationships between tradition and modernity in the suffrage campaigns, and the ways in which female symbols were mobilized to convey a complex social reality.

In this chapter, I focus on ways in which political values and meanings were inscribed on the bodies of women within the suffrage movement. For the suffrage militants, the female body came to stand as the ultimate symbol and defence through which 'Bodily purity came to mean rejecting men and embracing death for the vote' (Vicinus 1985: 276). The figure of the militant woman as embodied by Joan of Arc became a counter to the popular image of hysteria and deviancy attached to feminism. But, in calling upon conceptions of bodily purity to reinforce women's claim to moral superiority, how could emerging differences of class and sexuality within the suffrage movement also be acknowledged? How was 'the modern woman' to be represented?

Plate 8 Joan Annan Bryce as Joan of Arc in the Women's Coronation Procession, 17 June 1911.

POLITICS WRITTEN ON THE BODY

The issue of how a new female identity was to be embodied was central to suffrage debates. Should suffrage campaigns be seen as radically redefining what it meant to be a woman, articulating a significant shift in contemporary ideas about femininity? Or was the case for women's social and political rights to be made within the language and imagery of nineteenth-century conceptions of womanhood? Appeals to a 'true' female identity came to stand for a whole series of overlapping and conflicting understandings of the ways in which femininity was *written on the body* (Tickner 1987: 151). The visual and verbal images presented by and of women involved in the campaigns were a crucial part of the complex and contradictory set of debates circulating in the early twentieth century about women's rights and sexual roles.

One of the significant aspects of the suffrage campaigns in this respect was the importance they attached to visibility. Since women did not have a political voice – they were excluded not only from Parliament, but also from speaking at political meetings – they were forced to promote their cause through highly visible actions.[4] Beginning in 1908 huge public events, processions, pageants and demonstrations were orchestrated by all the main suffrage organizations. With the failure of mass demonstrations of popular support to sway the Asquith Government into sponsoring a suffrage bill, by 1912 the Women's Social and Political Union was focusing primarily on a campaign of direct action. The concept of 'agitation by symbol' was supplemented by 'propaganda by deed' according to the WSPU motto, 'Deeds Not Words'.[5] The significance of this slogan was twofold, not only in the sense of a commitment to acts instead of words alone, but of making their actions the *visible sign* of women's exclusion from the body politic. As Lisa Tickner suggests: 'For the Pankhursts, militant activity was itself a form of representation. It involved the public embodiment of a new femininity or what Christabel called "putting off of the slave spirit"' (Tickner 1987: 205). While there continued to be considerable differences about militant tactics which led to a series of splits in the movement by 1914, making the women's cause visible through a variety of means remained a central strategy of all the main suffrage organizations.[6]

The problem for middle-class women was that intervention into the public and political sphere, especially the increased militancy of the WSPU between 1911 and 1914, was constantly represented as transgressing the bounds of femininity. This unwomanly behaviour not only constituted a significant offence to upper- and middle-class decorum, but put their very sexual identity as women into question. Physical appearance was used as an index of femininity and mobilized ideologically by both sides in the debate. Fashion, and indeed rejection of fashion, was

one means through which political positions could be signified. The WSPU in particular attempted to represent 'true' womanliness to counter the popular image of an unruly 'shrieking sisterhood'. The fashionable dress of the suffragettes, even if wildly impractical in a violent fracas, implied conformity to contemporary dress codes and emphasized their femininity. But, as Katrina Rolley suggests, there were real contradictions involved:

> The use of the fashionable ideal to signify adherence to, or deviations from, the feminine ideal was fairly straightforward for anti-suffragists. For the suffragettes – who had to utilise definitions of femininity which were fundamentally at odds with the suffrage struggle – the process was ... a far more difficult one.
>
> (Rolley 1990: 67–8)[7]

In John Hassall's cartoon, the fashionable tailor-made jacket, fur tippet and gloves would have identified the suffrage supporter as a recognizable middle-class type in 1912. But at the same time, the figure's big boots, shorter skirt and ludicrous hat complete with political rosette – as well as her aggressive posture – clearly defined her as a militant.[8] Lisa Tickner points out that anti-suffrage propaganda tended to characterize suffrage supporters either as excessively feminine (hysterical) or as masculine (lesbian) in appearance. In this image the figure is both hysterical *and* masculine, thus raising the question of an ambivalent sexual identity. Countering the charge of deviancy presented real problems for suffrage women. They had to represent themselves as feminine and yet different from other women, without appearing to transgress sexual boundaries.

One way of evading the contradictions involved in representations of contemporary women was to use symbolic figures. Through identification with militant heroines from history, the donning of masculine accoutrements could be represented symbolically as women taking on the mantle of *female* heroism. As the model of the militant and martyr, a chaste hero who sublimated her passions to a higher calling, Joan of Arc provided a perfect vessel for militant suffrage ideals. In this context, one attraction of Joan for suffrage campaigners was her transvestism, symbolizing in this case not sexual deviancy, but spiritual victory over personal and sexual desires. The armour-clad maiden could be made to stand symbolically for autonomy and the control by women, not men, of their own bodies and sexuality.

THE 'GREAT TEMPLE OF WOMANHOOD'

Not the Vote only, but what the Vote means – the moral, the mental, economic, the spiritual enfranchisement of Womanhood; the release

of women, the repairing, the rebuilding of that great temple of
womanhood, which has been so ruined and defaced.

(E. Pethick-Lawrence, 'The Faith That Is in Us',
quoted in Vicinus 1985: 249)

Emmeline Pethick-Lawrence was drawing on a traditional religious meta-
phor in which the 'temple' of the body was seen as a receptacle of
virtue and wholeness. Woman's physical 'weakness' was to be displaced
by her moral, mental, economic and spiritual achievement represented by
the Vote. In an analysis of women's entry into male public space, Martha
Vicinus emphasizes the continuity between the images and rhetoric of
suffrage and nineteenth-century concepts of women's innate moral purity.
Women militants in particular drew on language infused with evangelical
imagery to claim their potential for spiritual as well as for political leader-
ship. While such appeals to spiritual superiority frequently derived from
conservative notions of womanhood, Vicinus argues that these were used
to make a radical challenge to male control of the public sphere, suggest-
ing that: 'The militants turned this superiority into a shield, protecting
them as they entered public space, and into a weapon, altering public
opinion as they asserted their rightful freedom' (Vicinus 1985: 257).

Nowhere was the conception of the spiritual and political body of
woman as strongly manifest as in the militant WSPU campaigns between
1911 and 1914 and in their primary symbolic representation, the female
warrior. Armour-clad from head to foot, holding a shield and banner and
seated on horseback, the figure that appeared on the cover of the WSPU
newspaper *Votes for Women* in May 1912 represents the archetypal image
of the sealed and resistant body of suffrage (Plate 9). This image of chastity
is, however, entirely different from the passive virtue traditionally repre-
sentative of Victorian maidenhead. The figure is erect, arms and legs
held straight, and impregnable. The image signifies *self*-possession rather
than male ownership, command over the passions and pride in female
resistance. The curious addition of a text from the 'Sayings of Buddha'
reinforces the image of militant virtue and self-control.

The physical body and its lower animal nature – represented here by
the white horse with its flowing mane and tail, a traditional signifier of
passion, is sublimated to a higher calling, that of the warrior ideal.[9] This
corresponds to a strong element within militant feminism which denied
any physical frailty to the female body. Like a soldier or saint, the
suffragette's feminine body must be subjected to a rigorous mental and
spiritual discipline.

In Judaeo-Christian tradition, the allegory of the virgin as a sealed
vessel was used to counter associations of the female body with nature.
In order to displace the disturbing connotations of yielding and porous
flesh or of flowing liquids and fluids associated with female reproduction,

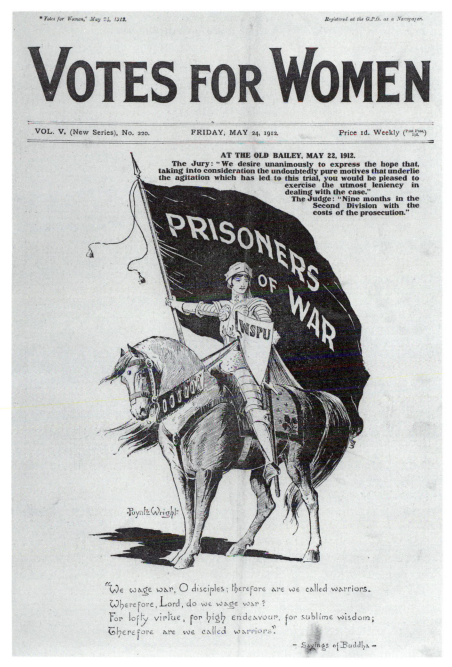

Plate 9 Prisoners of War, cover of *Votes for Women*, 24 May 1912.

'the physical condition of this metaphorical body had to be turned upside down, and the soft, porous, effluent producing entity made hard, impermeable and corked, so that its contents, dangerous on contact, could be kept hermetically sealed and safe' (Warner 1985: 251). Metaphorically, an equivalence is drawn between integrity, firmness and wholeness of the body and moral perfection. As Marina Warner argues, the symbolism of the armed maiden renders her a watertight, strong container: 'The armour inverts the sign of the woman's body so that it can properly represent virtues or ideals; it emphasises that a leaky vessel . . . has turned into a sound vessel (Warner 1985: 250–1).

In suffrage iconography, this displacement is literally on to the metallic 'skin' of the armour which encases the maiden warrior. What is being displaced is the soft, porous skin of femininity itself. Instead of implying, as in traditional iconography, that woman is inherently fallible, the suffrage image of the armed maiden draws on the inviolability of the allegorical figure to emphasize resistance to invasion of the body's integrity and her own control over its margins. In conflating the semiotics of masculine and feminine, the image of the maiden warrior posed a significant challenge to the fundamental organizing structures of nineteenth-century representations of gender difference while, at the same time, it drew on a common rhetoric of medieval chivalry. Like the Arthurian knight of romance, it was the quest for transfiguration which informed heroic female deeds, but the 'shield' and 'weapon' of the spiritual superiority were to replace the brute strength and violence of masculine endeavour.

John Everett Millais' painting of 1870, *The Knight Errant*, represents this gendered binary structure very clearly, relying on a contrast between unbound flowing hair and yielding female flesh and an armoured, masculinity wielding an outsize sword to convey its sexual meaning (Plate 10). The female nude is not only physically vulnerable to the sword which cuts through her bonds, she is also represented as the victim of previous sexual assault, her clothing lying scattered at her feet. This implicit narrative of sexual violence is reinforced visually by the rope which cuts into the soft flesh of her body. The strong vertical of the tree emphasizes the phallic thrust of the sword and angular male body in opposition to sinuous curves of the female nude. The gendered opposition is further reinforced by a series of visual contrasts between soft and hard, cool and warm, naked and clothed, bound and free, passive and active, which structure the symbolic meaning of the work. These contrasts are framed within a binary opposition of nature, represented by the female body, linked to the changing moon and watery landscape behind her, and culture, embodied in the interventive force of the male warrior. As Lisa Tickner explains: 'The task for suffrage art and rhetoric in this context was to reinhabit the empty body of female allegory, to reclaim its meanings on behalf of the female sex' (Tickner 1987: 209). For Tickner, the Militant

Plate 10 John Everett Millais, *The Knight Errant*, 1870, oil on canvas.

Woman remains exclusively an allegorical type, bearing little resemblance to the actual experiences of women. But there was one crucial arena in which this was not the case. The context in which the illustration 'Prisoners of War' appeared was a very specific one in which real female heroism was being enacted almost daily. Since the Asquith Government had introduced forcible feeding as a tactic against suffrage hunger strikers in September 1909, many suffrage supporters had been imprisoned and routinely subjected to torture. By 1912, after the defeat of the Conciliation Bill, these 'prisoners of war' had become the focal point of WSPU propaganda against the Government.

The testimony of militant women themselves suggests the figure of Joan of Arc provided an exemplary model rather than merely symbolic forms of identification. For example, Constance Lytton chose 'Jane' as a pseudonym before her arrest and imprisonment in 1910 because 'it was the name of Joan of Arc ... and would bring me comfort in distress' (Lytton 1988: 238). Will Dyson's pro-suffrage cartoon which appeared in the *Daily Herald* in 1914 makes this connection directly as Joan of Arc appears in a vision to an emaciated suffrage prisoner in her cell (Plate 11). The figure of Joan is erect and radiant and that of the prisoner slumped but both appear equally androgynous in their physiognomy and unswerving in their determination. The impregnability of Joan's female body, encased in armour like a corset, is in striking contrast to the open pose of the suffragist – only her tensed arms reveal her will to resist. While there may have been only one Saint Joan, each and every suffrage prisoner was her own 'Joan of Arc', carrying within her the model of female resistance to oppression. It was in this context that the sealed body of the suffragist took on more than purely allegorical significance.

Women's means to power lay, initially at least, in the exercise of control over their own bodies. Whether or not women were actually willing to die for the vote, or used such rhetorical threat as a strategy, is debatable.[10] What is not in doubt is that for many suffrage militants religious faith and imagery offered a way of interpreting the actions of themselves and others in the cause. In dedicating her account of prison experience to fellow prisoners, Constance Lytton writes movingly of the need to 'Reverence yourself':

> Unless you are able to keep alight within yourself the remembrance
> of acts and thoughts which were good, a belief in your own power
> to exist freely when you are once more out of prison, how can any
> other human being help you? If not the inward power, how can any
> external power prevail?
>
> (Lytton 1988: xiv)

Mental and bodily resistance to external pressure was an important source of strength and new-found self-identity for militant women. Lucy

AN INTERLUDE.

THE MAID OF ORLEANS (to an English Suffragist) : "Yes, I remember even in my day your English had a way with them in dealing with women !"

Plate 11 Will Dyson, *An Interlude*, 1915, from *Cartoons*, London: *Daily Herald*.

Bland sums up very clearly the way in which such concepts enabled women to construct a new position from which to speak:

> Feminists drew on the ideology of female moral superiority and altruistic maternity to claim a subject position from which to enter the public world as 'moral missionaries', and to insist, on the basis of their 'civilising capacities' on a right to political status.
>
> (Bland 1995: 305)

This ideology provided a powerful motivation for resistance when it came to the force-feeding of suffrage prisoners in the cause of obtaining their political rights.

EMPTY BODIES

> I was filled with terror in the morning when the gas jet was put out and in the evening when it was lighted again; within about half an hour of these changes in the light came the doctor and wardresses, the gag and all the fiendish consequences. I walked up and down my cell in a fever of fear, stopping now and then and looking up at the window, from which all good things seemed to come. I said 'Oh, God, help me! Oh, God, help me!'
>
> (Lytton 1988: 280)

Constance Lytton's lengthy account of her own experiences in prison in 1914 describes the act of force-feeding as a form of psychological torture which is also a physical violation of the female body. The forcible penetration of the hunger striker's body by a feeding tube inserted into her throat through a steel gag which prised her jaws apart was directly analogous to the instrumental rape by the steel speculum of women believed to be engaged in prostitution under the nineteenth-century Contagious Diseases Acts. In both cases, the woman's body was entered under duress and within the state-sanctioned auspices of the medical profession.[11]

In this process, the internal space of the female body was violated and rendered *public* and *political*. This translation of the female body from a private into a public domain through the act of the state became a *cause célèbre* in the suffrage campaigns just as it had for the purity campaigners in the 1870s and 1880s. And, just as detailed accounts of medical rape figured prominently in propaganda to repeal the Contagious Diseases Acts, so, too, descriptions of the tortures of forced-feeding were used extensively to support the cause of suffrage. The similarities between the women's treatment in each case are indeed striking:

> It is awful work; the attitude they push us into first is so disgusting and painful, and then these monstrous instruments and they pull

them out and push them in, and they turn and twist them about; and if you cry out they stifle you.

<div align="right">(Letter to Josephine Butler, quoted in
Walkowitz 1992: 92)</div>

And, from Emily Davison's account of her treatment in Manchester Prison in October 1909:

> The scene which followed ... will haunt me with its horror all my life, and is almost indescribable. While they held me flat, the elder doctor tried all round my mouth with a steel gag to find an opening. On the right side of my mouth two teeth are missing; this gap he found, pushed in the horrid instrument, and prised my mouth open to its widest extent. Then a wardress poured liquid down my throat out of a tin enamelled cup. ... As I would not swallow the stuff and jerked it out with my tongue, the doctor pinched my nose and somehow gripped my tongue with the gag. The torture was barbaric.

<div align="right">(Morley and Stanley 1988: 27–8)</div>

But there are also significant differences between these two first person accounts of torture, due in part to a different political framing of the events in which the women were involved. Emily Davison described her active resistance to the forced entry of her body, even during its enactment. For the anonymous nineteenth-century working-class woman subjected to rape by the speculum, such resistance was virtually impossible. Their subject positions are thus constructed differently within their narratives; while the former is clearly a victim of events, the latter claims the position of victim itself as the point of resistance.

Judith Walkowitz has suggested that accounts published by purity campaigners such as Josephine Butler can be seen to conform to the traditional narrative structures of nineteenth-century melodrama. In such scripts, Walkowitz argues, the story was cast in terms 'that allowed the weak to speak out and gain agency in their own defense' (Walkowitz 1992: 86). Usually, this took a political form in which the 'victim' was the innocent daughter of the working class, seduced and forsaken by an upper-class protagonist. However, the suffragists significantly re-wrote this script to take on the role of active agents as well as victims in the drama of women's oppression. In the change from the accounts of nineteenth-century purity campaigners to modern feminism, dramas of class began to be replaced by dramas of gender.[12] By opening up a space in which women could re-write the script, the nineteenth-century concept of women's bodies as the property of men, whether father, lover or husband, was being challenged by women who claimed ownership of their own bodies and persons. Hunger strikers chose starvation as a means of *conscious* resistance to demonstrate the strength and heroism of their cause.

The tension in the role that the hunger strikers acted out between weakness and strength, victim and agent, is brilliantly captured in a poster produced by the Suffrage Atelier to oppose the 'Cat and Mouse' Bill introduced by Home Secretary McKenna in 1913 (Plate 12).[13] The Prisoner's Temporary Discharge Act gave prison authorities the right to release suffrage prisoners temporarily without remission of their sentence so that they could be re-arrested after recovery from a hunger strike. In *McKenna's Cat 'Bill'*, the 'fat cat' of government is seen being overwhelmed by the hordes of suffrage mice. Reversing the expected power roles, the image undermines the authority of the state by poking fun at its claims to *force majeure*. 'What Cat Could Keep up with This?' it asks, and offers the spectre of an endless stream of 'timid' mice willing to exploit their natural weakness and sacrifice themselves to the bloated and supine cat. The image also turned around popular anti-suffrage propaganda which depicted the suffragettes themselves as 'cats', a term of sexist abuse in the period.[14] Unlike more direct depictions of the mechanics of forced feeding, and their own 'English Inquisitors' – complete with hooded figures, flaming torches and rack – the Suffrage Atelier's poster succeeds in evoking the tension at the centre of the suffrage propaganda; its emphasis, at one and the same time, on feminine disempowerment and on female heroism.

In her book, *The Hunger Artists*, Maud Ellman draws a series of parallels between the tactics of the suffrage hunger strikes and those of the Irish Nationalists from the time of the Easter Rising to the death of Bobby Sands and other Republican hunger strikers in the Northern Irish H Blocks in 1981. Although early Irish Nationalists did not recognize any debt to suffrage politics, Ellman suggests there is a connection via the concept of the *Senchus Mor*, an ancient civil code under Irish law. According to this code, a plaintiff had the right to starve at the door of the person who had injured him until the latter was shamed into righting his wrong. The point of this tradition of hunger striking, and its significant difference from terrorist tactics, was the way in which it mobilized the spectacle of weakness as a weapon of resistance. Unlike terrorist actions, it also acknowledged moral and social order for, in order for the code to operate, the defendant had to recognize his own moral debt and be driven by social sanction to make amends. Ellman sums it up thus:

> a hunger strike, far from sabotaging the idea of order, legitimates the very power that it holds to ransom. Because its secret is to overpower the oppressor with the spectacle of disempowerment, a hunger strike is an ingenious way of *playing* hierarchical relations rather than abnegating their authority.
>
> (Ellman 1993: 21)

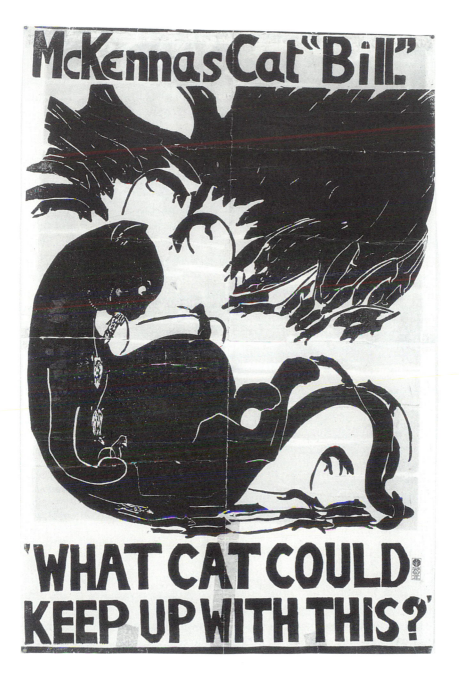

Plate 12 Suffrage Atelier, *McKenna's Cat 'Bill'*, c.1913.

If we follow Ellman's argument, then the suffragettes were employing two different strategies to further their cause, each of which operated within distinct discursive frameworks. On the one hand, civil disobedience, window-breaking and fire-bombing campaigns disrupted civil order, on the other, hunger striking appealed directly to the concept of civil rights – albeit these were, and are, undefined in British law. Both strategies, however, crucially depended on *visibility* for their political effect: both the terrorist act and the hunger strike must be *seen* to have meaning. In order to have significance beyond individual suffering, the suffragists' experiences of force-feeding had to be made visible. This accounts for the weight given to the publication of testimony and to visual imagery in their prison campaigns. As well as numerous first-hand accounts, a whole iconography grew up around the prison experience which included cartoons and posters, photographs of Mrs Pankhurst, Christabel and other WSPU leaders wearing prison clothes, embroidered handkerchiefs dedicated to prisoners, badges, memorabilia and even postcards of the prison cells at Holloway decorated with a tasteful border of prison arrows.[15] Such visual evidence was significant, not only to build up a sense of collective strength in adversity within the militant suffrage movement itself, but to convince the world outside of the moral force of their cause. But, 'playing hierarchical relations' could also have deadly serious effects: Constance Lytton was severely weakened in health by her prison experiences, suffered a subsequent stroke which partially paralysed her, and died early in 1923.

Ellman suggests that suffrage hunger strikers were 'obeying an unconscious wish to be force-fed and to experience the shattering of subjectivity it entails' (Ellman 1993: 35). Ellman's analysis rests on a sustained analogy between eating and the construction of self through language. By reversing normal relations, she argues, in force-feeding it is the object 'that invades the subject', thus fragmenting the subject's sense of self identity. 'What has been forced into her is not only the food but the ideology of her oppressors' (Ellman 1993: 33). Yet food is *not* the same as words. The suffrage hunger strikers may indeed have been forced to swallow the 'food' of their oppressors, but they absolutely resisted the words which accompanied it, as their autobiographical accounts make clear. Misunderstanding this material difference leads Ellman to depoliticize their actions. For, if '[a]*ll eating is force feeding*: and it is through the wound of feeding that the other is instated at the very centre of the self' (Ellman 1993: 35–6), then how can we separate eating from the torture inflicted by forced-feeding? It is not a continuum, but a reversal of the normative relations of self and other which eating represents.[16] To argue that suffrage hunger strikers willingly sacrificed 'self' is to misread their purpose. While it is true that pride in overcoming the self, in the sense of physical and psychological control, is a central trope in suffrage prison writing, so too is their will to resist the demolition of the ego and retain

a sense of identity.[17] One reason for stressing the resistance by hunger strikers to the disintegration of a coherent subject position was that this was precisely what the opponents of suffrage sought to represent.

SUFFRAGE, SEXUALITY AND THE WOMAN HYSTERIC

Sometimes when the struggle was over, or even in the heat of it, in a swift flash I felt as though my entity had been broken up into many selves, of which one, aloof and calm, surveyed all this misery, and one, ruthless and unswerving, forced the weak shrinking body to its ordeal. Sometimes, breaking forth, it seemed, from the inner depths of my being, came outraged, violated, tortured selves; waves of emotion, fear, indignation, wildly up-surging. Whilst all these selves were struggling, resisting, shrinking from the tortures, would rise in them a fierce desire to scream.

(Pankhurst 1977: 444)

Sylvia Pankhurst's powerful account of her own experience in prison in *The Suffragette Movement* (1977) describes the shattering of her subjectivity and the violation of self which force-feeding produced. It is not surprising in this context that women feared that insanity, 'all those voices, of those maddened, agonised sensations, those huge, untameable emotions, should overwhelm alike the ruthless and the calm self' (Pankhurst 1977: 444–5). According to Pankhurst, sedative drugs and bromides, similar to those administered in lunatic asylums, were regularly given to suffrage prisoners.[18] Conservative voices within the medical profession tried to represent militant feminism itself as a specifically female disorder and then, as now, deviant behaviour by women was linked to their 'monthly insanity'. Pankhurst explains how her own resistance to such disintegration was achieved through writing a diary and poetry and drawing. What retained her sanity under the threat of annihilation was the act of representation itself through which her experiences could be objectified.[19] The power to represent oneself through words and images was a crucial means by which those involved could retain control of their own bodies and persons. It was also crucial to the very legitimacy of the suffrage cause.

The image 'of the ruthless and the calm self', in contrast to press depictions of militant suffragists as violent and disorderly, was a political imperative. As Kathryn Dodd argues of suffrage writing, 'by constructing a narrative about rational and moral *female* leadership', the popular representation of the movement as hysterical, lawless and subversive could be challenged (Dodd 1993: 15).[20] In an interesting discussion of the political forms of Sylvia Pankhurst's writing, Dodd suggests that she adapted the

conventional form of the narrative of 'Great Men' in order to legitimize the constitutional claims of women to the vote. Pankhurst's early history of the WSPU, *The Suffragette*, was written at a key moment in 1911 when the Conciliation Bill for Women's Suffrage had gained two majority readings in Parliament and it seemed possible that constitutional reform might be granted by the Asquith Government. *The Suffragette* thus sought to legitimate the claims of the WSPU by reference to an accepted tradition of public political representation. Exactly the same point can be made in relation the visual rhetoric of the suffrage movement.

In official WSPU imagery, as Katrina Rolley notes, there was tendency towards static representation of figures. Suffrage studio portraits of leading women used on propaganda postcards usually portrayed them in bust length as dignified and monumental figures. The model of 'Great Women' served a dual function: it claimed a respectable political lineage for the cause and countered popular anti-suffrage iconography which invariably showed suffragettes as open-mouthed, screaming and dishevelled (Plate 7). Indeed WSPU women were exhorted to follow Mrs Pankhurst's example and show calm and restraint even under arrest. That this was not always the case is testified by the many accounts of active resistance by suffrage strikers to their violent treatment in the courts and in prison, but such struggle was rarely represented visually in suffrage imagery.[21] Both in official photographs and symbolic representations of suffrage there is an emphasis on visual order and restraint (Plates 8 and 9).

Parallels can be drawn between the tensions surrounding suffrage representation and the iconography of allegorical female figures in the nineteenth-century. Maurice Agulhon has shown how a typology of the French revolutionary symbol of Marianne can be divided into two streams, one representative of reformist and the other of revolutionary political tendencies. According to this typology, static representations are associated with constitutional politics and active representations with radical politics. The figure of the mature, statuesque but feminine woman is contrasted with the figure of woman as youthful and active with disordered hair and clothing. This symbolic dichotomy is reflected in the contrast between official photographs of Mrs Pankhurst and those of younger suffragettes. Agulhon classifies images of Marianne thus:

Bourgeois Liberalism	fixed allegory: an image of serenity; seated or standing but immobile posture; orderly hair; covered bosom; a mature, even maternal figure.
Popular Revolt	live allegory: an image of vehemence; always standing and sometimes on the march; free floating hair; uncovered bosom; youthful figure.

(Agulhon 1981: 88)

As Agulhon points out, there was a fierce struggle over the symbolic representation of Marianne as Liberty following the 1848 revolutions in France and this emerged particularly acutely in a competition to produce an image for the new Republic: 'Most of the competitors depicted veritable viragos, furies, shrews, enraged female devils with dishevelled hair and ragged clothing. Their look was fiery, their mouths hurled abuse' (Agulhon 1981: 77). Louis Desnoyers' ironic description of the artistic representations of Liberty which appeared in the Paris Salon of 1849 bears a striking resemblance to anti-suffrage rhetoric and imagery, particularly in its evocation of the female body as disorderly and excessive. A similar iconogaphy appears in contemporary press photographs of suffragettes being arrested, hatless, hair down and clothes unbuttoned. Thus it was crucially important for the suffrage movement to identify itself with recognizable codes of political representation during the period when militant activity put it increasingly in collision with the constitutional authority of the state. It is within the context of this politics of representation that the WSPU call for bodily control, including both physical decorum and controlled sexuality, must be properly understood.

The *Daily Mirror*'s full page photographic spread 'The Suffragette Face: New Type Evolved by Militancy' on 5 May 1914 (Plate 13) condenses these themes in a carefully composed ideological text. The layout of the page itself echoes the standard format of suffrage programmes for processions and demonstrations in which a central text was surrounded by photographs of the main speakers. In a deliberate contrast to these posed studio portraits, the *Daily Mirror* used a series of documentary shots taken during a demonstration showing unnamed suffragettes as well as two famous faces, Mrs Flora 'General' Drummond and, in the centre, larger than the rest, Mrs Pankhurst, 'the chief leader of the militant movement'. The appearance of the women and some of the textual captions, 'Dishevelled after fighting' and 'Screaming with impotent rage', recall Desnoyers' description of 'enraged female devils with dishevelled hair' who 'hurled abuse'. Thus, in a collapse of signifier and signified, the visible image of female disorder comes to stand again for militant politics.

The date of the newspaper's 'Special Number for Derby Day' on 25 May 1914 was also significant, recalling the sensational events of a year before when Emily Davison had thrown herself in front of the King's horse at the Derby. While Davison was mourned as a martyr by the suffrage movement in a massive display of solidarity, she was popularly represented in the press as an unbalanced and hysterical woman who had committed suicide for the vote.[22] Her death was treated as final proof of the 'insanity' of women involved in militant action. By featuring a full page photographic spread of militant 'types' on Derby Day, the *Daily Mirror* was deliberately re-evoking a series of pathological associations.[23] A further link can be drawn between the texts and images in the *Daily*

Plate 13 'The Suffragette Face: New Type Evolved By Militancy', the *Daily Mirror*, 25 May 1914.

Mirror and contemporary representations of hysteria. Captions to some of the photographs: 'Rather emotional', 'She uses supplication' and 'Ecstasy on arrest', recall the subtitles given by the late nineteenth-century neurologist and theorist of hysteria, Jean-Martin Charcot, to photographs taken of patients in a Paris psychiatric institution in his *Iconographie photographique de la Salpêtrière*, (3 volumes, Paris 1876–80). For Charcot, hysteria was a psychological disorder manifest in physical symptoms, and he claimed to identify in photographs of female nervous patients certain bodily states representative of hysteria. He identified these specific *attitudes passionelles* with different phases of the hysteric's progress through an attack that included '*Supplication amoureuse*', '*Extase*' and '*Erotisme*'. Although he also recognized forms of male hysteria, Charcot drew a direct connection between the hysterical 'poses' as performed by his patients and a pathologized female sexuality. The semi-clothed photographs of his model, Augustine, are indeed sexually charged and coded for erotic impact. Charcot's photographs thus interpreted, or staged, hysteria as a specifically female sexual disorder with strong erotic and visual signification.[24]

The idea that hysteria could be identified by a visible manifestation on the body remained prevalent in Britain before the First World War although this period saw the emergence of clinical psychoanalysis. Charcot's 'Lectures on the Diseases of the Nervous System: Delivered at Salpêtrière', published in London by the New Sydenham Society between 1877 and 1889, included ten leaves of plates and were subsequently popularized through the press. Freud and Breuer's *Studies in Hysteria* (1895) was first published in English translation in 1909 and the London Psychoanalytical Society was founded in 1913. It won little support from the medical establishment, including the British Medical Association, and the prevailing medical view was still that hysteria was founded in the biological functioning of the female reproductive system.[25] The high profile of debate over the nature of hysteria ensured that it entered into popular consciousness as indelibly linked with female disorder and, moreover, identified with feminism.

Where medical and popular views conjoined was in the belief that hysteria could be 'read' in the face and body: 'There is no longer any need for the militants to wear their colours or their badges. Fanaticism has set its seal upon their faces and left a peculiar expression which cannot be mistaken' (the *Daily Mirror*, 25.5.14). Correspondence between certain of the *Daily Mirror* photographs and Charcot's 'passionate attitudes' indeed is too strong to be merely coincidence. For example, the photograph of a suffragette captioned 'Ecstasy on arrest' bears a marked resemblance in the angle of her head and features, with eyes upturned, lips parted and nostrils flared, to Charcot's photograph '*Extase*'. The interpretation of the *Daily Mirror* photograph in terms of sexual ecstasy rather

than, as seemed more likely in the circumstances, an expression of distress or pain, could only be conditioned by the connection popularly made in the Edwardian period between hysteria and the suffrage movement. Hysteria had become an explanation which could be fitted to any and every deviation from the feminine norm.

A pose similar to that in 'Ecstacy on arrest' appears in the central photograph of Mrs Pankhurst. Eyes closed, lips apart and head tipped back, her face resembles, iconographically, the type of *femme fatale* common in European painting at the end of the nineteenth-century. While the heyday for representation of the femme fatale was in Symbolist art and literature of the 1890s, it survived in popular iconographic forms well into the 1900s, for example in the Edwardian type of the Gibson Girl, in the theatre and, rather curiously, in fashionable society portraits.[26] In its more malevolent Symbolist incarnations, the *femme fatale* drew on ancient archetypes of woman as betrayer and emasculator of men. She was Medusa or Salome, whom Des Esseintes, the hero of Joris-Karl Huysmans' *Against The Grain* (1884) described as 'the goddess of immortal Hysteria', connecting the tropes of sinful sexuality and death (Dikstra 1986: 382). The *femme fatale* figure is often shown in a state of sexual abandon or orgasm, head flung back with lips parted and eyes closed, a pose which is reproduced in that of Mrs Pankhurst, a reading reinforced by the latter's blurred features, loosened hair and floating feather. But if the *femme fatale* was a symbol of female sexual disorder, her erect and dominant pose also signified sexual threat.

The eruption of dangerous women in art and literature of the 1890s has been connected to the growing demand by women for political, cultural and educational rights. This translation of women's emancipation from a political threat into a sexual danger is strikingly illustrated in Sir Almroth Wright's litany of the dire consequences of women's suffrage in 1913:

> Women shall be included in every advisory committee, every governing board, every jury, every judicial bench, every electorate, every parliament, and every ministerial cabinet: further, . . . every masculine foundation, university, school of learning, academy, trade union, professional corporation, and scientific society shall be converted into an epicene institution – until we shall have everywhere one vast cock-and-hen show.
>
> (Sir Almroth Wright, quoted in Tickner 1987: 156)

Such language by male anti-suffragists is itself 'hysterical,' in the popular sense, in its evocation of the sexual chaos which would ensue from women's suffrage. But Wright's reference to the conversion of every male bastion into an 'epicene institution' suggests more specific masculine anxieties were at stake. In an essay entitled 'The Medusa's Head' (1922), Freud retells the myth of the Gorgon Medusa whose gaze turns men to stone.

The Medusa's head is covered with open-mouthed snakes, which Freud suggests, simultaneously represent the female genitals and 'replace the penis, the absence of which is the cause of the horror' (Freud, vol. 5, 1957). It is thus a reassurance against the threat of castration which the sight of the female genitals provokes in the male viewer. Freud further notes that the Gorgon's head is worn on the breastplate of Athena, the virgin goddess of wisdom and knowledge who repels all sexual desires. Disavowal of female sexuality is thus connected in Freud's analysis with fear of female control of power and knowledge. Like Salome, the Medusa's castrating power was often represented in the guise of a *femme fatale* at the turn of the century. We may thus read the photographic image of Mrs Pankhurst as a 'fatal woman' in terms of an attempt to disavow the threat posed by suffrage to the institutions of male power in civil society, a threat experienced by suffrage opponents such as Sir Almroth Wright as one of symbolic castration.

Fear of female disorder, insanity and sexual power over men are thus closely imbricated in the *Daily Mirror*'s text. Yet if feminism could be linked to men's fear of women's sexual power, its more popular representation in terms of sexual and social inadequacy was precisely the opposite. The figure of the sexless spinster and older woman ('Youth looks like old age'), connects it with stereotypes commonly used in anti-suffrage cartoons. Postcards with captions such as 'Suffragettes who have never been kissed' endorsed popular perceptions of suffrage women as embittered and frustrated. In Elizabeth Robins' suffrage novel, *The Convert* (1907), there is a telling encounter between Lady Vida Levering, the heroine, and Miss Claxton, the militant suffragette, in which the latter claims that, contrary to popular belief, it is not suffrage supporters but upper class women who are sexless because they have no 'sex-pride' (Robins 1980: 162). Such attempts to counter sexual stereotypes – indeed the glamorous figure of Vida Levering herself – were up against a long-standing and ingrained association between the demand for women's rights and the de-sexing of women.[27] Thus, both sexual *and* non-sexual femininity was represented as sharing the same structure of deviance which could be ultimately located in the dysfunctioning of the female sexual body. The problem of suffrage representation then was to steer a course between the Scylla of disordered feminine sexuality and the Charybdis of refusing to admit any sexuality to women at all.

SUFFRAGE AND THE 'SEX QUESTION'

For centuries . . . hysteria has indicated a failure of order, a refusal to take the place assigned, to be the difference, the woman. . . . There is a historical and political choice of perspective at stake: hysteria

is a disorder which proves the law of sexual identity, the given order; hysteria is a protest against the oppression of that law of sexual identity, that given order, painfully envisaging in its disorder and economy, a quite different representation of men and women and the sexual.

(Heath 1982: 47–8)

While hysteria may be indeed read as a form of individual protest against sexual oppression, it could hardly offer an adequate form for collective resistance to male institutions. Nor could it project any real way forward towards envisaging the 'quite different representation of men and women and the sexual' which many suffrage women consciously strove for in the 1900s. Given the importance to suffrage of representing the movement in terms of political legitimacy and of refuting its stereotypical associations with female disorder, it is not surprising to find few images which endorsed an emergent sexualized identity for women. Visual images were in any case too heavily compromised to be available as a public language for women's sexual desire.[28] In order to find such representations we need to look at more private debates and writing of the period and in strands of the suffrage movement represented by those who supported sexual reform and reproductive rights.

In 1885, a group of middle-class feminists and socialists based in London had begun meeting under the title of the Men and Women's Club to discuss sexual issues. The founder of the group, Karl Pearson, was a rationalist and a Darwinist who later became involved with the eugenics movement. But while scientific socialism provided the framing discourse for the Club's discussions, a few of its women members, like the South African feminist, Olive Schreiner, found the arguments of male members difficult to reconcile with their own politics.[29] Although attractive in some respects to feminists, a rational Darwinism which based its arguments on 'race evolution' insisted on women's intellectual inferiority and thus marginalized the contributions of women members. There were other conflicts too, for while the discussions of the Club were resolutely heterosexual and impersonal, more intimate relationships between women members of the club, as well as between women and men, created ideological and personal tensions that led to the disbanding of the Club in 1889.[30]

Schreiner herself was more interested in exploring utopian ideas of sexual love between men and women and in searching for a new language for female desire which she began to develop in a series of short stories she called *Dreams*, first published as a collection in 1890. 'The Buddhist Priest's Wife', written in 1892, offers a complex representation of female sexual identity. Based on Schreiner's own inconclusive relationship with Karl Pearson, it tells of an unnamed woman who leaves London for India

following her unrequited love affair with a male politician. In the course of their final conversation, which forms the substance of the story, they discuss the different meanings of sexuality for women and for men. Woman, the speaker argues:

> must always go with her arms folded sexually; only the love which lays itself down at her feet and implores of her to accept it is love she can ever rightly take up. That is the true difference between a man and a woman. You may seek for love because you can do it openly; we cannot because we must do it subtly.
>
> (Schreiner 1993: 93)

Schreiner's story clearly depicts a 'modern woman', cigarette smoking, sexually independent, and able to makes choices about the form of her relationships with men. Yet it is clear that she recognizes choice is unequal for women within contemporary social and sexual relations; if women are to retain their independence, they have to sacrifice their own sexual lives. In a brief allegorical fable published two years earlier called 'Life's Gifts', Schreiner presented the decision between Love and Freedom even more starkly and suggests that the only choice for women at the time was 'Freedom'.

Schreiner's 'dream' stories became popular reading for suffrage supporters at the turn of the century. As Constance Lytton wrote in 1914: 'Olive Schreiner, more than any one other author has rightly interpreted the woman's movement and symbolised and immortalised it by her writing' (Lytton 1988: 157). Lytton described how Mrs Pethick-Lawrence recounted 'Three Dreams in a Desert', much to the pleasure of fellow prisoners in Holloway Jail in March 1909. Schreiner's 'dream' parable was taken as a literal guide to suffrage action, it 'fell on our ears more like a an A B C railway guide to our journey than a figurative parable, though its poetic strength was all the greater for that' (Lytton 1988: 157).

Schreiner's more radical critique of heterosexual relationships as expressed in 'The Buddhist Priest's Wife' did not have much currency within the militant suffrage movement. However, the 'Sex Question' which included discussion of issues such as 'Free Union' or marriage, illegitimacy, family limitation and improved sexual relationships between men and women was in the forefront of discussion in radical circles. And the theme of women's sexual independence was represented elsewhere in suffrage fiction, for example in Elizabeth Robins' *The Convert*. Her heroine, the beautiful Vida Levering, has a 'past', a secret affair with a future successful politician, Geoffrey Stonor, as a result of which she had become pregnant. Forced by his abandonment to have an abortion, Vida later uses this knowledge to impel him to make amends by supporting the cause of women's suffrage in Parliament. Thus Robins gives a truly modern twist to the nineteenth-century topos of the 'wronged' woman.

And indeed, her novel marks a shift from Schreiner's *fin-de-siècle* pessimism; Vida does not die, but still has work to do at the end of the novel – if at the cost of losing her child. Robins herself argued for the right of single women to have children; she and her partner, Dr Octavia Wilberforce, did indeed adopt a son.[31]

Such 'Boston marriages', as they became known in America, were not at all uncommon between single women in the nineteenth and early twentieth centuries. However, any explicitly sexual relationship between women was not, and could not, be named even by the women themselves. A recognizably 'modern' male homosexual identity was beginning to emerge in the 1890s with the translation of Krafft-Ebbing's 1886 *Psychopathia Sexualis*, the writings of the charismatic socialist, Edward Carpenter in Sheffield, and the notorious trial of Oscar Wilde in 1895. While an equivalent lesbian identity could not be publically articulated, nevertheless women were beginning to acknowledge their divergence from conventional sexual codes. Nor was a lesbian identity 'overwhelmingly upper class and literary', but was being explored in personal relationships across different levels in society (Weeks 1982: 115). Crucially, the constellation of suffrage activity, socialist politics and sexual reform seems to have provided women with a set of terms through which to examine and explore their own sexual experiences. This is clearly the case in the intensely felt diaries and correspondence between two London working women, Ruth Slate and Eva Slawson, who were variously active in the Women's Freedom League from 1908, involved in the Independent Labour Party and engaged in discussing the 'Sex Question' in the Freewoman Circle in 1912.[32] The two women read Edward Carpenter's *Love's Coming of Age* (1896) in 1911 with interest and enjoyment, but it was not immediately clear to them how his theory of homosexuality as 'inversion' could relate to their own complex sexual feelings towards women and men. Eva's passionate friendship with another woman, Minna Simmons, was expressed in a masculine *and* feminine language of desire: 'I told her that if she were a man, I should feel absolutely completed; Minna says I rest her so, and that I am a robber and a thief, for I have stolen her heart' (Thompson 1987: 176).[33] It is clear that, in private at least, the sexual feelings and activities of many women involved in the suffrage movement were much more diverse than the model of respectable marriage or single-minded chastity, so publically embraced by the leadership, would suggest.[34]

MODERN WOMEN OR SAINTS?

The split in the movement between the WSPU leadership, under Christabel Pankhurst, and her sister Sylvia was the result not only of differences in ideology and political strategy, but of such personal and

sexual politics. The WSPU's consciously anti-democratic organization and autocratic leadership had already led to divisions. As Christabel argued to Sylvia in 1914 on the formal separation of the East London Federation of Suffragettes (ELFS) from the WSPU:

> a working women's movement was of no value: working women were the weakest portion of the sex: how could it be otherwise? ... You have your own ideas. We do not want that; we want all our women to take their instructions and walk in step like an army!
>
> (Pankhurst 1977: 517)

If the First World War marked the end of an era of active sexual politics within feminism, it also closed down debates around class within the WSPU. The figure of the modern working-class woman which had disappeared from WSPU iconography as it moved away from mass organization after 1907, resurfaced in the different medium of photography in the East London Federation.[35] Images of women and children used in militant suffrage propaganda, for example, the cover design for Ethel Smyth's anthem dedicated to the WSPU, *The March of the Women*, show an idealized group of figures whose clothing and demeanour is archaic and non-class-specific. In contrast, Norah Smyth's photographs of East End women and children published in *The Women's Dreadnought*, the ELFS newspaper, document the practical activities of the Federation and reflect the same ethos of day-to-day involvement in the lives of working women and children (Plate 15). They bear none of the tendency to sentimentalize or pathologize the 'poor', characteristic of Victorian and Edwardian photography.[36] Iconographically, the theme of working-class women and children can be traced back to Sylvia Pankhurst's design for the WSPU membership card in 1905–6 and her other early work, for example, a poster for Keir Hardie's 1905 ILP campaign for the unemployed, 'Workless and Hungry'. In the former image, the women are shown as powerful figures, one raising her arms to hold up a 'Votes' banner, another carrying a child, and a third a bucket, their clothes and strength denoting their working-class status. These figures are not entirely free of the nineteenth-century construction of the bodies of labouring women as physically powerful in opposition to the delicate bourgeois feminine ideal but, unlike many representations of working-class women, these are not overtly sexualized.[37] And, in contrast to her own ethereal female angel derived from Walter Crane's socialist 'Angel of Liberty', which was adopted as a WSPU design, Pankhurst's image of working-class women and children was deliberately modern. In style and iconography, it belongs to the tradition of social realism which she employed in her studies of working women painted during an extended journey through Britain in 1907, and bears comparison with Käthe Kollwitz's images of mothers and children from the same period.[38] In

some respects, the dichotomy between symbolic 'angel' and 'working woman' in WSPU imagery reprises the distinction between static and active figures in nineteenth-century political symbolism. What is more significant is that in dropping a class-specific iconography, the WSPU found it difficult to produce any alternative representations of women which were truly radical, realistic and *modern*.

This chapter began by setting up a contrast between a cartoon of the stereotypical modern feminist and the symbolic embodiment of Joan of Arc by a suffrage militant, in order to encapsulate the contradictions between modernity and conservatism within suffrage representation. I want to end with a similar visual contrast which suggests what was at stake in the tension between the different strands of feminism. The adoption of Joan, a pre-democratic feudal figure, as a model for women's claim to democratic rights was always bound to be contradictory. By 1914, Joan herself had been taken up as a symbol by the extreme right wing in France, where Christabel had spent the last two years avoiding arrest and directing the WSPU from a distance.[39]

An undated suffrage postcard in the Museum of London shows 'Saint Christabel', her manacled hands clasped in supplication in a pose identical to that adopted in Nadar's photograph of Sarah Bernhardt in Jean Barbier's play *Jeanne d'Arc*, c.1890 (Plate 14). Whether or not the postcard was produced with knowledge of Nadar's photograph, it shares the same theatricality of presence. Indeed, Christabel had adopted Joan as a personal symbol, identifying herself with the 'virgin saint' and quoting her in speeches. The figure of Christabel, however, is transposed into a stained glass window, rays from a sun and moon radiating from behind her head to fall, rather incongruously, on the Houses of Parliament. Christabel's canonization in the eyes of her supporters is signified by the halo and the religious connotations of the arched window which reinforces the intended spiritual reading. Christabel's own stance on bodily purity is implied by the peculiar star-shaped 'cracks' in the window suggesting that it has been shattered by stones. While this could be a reference to the militants' own stone-throwing activities, it seems more likely that the placing of the 'cracks' on Christabel's body is meant to signify the wounds that, like stigmata, she must bear in the Cause. Christabel was indeed coming under attack, not only from anti-suffragists, but from former WSPU supporters who were opposed to her autocratic leadership and personal pronouncements. In *The Great Scourge*, a collection of her articles from the *Suffragette* published in 1913, she had revived the concept of bodily and sexual repression which had been central to the social purity campaigns of the previous century, arguing against marriage on the grounds that venereal disease deriving from male sexual vice was the cause of women's ill health. The 'cure' was to be 'Votes for Women and Chastity for Men'.

However, as Lucy Bland suggests, such views of women's natural moral and spiritual superiority did not go unchallenged by contemporary feminists. Teresa Billington-Greig, commenting on the passing of the 'White Slave Traffic' Bill in 1912, which had been supported by Christabel and the WSPU, noted rather acidly:

> The Fathers of the old Church made a mess of the world by teaching the Adam story and classing women as unclean; the Mothers of the new Church are threatening the future by the whitewashing of women and the doctrine of the uncleanliness of men.
>
> (Bland 1995: 299–300)[40]

Billington-Greig's critique of the 'Mothers of the new Church', stemmed from a recognition that if feminism was to challenge the old sexual divisions which emerged with industrial capitalism at the beginning of the nineteenth-century, it had to claim a different space for women in modernity. It had to find new concepts and representations to articulate the presence of women in public and political space which did not call upon notions of women's innate purity and bodily sacrifice in order to assert their political rights.

The photograph of a small child (Plate 15) which appeared on the front page of *The Women's Dreadnought* on 9 May 1914 next to an article about a May Day rally in Hyde Park, represents something of the contradictions and ambiguities which a new presence of women in modernity involved. What is striking about the photograph is precisely an incongruity between the conventional image of the child's femininity, from her beribboned curls right down to the demure placing of her button-booted feet, and the radical assertion of a new political identity emblazoned in the slogan 'Votes for Women' on her sash. It is precisely this unexpected disjunction which makes it modern. A gap has opened up between an ideal model of femininity and its critique embodied in the person of a female child. The child's direct gaze into the camera suggests a degree of composure and self possession and yet an ambiguity of expression in response to the photographer. Unlike Christabel's pious gaze and gesture, it confronts the viewer with a question. Who is this child? Who is the woman she will become?[41] In a literal sense, the unknown child embodies and prefigures a more fractured and ambiguous identity for women as the twentieth century progressed, split between feminist assertion on one hand and feminine compliance on the other. She bears traces of the past too: the motto 'Self Denial' on the collection box for the East London Federation recalls an earlier model of female self-sacrifice, a continuing tension between the 'self-denial' of the suffrage hunger strikers and the need to articulate an active female agency in new terms.

The archaic symbolism of the warrior saint, enshrined forever in stained glass, is counterposed with the modern medium of the documentary

Plate 14 Saint Christabel, suffrage postcard, n.d.

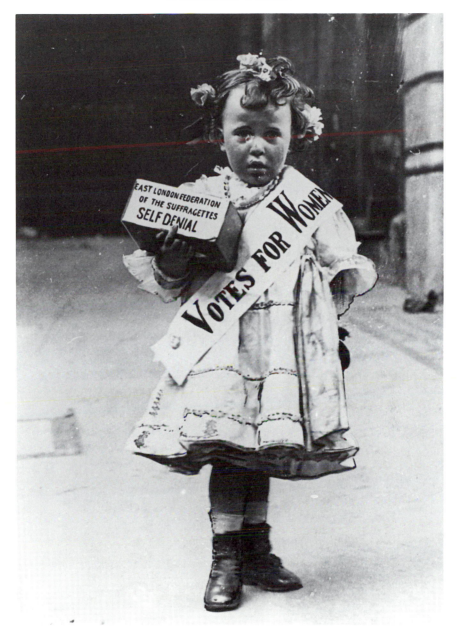

Plate 15 Photograph of a child, *The Women's Dreadnought*,
9 May 1914.

photograph grounded in the specific social reality of an East End child. And, whereas Christabel's image – despite its 'cracks' – is seamless, the disjunctures in the photograph are more profound, betokening a new set of relations between feminism and modernity which, fragile and fragmented, has persisted up to the present.

4

BODIES IN THE WORK

The aesthetics and politics of women's non-representational painting[1]

The question of how women can be represented through a variety of visual media has been central to feminist cultural politics over the last two decades. These debates have continued to focus primarily on questions of signification – to what extent, and by what means, can feminist practices contest the inscription of gender in cultural forms? In this context, it is hardly surprising to find that 'abstract' or 'non-representational' painting has been one of the most ignored areas for feminist intervention. In this chapter I shall explore the specific issue of non-representational painting and embodiment in order to examine the potential for reclaiming female authorship for abstraction. If modern painting is engaged in a set of interactions between the body of the painter and the body of the work, is it possible to challenge the modernist critical paradigm which persistently devalues the *female* body? Can painting, and the use of non-representational strategies in particular, constitute a feminist critical practice and create a discursive context through which women may represent themselves as embodied subjects?

As Shirley Kaneda has suggested, abstract painting 'is the most resistant and decisive discourse within modernism' (Kaneda 1991: 58). Indeed, the formalist project of abstraction was decisively rejected by a generation of women artists in the 1970s and has been largely dismissed within feminist art practice and criticism ever since.[2] Yet, the relationship between non-representational practices of painting and a feminist politics of representation is an important one, since it raises the question of just what, and how, abstract painting does represent.[3] The history of abstract art within modernism has been characterized by the attempt to invest non-representation with meaning, whether this was in terms of spiritual value (Kandinsky), a techno-utopian vision (El Lissitzky), or pure physicality of pictorial means (Pollock). It is the question of precisely how abstraction functions as a representation of *gender* difference, however, and more specifically of the differently gendered body, which modernist criticism has signally failed to acknowledge.

79

PAINTING, GENDER AND ABSTRACTION

I want to begin to explore the vexed set of relations between painting, gender and embodiment with the reading of one critical text. In her analysis of the use of sexual metaphor in relation to the female nude, Lynda Nead argues that the language of criticism both refers to and seeks to contain the threatened collapse of distance between aesthetic and sexual meaning, the body in the work and the body of the critic, which traditional aesthetic discourse maintains as distinct. In this process, sexuality is displaced from the subject represented on the canvas into the metaphorical language of critical discourse. As Nead puts it succinctly, 'Art criticism writes sex into descriptions of paint, surface and forms' (Nead 1992: 58). In accounts of abstract painting this sexual displacement is further condensed as the canvas itself is substituted for the depicted female body.

One of the most explicit examples of such sexualized description can be found in Peter Fuller's account of a colour field painting by the American artist, Robert Natkin, entitled *Reveries of a Lapsed Narcissist*. What is striking about Fuller's loving and prolonged description of his viewing experience – it lasts for three and a half pages – is how closely and self consciously it simulates the male sexual act: attraction, foreplay, penetration and, finally, release:

> The painting is undeniably saturated with a vibrant sensuality: it is *attractive* almost in the sexual sense. As you look, you are aware of the apparent unity of this seemingly seamless skin of light. You are compelled to confront it as a whole; your eyes caress and explore it horizontally and vertically almost like hands moving across another's body in the fore-play to lovemaking.
>
> (Fuller 1980: 177–9)

The canvas is described in stereotypically feminine terms: it is 'shamelessly beguiling', with 'the intimately sensual pinkness of white flesh', 'alluring, suspended cloth', 'seamless skin' and 'infinite recessive interior space' which seduces the viewer in.

Feminist critics have frequently argued that the figure of the masculine artist who expresses phallic mastery in the act of painting is one of the founding metaphors which informs modern western art. Nead points out that 'Within this metaphorical structure, the canvas is the empty but receptive surface; empty of meaning – naked – until it is inscribed and given meaning by the artist' (Nead 1992: 56).[4] This libidinal economy is sustained by a series of binary oppositions between active and passive, subject and object, penetration and reception which are implicitly – and often explicitly – gendered.

In this passage, Fuller as critic appears to mimic the phallic mastery of the artist: the painting itself becomes the object of his desire. The body

evoked in this passage is clearly female, the desire to penetrate and the consequent anxieties produced as the (male) viewer enters its internal spaces are classically phallic. This may partially explain Fuller's expressed unease and fear as he begins to 'penetrate deeper and deeper *inside* the painting', an anxiety which is reassuringly resolved as he comes to the realization that, 'when you engage with it receptively this Natkin painting offers the illusion that it is almost a "subjective object" or a picture of which you are more than a viewer, and almost a literal *subject*' (Fuller 1980: 179). The threat posed by the viewing experience is thus displaced by a process of identification in which the male critic substitutes himself for the painted object.

One way of interpreting the relationship of Fuller as critic to the painting by Natkin would be to suggest that it assumes the role of a fetish object; a metonymic displacement of the object of desire on to something else through the processes of disavowal. In an interesting revision of the classic psychoanalytic model of fetishism as a disavowal of castration anxiety, Lorraine Gamman and Merja Makinen offer a new reading of sexual fetishism from a female perspective. They suggest that it can be located at an earlier, pre-Oedipal stage than in Freud's classic account of the castration complex and, drawing on object relations theory, they connect it specifically to the oral phase of infancy. The threat which is then disavowed becomes that engendered by the process of separation from the mother.[5]

Fuller himself offers an explanation of his experience of Natkin's painting in similar terms of a psychoanalytic account of the infant maternal relationship. Drawing on D.W. Winnicot's concept of 'potential space', he describes the undifferentiated space of colour field paintings by Robert Natkin and Mark Rothko in terms of the process of individuation when spatial and psychic boundaries are still fluid. Individuation occurs when the infant perceives a separation between itself and the world of objects – between 'me' and 'not-me', a differentiation of the infant self from the physical and psychic environment of the mother. Fuller suggests that both the intense pleasure and the sense of anxiety, even fear, engendered by Natkin's painting are connected to this early psychic experience of closeness and separation. He thus maps an explicitly gendered, sexual reading of the painting on to a psychoanalytic explanation which deals with pre-Oedipal, non-gendered, experience.

What is interesting about Fuller's preliminary description and his own evident unease with it is the way in which, despite his model of sexual penetration, he suggests a different possibility of reading the work, one which would dissolve the rigid binary economy of sexual difference. Indeed, under its feminine 'skin' Fuller discovers a thoroughly masculine 'organised, architectural or skeletal *structure*; the painting itself turns out to be sexually ambivalent' (Fuller 1980: 180). All this suggests a degree

of ambiguity and fluidity, not to say sexual confusion, in the relationship between the body of the artist and the bodies in the work. Indeed, by phallicizing the relationship between male critic and painting, Fuller's account points to an instability of gender relations at its very core.[6]

This suggests a need to revise the terms of the phallic metaphor as it has been defined within a feminist critique. By exposing the phallic model, feminist critics have tended to overvalue it, thus reaffirming the very ideology which male artists and critics themselves have created. But, if we think of an abstract painting as a fetishization of the ambivalent maternal relationship, a focus of the subject's desire and loss, it opens up a space to explain the relationship between the insistent masculinity of artistic and critical discourse and what it seeks to disavow, the ungendered space of the pre-Oedipal. The painting as fetish object allows the critic/viewer immediate sensual pleasure and at the same time allows a denial of the 'threat' of loss.

Fuller himself is unable to explain the connection between his two readings of the painting because his position allows for no understanding of how sexual difference may shape psychic experience. While he offers an account of painting which is linked to specific bodily experience, this 'body' is taken to lie outside of historical discourse in the realm of the biologically given. In his quest to define aesthetic value in art, Fuller asserts that it is 'because all forms of effective expressive practice are so intimately enmeshed with the body that a work of art can outlive the historical moment of its production' (Fuller 1980: 232), but this body remains outside history and is absolutely gender free. What is transcendent in art turns out to be, yet again, dependent on an assumed, yet unacknowledged, relation between painting and *masculine* embodiment.

THE FEMININE IN THE MASCULINE

Fuller's use of a psychoanalytic model has been followed by other attempts to explore the body politics of painting which have emerged from a perspective more frequently linked to feminism. James Breslin has argued that a distinction can be made between the painting practices of Jackson Pollock and Mark Rothko based on the different relationship in each case between the body of the painter and his work. While Pollock struggled to assert direct physical mastery over the canvas, Rothko 'painted being before it had been split into body and spirit, before it had been firmly shaped, and separated, into a specific, vulnerable and bounded "self"' (Breslin 1993: 47). Like Fuller, Breslin links the development of Rothko's colour field painting to the lost relationship to the maternal body in infancy and, more specifically, to the death of Rothko's mother in 1948. He argues that rejection of autonomous, self-contained objects and hard-edged geometry by Rothko in favour of a dispersal of physical

boundaries represents a struggle to recover the relation with the maternal presence: 'subjectivity in the *process* of forming, prior to language, prior to the "fall" into hard boundaries' (Breslin 1993: 49). Breslin's description of Rothko's abstract colour paintings in terms of an evocation of the 'absent presence' of the maternal body is similar to Winnicot's concept of 'potential space'. Again, it is not the physical embodiment of the painter as *male* which is at issue, but the traces of an early psychic life prior to the formation of sexual difference.

Feminist psychoanalytic approaches drawing on Lacan have also paid attention to this pre-Oedipal state in order to explore workings of subjectivity and desire which are not yet structured according to systems of sexual difference. According to this argument, for male and female subjects alike it is the traces of pre-Oedipal pleasures and the memories of maternal *jouissance* which shape later experiences of desire and loss. However, it cannot be assumed that this automatically provides a basis for theorizing *women's* artistic production.

This point can be made clearer by reference to one of the most developed applications of post-Lacanian theory to painting. For Julia Kristeva, it is the relation between the pre-linguistic or 'semiotic' state of infancy and symbolic language which provides the key to the subversive potential of the aesthetic. Kristeva suggests that is through art that we can recover a former relation to the semiotic: 'traces of a marginal experience, through and across which a maternal body might recognise its own, otherwise inexpressible in our culture' (Kristeva 1980: 243). Significantly, she cites Mark Rothko and Henri Matisse as the two modern artists whose painting eclipses figuration and produces volume through colour. In such work, she suggests, there is potential to evoke maternal *jouissance*, the infant relation to the mother which is repressed in the symbolic system of language. Such marginal experience is made present, at 'the intersection of sign and rhythm, of representation and light, the semiotic and the symbolic' (Kristeva 1980: 242).[7] For Kristeva, it is primarily through avant-garde practices which disrupt the signifying process that access to the maternal relationship can be found. However, following the Lacanian model, Kristeva implies that women are placed in a negative position in relation to the symbolic order. Only men have full control of the signifying systems of speech and rationality. And, only male artists can occupy the position of being simultaneously in command of discourse *and* of transgressing it.

In a useful discussion of Kristeva's theory of the feminine, Elizabeth Gross argues that this is more than mere omission. For while Kristeva posits the semiotic as both feminine and maternal, it has no necessary relation with women as embodied subjects. The feminine for Kristeva, Gross suggests, is '*sexually* indifferent – distributed independent of sexual identity, predating the sexually distinguished positions of phallic, active,

male, subject and passive, castrated, female, object. She *disembodies* these designations, seeing them as independent of the female body, sexuality or subjectivity' (Gross 1986: 130).

So while Kristeva's analysis disrupts the terms of binary sexual difference in which the male artist necessarily expresses phallic identity, it is difficult to see in her account of the aesthetic any basis for a theorization of the position of *women* as producers of culture. Indeed, as critics of Kristeva have noted, all the artists she cites are male; she has nothing at all to say about women's cultural production.

In discussing these different accounts of the relationship between the masculine subject and painting, what emerges is a destabilizing of the position of the male artist. No longer assumed to be in a position of phallic mastery, his work can be seen to encompass the feminine, the maternal, and the repressed semiotic, as a potentially subversive agent within the established patriarchal order. The attraction of such theories for an account of painting as potentially representing a 'pre-linguistic' and ungendered space beyond the phallus are undeniable, but problematic. In suggesting that the phallic paradigm is not the only way of understanding the work of male painters, they begin to open up the masculinist discourse of abstraction. But, since modernist critical discourse persistently devalues *women*, reclaiming the 'feminine side' of male modernist painters via their relationship to the maternal may turn out, yet again, to be a way of marginalizing women's art production. There has been a long tradition of claiming femininity within post-Romantic concepts of the artist, as Christine Battersby has shown, whereby the possession of feminine attributes marked off genius from normal masculine rationality. As she points out, the key distinction remained, 'A man with genius was *like a woman*, but was *not a woman*' (Battersby 1989: 8).

GENDERED AMBIGUITIES

A different approach to the question of gender and abstraction has been to examine the terms of the critical discourse which underpins concepts of value in art. In 'Painting and Its Others', Shirley Kaneda examines the masculine discourse which surrounds abstract painting and suggests a different set of criteria for its making and viewing. She proposes a new concept of 'feminine painting' which is not dependent on the gender of the producer, but on the re-inscription of those values which have hitherto been suppressed in abstract art. The position she proposes would involve both dismantling the authority of modernist assumptions and the reassertion of marginalized values as central to the project of abstraction: 'Post-structuralism has brought out the multiplicity of criteria for any given text. When one eliminates the notion of decisive reading, the notion of closure and dominance comes to an end' (Kaneda 1991: 58). Thus, against

the 'universalist ideals' of masculinist discourses of art which put value on logic, aggressiveness, confrontation and toughness, she counterposes a series of terms for the feminine.

> 'Feminine' painting has always been contrary, eccentric and unprincipled, structurally and in regard to colour ... the arbitrary, matter of fact, take it or leave it attitude that has long been embraced by the feminine whereas the 'masculine' consistently attempts to be resolute, idealising linearity and closure.
>
> (Kaneda 1991: 62)

But, in calling for a postmodernist play of 'difference' to re-vitalize the tired masculine project of abstraction, Kaneda raises a number of problems for any attempt to theorize practices of painting in feminist terms.

Her call for a plurality of readings opens up the possibility of difference, but leaves the 'feminine' as simply one textual strategy among others. Indeed, Kaneda makes it clear that the discourse of 'difference' is itself 'more important than the gender or race of who puts it forward; how it is stated (the means) will determine the conditions by which it will be received and judged' (Kaneda 1991: 58). In thus detaching the 'gender values' in the work from the gender (and race) of the maker, Kaneda, like Kristeva, denies any connection between femininity and a specifically embodied female subject. When she later suggests of a woman painter's work that, 'Pictorial events are cued to the body' (Kaneda 1991: 63), it is hard to see in what sense this might be, if the feminine ceases to bear any relationship to the embodied experience of women as producers or readers. In seeking to avoid a reductive essentialism which equates femininity with women and thereby devalues it, Kaneda presents gender merely as a question of a textual choice.

Thus Barnett Newman and Mark Rothko are seen to be representative of 'masculine' and 'feminine' approaches to the sublime respectively, the one choosing to objectify it, the other to be engulfed by it. The system of morphology on which Kaneda draws has ancient roots. As Genevieve Lloyd points out, in the Pythagorean table of opposites which dates from the sixth century BC:

> femaleness was linked with the unbounded – the vague, the indeterminate – as against the bounded – the precise and clearly determined. The Pythagoreans saw the world as a mixture of principles associated with determinate form, seen as good, and others associated with formlessness – the unlimited, irregular or disorderly – which were seen as bad or inferior.
>
> (Lloyd in Whitford 1991: 60)

Such contrasts carry with them a weighty tradition not only of gender associations but of moral value. In discussing the feminine in terms of a

textual strategy, Kaneda is led to describe work by male and female artists in terms of just such paired opposites, albeit distributing values differently between the sexes. Thus, the 'difference' of the feminine turns out, yet again, to be found in the mirror image of masculine values.

Kaneda's arguments reveal very clearly some of the problems in discussing the relationship between gender and abstraction in 'disembodied' terms. What seems missing is precisely the connections between the masculine and feminine as textual categories and questions of gendered agency.

In her essay 'Minimalism and the Rhetoric of Power', Anna Chave is also interested in dismantling the male rhetoric of abstraction in what she sees as the most extreme form of modernism. She characterizes 1960s minimalism memorably as 'the face of capital, the face of authority, the face of the father' (Chave 1990a: 51).[8] Chave is not only concerned with the textual strategies of the work itself, but with the discursive contexts which make them meaningful. She quotes Theresa de Lauretis who explains that, 'the relations of power involved in enunciation and reception ... sustain the hierarchies of communication; ... the ideological construction of authorship and mastery; or, more plainly, who speaks to whom, why and for whom' (de Lauretis 1984: 179). Thus, Chave argues, the determining context for minimalism's 'rhetoric of power' is the celebration of the industrial-military complex in 1960s America. Chave points not only to a set of textual values which are be labelled as masculine, but also to the ways in which these may be mobilized as meaningful under certain historical circumstances. Furthermore, she exposes how the language of art history and criticism colludes in valuing masculine norms: 'The language used to esteem a work of art has come to coincide with the language used to describe a human figure of authority' (Chave 1990a: 55).[9] Thus, it is not simply a question of reversing textual strategies, but of challenging the terms of a critical discourse that gives them meaning. Chave does two things, she relates the mobilization of masculinity in art to certain ideological formations and points to the crucial role of critical discourses in sustaining their values.

'A WOMB WITH A VIEW': THE WOMAN ARTIST IN CRITICAL DISCOURSE[10]

The first major showing of Georgia O'Keeffe's work outside the United States at London's Hayward Gallery in 1993 provided an interesting case study of this gendered critical discourse in operation. O'Keeffe's status, particularly in the United States, ensured a degree of critical attention in the British media unusual for a woman artist. Because of her inscription into modernism as a quintessentially 'female' artist, O'Keeffe's work also raises directly the question of how a woman's body is figured in the work.

Much of the critical coverage of the exhibition was markedly hostile and it is the specific terms of that critical hostility which I want to explore in more detail here. What pervaded responses to the exhibition was the remarkable consistency with which critics made a connection between an aesthetic evaluation of O'Keeffe's painting and the sexualization of her life and work.[11] Recurring themes in the reviews were the dismissal of O'Keeffe's *painting* as inferior and the reading of her work in terms of bodily metaphor - it would be hard to find a more essentialist reduction than the 'viewing womb'. I want to suggest that the critics' evident unease with the formal qualities of her work and their obsessive interest in its supposed sexual content can be located in the same desire to *see* the sexual body of the artist.

In the most frequent response to the exhibition, critics dismissed O'Keeffe's painting as overrated and compared it to commercial art or photography.[12] For example, Richard Cork suggested her landscapes had the quality of 'Technicolor' or a 'picture postcard' (*The Times*, 9 April 1993), a comment which faithfully reproduces the terms of Clement Greenberg's distinction between pure painting and mass culture in his essay 'Avant Garde and Kitsch' (1939).[13] As Andreas Huyssen has shown, what is significant about such critical categories is the consistency with which they operate in gendered terms to align mass culture with femininity and to maintain high culture as a masculine preserve. Huyssen goes on to suggest that this gendering device will become obsolete with the visible and public presence of women artists in high art, but the case of O'Keeffe suggests something rather different occurs. In this alignment of the mass-produced copy, the pastiche, with the feminine, it is the gendering of the painting process itself which is at stake.

Significantly, O'Keeffe's work was attacked precisely for the absence of those spontaneous painterly and textural qualities which were seen to be requisite for the expression of *masculinity*. As William Packer, in his review of the exhibition, made clear:

> Rather it is the image that is all – which is another way of saying that the painter is no painter at all. For the true painter is always quite as much engrossed in the stuff of the painting he is making, as the pigment comes of [sic] the brush onto the canvas, as he is in the external reference or stimulus.
>
> (*Financial Times*, 20 April 1993)

Packer's comments perfectly reproduce the sexual ideology which underpins the modernist myth of the artist. The male painter expresses his sexuality through the medium of paint; his paintbrush 'comes' without his conscious control. These comments reveal the degree of libidinal investment by O'Keeffe's critics in the painting process itself. The flat, unemphasized and tight quality of her painted surfaces

after 1924 was taken as an indicator, that is, of her failure to 'be' a painter at all.

In one of the few substantive analyses of O'Keeffe's work which appeared at the time of the Hayward exhibition, Barbara Buhler Lynes argued that it was the initial reception of her early abstract and semi-abstract works which led O'Keeffe consciously to redefine her painting style. The language employed by critics from Alfred Stieglitz's circle in the 1920s had stressed that the sources of her early painting lay in the artist's sexual identity. For example, Paul Rosenfeld wrote of O'Keeffe's work in 1921:

> Her art is gloriously female. Her great painful and ecstatic climaxes make us at last to know something man has always wanted to know. It is a new sort of language that her paint speaks ... leading him always further and further into the truth of a woman's life.
>
> (Buhler Lynes 1993: 6)

We can see O'Keeffe's decision to move away from her early phase of expressive, lyrical abstraction towards greater technical precision in her paintings of the mid-1920s as a deliberate attempt to block readings of her work as essentially feminine and based in the body. It was the identification of her early abstract painting with female orgasm which O'Keeffe sought to avoid in her famous denial of sexual content in her work.

Significantly, it was these early works, shown in the first room of the 1993 Hayward exhibition, to which critics in the 1990s responded most favourably. What appeared to disturb them was that Georgia O'Keeffe's later paintings did not deliver such an unambiguous sexual reading. They could neither be recognized in terms of the masculine body of painterly expression, nor yet did they offer up the requisite female sexuality. This was particularly evident in discussion of her flower paintings (Plate 16). Many critics simply reiterated the sexual interpretation of her imagery which O'Keeffe had rejected in the 1920s. In a passage which positively bulges with sexual description, Frank Whitford referred to her 'flower paintings in which tumescent pistils emerge from most labia like petals, and buds strain against tightly enclosing, sheath like leaves' (*Sunday Times*, 11 April 93). One wonders precisely who is straining here, for the terms of his description belong properly to the language of *male* sexual desire, a desire which manifestly cannot be achieved. What then is the frustration such a text articulates?

One visual device used in a number of the reviews was to juxtapose O'Keeffe's flower paintings with the nude and semi-nude photographic studies of the artist by Alfred Stieglitz from 1921 (Plate 17).[14] Such a pairing renders visible what is unspoken in the critics' texts. In a transference between the painted image and the body of O'Keeffe herself, it is the body of the artist which is seen as penetrable. O'Keeffe's shirt is

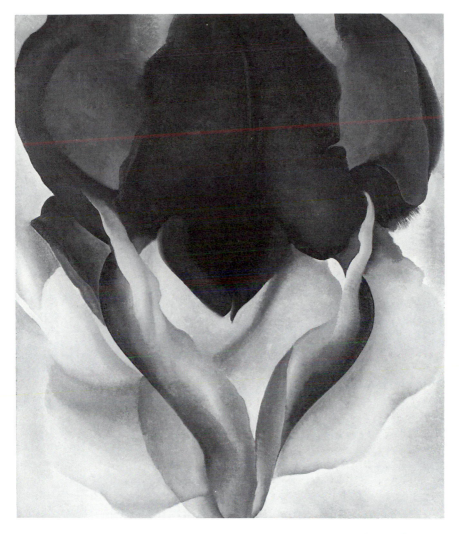

Plate 16 Georgia O'Keeffe, *Black Iris*, 1926, oil on canvas, 36cm × 30cm.

unbuttoned to expose her upper body to the viewer, her head is thrown back, gazing at the viewer in the classic pose of the *femme fatale*. However, unlike Fuller's description of Natkin's work, the painting does not open up under the critic's penetrating gaze; the tightly painted surface repels rather than attracts his eye. The painting *appears* to lay open the sexual body of the artist only to deny access to it in the final moment. What disappoints is precisely the failure of the painted surface to deliver the sensuous promise of the photographic image; it simply does not unfold a mystery, 'the truth of a woman's life' within.

89

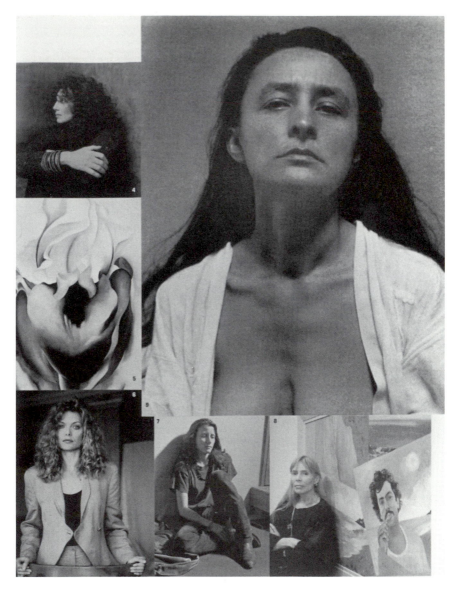

Plate 17 'Georgia's Girls', *Vogue*, April 1993: 193

In a brilliant account of 'writing from the body', Jacqueline Rose suggests that the hysterical feminine can be found in:

> writing where the passage of the body through language is too insistently present; it is writing in which a body, normally ordered by the proprieties of language and sexual identity gets too close. ... Its body can be called feminine to the precise degree that it flouts the rigidity (the masculinity) of the requisite forms of literary cohesion and control.
>
> (Rose 1991: 27–8)

In Georgia O'Keeffe's work we can see a body getting 'too close' in this sense but it is the body held in check, rendered impenetrable by technical control over the process of painting which O'Keeffe sought to develop after 1924. She deliberately refused the 'feminine' as a textual practice, which would have placed her in the position of the hysteric so aptly described by Paul Rosenfeld. By maintaining a tension between proximity and distance, sensuousness and control, the feminine and the masculine, O'Keeffe tried to resist the reading of her work in terms of sexual stereotypes. What so disturbs her critics now might be seen as precisely the refusal to accept these terms of gendered sexual difference. If her failure to 'be' a painter is a function of her femaleness, then O'Keeffe also stands condemned as insufficiently *feminine*. In the ordered and controlled application of the painted surface she denies the male critic access to the truth of the woman's body he so desires.

TOWARDS A FEMINIST AESTHETIC?

> For woman it is not a matter of installing herself within this lack, this negative even by denouncing it, nor of reversing the economy of sameness by turning the feminine into *the standard for 'sexual difference'*; it is rather a matter of trying to practice that difference.
>
> (Irigaray 1985b: 159)

What implications does this reading of recent critical responses to O'Keeffe's work have for feminist theories and practices of painting in the 1990s? It points again to the pitfalls of any attempt to reclaim the 'feminine' as *necessarily* subversive of masculine values. For, if anything, it shows that the feminine is already inscribed within modernist discourse, on the one hand as inauthentic pastiche, mass culture to male high art and, on the other, in terms of a fixed economy of sexual difference in which a female artist's work is always expected to reveal her sex. As Jacqueline Rose suggests in respect of literature: 'We can watch unfold a stark alternative between, on the one hand, a masculist aesthetic and on the other, a form of writing connoted feminine only to the extent it is

projected on the underside of language and speech' (Rose 1991: 27). This clearly presents some problems for thinking through the relations between painting and women's embodiment. How can we 'practise difference' except in terms of reversal?

In recent debates, women's painting has been located in the context of the wider reassessment of painting and its relation to tradition within postmodernism. While it is a much contested phenomenon, the postmodern in art has been generally understood in one of two ways. In its critical aspect, it has been argued the postmodern represents a destabilizing of the modernist project, in which the feminist critique of modernism represents one crucial strand.[15] The second, opposed view sees postmodernism as a legitimation of a 'return' to painting as an expressive medium. It is under this second aspect that a traditionally reactionary discourse of painting centred on the figure of the male creator re-emerged with some force in the 1980s.[16] On one hand, then, women's painting has been positioned in relation to the postmodern as critique and, on the other, to a renewed emphasis on the expressive potential of painting. It has been claimed both to be part of the deconstructive project of feminism in respect of painterly tradition and as 'an alibi for female expressivity; that is for seeking women's equal rights to the "body of the painter"'(Pollock 1992a: 146). This difference in interpretation accounts in part for the ambivalence with which contemporary attempts to develop a feminist practice and theory of non-representational painting have been received. Griselda Pollock has argued that such work does not fundamentally challenge the expressive transposition of 'self' into art which is at the core of modernist ideology, but merely substitutes feminine for masculine modes of expression. One strand of Pollock's critique is the way in which what she calls 'subtle misreadings' of French feminist writers have been used to justify a new theory of female expressivity (Pollock 1992a: 157).

The concept of *l'écriture féminine* – the attempt to develop a language and aesthetics based on the female body – has indeed been widely taken up within women's art practices. Drawing on the psychoanalytically based theories of such writers as Luce Irigaray and Hélène Cixous, some painters and critics have sought to develop an alternative aesthetic as a means to represent that which is repressed or marginalized within patriarchal culture. Using the morphology of the female body, they have found formal correspondences through which to represent feminine subjectivity and desire. This inscription of the feminine has frequently been conceived in formalist terms of the fluid, tactile and sensual properties of paint. Such attempts to define a new feminine aesthetic seem to echo feminist formulations from the 1970s, for example, Lucy Lippard's identification of a female aesthetic in *From the Center* as:

A uniform density, an overall texture, often sensuously tactile and often repetitive to the point of obsession; the preponderance of circular forms and central focus; often empty, often circular or oval, parabolic baglike forms . . . layers or strata; an indefinable looseness or flexibility of handling; a new fondness for pinks and pastels and the ephemeral cloud colours that used to be taboo.

(Lippard 1976: 49)

Thus *l'écriture feminine* has, in some respects, been assimilated to earlier attempts to define female qualities in art based on the expression of sexual difference. For Lippard, however, such differences were not given, but were the product of a relationship between a subordinate group and a dominant culture.

One idea which has been widely taken up has been that made famous in Irigaray's essay *This Sex Which Is Not One* that the imaginary has a sex, and that the female imagining mind bears the marks of female sexual body which can be characterized in terms of fluidity, multiplicity and non-linearity. It is here that Irigaray has appeared most open to her critics' charges of essentialism, with a desire to equate female subjectivity with the non-symbolized female body. It is also, ironically, the aspect of her ideas which have been most readily assimilated into women's art practices.

Irigaray, in a well known passage, proposed different terms for female sexual desire linked to the concept of auto-eroticism: 'As for woman, she touches herself in and of herself without any need for mediation, and before there is any way to distinguish activity from passivity' (Irigaray 1985b: 24). But, while Irigaray described female desire in terms of touch, closeness, plurality and diffuseness, she also asked whether this might not be understood to be a consequence of women's marginal position within patriarchal culture, 'as shards, scattered remnants of a violated sexuality? A sexuality denied?' (Irigaray 1985b: 30); in other words, that it is an *effect* of sexual difference rather than a means of disrupting it.

This passage stands in the context of a broad and profound critique of western rationality and must be seen in this light. To suggest that Irigaray privileges 'female nature' over male rationality is to miss the point of her attack on the fundamental dualism in western thought, in which the female, together with nature, is defined as inferior. Irigaray is not concerned primarily with constructing a feminine aesthetic, but with developing the means of opposing male myths of cultural origin. She herself is careful to make the distinction between the biological body and the 'imaginary body', which may be understood both in the sense of unconscious fantasy and as the product of the conscious imagining mind.

There is yet another problem in transposing Irigaray's ideas too literally into visual art practice, and this lies in the differences between verbal and visual representation. In her essay, Irigaray contrasts *parler femme*

(speaking (as) woman) with a male scopic economy in a way which seems explicitly to exclude the possibility of a female *visual* language:

> Within this logic, the predominance of the visual, and of discrimination and individualisation of form is particularly foreign to female eroticism. Woman finds pleasure more from touching than from looking and her entrance into the dominant scopic economy signifies, again, her consignment to passivity: she is to be the beautiful object of contemplation.
>
> (Irigaray 1985b: 25–6)

Drawing on the psychoanalytic model in which it is visible *sign* of difference, the penis, which above all governs the recognition of sexual difference, Irigaray makes a critique of the dominant visual economy in which woman can only function as a mirror to reflect masculinity, and is thus is unrepresented in her own right. Within this frame, it is difficult to see how Irigarayan 'feminine speech' could be directly mapped on to a visual art practice. Speaking (as) woman cannot be the same as painting, photographing, drawing or even sculpting as a woman since the gendered relations and practices of speaking and looking are different. Irigaray herself has recently emphasized this difference, but has given greater priority to the visual. Using the model of psychoanalytic practice, she suggests that the 'talking cure' has been developed at the expense of visual experience, a perceptual imbalance which risks 'uprooting the patient from his or her body and history' (Irigaray 1993: 154–5).[17]

Clearly, the attempt to transpose Irigaray's female imaginary directly into a prescription for a visual aesthetic is problematic for a number of reasons. But this is not to say that Irigaray's ideas are of no use to visual artists. Nor need the fact that she herself, like Kristeva, is unsympathetic to much contemporary art by women necessarily mean her ideas have no relevance to them.[18] The central issue is how these are used in practice.

PAINTING FEMININITY

If we think about what the relationship of Irigaray's ideas to practices of art might be, it seems clear that the adoption of the 'feminine' must be primarily strategic. A crucial aspect in Irigaray's writing is the importance she gives to the connection between feminine subjectivity and female embodiment and the psychic and social effects of that embodiment for women. But, this need not involve, as some critics have suggested, a literal illustration of female morphology, nor a formalist association of the painting process with the female body. Katy Deepwell has suggested that some women painters 'mistakenly associate a recovery of texture/tactility/facture as a textual strategy for writing of the feminine body from the position of the woman's body as painter' (Deepwell 1994: 16).

However, it would be a mistake to assume that 'painting from the body' can be reduced to a single strategy or necessarily implies a uncritical relationship to female embodiment. Indeed, contemporary women painters working with abstraction rarely simply celebrate the female body, but rather interrogate its meaning within a set of gendered power relations. As Eve Muske has commented of her work, 'I don't want to put forward a feminine specificity or to countervalorise female materiality/corporeality/sexuality. The feminine is used strategically, at once acting on behalf of and at the same time against' (Muske, *Artist's Statement* in Betterton, 1992b unpaginated). In non-representational painting by women we can see various 'writings of the feminine body' to explore how women are positioned within cultural categories. One such strategy is self consciously to reclaim femininity as a critical site on which to work.

Plate 18 Eve Muske, *orange, blue, mirror, skin, grid*, 1992, mixed media on canvas installation, overall dimensions 182.9cm × 274.3cm.

In Eve Muske's installation piece made up of multiple canvases of different size and shape, such as *orange, blue, mirror, skin, grid*, 1992, images or textures allude to the feminine but these references remain suspended and unresolved (Plate 18). Femininity is the reference point for a series of iconic signs, for example, painted pieces of cloth, details of clothing, mirrors, skin, which hint at a female narcissism, but in a literal sense do not 'add up' to a coherent representation of what women are like. As viewers, we are unable to penetrate the feminine body of the work, since we are constantly forced to evaluate the process by which painted marks construct signs of gender in the text. The quotation of various 'masculine' styles of painting: geometric abstraction, minimalist grids, colour fields, points us to the constructed nature of the painted text. Unable to be read as expressive signs, these act as signifiers of the gendered discourse of modernism. Painting as a practice which structures and reproduces the meanings of sexual difference is here put into question. Yet the references in Muske's work to her own childhood formation as a feminine subject through clothes, dolls, and relationships to her mother and grandmother, locate this in specifically female embodied experience which is socially inscribed and historically marked. Her work explores the complex and culturally changing set of relationships between gendered and embodied experience, between femininity and women's identities. As a strategy then, painting 'femininity', as opposed to painting women, can address the issue of the body in the text in terms of women's diverse historical embodiments.

Laura Godfrey-Isaac's series of paintings from the early 1990s explore the metaphorical and literal equivalencies between the feminine body and the surface and textures of oil paint. At first sight, works like *Pink Surface*, 1992 and *Pink Skin*, 1992 seem to bear out an identification of certain kinds of painterly process with the female body (Plate 19). But the large scale of the work and an excess of sickly DayGlo colour, a wrinkled and sagging surface containing viscous layers of oil paint, point to a parodying rather than to any straightforward celebration of femininity. We are again unable to locate any 'truth' of the female body in the text, for it is produced on the surface as excess. Pinkness, softness, malleability and disorder are the signs of the feminine body within the symbolic order; they evoke a multiplicity of cultural associations from Barbie dolls to Barbara Cartland. Godfrey-Isaacs does not celebrate femininity as a transgression of masculine norms, but suggests its sinister undertones: behind 'the sugar and spice and all things nice' signified by 'pinkness' is a fear of corporeal engulfment. Femininity here is not the *unrepresented* of our culture, but what is all too present on its surface as fetishized object.

This kind of painting seems close to a strategy at work in Irigaray's writing, that is the idea of mimicry or mimesis; the excessive feminization

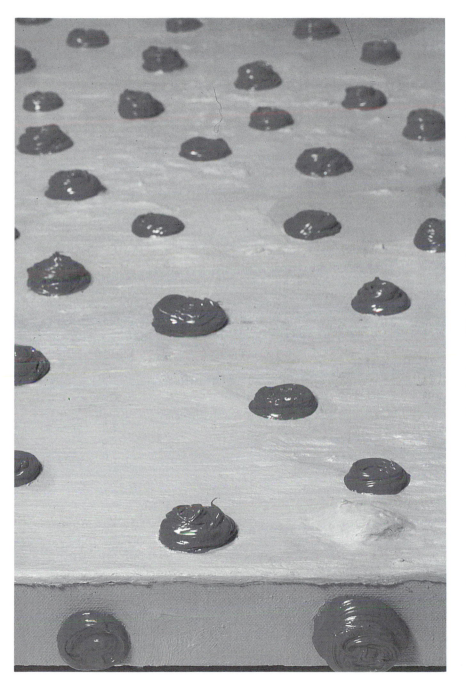

Plate 19 Laura Godfrey-Isaacs. *Pink Surface*, 1992 (detail), oil on canvas, 188cm × 198.1cm.

or parodying of the feminine which exposes it as a product of the male imaginary:

> One must assume the feminine role deliberately. Which means already to convert a form of subordination into an affirmation, and thus begin to thwart it. Whereas a direct feminine challenge to this condition means demanding to speak as a (masculine) 'subject', that is, it means to postulate a relation to the intelligible that would maintain sexual indifference.
>
> To play with mimesis is thus for a woman, to try and locate the place of her exploitation by discourse, without allowing herself to be simply reduced to it.
>
> (Irigaray 1985b: 76)

But, mimicry can be a tricky enterprise for women and, as Toril Moi has argued in relation to Irigaray's own writing, always runs the danger of reproducing what it mimics. Strategies of parody and irony are ambivalent in terms of their complicity with and critique of dominant cultural codes, a criticism which has been made in relation to postmodern culture more generally.[19] Certain kinds of critical feminist practice, however, have been widely discussed in terms of such a strategy of mimicry. For example, in Cindy Sherman's early *Film Stills*, 1977–80, femininity is displayed as a facade behind which the 'real' is endlessly displaced. Subjectivity for women has no central meaning according to Sherman; it cannot exist except as surface, as a series of staged identities in which gender itself becomes the performance.[20] To mime suggests at once an intimate knowledge of the ways of femininity and yet a critical distance which allows it to be seen as a construct. Elisabeth Gross suggests that:

> To mime is not merely a passive reproduction, but an active process of reinscribing and recontextualising the mimicked 'object'. It is to position oneself both within and outside the system duplicated to produce something quite other than and autonomous from it, using recognisable actions for new purposes.
>
> (Gross 1986: 143)

In the painting practices of Eve Muske and Laura Godfrey-Isaacs, the 'mimicked object' is femininity, and the recognizable actions are those of modernist painting itself. The new purposes to which they are put are to undo the central expressive fallacy of modernism which posits an unmediated relation between the body of the artist and the body of the work.

In Rebecca Fortnum's paintings there is also a conscious recognition of the body as a problematic site for women. We do not have an adequate language in which to talk about female sexuality, nor do we possess the critical terms to describe the dimensions of an embodied female subjectivity – there is no feminine equivalent to the virile, potent and penetrative

in the language of aesthetics.[21] Fortnum's paintings raise the question of how experiences of female embodiment which are not named can be represented; they open up a space to pose the question of what a female relationship between words and the body might be. Like Luce Irigaray's extended metaphor of female sexuality, the images stand for a different set of relationships of women to their bodies, but also to the world and to language. For if, as Irigaray has argued, the morphology of the male body has given us the phallocentric logic and language of the symbolic order, the female body too is imagined within a phallic system

Plate 20 Rebecca Fortnum, *Performance Utterance*, 1993, oil on canvas, 244cm × 244cm.

of representation. Since these bodily forms are marginalized or negated, they may provide a starting-point for a critique of the system itself.

In Fortnum's painting series entitled *Wounds of Difference* from 1990, metaphors of the body recur, oil paint is treated like a skin in which gaping wounds and fissures open up the surface to expose interior body spaces. These works inscribe the female body as lack, the wounds of sexual difference which scar women within the symbolic order. Thus it is as dissonance from *within* rather than as proffering an alternative *outside* the system that the mobilization of the female body may function in Irigarayean terms. The female imaginary body can be seen both as a product of, and as a necessary counter symbolization to, the binary logic of patriarchal systems. In Fortnum's *Agent and Patient* series from 1992, division of the canvas into two parts seems to suggest just such a binary logic, but this is subverted by the mirroring and reversal of the shapes which open up like lips in each half of the canvas. Recalling Luce Irigaray's 'two lips re-touching', the paintings also invoke a more ambiguous set of power relations; just who is the agent and who is acted upon here?

Fortnum's recent paintings mark a shift from concerns with the interiority of the unnamed female body to questions of how the body itself is made meaningful, with reading the body as a system of signs which lie at once within and beyond language. The large scale and huge physical presence of these paintings suggests the body's materiality, but it is a bodily landscape in which the borderlines are unfamiliar, inside and outside, surface and depth, solid and space are uncertain. This work does not let the visual 'speak for itself', as modernist aesthetics would have it, but points to the body's very inarticulacy; to the complex relation between forms of embodiment and forms of speech. The title given to four paintings, *Performative Utterance* (1993) suggests precisely the problem of making the visual speak (Plate 20). A gridlike repetitive structure of verticals and horizontals is both rhythmic and suggestive of enclosure and imprisonment. Words cannot describe physical pain and yet they provide its 'resistance to objectification' (Scarry 1985: 56). In thus exploring the limits of the body's inarticulacy, Fortnum is also addressing a silence in modernist painting; its refusal to speak about the body and the fears which it engenders. In her work the body is reinscribed both as a material and physical presence and as one which shapes our psychic responses and desires.

A third strategy present in contemporary abstract painting by women is the disruption of the binary oppositions which enshrine sexual difference in terms of either/or: active/passive; rigid/flowing; contained/dispersed. By refusing fixed meanings and embracing contradiction between representation and abstraction, this work embodies the possibilities of a language of non-representational painting which does not merely reproduce the feminine. In 'Flesh Colours', Luce Irigaray argues

100

that cultures which privilege writing and arbitrary codes tend to repress female genealogies:

> Writing has difficulty translating colours, sounds, bodily identity. ... All the civilisations that give priority to non-figurative writing, arbitrary forms and formal codes, move away from colour and from tonality as qualities of flesh, gender, genealogy. They express these as numbers. Mastery and abstraction of the living being?
>
> (Irigaray 1993: 160)

In Rosa Lee's paintings, underlying numerical systems are dissolved within webs and repetitive rhythms of rich colour and tonal and textural variation. A geometrically generated structure resists the assumption of the intuitive nature of creativity, but at the same time underpins a surface which is detailed and decorative. Against the search for purity, closure and control, the contained object and the finished statement in minimalist painting, her work offers openness and a willingness to let the impurity of life spill into paint. This is reflected in Lee's desire 'to make paintings

Plate 21 Rosa Lee, *Speculum No. 7*, 1990, oil on canvas, 91.5cm × 101.5cm.

Plate 22 Beth Harland, *Lacquer*, 1992, mixed media on canvas, 139.7cm × 213.4cm.

of unnecessary detail' (Lee, *Artist's Statement*, 1992, unpaginated), where purity is rejected in favour of a complex, ornamental, but insistently material presence. Lee's paintings demand a shifting of critical categories towards a re-evaluation of the 'merely' decorative in painting. In *Speculum No. 7*, 1990, the texture and patterns suggest the decorative surface of a brocade, but the title also refers us to Irigaray's metaphor of the concave mirror in which femininity is at once reflected and elusive (Plate 21). As Angela McRobbie has remarked, in Lee's work 'there is a refusal of essentialism, an acknowledgement of fragmentation, and a questioning of identity' (McRobbie 1991: 12).

Beth Harland's paintings similarly throw fixity and identity into question. Her use of multiple canvases and mixed media, as in *Lacquer*, 1992, questions the traditional boundaries of the two-dimensional containing frame, allowing for a more open and unresolved dialogue with the viewer (Plate 22). Recognizable photographic texts are obscured or dissected by areas of flat paint placed geometrically across space, denying our attempts to resolve the whole into a finite image. As Harland suggests, 'by dismantling unity and image the work seeks to question a framework for identity and gender that operates by repeating a structure until it appears "natural"' (Harland quoted in McRobbie 1992, unpaginated). Unlike Eve Muske's work, however, the references are not personal; Harland erases the traces of the artist as an individual subject and any desire to read the work transparently as an expression of the feminine.

The range of different strategies employed by women in relation to non-representational painting clearly cannot be collapsed into a singular, undifferentiated practice. To accuse such painters of naivety in seeking to reclaim an authentic feminine identity outside the symbolic order is to misunderstand their aims. Women's abstract painting can be seen as *one* site in which questions about feminism and representation are being re-addressed in the 1990s and to insist that such painting is simply an individual enterprise carried out in the studio, paradoxically ignores questions of the critical and discursive contexts which are crucial to any feminist art practice. But, an important question remains. If feminist practices of painting are to disrupt the canonical forms of modernism, this cannot be through textual strategy alone. The body of the painter is not only made present in the work, but as a figure within systems of art dealing, exhibition, and criticism.

THE POLITICS OF WOMEN'S PAINTING

While the quest for an alternative female language of painting grounded in the female body may be inappropriate, an exploration of the relations between networks of language, bodies and power is clearly important in the work of contemporary women painters. If psychoanalytic theory

has informed us about some of the complex ways in which art is bound up with our pleasures and displeasures in the gendered body, then it seems the search for different kinds of possible relations between painting and embodiment are not only worth pursuing, but politically urgent. If women are to redefine the gendered discourse of abstraction, this implies both a textual practice which interrogates the terms of painting itself and a critical practice of reading which challenges the institutional discourses which sustain gender divisions.

In the economic and political climate of 1990s, with massive cutbacks in arts funding, a 'return to painting' has been interpreted by some as a desire for 'safe' art; for acceptability within the art world system and an abandonment of direct feminist politics by women artists – not just a symptom of postmodernism then, but of postfeminism. But, politics are not about practices alone, the critical and institutional contexts in which work is placed, its reception and audience will all determine the readings made of it. As Janet Wolff comments:

> We may certainly point out the potential advantages, limitations or dangers of such textual politics, but in the end we cannot legislate about effectivity without reference to the specific circumstances of readers and viewers. . . . A systematic exploration of feminist art practice and of body politics would necessarily involve a serious attempt to relate textual strategies to practices of reading and viewing, and to the contexts and institutions of reception.
>
> (Wolff 1990: 5)

Exhibitions are one kind of intervention within the system. Where these have been collectively organized by women or addressed primarily to a women's audience, they have been as much about creating a space for a feminist art practice and critical discussion of its diversity, as developing particular approaches to painting and sexual difference. Meanings are generated through a process of debate both in the course of production and reception of the work. Discussion with audiences, artists' workshops, conferences and seminars, as well as critical responses to the work, all contribute to developing new practices of viewing. By thinking of painting as a collective practice which engages centrally with questions of feminist knowledge, different values and criteria for the making and viewing of painting begin to be articulated. In this respect, there is a world of difference between the interpretative context of a collective exhibition in a public institution and the same work in a one person show in a private gallery. While one context is not automatically better than the other, they do produce a different politics of spectatorship.

The current critique of modernism indicates some of the ways in which the masculine body of art might be redefined and contested. Rather than assuming a unified category of gendered abstraction, it points to a series

of historical alignments between the body of the painter and the dis-
cursive construction of gender in painting. The examples of Fuller and
Kristeva discussed above show that psychoanalytic accounts based on the
maternal relationship alone will not be adequate as a basis to theorize
painting by women, nor will they suffice to undermine hierarchies of value
and meaning in art. We also need an understanding of practices of abstrac-
tion in relation to women's embodiment, not merely in relation to a
feminine or maternal principle, but in terms of psychically and socially
inscribed differences. The kind of practices I have described take account
of female embodiment and the psychic effects of that embodiment, and
question the power relations which place the feminine as an inferior term
within modernism. Without such intervention, any attempt to develop a
language of sexual difference based in the female body may succeed in
re-inscribing the feminine, but leave the critical categories which define
it intact. What is required is the kind of discussion and writing which
would allow for critical distinctions between women's diverse painting
practices to emerge. Such critical debate would enable the monolith of
male abstraction to be dismantled to encompass many histories previously
denied or submerged. It would open up a space for the discussion of the
historical diversity of women's abstract painting and its crucial presence
within modernist practice in the twentieth century – a history which has
still to be written.

5

LIFE AND A.R.T.

Metaphors of motherhood and assisted reproductive technologies[1]

Since the birth of the first 'test-tube' baby, Louise Brown, in 1978, using *in vitro* fertilization techniques pioneered by Dr Patrick Steptoe and Professor Robert Edwards, there has been intense debate in the media on the subject of new reproductive technologies. It is almost impossible to open a magazine, switch on the radio or watch TV these days without coming across some reference to infertility or to new developments in reproductive technology. The dominant and framing discourse in this debate has been that of medical science. This medical adventure tale has been told in familiar terms of the conquest of unknown territory, in this case the 'inner space' of the female reproductive system and the recesses of the human gene. Media coverage has largely reflected this model of medical progress in which each new step is greeted as a miracle breakthrough. This is given human emphasis by reference to the 'triumph over tragedy', usually of an infertile heterosexual couple.[2] In this respect, *in vitro* fertilization is represented as the exemplary medical success story. Given the current glamour, status and huge commercial investment in biotechnology, it is perhaps not surprising that IVF has attracted the most attention and the highest funding of all infertility treatments.[3] Literally on the cutting edge, its popular image, the test-tube, is emblematic of science itself.

But this narrative has not gone unopposed. Feminist critiques from scientific, sociological and legal perspectives have sought to reassert a discourse of women's rights as central to reproductive choice and to re-inscribe the mother as subject of the birth process. However, feminist critics have not agreed in their responses to reproductive technologies, or in their identification of the new maternal subjects which may emerge from them. Feminists have broadly taken one of two stances on reproductive technology. Some, like Renate Duelli-Klein and Gena Corea, have opposed reproductive technology on the grounds that it is yet one more example of men's desire to control women's bodies, begun with the medicalization of childbirth and leading to the scientific management of conception. A contrary position from a liberal perspective is that such

technologies genuinely offer women freedom to extend their choices about how, when and in what circumstances to mother. The debate, then, is often over women's right to make choices and degree of control over their own bodies and fertility.

One important way of conceptualizing what is at stake for women in the new reproductive technologies has been to frame this debate in terms of nature versus technology. According to Gena Corea in *The Mother Machine*, technology itself must be opposed if women are not to become the raw material for reproductive experiment. She outlines a doomsday scenario in which women's bodies will be merely a collection of spare parts – eggs, ovaries, wombs – in which the true agenda is control over human evolution (Corea 1985). But the appeal to nature against science is problematic for feminism, not least because it places women in the contradictory position of wanting to assert control over reproduction while being against technological intervention. And, in opposing reproductive technologies, feminists may find themselves aligned with the Catholic church and Christian fundamentalists, neither of whom are noted for their concern with women's rights. For other feminist critics, the issues are more complex. It is not technology itself but its social implications which are important. Michelle Stanworth sums it up thus:

> In the feminist critique of reproductive technologies, it is not technology as '*artificial* invasion of the human body' (Duelli-Klein 1985) that is at issue – but whether we can create the political and cultural conditions in which such technologies can be employed by women to shape the experience of reproduction according to their own definitions.
>
> (Stanworth 1987: 35)[4]

In this chapter I am interested in the kinds of political and cultural conditions which shape current representations of reproductive technologies, and their relation to changing concepts of motherhood. While feminist critiques have been very important in contesting the claims of medical science and its impact on women's reproductive rights and choices, these have not on the whole addressed how representations of reproductive technologies, and the anxieties engendered by them, intersect with other cultural discourses to produce new meanings.[5] What kinds of narratives of fertility and birth are being recounted to us, and what do they tell us about the representation of maternal identity? If A.R.T. (assisted reproductive technology) is not just a medical story and raises legal and ethical issues, what cultural and social anxieties about women as mothers, birth and children, does it articulate? The separation of birth from conception raises central questions for our models of creativity and subjectivity. If reproductive technologies have the potential to appropriate women's unique capacity to give birth, what consequences might this have for our

107

cultural understanding of birth and its relation to maternal subjectivity? In this respect, the issue is very much one of cultural politics, the struggle to transform the contemporary myths and beliefs which shape our experiences and our interpretations of them.

I want to look first at how the story of A.R.T. has been framed through various discourses in medicine, law and the media, and suggest some ways in which feminist cultural analysis might begin to reconfigure these representations and offer different readings of them. What we see in such discourses is not only an attempt to 'delete' the mother with a new emphasis on 'fetal personhood' (Franklin 1991: 90), but also a desire to control emergent and contradictory representations of motherhood. The dilemma which reproductive technologies pose for feminism is that of whether to reassert a relationship between maternal fertility and nature or to engage with the radical possibilities of rethinking the relations between biology and motherhood which assisted conception may offer.

THE MEDICAL MODEL AND MATERNAL SACRIFICE

I would have stood on my head in a field for nine months if necessary to give him a family. I never thought of the consequences really to myself.

('Joan's story', *Labours of Eve*, 1995, BBC2)

For women, the decision to have or not to have a child, whether by choice, circumstance, or reason of infertility, is inevitably shaped by representations of what motherhood means in our culture. Childbearing and childlessness are intimately connected with a sense of identity and self-worth for women. The issues are complex and often deeply contradictory, offering little alternative between the pain of infertility and concerns about medical invasion of the body. Such ambivalences and dilemmas are to be expected in an area which is so deeply entwined with our innermost fears and desires. Paradoxically, by extending choice to more women, reproductive technologies reinforce the idea that reproduction is essential to femininity. By identifying infertility as a problem of biology rather than of culture, medical definitions of fertility have cut short analysis of the range of social, cultural and economic circumstances that may also preclude women from mothering.[6]

It is a paradox that the maternal subject is absent in the very place that we would expect to find her, in discussions of reproduction and infertility. In the proliferating discourses on reproductive technologies in medicine, in law, and in the media, women are present only as individual

108

victims of their own biology. Technology steps in when women's bodies 'fail to perform'. The narrative of infertility takes the form of an account in which women's lack and desire can only be fulfilled in the person of the male doctor. This narrative has been framed almost entirely within the terms of a medical account which takes women's bodies as its object, but in which women's voices as subjects are rarely heard.[7]

This is not, of course, to say that women have not given individual accounts of their experiences of infertility treatment, both its successes and its failures, but these accounts are firmly located within the sphere of the personal. Personal testimony validates women *as* individuals, but it does not render them part of a public debate. In this narrative structure, women are ideologically placed within the private sphere and in a position of relative powerlessness in relation to scientific and medical discourse. The medical model can be seen to reaffirm a traditional paradigm of maternal sacrifice, the woman who submits herself, in this case to prolonged, invasive, often painful and potentially dangerous, medical intervention for the sake of her – as yet unborn – child.[8]

Women as maternal subjects, in so far as they are represented at all, appear within the powerful and conservative set of medical discourses which frame reproductive technologies as private rather than as public persons, and as individuals within the heterosexual family unit rather than as members of a group with social rights. I want to suggest that this is not the only way of understanding the implications of reproductive technology and, indeed, that there are contradictory imperatives at work which are significant in relation to new representations of maternal identity. For this we need to turn to some of the ways in which reproductive technologies have entered into the domain of popular culture and representation. The representation of reproductive technologies can be seen as a 'site of struggle', one space in which women's identities as maternal and non-maternal subjects are being redefined.

UNRULY MOTHERS

On Christmas Day a 59 year old businesswoman gave birth to artificially fertilised twins at a London hospital.

(*Guardian*, 1 January 1994)

The Bourn Hall Clinic in Cambridge is to implant eggs from a white woman into a black woman after they have been fertilised by the black woman's mixed race partner. The Clinic said it was ethically permissible because no eggs are available from black donors and it is the only way to help the couple.

(*Guardian*, 1 January 1994)

What is striking about many of the media stories which have appeared recently is their *lack* of order and proper endings, a kind of unruliness which points to the specific unease which A.R.T. generates. Press accounts show this breakdown of framing devices very clearly. In the first example cited above, it is the juxtaposition of 'Christmas Day' with the age and status of the '59 year old businesswoman' which constructs the 'artificiality' of the birth, while in the second, the twin spectres of miscegenation and eugenic control hover behind the Bourn Hall Clinic's carefully worded statement. In both cases, as in other similar media stories, it is the *exceptional* nature of the motherhood which is at stake.

In May 1993, newspapers had been full of the story of Jean Gibbins who successfully gave birth to sextuplets after IVF treatment or, as the *Daily Express* put it winsomely, 'Six tiny miracles for mother who wouldn't give up' (21 May 1993). Only two days later, however, the story began to spin out of control as the media discovered that this was *not* the ideal nuclear family: 'SCANDAL OF SEXTUPLETS – Test tube father now has ten children. She lives in a council house with their son and her elderly father. He lives several miles away and has three children.' The *Mail on Sunday* continued, 'Family life is easy to mock, easy to dismiss as old fashioned. Yet it remains the bedrock of stable relationships, both between adults and especially for children' (23 May 1993). As a predictable result of this story, there were press calls for a clampdown on fertility treatment for poor and unmarried couples or, as the *Daily Express* crudely demanded, 'Is the NHS in the business of sponsoring illegitimacy?' (24 May 1993). This response can be compared to similar calls in the late 1980s to restrict AID (artificial insemination by donor) treatment to heterosexual couples after well-publicized births to single and lesbian women who had been assisted by the British Pregnancy Advisory Service. These reactions would seem to suggest that reproductive technologies can in themselves engender a repressive backlash against alternative patterns of motherhood. And media representations clearly do contribute to a wider disciplinary discourse which seeks greater regulation of women's reproductive rights – to whom infertility treatment should be available and under what circumstances.

In Britain the state stepped in to regulate and control medical research and applications in the area of new reproductive technologies through legislation in 1990. The Human Fertilisation and Embryology Act created a statutory licensing authority (HFEA), to regulate the provision of infertility treatment and to license and supervise research on human embryos up to fourteen days. The Authority has also conducted a series of public debates on issues such as the use of aborted fetal tissue for genetic experiment, which had become a matter of public concern by the mid-1990s. Although, unusually, the initial membership of the authority comprised a majority of women (eleven women to ten men), it appears

to have barely registered the presence of a feminist discourse on women's reproductive rights.[9]

The setting up of a regulatory authority with legal powers contrasts sharply with the ideological imperative to *deregulate* of all Conservative governments since 1979. This indicates the extent to which attitudes to reproductive technology have been formed within the context of that other ideological battleground of the 1980s, the family. The concern with regulating sexuality and confining reproduction to heterosexual couples was evident, for example, in the notorious Section 28 of the 1988 Local Government Act and its strictures on any 'pretended family relationship'.[10] It is the potential for reproductive technologies to reinforce the emphasis on reproduction as central to family life *and* to undermine the heterosexual nuclear unit which is at stake here. This may in part account for the extreme caution with which the 1990 HFE Act was framed to acknowledge developments in medical research while not being seen to conflict with 'the concern we attach to family values', as the then Lord Chancellor, Lord Mackay, put it in the course of the parliamentary passage of the Bill. In fact, amendments which would have restricted treatment to married couples only were defeated, and the Act shifted away from the explicit commitment to heterosexuality evident in the earlier *Report of the Warnock Committee of Inquiry into Fertilisation and Embryology* of 1984.[11] The 1990 Act was more ambiguous in its reference, placing primary emphasis on the welfare of any potential future child:

> A woman shall not be provided with treatment services unless account has been taken of the welfare of any child who may be born as a result of the treatment (including the need of that child for a father), and of any other child who may be affected by the birth.
>
> (HFEA 1990, Section 13.5, quoted in
> Morgan and Lee 1991: 194)

Individual doctors and health authorities were thus empowered to take decisions about which kinds of women were fit to receive treatment in view of the needs of their, as yet unconceived, child.

Despite the Government's clear intention to restrict access to reproductive technology to certain types and groups of women and couples, access to infertility treatment has in practice more often been controlled by rationing of resources to certain groups than by the primary legislation itself.[12] As some commentators have concluded:

> Assisted conception is to be, for the most part, for the married, mortgaged middle classes; a conclusion which is entirely consonant with infertility services being unavailable on any scale through the National Health Service.
>
> (Morgan and Lee 1991: 146)

111

What is telling about the media stories about reproductive technology is the way in which the 'wrong' women keep getting into the frame: lesbian mothers, single mothers, couples of mixed race and older mothers constantly appear in the news. It is significant that these do *not* conform to the dominant model of heterosexual motherhood which is promoted within both medical and state representations of reproductive technology. Media narratives of A.R.T. point precisely to the difficulty of controlling access to reproduction when this is dependent on the decisions of individual doctors, more often than not working privately outside the NHS.[13] Despite intense control and regulation, and the very high personal and financial costs involved, all kinds of women, single and married, old and young, lesbian and heterosexual, black and white, are using reproductive technologies. I do not want to underestimate the real limitations on access – while only one in ten IVF treatments is available on the NHS, it is clearly still rationed by cost – but this does suggest that there is an ongoing struggle over reproductive rights which is not yet resolved. What is at issue is *which* women have the right to choose when and how to mother, irrespective of their status.

By focusing on socially taboo categories which function as objects of fear and anxiety, media representations of A.R.T. tap into a wider repertoire of sensitivities around women's changing roles within and outside the family. What we can see in both media and state responses to reproductive technologies is the attempt to re-establish the order of the heterosexual unit which is potentially disrupted by them. In this way, media rhetoric, 'serves as a drama in which dominant ideas about motherhood, social progress and a range of other issues can be played out' (McNeil and Litt 1992: 127).

This is particularly evident in the pathologization of the single mother. Since the Conservative Party conference when Peter Lilley, the Secretary of State for Social Security, drew up his notorious 'little list', the single mother has been a scapegoat for social and economic problems and the focus of a considerable moral panic from the right to the left of the political spectrum. Single mothers have been targeted as producing crime, delinquency and low achievement in children and even, following Charles Murray's arguments in *The Bell Curve*, for the emergence of a new underclass. This demonization of the single mother in the early 1990s bears a strong resemblance to the first publicized cases of commercial surrogate motherhood in the United States and Britain in the mid-1980s. In the notorious 'Baby M' case in America, it was the surrogate mother who bore the child and then claimed custody, who came under sustained attack in the media. Mary Beth Whitehead was stigmatized as a high school dropout, a welfare mother and a go-go dancer, an unfit subject for motherhood.[14] In Britain, it was the fact that the surrogate mother, Kim Cotton, received a payment of £6,500 for entering into a surrogacy

agreement with an American couple which aroused press calls of 'Rent-a-Womb Mother'. This led to the subsequent hasty passing of the Surrogacy Arrangements Act in 1985 which outlawed commercial surrogacy in this country.

In the renewed political focus on the roles and responsibilities of mothers, certain forms of motherhood are placed outside the frame and rendered dangerous. Thus in the United States, legal action has been taken against pregnant women charged with endangering their fetuses through the use of drugs, alcohol or cigarettes or for refusing, against medical advice, to undergo Caesarean sections. In Britain, a similar attempt to make a fetus a ward of court in order to control the behaviour of its pregnant mother failed. However, a woman who was a former prostitute was removed from IVF treatment on the grounds of unfitness for mother-hood and her application for judicial review was refused.[15] Common to all such cases was that the fetal or embryonic life was given priority over the rights and wishes of the mother. In this contest the power to deter-mine the significance of an event and from whose point of view it is represented, becomes all important. In the legal concept embodied in the 'welfare of any future child who may be born', and in the medical concept of 'fetal personhood', the fetus is not only represented as being separate from the mother, but as having interests which may be opposed to hers. If mothers are unruly and out of control, then the fetus has increasingly assumed the status of a subject with determination in its own right. The visual construction of a free-floating fetus outside the maternal body acts as a framing mechanism that shapes and shuts out the potential of repro-ductive technologies to disrupt stable maternal identities.

THE FRAMED FETUS

A complex feminist analysis has been developed in relation to the emer-gence of fetal personhood as a cultural category. This critique has been given political urgency because of the way in which the concept has been mobilized in abortion debates both in the United States and in Britain.[16] The debates around reproductive technology have reopened the question of abortion by highlighting the issue of the ethical and legal status of the embryo. It is significant that in Britain the major amendment to the 1967 Abortion Act, which lowered the upper limit on abortions from 28 to 24 weeks of pregnancy, came as part of the 1990 Human Fertilisation and Embryology Act, rather than through the repeated attempts at amending legislation by anti-abortion MPs. In the course of lobbying and parlia-mentary debate on the Act, the issues of embryo research and abortion were linked in tandem through the issue of fetal personhood, the stage at which the fetus may be defined as an independent subject. While the fetus has no status as a person under English law, the discrepancy between

the limit placed under the Act on embryo experiment at 14 days and on abortion of a fetus at 24 weeks opened up a dangerous space for renewing the whole abortion debate.

Images of the fully formed fetus have been a powerful weapon in anti-abortion campaigns, for example, in the notorious 1984 'Right to Life' video, *The Silent Scream*, which purported to show an actual ultrasound sequence of an abortion from the point of view of the fetus.[17] In such propaganda, the mother's body is invisible, she is consistently deleted from discursive and visual representation and the fetus is represented as the independent subject of the abortion experience. Opponents of abortion have orchestrated a politically powerful lobby in the United States with, for example, the appearance of a series of pro-Life commercials using fetal imagery on national TV networks. Sarah Franklin (1991) has pointed to a similar convergence in Britain between the medical-scientific construction of fetal personhood and the rhetoric of anti-abortion campaigns during the progress of the Alton Bill in 1987–8. Despite the failure of that Bill, the continuing focus on lowering the limit of fetal viability constructs the *fetus* rather than the woman as the true subject of an abortion.

Visual technologies have played a crucial role in the emergence of the fetus as a political subject. Imaging techniques such as ultrasound have become routine in the management of pregnancy, largely displacing reliance on women's experience of their own pregnant bodies, for example, in confirming the due date of birth. The ascendancy of visual technologies tends to privilege sight over touch as a primary means of gaining knowledge and, as Evelyn Fox Keller argues, this 'biological gaze' objectifies what is visualized, detaching the viewer from what s/he perceives.[18] In the practice of reproductive surgery, ultrasound imaging or laprascopy is used extensively in techniques where a fibroptic telescope is inserted to recover eggs from a woman's ovary. Such image technology not only provides a whole new visual rhetoric from pre-conception to birth, but detaches the fetus from any material context within women's bodies. This is graphically illustrated by the words of a male embryologist who, while carrying out the micromanipulation of eggs through a video screen, commented, this 'should be done by 13 year old boys who are used to computer games, because that's all it is, just a load of joysticks, like driving a helicopter.'[19]

Such visual rhetoric acquires powerful symbolic meaning from its aura of medical authority and technological impact, but it also gains currency through entry into popular culture and consciousness, whether it be in science fiction films like *2001: A Space Odyssey* or through advertising. Two examples of recent advertising reveal contrasting projections of fetal representation very clearly. In a French advertisement for Wrangler Jeans from 1986 (Plate 23), the fetal image appears as though

114

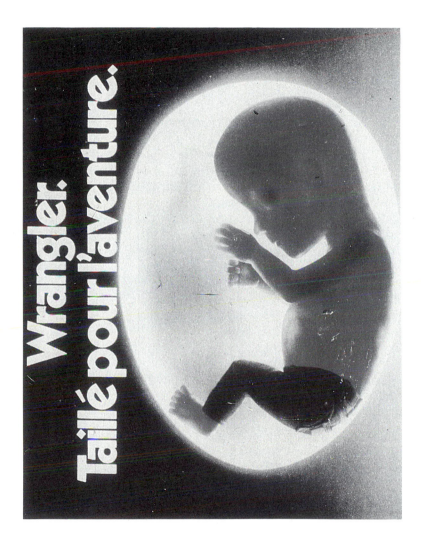

Plate 23 Advertisement for Wrangler Jeans, '*Taillé pour l'Aventure*', 1986.

independent and autonomous. The womb, the maternal space, has disappeared and the fetus floats alone in its designer jeans: 'Cut out for the future'. The deliberate ambiguity of the text – are the jeans tailored for the future baby, or is the fetus 'cut out' for the jeans, cleverly plays on current fears about 'designer babies'. Here 'jeans' stand in for the 'genes' which can be designed through biotechnology to eliminate certain inherited diseases and, potentially, to predetermine a future child's genetic characteristics.

In making a connection between the jeans and the fetus as consumer items, the advert implies that similar kinds of choices are involved. In the case of reproductive technologies, the question of choice has re-entered the reproductive debate in a new form. To what extent can 'a woman's right to choose' be extended to choice over the genetic identity of her baby? For feminist critics like Gena Corea, the association of terms like 'choice' and 'freedom' with new technologies is a perversion of feminist rhetoric, used to justify scientific experiments over which women themselves have no control. Rachel Bowlby reframes the debate in more useful terms when she asks how far a liberal discourse of rights and choice is appropriate to the area of reproduction at all (Bowlby 1993: 85). How is such choice to be understood? As Bowlby acutely remarks, individual choice is now more commonly posed within the rhetoric of consumer culture and of the free market than in the language of civil or human rights. And, as in other areas of consumer choice, new technology opens up possibilities for which it then creates both needs and desires.

A further striking visual characteristic of Wrangler's representation of the fetus is its fully formed and clean-cut image. Like the jeans, this fetus is man-made rather than grown in the maternal body. It thus carries another connotation of genetic technology, the purity of the scientist's test-tube as opposed to the messiness and potential threat posed by the female womb. We can identify with it as a future human being, an individual 'in embryo'. Sarah Franklin has argued that:

> The position of the spectator constructed by these images is most significantly defined by the structuring absence of the mother, who is replaced by empty space. . . . Through this technique, the conditions for spectator recognition of and identification with the fetus are achieved on the basis of its separation and individuation from the mother.
>
> (Franklin 1991: 195–6)

In the medical, scientific and anti-abortion discourses that she describes, the fetus is often linguistically denoted as a male subject. In this case, given the association of jeans with virile masculinity in the rhetoric of advertising, we can also assume the fetus to be gendered as masculine. The identification we are offered as viewers then is not only one in which

the maternal body is absent, but with a fetus which is implicitly constructed as male. The separation of the fetus from the maternal body is thus further accentuated by its gender difference. As Rosalind Petchesky remarks, what we are led to see 'is not the image of a baby at all but of a tiny man, a homunculus' (Petchesky 1987: 61).

I want to contrast this image with the infamous 'Benctton Baby' advertisement which appeared on billboards in Britain in September 1991 and was almost immediately withdrawn (Plate 24). (In the United States, *Child* magazine had already refused to carry the advertisement.) Rachel Bowlby has argued that the public outcry over the advertisement was due both to the unfamiliarity of the image and to the way in which it violated an essentially private moment of birth by inserting it into the public realm of consumer consumption. Leaving aside the ethical issues raised by Benetton's exploitation of such imagery, I want to explore its shock effect in another way.[20]

In her essay, *Powers of Horror*, Julia Kristeva defines the abject as that which collapses the border between inside and outside, self and other, the 'integrity of "one's own and clean self"' (Kristeva 1982: 53). Following Mary Douglas, she argues that anything which is expelled from the body (menstrual blood, snot, urine, shit, vomit, etc.) is defined as unclean and subject to cultural taboo. The disgust which we may feel at such bodily wastes, however, is not the product of their intrinsic uncleanliness, but of the unsettling of boundaries and the threat to identity and loss of an integrated self which the contained body represents. And, in Kristeva's account, the prototype of the abject body is the maternal body.[21] The threat posed by the maternal space is the collapse of distinctions between the subject and object.

This offers another way of reading the shock effect of the Benetton advert. The blood and afterbirth which emerge from the mother's body with the newborn baby are visible signs of the connection – shown literally here by the umbilical cord – between inside and outside, self and Other, subject and object in the body of the mother. The 'horror' evoked by the image is that it shows us the passage from interior to exterior. In contrast to the sanitized fetal imagery in the Wrangler advertisement, it renders the mother's body, if not actually visible, all too insistently present. Rather than being an embryonic individual separated from the maternal body, the representation of the baby attached by its umbilical cord makes visible to us the pre-Oedipal state of infant dependency, the only time in our lives we are utterly inseparable from another human subject. What is useful about Kristeva's theory is that, in offering an account of the abject in psychoanalytic terms, she suggests that what might be at stake in the elimination of the maternal body is the fragility of the symbolic order itself and of the concept of individual identity which it sustains. In the representation of fetal personhood as an autonomous (masculine) individual, what

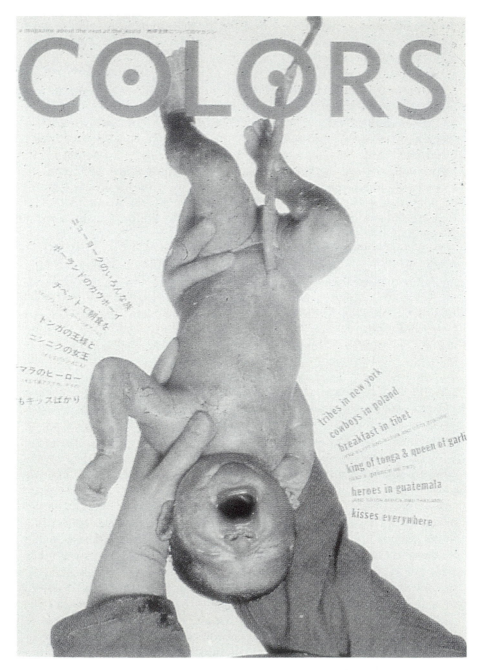

Plate 24 Benetton 'Baby' advertisement, 1991.

is being disavowed is the pre-Oedipal state of dependence on the mother. The free-floating fetus becomes the child without origin.

STORIES OF ORIGIN

> In the late twentieth century, this continuing narrative of the em-
> battled and calculating mortal individual elaborates the fantasy of
> the breakdown of the already fantastic 'coherent' subjects and
> objects, including the Western self, for both men and women. All
> subjects and objects seem nothing but strategic assemblages,
> proximate means to some theoretic end achieved by replicating,
> copying and simulating – in short, by the means of postmodern
> reproduction.
>
> (Haraway 1990: 143)

In the 'Once upon a time' of fairy tales we are assured of a story of origin; once upon a time there was a symbolic set of Oedipal relation-ships which is disrupted, usually by the absence/death of the mother. In the classic fairytale (Snow White, Cinderella) the figure who disrupts the symbolic order is the stepmother and, in the course of the tale, order is restored through the figure of the handsome prince. Such stories confirm a sense of proper origin and ending within the heterosexual family romance. But, like the stepmother or bad fairy at the christening, repro-ductive technology potentially fragments that symbolic order, the familiar metaphors of birth and origin. Another way of reading the representation of fetal personhood, then, would be as constructing a new myth of origin in which the fetus as self-determining and autonomous subject replaces the absent – or aberrant – mother.

One of the questions frequently raised in relation to reproductive tech-nologies is that of what to tell a child born of such techniques about its identity and origin. One of the fears raised by the suggestion of using the eggs from aborted fetal tissue to produce new embryos was what it would mean for a child to be born of a 'mother', a maternal body, which had never existed.[22] Reproductive technologies generally are witness to the anxieties attached to just such a disruption of self-identity and relation-ship. As Mary Ann Doane suggests, this indicates 'the traumatic impact of these technologies – their potential to disrupt given symbolic systems that construct the maternal and the paternal as stable positions' (Doane 1990: 175). By unsettling boundaries between nature and technology, heterosexual sex and motherhood, conception and birth, A.R.T. destabi-lizes fundamentals of identity and origin, the nature of the subject and how that subjectivity is formed.

In her analysis of cinematic representations of motherhood, Ann Kaplan notes that there was a spate of Hollywood films in the 1980s in which

mothers were either marginalized or absent altogether or the fetus itself is accorded independent status. The popularity of films such as *Three Men and a Baby* (1988) and *Look Who's Talking* (1990), both of which have spawned sequels, are witness both to our fascination with and anxieties about current changes in maternal and gender roles. More directly concerned with the threat of reproductive technology, science-fiction horror films are also frequently preoccupied with fantasies of birth and the maternal body. As Barbara Creed has shown in her analysis of *Alien*, a fascination with, and fear of, the female reproductive system is central to the construction of the horror in such films. As she suggests:

> The science fiction horror film's current interest in the maternal body and processes of birth point to ... developments taking place in reproductive technology which have put into crisis questions of the subject, the body and the unconscious.
>
> (Creed 1990: 214)

Ann Kaplan suggests that what is revealed by films in the 1980s is a fundamental shift in paradigms of motherhood, equivalent to that which occurred in western societies in the 1830s. In this shift, women and reproductive rights are visually and discursively deleted from popular representation. As Kaplan puts it, 'Fetal interpellation manifests a new form of the old desire to absent (or deny) the mother' (Kaplan, 1992: 209). While agreeing with Kaplan's argument that a discursive shift is taking place, I have shown that this is a more contradictory and incomplete process in which medical, legal and media representations struggle to frame and contain motherhood in particular ways, rather than simply to delete it.

It is significant in this context that it was felt necessary to define the meaning of 'mother' for the first time in British law as a consequence of the new reproductive technologies. The 1990 HFE Act states that:

> The woman who is carrying or who has carried a child as the result of the placing in her of an embryo, or of a sperm and eggs, and no other woman, is to be treated as the mother of the child.
>
> (HFEA 1990, Section 27.1)

Thus in legal terms, the biological mother takes precedence over the 'social' mother.[23] In contrast, the law defines the 'father' not as the donor of the sperm, but as 'the other party to the marriage unless it be shown that he did not consent ... to her insemination' (HFEA 1990, Section 28.2b). Thus, paternal rights are based on the social authority of the male partner in marriage, rather than on any direct biological connection.[24] However, the necessity to define motherhood *at all* in law suggests, paradoxically, that biological motherhood is in effect being deconstructed. In current usages of the term in various forms of assisted conception we

are seeing a fragmentation of essentialist concepts of motherhood. As Eileen Manion suggests, if new technologies offer ways of dealing with the problems of infertility, we also need more creative thinking about the social possibilities of assisted conception and new ways of exploring maternal and non-maternal relationships which may ensue (Manion 1988). How can a space be opened up for feminist representation in an arena in which the maternal body is absent, pathologised or deconstructed? If the Oedipal story and the symbolic identities it supports is fragmenting, how might alternative stories be told? To what extent can feminist cultural texts intervene within popular and scientific discourses and reframe representations of maternal subjects in new ways?

WAITING . . . AND WATCHING

An Australian film, *Waiting*, directed in 1990 by Jackie Mackimmie, shows one way in which a feminist narrative has tried to reconfigure maternal identities outside the Oedipal relationship. The film recounts the story of four women friends who have gone to a farm in the Australian country-side to await the birth of a surrogate baby to one friend, Claire, on behalf of another, Sandy. Claire is an artist who is shown throughout the film painting a set of portraits of the four women. Each is signified by an inscription on the canvas: Sandy, who desires a child but cannot have one, is the 'CREATOR'; the feminist film-maker who is shown ironically throughout the film attempting to make a documentary about natural childbirth, is the 'NARRATOR', and a fashion journalist friend is the 'SPECTATOR'. Claire inscribes her own self portrait, 'POR/TRAIT/OR', that is, the one who portrays and also, from the French, *mère porteuse*, which means surrogate mother from *porter*, to carry or bear. (Claire's vocation as a painter is signified stereotypically by her desire to go to Paris – she is shown learning French throughout the film.) What is interesting about *Waiting* is that it deals centrally with the relationship between creativity and birth and with the question of maternal identity. Is the 'creator' here the same as the mother?

The world represented in the film is one in which men are weak and marginal, or as one male character puts it, 'women are running the show'. Women make and share the decisions about birth and take responsibility for the children of others in various forms of social parenting.[25] In dealing with surrogacy, the film also disrupts the symbolic Oedipal scenario. Claire has a baby outside marriage and she has chosen not to marry her male partner, who may or may not be the biological father of her child. She also refuses to make a choice between child and career, between being a mother and being an artist. What the film offers is an account of the intensely personal dilemmas which such choices throw up for women in which reason and desire often conflict. But, in spite of this explicit

121

Plate 25 Final frame from *Waiting*, director Jackie Mackimmie, 1990.

narrative of women's autonomy and of alternative family patterns, a different reading can be made.

Throughout the film, the two central women are established in contrast to each other. Sandy who wants a child but cannot have one, is shown as tense, controlling and obsessive. Claire who bears the baby is fulfilled, at one with herself, with her painting and with nature. The maternal subject is identified visually with plenitude, and with a dual fertility which is both cultural and natural – in one scene she is shown dressed in red and hugely pregnant, disappearing into a fecund and radiant landscape. By contrast, Sandy, the non-maternal subject, is represented as 'unnatural' – she insists on Claire reading books about childbirth – and as almost witchlike in her appearance with a childishly thin body and long black hair.

It can be argued that the representation of the two characters works against and undermines the progressive narrative of the film. It returns us to a patriarchal vision in which fertility for women is equated with nature, while infertility is seen as the site of lack and unfulfilled desire. It illustrates the difficulty for a feminist narrative of dislodging what Julia Kristeva has called the 'virginal maternal', the powerful triangulation of nature, woman and birth as a source of conservative power and mystique (Kristeva 1986a: 160). (Although – it is worth remembering – the Virgin was the most famous, if not the first, of surrogate mothers.) Indeed, the final freeze frame of the film as the credits go up presents us with an image of a smiling Claire cradling a (male) child in her arms (Plate 25).

'BEING ON THE OUTSIDE OF NATURE'[26]

It is not surprising, given its very recent development, that there are as yet very few cultural representations which address the implications of reproductive technology in relation to creativity and birth. Women's experiences of infertility treatment and the body's invasion by reproductive technology are historically very new. For many women indeed, the experiences of infertility and its treatment are still too close, both emotionally and in time, to make work about it. Motherhood, in all its diverse and contradictory forms, has been explored by feminist artists over the last two decades from Mary Kelly's *Post Partum Document* in the late 1970s through to more recent attempts to 'reclaim the Madonna' in the 1990s.[27] Such work shows a commitment to deconstructing the social and cultural meanings of motherhood for women or to exploring these in relation to different personal experiences. In both cases, artists have a long cultural tradition of maternal representations to draw upon, however critically these might be viewed. But, the experiences of infertility and childlessness have not been similarly explored nor validated as subject for art. Indeed, the *absence* of visual representation points to a more general silence on the subject.

TWO/ She must have wanted this, this predicament, these contra-
dictions. She believes physical conception must be 'enabled' by
will or desire, like any other creative process.
(Pregnant with thought. Brainchild. Giving birth to an idea.)

Plate 26a Susan Hiller, *Ten Months*, 1977–9 (detail), 10 photographs 56cm ×
23cm, 10 texts 40cm × 12cm.

In 1992 a major exhibition was held at the Joan Miró Foundation
in Barcelona entitled *In Vitro: From the Mythology of Fertility to the
Boundaries of Science*, whose central theme was a dialogue between art
and science on issues of fertility. As the title suggests, it bridged a gap
between scientific discourses on *in vitro* fertilization on the one hand, and
cultural images and myths of fertility on the other. The exhibition was
extraordinary in its breadth and diversity, ranging from prehistoric fertility
symbols to micro-images of human cells *in utero*, from nineteenth-century
gynaecological instruments to Susan Hiller's photo-text installation on
her pregnancy, *Ten Months*, 1977–9 (Plates 26a and b). While it is hard
to imagine such a breadth and ambition in Britain in the 1990s, some
attempts have begun to be made to integrate the philosophy and culture
of science with cultural analysis and practice in relation to the new
technologies. And work is starting to be made which addresses the complex
interrelationship between creativity and birth, fertility and infertility,
nature and technology from a feminist perspective.[28]

Deborah Laws' *The Conception Prayer Series*, 1994–5 (Plates 27a and
b) does not deal with the new technologies of reproduction themselves,
but with the dreams and fantasies of the woman who desires a child. In
a series of symbolic images her work charts her own desire to conceive
as well as her feelings about wanting to have children. These cycles of
fertility are deeply inscribed in the body, its bleeding, and even its genetic
makeup, and yet are experienced on an emotional level as cycles of longing

TEN/ 10 Months
'seeing' (& depicting) . . . natural 'fact' (photos)
'feeling'(& describing) . . . cultural artifact (texts)

She needs to resolve these feelings of stress caused by having internalised two or more ways of knowing, believing and understanding practically every thing. She affirms her discovery of a way out through "truth-telling": acknowledging contradictions, expressing inconsistencies, double talk, ambiguity. She writes that she is no longer confused.

Plate 26b Susan Hiller, *Ten Months*, 1977–9 (detail), 10 photographs 56cm × 23cm, 10 texts 40cm × 12cm.

and despair. Her images have a incantatory quality which implies a prayer or mantra, a circle of words and images which, when repeated often enough will bear meaning. The relation between words and flesh, conception and fruition, are central to her work. Fertility here is not a matter of biology alone, but of 'will or desire, like any other creative process' (Hiller 1977–9). Unlike the ultrasound image of an isolated embryo as seen through a video screen, here 'seeing' and 'feeling', 'natural fact' and 'cultural artefact' are conjoined in images both of desire and loss.

In her book of essays *Simians, Cyborgs and Women: The Reinvention of Nature*, Donna Haraway argues for a similarly complex understanding of the relations between nature and culture, science and representation. In the image of a cyborg, a hybrid 'boundary creature' composed of organism and machine, she proposes a more fruitful interaction which may, 'hint at the ways that the things many feminists have feared most can and must be put back to work for life and not for death (Haraway 1991: 4). I find Haraway's attempt to reconfigure such relationships very helpful in moving feminist debates beyond the impasse presented by the dichotomy of technology versus nature. It recognizes the complexity

Plate 27a

Plate 27b

of experiences and representations in the late twentieth century in which technology can neither be simply rejected nor demonized. As women, we have emotional investments in and fears about interactions between technology and the body, and nowhere are these more evident than in relation to reproduction and birth. The position of women as maternal subjects has been 'intimately restructured through the social relations of science and technology' (Haraway 1991: 165).

In Madeleine Strindberg's *Breathe*, 1991–2 (Plate 28) we can see this necessary ambivalence in feminist responses to and representations of the maternal body. This is one of a series of 'metal' paintings Strindberg began in 1987–8, 'utilizing industrial materials such as aluminium, steel and bitumen, the work deals with aspects of (inflicted) violence, vulnerability and aggression, sexuality and bodily exposure that eventually lead to a process of denuding the female self' (*Artist's Statement*, 1992, unpaginated). More specifically here, it is the maternal self which is 'denuded'. The installation explores the intensely personal territory of the premature birth of twins and their intensive care in a hospital special unit. The mother's body is replaced by the terrifying paraphernalia of medical technology; drips, tubes and machine-like shapes. A man-made life support system which connects the paired metal oval forms to a 'breathing apparatus' acts as a substitute for the umbilical cord. The title, *Breathe*, functions both a description and a desperate injunction. As in Deborah Law's work, it is an incantation to ward off possible harm. The cold, reflecting surface of aluminium both reflects and repels the viewer while the blood-red paint leaks across it. Pure and abject, mechanical and organic, controlled and desperately fragile, the work explores an intimate dependency between human life and the technology of birth.[29]

MOTHER NATURE?

I would rather be a cyborg than a goddess.

(Haraway 1991: 181)

The proliferation of definitions of 'mother' is at once the site of intensifying oppression and potential liberation.

(Stabile 1992: 199)

Reproductive technologies are contradictory in their implications for women. On the one hand, they have extended the regulation of the female body from pregnancy to the period of pre-conception, and reinforced the identification of women as primarily reproductive beings. *In vitro* techniques, in particular, represent an extension of medical intervention into

Plates 27a and b Deborah Law, *The Conception Prayer Series*, 1994–5 (details), etching and aquatint, 26.5cm × 36cm.

the process of conception itself and, through image technology, of surveillance of the female body and of its fertility. At the same time, AID and surrogacy have broken the necessary link between heterosexual sex and conception, offering the possibility of bearing children to lesbians and to celibate women. It is not accidental that both surrogacy and AID can still be practised on an informal and social basis without recourse to medical and legal intervention and are thus much harder for the state to regulate.

But, the struggle over women's access to and control over their reproduction is not a matter of medical and legal rights alone. It is also a matter of cultural politics that can engage with the potential of assisted reproductive technologies in ways that contest the medical, political and media images and practices through which these are currently framed. As Donna Haraway argues:

> Both symbolically and practically, the fights over reproductive politics are carried out paradigmatically in and on and over the bodies of real women. But they are also carried out in the images and practices of scientific and technological research, science-fiction film, metaphoric languages among nuclear weapons researchers, and neo-liberal and neo-conservative political theory.
>
> (Haraway 1990: 142–3)

The dilemma that such technologies pose for feminism is between the reassertion of a natural relationship to fertility, using 'nature as a territory on which to stake our claim' (Stanworth quoted in Stabile 1992: 198–9), and engaging with the more radical possibilities of rethinking the relationships between biology and motherhood which assisted conception may offer. This might involve precisely uncoupling the links between the 'creator' and 'bearer', the social mother and birth mother which have been the central cultural metaphors through which birth and creativity have been understood.[30] I have argued for a more positive view of different kinds of assisted conception and their potential for refiguring family relationships than is sometimes assumed in feminist critiques. In contemporary cultural practices we can begin to discover the kind of complex, contradictory and multi-layered representations of women's diverse experiences of non-mothering and mothering, infertility and fertility which need not return us, yet again, to Mother Nature.

Plate 28 Madeleine Stringberg, *Breathe*, 1991–2, mixed media, overall dimensions 243.8cm × 487.7cm.

6

BODY HORROR?

Food (and sex and death)
in women's art[1]

You're scared as hell, of yourself, of the body you once thought you
knew.
> (*Death Becomes Her*, director Robert Zemeckis, 1992)

Fear and loathing of the female body has a long and well founded tradi-
tion within European culture. From the early Church fathers to the modern
horror film, the 'true' nature of women has provoked both desire and
disgust in equal measure.[2] But if a woman's body is abhorred, her supposed
deceit in covering up her essential nature provides the necessary struc-
tural mechanism through which this horror can be disavowed. The moral
condemnation of woman's vanity provides a distancing device through
which the fears aroused by the female sexual body can be displaced.

A recent Hollywood film recasts this familiar theme in a novel form.
Death Becomes Her takes as its explicit subject matter the female
body – and some of the very nasty things that happen to it in the process
of ageing and of resisting age.[3] The bodies of the two central characters,
played by Goldie Hawn and Meryl Streep, undergo a series of trans-
formations and mutilations ranging from cosmetic surgery, through magical
rejuvenation, to a literal remodelling of bodily parts, courtesy of stun-
ning special effects. In each case, we are made aware that femininity is
a construction, it is literally 'made up' in every sense of the word. The
paradox which the film exposes is that while femininity is revealed as
artifice, to be a woman in her 'natural' state is to invite disgust. Women
take the blame for not being what they seem.

In *Death Becomes Her*, horror strays into the altogether different
domain of comedy and the women's picture. But, although it is played
for laughs, this is a black comedy. In so far as it is a horror film, what
we are horrified by is the threat of bodily disintegration in death, which
is itself feminised – Death Becomes *Her*. Feminine identity is represented
as unfixed and unstable, an unbounded female body which changes
shape and decays before our eyes. As one character remarks when offering
the elixir of eternal life to Streep, 'Don't drink it and continue to watch

yourself rot.' Female bodily wastes are seen as the true source of repugnance, not least because they reveal what the cosmetic surface works to conceal: women's own desiring corporeal being. In a final sequence which is both funny and deeply disturbing, both women's bodies literally 'fall apart'.

In a powerful analysis of cultural control of the female body, Susan Bordo has argued that production of the 'normal' body is one of the central disciplinary strategies within our society. She suggests that the dominant ideal of a slender body in twentieth-century culture represents a desire to contain the body's margins, a desire which is encoded both morally and socially. Food and diet have become the central arenas for the expression of contradictions between conflicting needs in consumer capitalism:

> Many of us may find our lives vacillating between a daytime rigidly ruled by the 'performance principle' while our nights and weekends capitulate to an unconscious 'letting go' (food, shopping, liquor and other addictive drugs). In this way, the central contradiction of the system inscribes itself on our bodies, and bulimia emerges as a characteristic modern personality construction.
>
> (Bordo 1990: 97)

This tension between repression and release is inscribed especially on the bodies of women through eating.[4] Femininity and the consumption of food are intimately connected and, in women, fatness is taken to signify both loss of control and a failure of feminine identity. The hysteric patient of an early disciple of Freud poignantly described her alienation from her self, as she repeated a constant litany, 'Woman–Shame–Fat':

> When I looked at the shape of my body I was ashamed of being a woman. I wondered what men really thought about women – I was humiliated being a woman and annoyed to feel anyone looking at me. Being fat seemed to me particularly humiliating because the shape of my body seemed even more to blame. I really didn't want anyone to be able to distinguish the female outline of my body beneath my clothes.
>
> ('Renata', 1912, quoted in Stallybrass and White 1986: 184)

A link between food, fat and insanity in women is further reinforced within popular cultural forms. In a telling sequence from near the beginning of *Death Becomes Her*, 'Hel', played by Goldie Hawn is shown, with the aid of heavy prosthetics, eating her way into an asylum. After Meryl Streep has stolen her man, she is transformed in the space of a few minutes screen time from one negative stereotype – an embittered spinster – into another – a woman out of control. As she crams food into her mouth,

she repeatedly watches a video clip in which a character played by Streep is strangled over and over again. Her murderous fantasies are thus entwined with her oral compulsions. Hawn's 'cure' from obsession is signalled by her emergence from an asylum, without further explanation, svelte and slinky in a scarlet dress, as the best-selling author of a slimming book. In this rite of passage towards sexualized femininity, murderous pathology is linked directly to bodily excess. Similarly, in another recent Hollywood success, *Misery*, Kathy Bates as the sadistic psychopath is distinguished both by her physical grossness and the active pursuit of her murderous desires. In the final sequence of *Misery*, after the Kathy Bates character is herself killed, her former victim thinks he 'sees' her again. Significantly, for my later argument, she appears wheeling a trolley loaded with cream cakes. The message is clear – fat women are mad and murderous.

The pathology associated with eating and loss of bodily control, the fear of bodily disintegration, and the horror provoked by the female sexual body are all themes which emerge from these films. More interestingly, they also reveal something about women's own fears of their bodies which grow fat or old while still fully possessed of appetites and desires. I have chosen examples from film to begin to explore certain obsessions with the body that also appear in contemporary avant-garde art practices. In the 1990s, the body has become a vehicle for the expression of loss of corporeal identity and boundaries in images of death, dismemberment and destruction.[5] It is only in a cultural and political climate of uncertainty and powerlessness that body pollution and disintegration has again become a powerful metaphor for the breakdown of moral and social certainties. But, whereas in popular film the female body becomes a focus of cultural anxiety and disgust, in art works made by women that deal with the body's margins and its oral and erotic pleasures, we can see an attempt to explore our ambivalent fascinations with and fears of our own changing, consuming, and desiring corporeal being.

THE 'MONSTROUS-FEMININE'

In revealing the tropes of death and the disintegration of the body so clearly, *Death Becomes Her* can be linked to a genre of science-fiction horror film that emerged in the 1980s in which the human body itself becomes the site of unspeakable and unnameable horror.[6] No longer treated as an inviolable or bounded unity, the body in these films is invaded by the monstrous (*Alien*), reconstructed in robotic form (*Robocop*), or opened up to gynaecological investigation (*Dead Ringers*). Barbara Creed has argued that the transgression of borders, particularly that between the human and the non-human, is central to the construction of the monstrous in such films. She locates the experience of horror in what she

132

calls 'the monstrous-feminine' (Creed 1986: 44). Freud, in his 1922 essay, 'The Medusa's Head', had connected this horror to disavowal of the traumatic sight of the 'castrated' woman and thus to the recognition of sexual difference. The ideological project of filmic representations, Creed suggests, is to maintain the symbolic order by expelling that which threatens to destabilize it. The feminine appears in an alien form as what must be 'repressed and controlled in order to secure and protect the social order' (Creed 1986: 70). In her analysis of *Alien*, Creed argues that abjection is projected in the form of the monstrous primal mother who threatens the fragile human subject with annihilation.[7] She cites the horror film in general, and *Alien* in particular, as exemplifying the feminine-maternal as a primary source of abjection in contemporary culture. The horror film constantly restages the threat and rejection of the feminine:

> Images of blood, vomit, pus, shit, etc. are central to our cultur-ally/socially constructed notions of the horrific. They signify a split between two orders: the maternal authority and the law of the father. On the one hand these images of bodily wastes threaten a subject that is already constituted, in relation to the symbolic, as 'whole and proper'. Consequently they fill the subject . . . with fear and loathing. On the other hand, they also point back to a time when a 'fusion' between mother and nature existed; when bodily wastes, while set apart from the body, were not seen as objects of embarrassment and shame.
>
> (Creed 1986: 51)

Creed draws on Julia Kristeva's essay *Powers of Horror* for her definition of abjection. In Kristeva's writing, the abject is 'the place where meaning collapses', the liminal, the borderline, that which defines what is fully human from what is not (Kristeva 1982: 2). It is precisely that which cannot be imagined, at the edges of meaning, which threatens to annihilate the existence of the social subject. What is at the borderlines or indeterminate is potentially dangerous, because it is ambiguous:

> It is thus not lack of cleanliness or health that causes abjection but what disturbs identity, system, order. What does not respect borders, positions, rules. The in-between, the ambiguous, the composite. The traitor, the liar, the criminal with a good conscience, the shameless rapist, the killer who claims he is saviour.
>
> (Kristeva 1982: 4)

The most significant borderline is that which separates the inside from the outside of the body, self from Other. It is for this reason, Kristeva argues, that the abject holds powers of fascination as well as horror and, as such, is subject to a range of cultural and social taboos. Food, bodily wastes and sexual activities are all keys to transgressive symbolic systems

Plate 29 Cindy Sherman, *Untitled # 175*, 1987, colour photograph (edition of six, 180.3cm × 119.4cm).

since each traverses the external boundaries of the body. The typology which Kristeva describes in *Powers of Horror* distinguishes three main categories of the abject as food, corporeal alteration and death, and the female body. Her typology corresponds closely to the preoccupations of contemporary avant-garde art which explores an aesthetic of bodily transgression, often symbolically enacted on the female body. How can we explain the appropriation of the abject by women artists in a variety of transgressive forms which range from symbolic disintegration, through sado-masochistic imagery to actual bodily mutilation?

In the tradition of the fine art nude, the unregulated sexual body is repressed in order to maintain the unity and integrity of the viewing subject.[8] The aesthetic forms of Hollywood cinema and the pin-up similarly perfect the female body as an object of desire for the heterosexual male spectator. But the horror film breaks through the boundaries of representation and 'invades' the space of the viewer, inviting a range of physical reactions from hiding the eyes to stomach churning or even nausea. Laura Mulvey has suggested that 'the smooth glossy body, polished by photography, is a defence against an anxiety provoking, uneasy and uncanny body' (Mulvey 1991: 144). Thus the fetishized surface of the female body masks the horror of the 'marginal matter' contained in its interior. Mulvey argues that the exposure of femininity as fetish is taken to its logical conclusion in the development of Cindy Sherman's photographs over the last decade. Sherman's work takes us on a topographical journey as she 'dissects the phantasmagorical space conjured up by the female body from its exteriority to its interiority' (Mulvey 1991: 139). While Sherman's *Film Stills* from the 1970s represented the feminine body as spectacle, in recent work this fetishized surface has burst open to reveal its disturbing interior. If the cosmetic body of a woman merely masks the horror of lack, Sherman uses the grotesque, not so much to elude the objectifying gaze, as to expose its profoundly fetishistic structure. In Mulvey's view, Sherman's work thus *reveals* the iconography of misogyny. But do her photographs, as Mulvey suggests, '"unveil" the use of the female body as a metaphor for division between surface allure and concealed decay' (Mulvey 1991: 145) – or do they merely reproduce it?[9]

In the series of large colour photographs, *Untitled*, 1987–91, Sherman reconstructs her own body in a monstrous anatomy made up of prosthetic parts or else fragments it in a waste of bodily fluids, decaying food, vomit and slime (Plate 29).[10] As Rosalind Krauss acutely remarks, in these photographs 'the interior of the female body is projected as a kind of lining of bodily disgust' (Krauss 1993: 192). Sherman's device of using a mirror image of her face, a fragment of self-identity reflected in a pair of sunglasses, reinforces the horror at seeing a disintegration of the self. According to Luce Irigaray, the mirror image reflects a male imaginary

and, within this system of representation and desire, the woman's 'sex organ represents *the horror of having nothing to see*' (Irigaray 1985: 26). As Irigaray comments, such representation 'puts woman in the position of experiencing herself only fragmentarily, in the little structured margins of a dominant ideology, as waste, or excess, what is left of a mirror invested by the (masculine) "subject" to reflect himself, to copy himself' (Irigaray 1985: 30). Irigaray's terms correspond very closely to Cindy Sherman's scenario of an abjected self. The question which Irigaray poses is whether women's own desires can ever be adequately represented within such phallic systems of representation. If Sherman's photographs render explicit the horror that lurks within a film like *Death Becomes Her*, they do so at the cost of invoking a powerful tradition of disgust for the female body already implicit – and sometimes explicit – within popular culture. While her photographs are clearly transgressive of prevailing images of the feminine body, is such transgression productive for women?

FEMINISM, FEMININITY AND TRANSGRESSION IN ART

Although 'abject art' is a play on 'object art', the term does not connote an art movement so much as it describes a body of work which incorporates or suggests abject materials such as dirt, hair, excrement, dead animals, menstrual blood, and rotting food in order to confront taboo issues of gender and sexuality. This work also includes abject subject matter – that which is deemed inappropriate by a conservative, dominant culture.

(Ben Levi *et al.* 1993: 7)

According to the authors of the Whitney Museum catalogue, *Abject Art: Repulsion and Desire in American Art*, 'abject art' has become the oppositional art form of the 1990s. It encodes the traditional stance of the avant-garde which positions itself outside the mainstream and seeks to flout artistic and social conventions. But an all-embracing definition of abject art does not specify how gender perspectives may affect what kinds of 'taboo issues' artists choose to represent, nor indeed, how their work may be differently read. As the abject becomes fashionable 'raw' material for art at the end of the twentieth century, is all transgression of boundaries equal?[11]

The use of 'forbidden' materials and images in art to explore sexual themes can be traced back through a range of practices by women artists this century, most obviously in Surrealism, for example, in Meret Oppenheim's 1936 *Fur Breakfast* or Toyen's disturbing and erotic illustrations to de Sade. But, while the work of male Surrealist artists was understood to confront social and sexual taboos, that of women was more

likely to be interpreted by reference to their individual sexual identities.[12] In a useful discussion of transgressive femininity in the art of the 1960s and 1970s, Leslie C. Jones has demonstrated how transgression by women artists of the later period was quite differently received from that of their male colleagues. While men using 'feminine' strategies to challenge modernism in art were acclaimed as subversive, women were more likely to been seen as expressing their femininity in stereotypical ways. So, while Claes Oldenburg's soft sculptures were seen as a radical exploration of body language intended to counter a minimalist aesthetic, Eve Hesse's similarly witty explorations of non-traditional materials and unbounded forms was taken to be intuitive, 'a reflection of self as unmediated, pre-formalised origin, as the purest and most authentic feeling' (Krauss in Jones 1993: 44). Jones concludes that while the specific meanings and intentions of their work continue to be erased, transgressive femininity cannot be an option for women artists.

The same conclusion is drawn by the critics Lynda Nead and Janet Wolff in discussing transgression in recent feminist art practices. The metaphorical structure on which early feminist performance and body art rested, for example, Judy Chicago's *Red Flag*, 1971, and Carolee Schneeman's *Interior Scroll*, 1975 and 1977, was that of making the invisible visible.[13] By revealing hidden aspects of women's bodies such as menstruation, their aim was to challenge the silencing of women's sexuality within culture. The problem which this work raises is whether such revelation can, of itself, transform the discourses through which women's sex is conceived as monstrous or unclean. Lynda Nead has argued that feminist performance art in the 1970s inverted rather than deconstructed the binary division through which the female body is identified with base matter. She concludes that an 'aesthetic that is based on transgression, of "breaking open the boundaries" of the dominant discourse, can only have a limited viability for a feminist politics of the body' (Nead 1992: 69).

Similarly, Janet Wolff has argued that 'reinstating corporeality' is an important but necessarily fraught and contradictory enterprise for women artists. Since women have always been represented as body and nature against the masculine appropriation of mind and spirit, reclaiming the materiality of the body in any straightforward way is impossible. While recognizing that the grotesque female body which eats, has sex, menstruates, excretes and ages has been systematically denied and suppressed within European bourgeois culture, Wolff warns against a too literal attempt to reclaim it. Such transgression by women, she suggests, is all too often punished.[14] However, Wolff leaves open the question of whether the grotesque or the monstrous-feminine can render 'the (abject) body a potential site of transgression and feminist intervention' (Wolff 1990: 130). Despite warnings from feminist critics, this clearly is an area in which

many women artists are currently interested – the concept of bodily transgression has become a potent one.

While preoccupations with bodily metaphors of interiority and exteriority remain, it is the power of the body to subvert rationality and to evoke disorder which is at stake in recent work. For Judy Chicago in the 1970s, the internal space of the female body could be represented by the unfolding petals of a flower, but for artists working in the 1990s bodily landscapes are more likely to be fraught with both fear and fascination. Since the onslaught of AIDS, the sexual body has been explored through viral and visceral metaphors which display both disease and desire. Work of the 1990s also marks a shift away from the figuration of the female body as an integral whole in earlier feminist art – whether photographed, painted, drawn or performed – towards breaking open its boundaries to invoke the disturbing fantasy of the 'body-in-pieces'.[15] From Cindy Sherman to Cathy de Monchaux to Orlan, such symbolic strategies include fragmentation and evisceration, sado-masochism, and even dismemberment, often using violent imagery that elicits strong emotional and physical responses. But, however shocking the work may seem, for the artists concerned this is less significant than the exploration of the body as a problematic site which disrupts normative assumptions of gendered difference. The essentialism which characterized earlier feminist body art has been replaced by attempts to represent experiences of the feminine body that are psychically and culturally determined.

To insist on a gendered definition of abjection in art is to hold on to the important feminist project of re-evaluating that which is excluded or defined as inferior within male culture. At the same time it suggests a specific investment which women have in changing the meanings of the body that cannot be reduced merely to a desire for transgression. As we have seen, within feminist cultural analysis the concept of abjection has been mobilized to explain the misogyny of the culture and its deep hostility to the female and maternal body. For this reason, the 'monstrous-feminine' cannot simply be reclaimed for women, and its use in art remains a deeply ambivalent process.

In order to suggest one way in which abjection might be reconstituted from women's point of view, I want to trace a pathway back to food as one of the primary sources of cultural taboo. Drawing on the work of Mary Douglas, I argue that there is a need to separate certain aspects of the abject, particularly in relation to orality, and to specify their significance for women in contemporary culture. In art practices that deal with food and sex – and to a certain extent also with change and decay – we can see an investigation of aspects of the abject which have been specifically identified with the female body and its appetites. These offer a means of exploring the complex role of corporeality in the constitution of the (female) speaking subject.

'THE MOUTH IS INTERESTING BECAUSE IT IS ONE OF THOSE PLACES WHERE THE DRY OUTSIDE MOVES TOWARD THE SLIPPERY INSIDE'

(Jenny Holzer, *The Living Series*, 1981–2)

The focus on food as a primary source of abjection is an ancient one and follows precisely from its significance as an oral object. Food enters the body from outside, crossing the dividing boundary between the self and that which is external to it. Mary Douglas's key insight in *Purity and Danger* is to recognize that, in this, the human body stands as a metaphor for social structures. Just as societies are threatened and precarious at their margins, so bodily margins too are invested with special vulnerability:

> The body is a model which can stand for any bounded system. Its boundaries can represent any boundaries which are threatened or precarious. The body is a complex structure. The functions of its different parts and their relation afford a source of symbols for other complex structures. We cannot possibly interpret rituals concerning excreta, breast milk, saliva and the rest unless we are prepared to see in the body a symbol of society, and to see the powers and dangers credited to the social structure reproduced in small on the human body.
>
> (Douglas 1991: 115)

For that reason, Douglas argues, many cultures and religions operate powerful taboos on 'unclean' food, policing the boundaries between what may or may not be legitimately consumed. Food taboos, along with taboos on certain sexual practices and bodily wastes are the most common symbolic categories through which systems of purity are maintained. Douglas's claim, based on her anthropological research, was that all societies and cultures including our own, maintain systems of classification which define the sacred from the profane and the pure from the impure. What is defined as unclean is not necessarily dirty or loathsome in itself, but that which blurs categories of difference within a given symbolic system: it becomes 'matter out of place' (Douglas 1991: 35). So, while a single hair from the head appears as a shining line of gold in the light, the same hair swallowed in a mouthful of food makes us gag with disgust.

Defilement occurs when the body's borderlines are transgressed or when, in the case of food, different categories or classes of thing are mixed together.[16] But, Douglas insists, not all bodily margins and wastes are equally dangerous nor are pollutants interpreted in the same way. Since each society constructs its own systems of marginality, the dangers which are attributed to certain foods or aspects of the body are historically and

Plate 30 Helen Chadwick, *Eat Me*, 1991, cibachrome transparencies, glass, aluminium, electrical apparatus (three parts 53cm × 90cm × 15cm, one part 76cm × 47cm × 15cm).

culturally variable: 'Each culture has its own specific risks and problems' (Douglas 1991: 121).[17] Liminal foodstuffs have particular power to confer symbolic meaning because of their slippery signification within the social order.

Oysters are perhaps the prototype food in this respect endowed with shifting connotations of luxury and secrecy. Forbidden according to Biblical laws of Leviticus as neither flesh nor fish, neither alive nor yet dead, neither solid nor liquid, they evoke shivers of pleasure and horror in equal

measure. In her photographic series, *Food* and *Sex*, Hannah Collins uses images of food photographed in close up to suggest its ambivalent meanings. In *Sex II*, 1991, opened oyster shells reveal their raw and vulnerable contents which are disturbingly suggestive of wet and gleaming vulvas. Collins employs the erotic connotations of oysters, reputed as an aphrodisiac, to point to the ambiguous relation between what we eat and what we are. Helen Chadwick make the sensory experience of seduction even more explicit and entirely enjoyable in *Eat Me*, 1991 (Plate 30). An opened oyster nestles in its shell at the centre of a wreath of rich yellow buttercups, a feast for the eyes it also invites the touch of the tongue. We are invited to look, but simultaneously held at a distance by the lit photographic panel which casts a glow around the image, suggesting almost a quality of reverence. For a female viewer, the effect is partly celebratory and partly erotic; the title invites an imagined cunnilingus. By exploring the metaphoric and metonymic associations between foodstuffs and the female sex, this work retraces the process by which the precarious frontiers of the body are maintained. By choosing to represent food which itself occupies the borderline between the edible and the polluting and thus carries an ambivalent resonance of the 'unclean', it disturbs accepted differences between what is properly 'inside' and 'outside' the body.

A number of artists have drawn on visceral or corporeal imagery to explore the internal/external borderlines of the body. Beyond an immediate effect of aesthetic shock and revulsion, 'carnal art' such as Helen Chadwick's *Enfleshings*, Jana Sterbak's *Vanitas: Flesh Dress for an Albino Anorectic* or Kiki Smith's *Blood Pool*, can provoke reflection on the close contiguity between disgust and desire. Jayne Parker's poetic black and white films juxtapose her own naked body with images of viscera, blood, eels or oysters, but their shock effect is mediated by the formal beauty of composition and visual restraint of monochrome. In *K*, 1989, the artist appears to expel a long string of viscera from her mouth which she then 'knits' with her arms into a dress which hangs down in front of her naked body (Plate 31). But, rather than suggesting a violent disembowelling, the film offers a meditation on the interiority of the body and the irrational fears it engenders. The disgust and horror we might feel at 'innards' revealed is converted into a recognition of beauty, even of domesticity, as she slowly weaves her body's visceral covering. In *Cold Jazz*, 1993, Parker uses sequences of cutting and opening oysters, water washing over oysterbeds and her naked body on the seashore lapped by waves and pebbles, intercut with images of the saxophonist, Kathy Stobart, whose playing provides the soundtrack. The film draws on visual and thematic connections which invoke the permeable boundaries and material surfaces of the body. Liquids and solids, breath and water, like rhythms of ingesting and exhaling, pass through the music, the sea and the bodyscape.

Plate 31 Jayne Parker, *Still from 'K'*, 1989, 16mm film, black and white, 13 minutes.

By contrast, Chadwick's *Loop My Loop*, 1991, in which a gleaming pig's intestine intertwines with golden Barbie doll hair in a braided embrace, seems more deliberately perverse in its pleasures (Plate 32). Femininity is represented here both as surface *and* depth. The fetishized sign of femininity is inseparable from a visceral and forbidden interior. If the theme of a traditional Vanitas painting exposes surface allure as a mask for interior corruption, Chadwick's work refuses such a simple structure of disavowal. The golden hair has a dual function as a fetish object, both erotic and, in a form of *memento mori*, marking lack – the hair which was braided into Victorian jewellery to commemorate a dead loved one.[18] Typically, Chadwick suggests a slippage between opposites, living and dead, human and animal, surface and depth, to suggest an indivisibility of erotic attraction and repulsion which are held apart within the conventional binary division of sexual difference. Like a hermaphrodite who combines the two sexes in one body, *Loop My Loop* suggests a potential bisexuality of desires in which self and other cannot be fully separated. In place of the 'properly' unified, gendered subject, Chadwick reveals a multiplicity of sensations mediated through the body,

Plate 32 Helen Chadwick, *Loop my Loop*, 1991, cibachrome transparency, glass, steel, electrical apparatus, 127cm × 26cm × 17cm (collection the artist).

whether it be of seduction or revulsion or both. In this, food stands in for and replaces words and verbal description. For, as Maud Ellman reminds us:

> It is through the act of eating that the ego establishes its own domain, distinguishing its inside from its outside. But it is also in this act that the frontiers of subjectivity are most precarious. Food, like language, is originally vested in the other, and traces of that otherness remain in every mouthful that one speaks – or chews.
>
> (Ellman 1993: 53)

While the vulnerability of the borderline is a threat to the integrity of the '"own and clean self"' (Kristeva 1982: 53), it can also offer a liminal space where self and other may intermingle.

'I FEEL LIKE VOMITING THE MOTHER'

(Kristeva 1982: 47)

In a dizzying passage characteristic of the brilliant opening description of *Powers of Horror*, Julia Kristeva evokes the particular sensation of abjection and its violent convulsions experienced in the body:

> When the eye sees or the lips touch that skin on the surface of the milk – harmless, thin as a sheet of cigarette paper, pitiful as a nail paring – I experience a gagging sensation and, still farther down, spasms in the stomach, the belly; and all the organs shrivel up the body, provoke tears and bile, increase heartbeat, cause forehead and hands to perspire. Along with sight-clouding dizziness, *nausea* makes me balk at that milk cream, separates me from the mother and father who proffer it. 'I' want none of that element, sign of their desire. 'I' do not want to listen, 'I' do not assimilate it, 'I' expel it. But since food is not an 'other' for 'me', who am only in their desire, I expel *myself*, I spit *myself* out, I abject myself within the same motion through which 'I' claim to establish *myself*.
>
> (Kristeva 1982: 3)

In a striking textual shift, she also points us to the source of abjection in the contradictory process of separating our infant selves from our parents. Central to Kristeva's analysis of abjection is that it can be located in the period of intense dependency on the mother during which the infant experiences itself one with the maternal body. Abjection is the psychic expression of fears associated with that archaic dependence *and* the loss involved in becoming an independent subject. For Kristeva, 'food is the oral object (the abject) that sets up archaic relationships between the human being and its other, its mother who wields a power as vital as it

is fierce' (Kristeva 1982: 75–6). Kristeva's archaic mother figure is ejected from the body, only to return psychically in the form of an hallucination which threatens to annihilate the self from outside.

But the borderline between self and other is still permeable in the womb as the fetus is nourished through the placenta and, after birth, as the infant is sustained by milk from its mother's breasts.[19] In this relationship, Kristeva suggests, we are unable to separate what is our 'selves' from that which is outside us, food is not yet the 'other'. But, in the process of learning to accept the gift of milk which is proffered us, we must also learn that we are the separate objects of desire. The response to the refusal to separate is conflict expressed as physical nausea. Food thus becomes a powerful metaphor for the conflicted relationship of sameness and difference between our mothers and our selves.

Kristeva's account of the experience of abjection also stands as a powerful description of the eating disorders, anorexia and bulimia, which have been similarly linked to a difficulty in individuating the self. Writers on eating disorders have argued that these operate in various ways as mechanisms to resolve psychic conflicts which occur during the complicated passage into adult womanhood. In the most widely rehearsed feminist argument which connects eating disorders with the cultural definition of femininity, it has been suggested that anorexia nervosa represents a 'flight from femininity', a form of protest against the imposition of unattainable sexual and feminine ideals.[20] In refusing to ingest the feminine role, the anorexic's body may indeed literally deny her own sexuality as she loses body weight and ceases to menstruate. But, as Susie Orbach and Kim Chernin suggest, the anorexic's refusal of food also implies something about separation and dependence on her mother, with whom the taking and the making of food are identified. Relationships between daughters and mothers are often expressed through conflicts over food, in a series of injunctions which act both as signifiers of the mother's desire for control and of the child's resistance to it: 'Eat it all up, just one more mouthful, no more sweets, don't put that in your mouth!' Food and the mouth (the oral) is an intense and continuing focus of control and, especially for girls, remains an arena of conflict in which food and words can never be entirely separated.[21]

Yet another way of understanding the anorexic's refusal to eat can be explored via Mary Douglas's account of dietary prohibitions. In such symbolic systems, wholeness is frequently equated with holiness, especially in relation to the integrity of the human body: 'To be holy is to be whole, to be one; holiness is unity, integrity, perfection of the individual and of the kind. Dietary rules merely develop the metaphor of holiness on the same lines' (Douglas 1991: 54).

Eating represents a process of transformation in which one form of organic matter (milk, meat, fruit, vegetables) enters the body and

is changed into another (flesh, skin, blood and bone). In her rituals of purification, the anorexic refuses the invasion of her body by external matter which enters into and transforms her. Only by rejecting the 'pollutant' food can she retain purity and essence, the bare bones of her being, and be whole: 'The ultimate self-abjective wish becomes the desire to completely eliminate "flesh", to become "pure"' (Comand 1994: 18).

Nicoletta Comand's installation, *The Food I Ate Turned into Flesh*, 1994, explores this ambivalent fascination with and fear of food by the anorexic/bulimic. The piece arose from Comand's conscious decision to make work about eating disorders which she had herself experienced as young woman growing up in Italy. Presented on the one side with the powerful Catholic tradition of maternal sacrifice and on the other with media images of a highly sexualized femininity, her response was to assert control over her own body by refusing food. From an initial process of 'playing' with foodstuffs – icecream, sweets, playdough shapes – Comand began to explore in her work the guilt associated with eating in a series of close-up photographs of contaminated foods, for example, shards of glass in a chocolate cake. The work re-enacted the process by which an infant's uninhibited physical exploration of, and pleasure in, food is displaced by a culturally defined feminine awareness of its association with pain and denial.[22]

This ambivalence over food is central to the installation which uses the apple as a potent symbol for women's conflicted desires. Photographed in close up, these carved apples become the focus of the viewer's experience. Appearing at first as faces suspended in space without context or framing, we seem to be immersed in images of ageing and withered flesh (Plates 33 and 34). The shrinking eyes and mouths convey an intensity of individual expression which is difficult to read. With the realization that these are not human faces at all, but carved apples which have begun to wither and decay, comes a frisson of the uncanny, that which is familiar suddenly made strange. The effectiveness of Comand's work lies in the way that the withered apples evoke a direct analogy with flesh.[23] They are disturbing, at once soft and disintegrating, evoking very precisely the sensation of food turning into flesh, the fear of a thing which is 'Other' entering into and transforming the human. Uncertainty about whether something is animate or inanimate is one characteristic which Freud ascribes to the uncanny (*unheimlich*), which he links to a compulsion to repeat associated with the death instinct. This involuntary repetition, represented by Comand's compulsive carving of apples over and over again, recalls the (in)voluntary compulsions of an eating disorder.

The lines of carved and dried apples also appear in a collecting cabinet, like diminutive scalped heads invoking more violent associations with

Plate 33 Nicoletta Comand, *The Food I Ate Turned Into Flesh*, 1994, colour
photograph, (one part of seven, 110cm × 110cm).

bodily mutilation. The ritualistic carving of apples with dental tools by
Comand, recalls earlier feminist work by Roberta M. Graham and Gina
Pane which involved symbolic and actual cutting of the face or, more
recently, the use of plastic surgery by the French performance artist, Orlan.
Such work both alludes to a cultural norm of feminine beauty and trans-
gresses it by enacting rituals of pain on the body through cutting and
dismemberment. Its shock value derives from sight of a woman who
'remodels' her face and flesh through her own action or by surgery. Like
the story of the Ugly Sister in Cinderella who cuts off her toes to fit the
prince's slipper or the Little Mermaid who walks on knives in Hans
Andersen's story, mutilation of the flesh stands as a powerful negative
message that female desire can only be achieved through pain. Cosmetic
surgery is ambivalent in its assertion, on the one hand, that we have the

147

freedom to transform our bodies as given in nature, and on the other, that such self-mutilation inscribes a cultural ideal. But while the sculpting of apples symbolically re-enacts the carving of flesh, in a reversal of the cosmetic surgeon's scalpel that seeks to deny the ageing process, Comand opens up the 'flesh' to bloom and to decay.

If, in the tradition of fairy tales, women are punished for their desires, the apple recalls a more ancient linking of sin and female sexuality, that of Eve and the Fall from Paradise. Eve as the original temptress invited sin into the Garden of Eden through the act of eating, an indulgence of her appetite which brought with it both awareness of sexual difference, and of ageing. Eve's punishment was not just to be cursed with the consequences of painful childbirth, but to grow old – sexual knowledge and the passage of time are linked. In early Christian writings it was the sexual

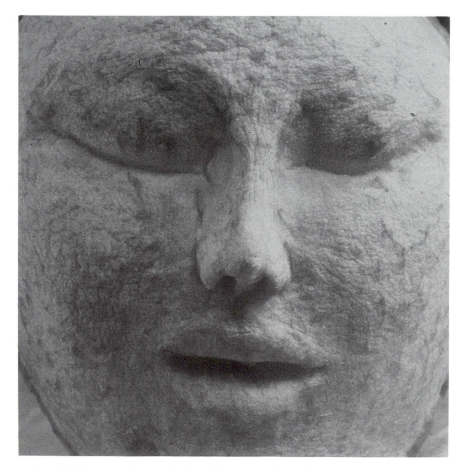

Plate 34 Nicoletta Comand, *The Food I Ate Turned Into Flesh*, 1994, colour photograph, (one part of seven, 110cm × 110cm).

body of women which was specifically reviled, whereas the pure, sealed body of the virgin was exempt from physical disgust. Eve as the original temptress was the prototype of all women whose lust brought about the destruction of male rationality, and thus came to be seen as emblematic of the bestial side of human nature.[24] The figure who reversed Eve's sinful legacy was, of course, the Virgin Mary, for whom the denial of sexuality was replaced by maternity and eternal life. In rejecting food, the anorexic as holy virgin not only denies her sexuality, but also her changing and ageing body. By allowing the flesh of the apples to wither and decay, Comand confronts her own anorectic fear of a body which changes and grows old – becoming like that of her mother. Her work can be seen to address the impossible imperative for women to pass from innocence to maternity without indulgence of their (sexual) appetites.

In tracing a connection between the process of individuation and orality, Kristeva offers an interesting means, which she herself does not pursue, of reinterpreting women's specific relationship to abjection via food and eating. But, can the abject be reconfigured in a way which is not dependent on repression of the mother? Kristeva's own text offers a clue to this process when she suggests that when, rarely, a woman does 'tie her desire and her sexual life to that abjection ... it is through the expedient of writing that she gets there' (Kristeva 1982: 54).[25] Art works that deal with themes of food and the body confront the complex relation of daughters to mothers and begin to offer a way of constituting women's *own* desires without repression of the maternal relation.

'A WOMAN HAVING AN EXCESSIVE RELATIONSHIP WITH A CREAM CAKE IS SEEN AS DEFICIENT IN HER FEMININITY'

(Gamman and Makinen 1994: 167)

In a new reading of fetishism from a female perspective, Lorraine Gamman and Merja Makinen have developed an account of women's fetishism linked specifically to food. Fetishism, they argue, is culturally gendered and, for women, focuses primarily on food as its object. Their work offers an important revision of the model of (passive) female sexuality within orthodox psychoanalytic accounts and reconstitutes women as active agents of their own desires. Gamman and Makinen are careful to draw analytic distinctions between different types of fetishism which are frequently collapsed together.[26] While each shares the same structure of metonymic substitution of signs, according to Freud, the true sexual fetish:

> only becomes pathological when the longing for the fetish passes beyond the point of being merely a necessary condition attached to

149

the sexual object and actually *takes the place* of the normal aim, and, further, when the fetish becomes detached from a particular individual and becomes the *sole* sexual object.

(Freud 1977: 66–7)

Gamman and Makinen argue that women's relationship to food parallels sexual fetishism in its structures of disavowal, but is based on oral rather than on genital gratification. Instead of understanding this as an entirely pathological practice, they suggest that different degrees of food bingeing are used by many women as a coping mechanism to disavow anxieties about identity. Like Kristeva, they locate the structures of female fetishism within the oral stage of infancy, prior that is, to the Oedipal phase which is crucial to Freud's account of fetishism in men. It is separation from the mother which produces the intense psychic conflict productive of fetishism. However, in contrast to Kristeva, Gamman and Makinen develop an analysis of this process which specifically addresses gender difference:

> The sexual fetishist chooses a leather shoe, the food fetishist chooses chocolate cream cakes – and the shoe and the cake are cultural objects with a definite relationship to cultural norms of masculinity and femininity. In both instances, the objects are found 'wanting' by the norms, which form part of that culture.
>
> (Gamman and Makinen 1994: 167)

Although in the passage previously cited, Kristeva speaks in the first person voice, implicitly gendered as female, elsewhere in *Powers of Horror* she does not generally differentiate any specific position for women as subjects, nor how their early development might be constituted differently from that of men. Following Freud and Lacan, she accepts the psychoanalytic account of childhood development founded on repression of the maternal relationship following the Oedipal complex. While the abject, like the semiotic, is aligned with the feminine in Kristeva's argument, this does not accord any special status to women as such. Indeed, her account of women's relation to the abject is extremely contradictory. In one of a few specific references she makes to women's experience, Kristeva suggests that it is connected to their maternal function rather than to their relationship with their own mothers.[27]

However, in developing the connection between abjection and orality, she cites the discussion by Anna Freud of the phobia of a little *girl* who was afraid of being eaten by a dog. Kristeva suggests that this phobia of being devoured is crucially linked to language, and followed upon the child's separation from her mother. As the child became more phobic, the more she spoke. 'Devouring language' points to the importance of orality as that which *takes the place* of the girl's lost relationship to her

150

mother: 'Through the mouth that I fill with words instead of my mother whom I miss from now on more than ever, I elaborate that want, and the aggressivity that accompanies it, by *saying*' (Kristeva 1982: 41).[28] Constitution of the subject involves not only separation but, crucially, a shift from a maternal relation mediated by eating (milk from the breast) to one of speaking. Language is the condition of becoming an independent subject and yet language always masks or substitutes for the absence/loss of the mother:

> But is not language our ultimate and inseparable fetish? And language, precisely, is based on fetishist denial ('I know that, but just the same', 'the sign is not the thing but just the same', etc.) and defines us in our essence as speaking beings. Because of its founding status, the fetishism of 'language' is probably the only one that is unanalysable.
>
> (Kristeva 1982: 37)

Whereas to Kristeva language is the fetish which ultimately substitutes for the absent mother in the symbolic order, for Gamman and Makinen it is food which offers women a means of disavowing that loss and of compromising with society's view of the gendered self.

If anorexia implies total rejection of the (maternal) body, bulimia, on the other hand, provides a dual mechanism through which the oral pleasures of eating can be gratified by bingeing while, at the same time, through vomiting, the burden of flesh can be denied. The fetishistic aspect of bulimia lies in this dual structure of bingeing *and* vomiting: the 'doing and undoing' characteristic of the process of disavowal. The fear of food taking over the body and of its physical boundaries being dissolved is thus held at bay. Bulimics indeed describe the intense pleasures they derive from eating, especially food associated with indulgence and excess like ice-cream, chocolate or junk food. (Even the sensation of vomiting, controlled as a technique, can offer a sensual satisfaction akin to excretion in expelling wastes from the body.) But at the same time, feelings of guilt, depression and self-loathing which accompany the bulimic experience would suggest that it represents an attempt to deal with contradictory nexus of repressions and desires around the female body. Unlike the anorexic, the bulimic disguises her activity, its hidden or secret status can become a source both of shame *and* strength. As Gamman and Makinen suggest, bulimia represents 'not a conflict as with anorexia, but a compromise, a creative coping mechanism' (Gamman and Makinen 1994: 132).

If bulimia represents a fetish structure, this usually surfaces for young women at the stage of moving away from the domestic home when a daughter may experience an oscillation between guilt at leaving her mother behind and panic at not being able to be fully separate from her.[29]

Plate 35 Laura Godfrey-Isaacs, *Alien Blob*, 1993,
resin, 15cm × 15cm × 5cm.

We can see the creation of such fetish objects in the series exhibited by Laura Godfrey-Isaacs in 1993. Repeated objects make a connection between orality, food and a relation to maternal space that was also evoked by the exhibition's title, *The Alien and the Domestic. Alien Blobs* are three-dimensional, flesh-coloured bumps projecting several centimetres from the surface of the wall which disturbingly resemble edible nipples (Plate 35). As in Nicoletta Comand's installation, familiar objects metamorphose into something strange and other. These *Alien Blobs* are disturbing, even disgusting, and yet appeal, evoking a conflict of tactile sensations. They are both oral – the 'nipple' suggests sucking as well as food – and yet, being made of industrial resin, the 'blobs' are literally repellent to the touch. More accurately, perhaps, they recall not the intimacy of the mother's breast, but the soft and mucilaginous quality of a well-sucked baby's dummy.

In the process of individuation, that which was inseparable from us becomes alien. The child's autonomy involves separating itself from the mother's body, but this separation is founded on feelings of disgust against the unclean and the undifferentiated. Because it is from the mother that the child learns the limits of its body and how to separate clean from unclean, 'proper' from 'improper' areas, she becomes identified with the ambivalent feelings the child has towards its own body. The body and its wastes as a source of pleasure and play become replaced by embarrassment, shame and disgust. From then on, it is argued, the maternal relationship becomes the site of intense and conflicting desires. The series of *Padded Paintings* evoke a similar mix of oral pleasures and disgust (Plate 36). They resemble glutinous Chinese Dim Sum or sticky buns bursting with sugar and E-numbers, a kind of comfort food to be crammed into the mouth – and subsequently feel sickened by. According to the artist, they 'suggested and felt like cushions or furniture padding which were soiled or discarded. . . . These are domestic items one would normally want to expel from the domestic sphere' (Godfrey-Isaacs 1994: unpaginated). The dual image of food which is ingested and dirty cushions which are expelled evokes precisely that conflict between comfort and rejection, dependence and independence, which characterizes separation from the mother. If the problem for daughters in separating from their mothers is represented in terms of a process of disavowal (I am not like her, but all the same), then this work functions in a similar way as a fetish which both alludes to and denies that loss.

The *Alien and the Domestic* marks a shift away from Godfrey-Isaac's earlier series, *Slime*, 1992, which dealt explicitly with the body and its wastes in relation to dirt and defilement, towards reconstituting the abject for women through transitional objects – food and cushions – from domestic space. Some commentators have read in this a move 'away from certain well-established feminist narratives of the body' (Kharibian 1994: unpaginated). While certainly less obvious in its reference to the

Plate 36 Laura Godfrey-Isaacs, *Padded Paintings*, 1993, 25cm × 15cm.

feminine, Godfrey-Isaac's current work re-examines our relation to the body, and more particularly to the maternal body. If the *Alien Blobs* and *Padded Paintings* are indeed 'transitional objects' in Winnicot's sense, then Godfrey-Isaac's 1994 installation, *Monstrous*, takes us to the 'place-body' described by Julia Kristeva before fixed boundaries are defined in language.

Monstrous is about pleasure in food, bodies, and excess (Plate 37). Like mountainous puddings or fungi, these sculptures appear to wobble and dissolve, spilling out over the floor in gigantic mounds that threaten to engulf us. Made of rapidly expanding insulation foams and coloured custard-yellow, salmon-pink or pale mushroom-brown, they spread and drip in congealed forms which still retain a quality of liquid dissolution. The physical materials that were once contained within the recognizable limits of paintings or objects have erupted outwards. They are physically disorienting in their scale – some are fifteen feet in diameter – their lack of fixed boundaries and ambiguity between solidity and softness.

These are 'bodies' which are not yet mapped according to boundaries into erotogenous zones that are categorized as either pure or impure, innocent or guilty. This spatial semiotic belongs to the feminine-maternal, a *'place body'* before the *'speech-logic of difference'* ensues (Kristeva 1982: 72). While maternal authority is concerned with mapping of the body in terms of space, paternal law imposes the logic of time:

> Through frustrations and prohibitions, this authority shapes the body into a *territory* having areas, orifices, points and lines, surfaces or hollows, where the archaic power of mastery and neglect, of the differentiation of the proper-clean and improper-dirty, possible and impossible is impressed and exerted. Maternal authority is the trustee of that mapping of the self's clean and proper body; it is distinguished from paternal laws within which, with the phallic phase and acquisition of language, the destiny of man will take shape.
>
> (Kristeva 1982: 72)

What is suggestive about Kristeva's use of spatial metaphor is a concept of a bodily identity which is different from Lacan's 'mirror' in which we see ourselves reflected as ideally integrated selves. Anterior to language is a mapping of the boundaries between subject and object through food, which is semiotically rather than linguistically defined. *Monstrous* similarly shifts us from a purely visual (voyeuristic) experience to a tactile (fetishistic) one. These monstrous soufflés enter into our space and spread beyond the eye, lurking at the corners of vision. Vision is replaced by touch, our primary sensation as infants.

Laura Godfrey-Isaac's work retains that sense of the child's pleasure

Plate 37 Laura Godfrey-Isaacs, *Monstrous*, 1994, insulation foam
and acrylic.

in the forbidden, playing with food, dirt and excrement before we are made aware of shame or embarrassment. It asks what would happen if the 'monstrous' were not expelled, if it did not return in an alienated form, but was ever present with us as manifest in more familiar sites of disgust – spilt food or the skin on custard. Just as Primo Levi wrote in 'praise of impurity, which gives rise to changes, in other words, to life' (Levi 1985: 34), so to Godfrey-Isaacs incites willingness to accept physical disorder, spreading flesh, sex, food, and let these spill over the 'clean and proper self'.

MY BEST EVER CHOCOLATE CAKE

For me, this is simply the best chocolate cake there is. The wonderful flavour of hazelnuts and dark chocolate, with a hint of orange, combined with a delicate moist texture make it a perfect party dessert. It may be extravagant, but for a special occasion it is worth every penny – and your guests will be ecstatic in their appreciation. Serve the cake with cream if you like.

(Dimbleby 1985: 44)

Sweets for my sweet, sugar for my honey,
I'm never ever gonna let you go.

(The Drifters 1961)

From a fascinating brief survey conducted as part of their research, Gamman and Makinen learnt that women appeared to prefer (talking about) food to sex. Chocolate was rated most highly as a 'guilty pleasure', with nearly three-quarters of those surveyed naming it as a major source of satisfaction. The authors concluded that, when it came to pleasuring themselves, 'Food was clearly a more "speakable" outlet for women, though one often surrounded by guilt' (Gamman and Makinen 1993: 139). It is perhaps for this reason, as well as for its stimulant effects, that chocolate is now on the increase as a form of 'safe sex'.[30]

The idea that chocolate may be preferable to sex comes as no surprise. Sweets and chocolate have long been metaphoric substitutes for sex in popular songs and in advertisements – like the notorious invitations by Haagen Dazs and Milk Flake to orgasm over icecreams and chocolate bars – while cookery books offer us seduction by recipe. In the language of lovers' appetites, women and girls are often 'sweeties', 'sugar' or 'honey pies', metaphors of consumability which point to an equivalence between the female body and sweet foodstuffs. Margaret Atwood's *The Edible Woman* subverts this metaphor as the heroine bakes and ices a woman-shaped cake and, finally, eats her. Eating 'herself' both marks the end of the heroine's anorexia and symbolizes her rejection of a stereotyped feminine sexuality: '"You look delicious,"' she told her. "Very appetising.

And that's what will happen to you; that's what you get for being food"'(Atwood 1979: 270).[31]

In a delightful essay on the cultural and social significations of confectionery, Allison James points out that its ambiguous status as a foodstuff makes it ripe for such symbolic elaboration. As she suggests, 'confectionery is conceptually *both* food and non-food, an ambiguous substance and, as such, is replete with ritual significance' (James 1990: 673). Drawing on the work of Mary Douglas, James argues that confectionery – like oysters – is a liminal food: neither one thing nor the other, it carries the attractions and dangers of a borderline. Chocolate, in particular, has taken on a symbolic cultural role with its connotations of richness and exclusivity and of wickedness and excess which gives it a moral as well as an edible dimension. Sweets and chocolate have become increasingly used as metaphors in art by women in the 1990s. Anya Gallacio painted the walls of a London gallery with melted Cadbury's Bournville chocolate in 1994, Nicola Petrie's exquisite *Sugar Chandeliers*, 1994, are made from toffee, crystallized fruit and biscuits (sponsored by Trebor Bassett), and Janine Antoni's *Lick and Lather*, 1993, consists of fourteen self-portrait busts made of chocolate and soap which she 'licked' and 'lathered' in an erosion of her own image. Fascination with the symbolic medium of chocolate can be partly explained by its richly ambivalent sexual and cultural significance. Jean-Paul Sartre offers another explanation for its ambivalence in a discourse about stickiness, paraphrased by Mary Douglas in *Purity and Danger*:

> The viscous is a state halfway between solid and liquid. It is like a cross-section in a process of change. It is unstable but it does not flow. It is soft, yielding and compressible. There is no gliding on its surface. Its stickiness is a trap, it clings like a leech; it attacks the boundary between myself and it. Long columns falling off my fingers suggest my own substance flowing into the pool of stickiness.
>
> (Douglas: 1991: 38)[32]

Sartre's description of the attractive and repellent qualities of treacle bears a strong resemblance to my own experience of Helen Chadwick's installation, *Cacao*, shown in the Serpentine Gallery in 1994. As elsewhere in her work, Chadwick plays on the interchangeability of oral and sexual gratifications, but *Cacao* goes further in its implicit exchange of the pleasures of eating for those of sex. Here, Helen Chadwick as fetishist literally substitutes chocolate for sex (Plate 38).[33] The work consists of a circular bath of slowly bubbling chocolate with a central fountain which pumps continually down from a rod into the pool below. The small dimensions of the rod and the slippery quality of the chocolate precisely imply pleasure in the penis, rather than the phallus, a combination of softness and hardness, smoothness and stickiness, of the familiar and the

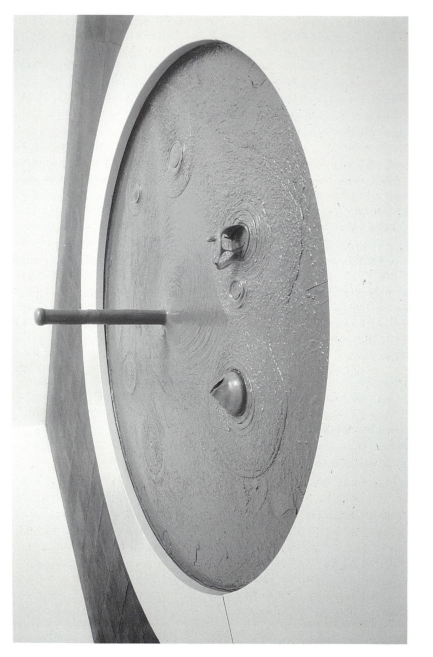

Plate 38 Helen Chadwick, *Cacao*, 1994, chocolate, aluminium, steel, electrical apparatus, 85cm × 300cm × 300cm.

alien. But, as in Chadwick's *Loop My Loop*, the work dissolves fixed categories of gender difference into more heterogeneous sexual desires. The cloying, sweet smell of warm chocolate arouses an equally strong sensual reaction, a mingling of pleasure and disgust. In *Cacao* the liquid chocolate is both pleasurable and repellent in its excess. The fat bubbles which burst slowly on the surface of the chocolate pool are also suggestive of swollen nipples. Like *Monstrous*, *Cacao* indicates the possibility of a return to that state of 'polymorphous' infantile pleasures which Freud identified in his analysis of the sexual life of children (Freud 1977: 109). Freud made a distinction between sexual and genital activities, arguing that thumbsucking, tickling, anal stimulation and masturbation are all sources of auto-erotic pleasure for the infant. *Cacao's* bubbling surface suggests just such indiscriminate desires when mud, shit and chocolate are all equally pleasurable in their brown stickiness.

But, while any part of the subject's own body can become an eroto-genous zone, Freud suggests that the mouth is an especial site of stimulation. In the oral phase, the sexual aim is to *incorporate* the object: 'in thumbsucking ... the sexual activity, detached from the nutritive activity, has substituted the extraneous object one situated in the subject's own body' (Freud 1977: 117). The thumb, or any oral substitute, becomes the fetish which replaces the mother's absent body. Interestingly, Freud himself linked thumbsucking to eating disorders especially in his women patients.[34] Thus, the pleasures of chocolate brings us full circle to the bingeing and vomiting characteristic of bulimia in which, as we have seen, the problem of separation between self and (m)other is central to the dissolution of 'the boundary between myself and it'.

Luce Irigaray has also suggested that we need to rethink 'the "mechanics" of fluids', if we are to transform gender relations. The properties of bodily fluids, milk, saliva and mucous offer a model of the unstable inside/outside of sexual discourse. But, she asks, 'where are we to find our subjective status in all these disintegrations, these explosions, these splits or multiplicities, these losses of bodily identity?' (Irigaray 1993: 205). In horror films, the threat of the abject is displaced on to the monstrous or the alien, which must be expelled in order for social body to be restored and psychic resolution achieved. Horror films enable us to address our fears and fascinations with the boundaries of sexual differ-ence, but only at the cost of casting into darkness the terrors we cannot accept or tolerate. The feminine-maternal body in its changing state is linked to bodily wastes, dissolution and decay that signify the dangerous permeability between inside and outside and the threat to the individual subject.

In aspects of contemporary women's art which deals with the body's margins and its oral and erotic pleasures, we can find a means of acknowl-edging those aspects of the abject which are specifically identified with

the female sexual body. Food offers a way of exploring the pleasures and dangers of the body's limits in ways which are particularly relevant to women, both because food is culturally gendered as feminine and because it provides means of discovering the contradictory, ambivalent and often unresolved feelings relating to feminine identity and maternal loss. But, if this work represents the potential for an active female desire, it does so in unexpected ways. Body horror is converted into pleasure, but the ultimate horror (for men at least?) may be the discovery that the source of that pleasure lies not in men's bodies – but in chocolate.

7

IDENTITIES, MEMORIES, DESIRES

The body in history

> Bodies too are like time slices through the fabric of social lives;
> bodies tell a contested political history.
>
> (Haraway 1987: 73)

For women, authorship and subjectivity are political issues. The problem lies in how the self as subject and as artist is to be represented. For, if the Romantic concept of the artist as the single source of identity and meaning no longer holds, how may the relationship between the art work and the 'self' who produces it be understood? More specifically, in what ways can this question be addressed in practices which engage explicitly with the question of women's subjectivity as artists – where '"woman as artist" and "woman as subject" are present as interrelated conditions' (Klinger 1991: 42).

These questions have become the focus of feminist debates about authorship and its critique within contemporary critical theory. On one side, there are those who believe that women have a vested interest in the deconstruction of the powerful authorial figure defined within Enlightenment aesthetics, a tradition of mastery within a predominantly white, male, Eurocentric narrative. On the other, are those who argue that women have too recently acceded to artistic identity and subjectivity to let it go. If authorship as a position of mastery has come under attack, so too has the de-centred subject of poststructuralist theory. As Rosi Braidotti puts it neatly: 'In order to announce the death of the subject one must first have gained the right to speak as one' (Hekman 1990: 80).[1]

While the critique of 'man' as a subject constituted in western thought clearly has resonance with feminist attempts to reconfigure subjectivity from the point of view of women as speaking subjects, the issue of authorship remains contentious. Indeed, it has resurfaced within contemporary critical discussion of postcolonial art practices. Artists like Sutapa Biswas, Sonya Boyce, Chila Burman, Lubaina Himid and Maud Sulter have interrogated authorship as a position caught up within a network of dominant institutions, practices and traditions. As Joan Borsa suggests, this implies

a politics involved in examining one's own location, inheritances and social conditions: 'To speak about and search for a "politics of location", is not to desire a final resting place, an essence that we can comfortably attach ourselves to, but a "position" that works against disembodiment, immobilization and silence' (Borsa 1990: 40).[2]

Metaphors of *space* and *location* have been peculiarly characteristic of postcolonial cultural practice and criticism.[3] The term 'hidden from history' used within western feminism since the 1960s has been overlaid by a spatial model of 'mapping' the relationships between absence and presence. This reconceptualization of history in spatial terms can be linked to the particular postcolonial experience of diaspora as both an identity and a experience.[4] Within visual art practices, its representation may be seen best in work which simultaneously incorporates temporal and spatial dimensions:

> Installations too exist in this dual reality, not as mere reflections of it but as interventions in time and space. As such, they map out a territory which, although largely consistent of familiar elements, signifies neither their usual function nor their usual habitat.
>
> (Markiewicz 1993: unpaginated)

For this reason installation art has had particular significance within postcolonial feminist art practices, allowing for the exploration of identities that are 'founded on imaginary trajectories of here and not-here, I and not-I and hence on metaphors of movement and place' (Robertson *et al.* 1994: 2). The attempt to map a new space for female postcolonial subjectivity has become a central issue within contemporary art practice. The themes of exile, separation and return have provided a powerful means of exploring the self as an ongoing process of construction in time and place through the operation of memory as well as in the present, and in the articulations of loss and desire. The presence and absence of the body in the text functions as a metaphor for the difficulty of fixing identity as a subject in history.

In this chapter I shall explore these themes within the work of five artists, Lesley Sanderson, Pam Skelton, Lily Markiewicz, Leslie Hakim-Dowek and Mona Hatoum. Their art practices address questions of self and identity directly but no longer take for granted the central concept of the artist underpinning modernism. The 'self' here is deliberately hybrid rather than a fixed or given essence. It is inscribed within different speaking positions and discursive traditions which shift and overlap. In this sense then, it is postmodern. But equally, it is a practice and a set of representations of embodiment that is grounded in the recognition that we are made through our own and others' histories. These representations of self and others assert *this body, the particularity of this history* against prevailing gender and racial stereotypes.

AUTHORS AND AGENTS

Two encounters in 1993 seemed to encapsulate the contradiction in contemporary feminist cultural theory and practice between the need to contest available masculine models of the artist and simultaneously to resist the 'seemingly endless dissolution of the subject' within post-structuralist theory (McNay 1992: 6). In the first example, a student at a London art college showed her work in a final degree show as though authored by four fictional female artists.[5] Each of four installations was exhibited under a different name which wittily referred to current debates about subjectivity, identity and difference. So, 'Elizabeth Boddis' produced a 'text of the body' in the form of an embroidered book and hospital screen, while 'Anna Hitchcock' showed a discontinuous 'journey' on film projected in the interior of a padded booth. An automatic photo machine by 'Frances Francis' delivered a series of small passport photos, and 'Sarah Scribner's' peephole installation reflected an infinity of steel bars with the word 'Where?' inscribed on its mirrored interior. These works could be summed up as deconstructive installations in which a woman's body was signified but absent. The device of using four invented artists both parodied and deconstructed the notion of the artist as the single source of meaning in a work of art.

The second example came from a statement published in Belgrade on 8 March 1993 during the civil war in former Yugoslavia:

> We are a group of women who, in BLACK and in SILENCE, express our protest against the war.
>
> Women wear black in our countries to show grief for the death of their loved ones. We wear black for all victims of this war, known and unknown; for the destruction and devastation of the cities; for the expulsion of people from their homes and their villages; for the destruction of human relationships solely because of belonging to a different ethnic, religious or political identity.
>
> (Zajovic 1993: 22/50)[6]

By translating cultural symbols into political actions – here, the wearing of black as sign of mourning – and creating new meanings from them, the Women in Black challenge the traditionally passive role assigned to women in war. In this sense their action is both political and aesthetic; one which seeks to transform existing language and its effects. But it also depends on a sense of a shared political and cultural identity which can be physically embodied by women through performance.

It recalls the use of similar symbolism by the American artists, Suzanne Lacy and Leslie Labowitz, in the memorial performance, *In Mourning and In Rage*, held for nine women raped and murdered in Los Angeles in 1977, in which nine seven-foot-tall women, draped in black, stood on

the steps of the City Hall. Working collaboratively as *Ariadne: A Social Network*, Lacy and Labowitz aimed, like the Women In Black, to speak on behalf of women and to transform cultural myths of women's victimization. By taking place as a performance in the public domain their work challenged a traditional separation between aesthetics and politics. As Lucy Lippard suggested, they 'used "the expanding self" as "a metaphor for the process of moving the borders of one's identity outward to encompass other women and eventually all people"' (Lippard 1980: unpaginated). In connecting aesthetics and politics, the work also raises the difficult question of what kind of *pleasures* we might find in such art.

In the first example, we can see a theoretically sophisticated postmodern art practice which addresses the 'death of the author' and reconstitutes the female artistic subject in different terms. In the second, a political demonstration involves women acting collectively and using their own bodies as cultural symbols of resistance. However unconnected these two might seem, I want to suggest that they represent a contradictory potential within current art practices by and about women. They are, in a sense, different ends of a continuum of relationships between self, aesthetics and politics or, more specifically, between artistic identity, art practices and feminism. At one extreme is the recognition that the traditional gendered notion of the artist in western cultural theory has to be deconstructed, taken apart. At the other, the need to retain a sense of identity, a place from which to speak or act *as* women, individually or collectively, in order to contest and to transform culturally given meanings.

In his essay, 'The Death of the Author' (1968), Roland Barthes linked the question of authorship and artistic origin – a self who is expressed through the work of art – to the critique of the individual as the source of thought and action. As he put it:

> The author is a modern figure, a product of our society insofar as, emerging from the Middle Ages with English empiricism, French rationalism and the personal faith of the Reformation, it discovered the prestige of the individual, of, as it is more nobly put, the 'human person'.
>
> (Barthes 1977a: 142–3)

Against this Enlightenment subject, Barthes argued for an authorial position constituted through language which 'writes' the writer. Language itself is seen as constructing an imaginary coherence of the self which achieves its unity only in the act of being read; authorship gives way to writing in 'a theory and practice of textuality' (Miller 1986: 104). Language thus offers us positions through which we are able to 'speak' ourselves.

But, if language and the institutional discourses which frame it are predominantly masculine, these offer a sense of selfhood to men which is not the same as that offered to women. One issue which has been

explored in recent feminist theory has been that of defining a space from which women may speak and act as subjects.[7] A female artist cannot simply inhabit masculine artistic space because, as a woman, she is differently positioned within language. Within a poststructuralist feminist critique, the problem of artistic subjectivity has been redefined from one of the gendering of the author to the gendering of language itself. It is the mastery of language and codes of representation which must be disrupted in order to open up a space for the feminine. And, since language and meaning are themselves open to change, this self is not fixed, but continually in change and sometimes in conflict: the site of what Julia Kristeva has called the 'subject *in process*' (Kristeva 1987: 9). It is perhaps ironic that Barthes' essay first appeared in 1968 at precisely the point when social groups marginalized within western society had begun to claim the right to represent themselves. For to be female, black, lesbian or gay, is to be displaced from a position of imaginary coherence, to be marginalized within language and discourse and, there-fore, indeed to experience subjectivity or selfhood more often as a matter of conflict.

At the end of his essay from the following year entitled 'What is an Author?' (1969), Michel Foucault asked if it mattered who was speaking (Foucault 1977: 138). But, of course, it matters more for some than for others. As Andreas Huyssen comments: 'The male, after all can easily deny his own subjectivity for the benefit of a higher aesthetic goal, as long as he can take it for granted on an experiential level in everyday life' (Huyssen 1986: 46). The new version of the 'author' presents a more complex situation to those whose institutional position has always been on the margins. The politics of the subject has been particularly impor-tant in the 1980s for those artists who have sought to represent their own identities in opposition to a dominant culture which denies them subjec-tivity.[8] In pronouncing the author dead, poststructuralist critiques 'jettison the chance of challenging the existing structures of class, gender and race which define the particular '*ideology of the subject* (as white, male and middle class) and of developing alternative and different notions of subjec-tivity' (Huyssen 1990: 264). The representation of the artist within such art practices is necessarily quite distinct from an earlier concept of 'self expression' of an individual being, 'the voice of a single person, the *author* "confiding" in us' (Barthes 1977: 143).

Maud Sulter's photographic installation *Zabat*, 1989, explored the rela-tionships between black women, creativity and western cultural tradition. Whereas black women have only appeared at the margins of representa-tion and of history, Sulter asserts their magnificent centrality.[9] The implication is that different sources of knowledge and power are possible, if suppressed, within a Eurocentric vision. Representing nine life-size portraits of black women painters, photographers, musicians and writers

as the Muses, it was part of Sulter's attempt 'to discover "the poetics of a family tree", to investigate the possibility of her personal family album' (Morgan: 1990: 65). This implies a sense of self which is created through identification with a community of black women artists, a collective identity formed within a particular history.

The key question here is one of agency; of the *subject* in its dual sense of being either an empowered individual or subjected to external authority. It is here that work of postcolonial feminist artists provides a model for our understanding of how we may be produced through discourse, and yet able to reflect upon and contest those discursive constructions as individuals who are both constituted and yet capable of moving out of the margins of history and culture. In the space vacated by the figure of the author, a resisting subject is installed – 'one who will be capable of the agency and enabling selfhood of the "active" early subject, while at the same time acknowledging the politics of difference' (Sunder Rajan 1993: 11).

SPLITTING THE DIFFERENCE

In his Introduction to *Culture and Imperialism*, Edward Said offers two definitions of culture, the first of which includes: 'all those practices like the arts of description, communication, and representation, that have relative autonomy from the economic and social realms and that often exist in aesthetic forms' (Said 1993: xii). The second definition, he suggests, is that derived from Matthew Arnold's concept of culture as 'the best which has been thought or known in the world', an elevating and uniting principle within wider society (Arnold 1981: 70).[10] Turning this traditional definition on its head, Said argues that culture has all too often been linked to concepts of nation and state, to what differentiates 'us' from 'them':

> Culture in this sense is a source of identity, and a rather combative one at that, as we see in recent 'returns' to culture and tradition. These 'returns' accompany rigorous codes of intellectual and moral behaviour that are opposed to the permissiveness associated with such relatively liberal philosophies as multiculturalism and hybridity. In the formerly colonised world, these 'returns' have produced varieties of religious and nationalist fundamentalism.
>
> (Said 1993: xiii–xiv)

Culture then can provide a source of authority for imperial, patriarchal or fundamentalist identities as well as a means of combating them. Said recognizes this paradox of culture as both a place of ongoing re-definition of identities, and a 'protective enclosure' into which national, ethnic or gender identities are corralled. Cultural identity offers a means

of resistance to imperial and colonialist narratives and yet poses the problem of creating a new kind of cultural essentialism.[11]

For many women artists, the investigation of self-image has offered a necessary and important stage in the deconstruction of cultural and gendered identity. Lesley Sanderson's early works, such as *Self Portrait as a Chinky*, 1984, were initially based on self portraits which dealt directly with racial and sexual stereotypes while reclaiming the 'authorship' of her own image. In recent work she has moved out to encompass wider relationships between self and Other situated within a variety of cultural spaces from the tourist gaze to the site of the museum. As for other Asian and Afro-Caribbean artists of the same generation in Britain, Sutapa Biswas, Chila Burman and Keith Piper, this has meant a shift from direct confrontation with racism to a more complex investigation of how racial and gendered categories are produced.

Sanderson puts together three existing visual discourses – academic life drawing, Orientalist iconography and the traditional artist's self-portrait – to produce different meanings and pleasures. She stages her own image as a performance which reveals how the identity of 'Oriental woman' is constructed. Using her own face and figure, she transforms the ways in which cultural stereotyping produces 'Third World Woman' as passive object of the gaze. According to Craig Owens, 'the stereotype is truly an instrument of subjection; its function is to produce ideological subjects that can be smoothly inserted into existing institutions of government, economy, and perhaps most crucially, sexual identity' (Owens 1984: 132). By using dual or multiple images with different orders of the 'real' and 'imaginary', Sanderson implies that such subjectivity is always fragmented and, as well as being shaped within existing cultural codes, can also resist them.

In *Time for a Change*, 1988, Sanderson achieved this by splitting the representation between two images: a naked figure sits on the floor in front of a painting of an Oriental woman. The work plays precisely on an ambiguity of identity and difference between the two – subject and object, the 'artist' and the 'model'. The 'model' in the painting is clothed in eroticized Far-Eastern costume. Discreetly made up with a flower in her hair and seated on the ground, eyes modestly downcast, she resembles Tretchikoff's popular print, *Chinese Girl*, desirable and unchallenging, the stuff of western male erotic fantasy.[12] In contrast, the artist is shown unclothed, ambiguously gendered – she covers her breasts and her head is shaved – and confronts the viewer with an uncompromising stare. The exotic Other and its potential in the pornographic imagination is destabilized as the figure of the artist interposes herself between viewer and viewed. As Sanderson comments, the gaze of the person is always central to her work: 'Challenging rather than traditionally passive, it leaves no room for voyeurism and makes one aware of the figure in an unnerving,

167

Plate 39 Lesley Sanderson, *He Took Fabulous Trips*, 1990, pencil and
acrylic on paper, 195.6cm × 246.4cm.

uncomfortable way' (South Bank Centre 1990: 100). As viewers, our own
gaze oscillates between the figures of the two women, unable finally to
resolve their likeness or difference, an ambiguity that unsettles any attempt
to make a fixed reading of the work.

Gayatri C. Spivak describes the position of two figures within post-
colonialism, one the 'disenfranchised female in decolonised space' whom
she names the 'gendered subaltern', and the other the subject of 'an as-
yet-unreadable alternative history . . . a "diasporic postcolonial"' (Spivak
1989: 1121). While the first has no voice, either within postcolonial
discourse or within feminism, the danger is that the second will be
co-opted into counter-narratives which legitimize reactionary aspects of
traditional cultures.[13] The question for the postcolonial artist is how to
speak in a language which belongs to the colonizers and yet represent
the viewpoint of the colonized. Against these two possibilities, Spivak
proposes a third strategy which 'speaks from within the emancipatory
master narratives even while taking a distance from them' (Spivak 1989:
1123). This aptly describes Sanderson's practice, which intervenes in the
space between the 'gendered subaltern' (the Asian woman) and master

narrative (the western tradition of art making) using the particularity of her own experience as a means of interrogating both. As a Malaysian-born artist, educated and living within Britain, Sanderson uses her art to explore cultural hybridity – what it means to be raised within one culture, and to represent oneself through the visual traditions of another.

The use, and implicit critique, of academic life drawing is central to Sanderson's work and in this context, realism of style becomes ironic. Life drawing, traditionally associated with recording truth to appearance, is undercut by frequent transition between different orders of representation within a single frame. Part of its sheer pleasure is her drawing skills which make frequent transitions between densely worked areas and delicately deft outlines. The drawing itself also functions semiotically to signify both political and personal meanings. In *He Took Fabulous Trips*, 1990, patterns of unequal global exchange are woven into the image of her mother and father's naked and sandalled feet (Plate 39). 'Exotic' textiles produced by cheap female labour in countries such as Malaysia and Thailand appear initially as pure decoration. On closer inspection, small squares of brightly painted 'fabric' scattered across the drawn surface reveal themselves to be patterned with a repeated motif of an ex-colonial type in a pith helmet and dark glasses. Sanderson uses the physical immediacy of such precisely detailed objects, the pattern in a textile, a palm leaf fan, a Chinese bowl, to trace the relations between self and Other, interconnected fragments of western and eastern identity. In this 'portrait', the 'Western focus on the face of the sitter is replaced by drawings of her parents' feet – colonising masculinity and colonised femininity' (Beckett 1994: 12–14). But if these feet signal differences in power, they also suggest a certain complementary intimacy. Two distinct drawing styles are used on both figures – one delicate and linear, the other strongly modelled in chiaroscuro – which simultaneously reveal and subvert divisions of gender and culture.

The installation *These Colours Run*, 1994, represents the culmination of a number of these themes in Sanderson's work: the use of intimate pencil drawings on a monumental scale, a play with different conventions of visual representation, and a critique of Eurocentric vision displayed metaphorically by the museum.[14] The scale of the piece is larger than anything Sanderson has attempted before. Three panels occupy one wall with large detailed drawings of the artist's hand and skin (Plates 40 and 41). As in her other work, a suspended moment – something about to happen – is suggested by a precise yet unreadable gesture of the cupped hand. It recalls the aesthetic principle within Eastern art in which change and becoming are implicit in a preceding moment of stillness. On either side, parts of the same hand are magnified to a scale where they become a web of abstract lines delineating an unknown body landscape that is both physically intimate and yet distanced from the viewer. The close

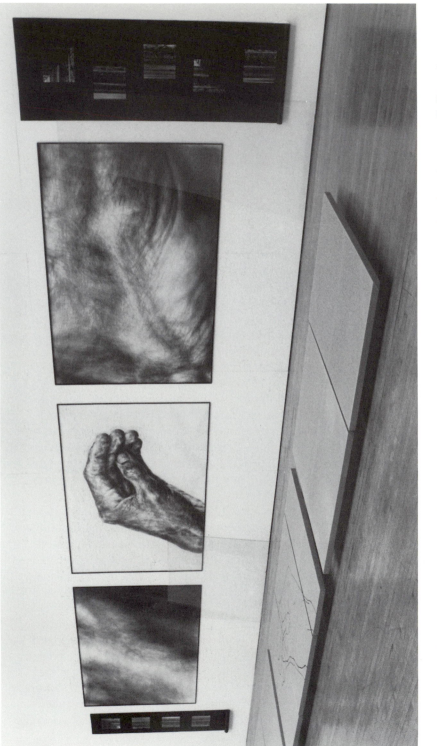

Plate 40 Lesley Sanderson, *These Colours Run*, 1994, pencil on paper, colour photographs, silk, glass, overall dimensions 230cm × 840cm × 245cm.

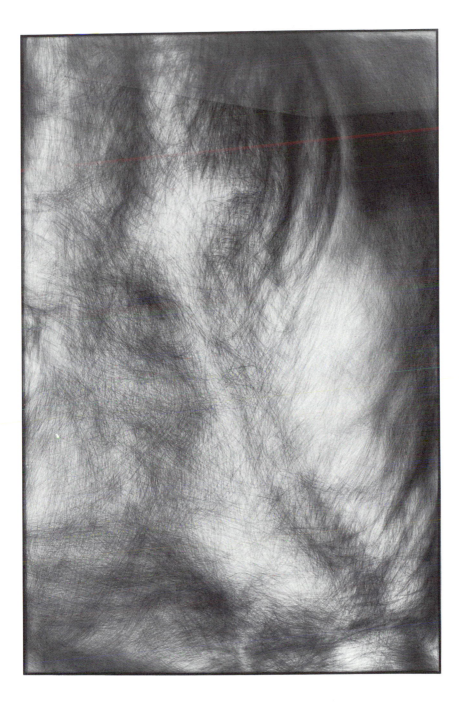

Plate 41 Lesley Sanderson, *These Colours Run*, 1994, detail, pencil on paper, glass.

scrutiny of the skin's surface and the light that reveals its texture refuses any simple reading of racial or gendered characteristics. On the floor below, three panels are placed horizontally and stretched in brilliant yellow silk. On the central silk panel the artist's hand appears again, but in outline, like a cartoon drawing, as though in a distorted reversal of its original gesture. Here, yellow signifies both the royal colour of Malaysia and the colour of racist abuse – 'the Yellow Peril' of imperialist nightmares.

Initially, the structure of *These Colours Run* recalls a Renaissance triptych in its clear tripartite geometry, but subtle irregularities in the proportions of the yellow silk panels suggest a different sensibility at work. On each side, vertical black scrolls bear colour photographs of lavishly gilded 'Old Master' frames which, broken into segments, refuse to reveal any single perspective view. Two sheets of glass are propped, apparently at random, partly covering the drawings and one of the scrolls, to open up a new sense of spatial relations outside the picture frame. Sanderson has dispensed with the 'window on the world' familiar to post-Renaissance eyes and replaced it with an unfurling series of spaces which break through the confining logic and fixity of the western gaze. As in Chinese scroll paintings we are forced to abandon the unified viewpoint of a western observer in favour of a differently located experience of space and time. It is precisely this capacity to draw upon western and eastern visual traditions, and yet to question them, that constitutes the subversive power of Sanderson's work.

Opposing fixed concepts of cultural identity and tradition, such works are deliberately 'hybrid in their genealogy and address' (Sunder Rajan 1993: 1). That this is more than a postmodernist game is evident in another, much smaller work which draws on a previous site-specific installation. In *A Different Direction*, 1993, two panels show the artist's bare feet, exquisitely drawn yet firmly planted, facing away from a neo-classical female bust on the ground beside them. The bust, by the nineteenth-century English artist, George Frederick Watts, represents the sunflower nymph, Clytie, whose gaze turns from East to West as the sun passes. Within the new space offered by Sanderson's work, it can also be read as the colonized female body, twisted and distorted by the colonizer's gaze. Turning her back, the artist's naked feet signal a new direction; a shift in perspective that indicates a postcolonial art in the making.

RETRACING THE PAST

We all return to memories and dreams like this, again and again; the story we tell of our own life is reshaped around them. But the point doesn't lie there, back in the past, back in the lost time when they happened; the only point lies in interpretation.

(Steedman 1986: 5)

The stories we tell ourselves about who we are – the half-remembered events and places which shape our lives – are the foundations on which we build up a sense of self. Re-working what has already happened, we also give it current meaning, for history always represents the present as much as the past. The autobiograpical has become an important means through which women have explored the social and psychic production of feminine identity; how particular patterns of gender and family, of class, race and history are mapped out within individual narratives. In the 1970s and 1980s feminist practices of writing, film-making and art emerged that used the investigation of the past in order to uncover clues to the present.[15] They have explored how subjectivity is formed within circumstances that are neither self-determined nor yet wholly determining. In the conventional form of autobiography, a line is tracked from childhood to the achievement of an adult identity that is conceived as an endpoint, as the resolution of choices made and obstacles overcome, however convoluted the journey. Feminist writing of the self, on the contrary, resembles unfinished business, often taking the form of a series of movements between present and past, self and Other, towards the production of an identity that is still 'in process'.

This kind of 'writing' of the self undermines the dominant narrative of history as uninterrupted linear progress and corresponds more closely to an historical model that 'proceeds by knight's moves, through the oblique and unexpected rather than the linear and predictable' (Mulvey and Wollen 1982: 27). Elizabeth Grosz has argued that this kind of 'counter history' is characteristic of subordinated social groups: 'This repressed but subversive tradition provides a history that is uneven, scattered, a series of interruptions, irruptions, outbreaks and containments – an intellectual history of skirmishes in an undeclared conceptual war' (Grosz 1990: 78). Citing Jewish history, she draws an analogy with the position of women as a marginalized group and suggests that the formation of the Jewish and female subject in history is the product both of oppression and of resistance to that oppression: 'The otherness of the Jew, like women's cultural otherness, is not self chosen – it is always an effect of power relations' (Grosz 1990: 81). What characterizes the formation of such 'cultural outsiders' is the need to give meaning to their position in history and to the history of that position. This also describes the kind of artistic practice that recognizes the instability of identities that are rooted solely in nation, territory, gender or race and yet, at the same time, the need to define the self within networks of memory, place, family and culture. The desire for a 'historical ontology of ourselves' (Foucault 1984: 46) crosses the borderlines between autobiography and history and seeks to constitute women as concrete historical subjects – the subjects of their own lives.[16]

Pam Skelton's current work interrogates the self as a subject in history and the interactions between Jewish genealogy and memory. The sense

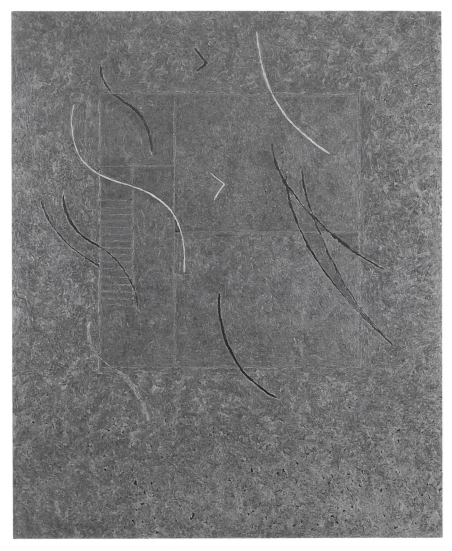

Plate 42 Pam Skelton, *Fear of the Father*, 1989, acrylic on canvas, 244cm × 193cm.

of a dialogue with the past is a powerful theme running through her paintings of the last decade and in her more recent installation pieces. The special power of places to call up the past is central to her work. The shape of a room, the opening of a door and the lost passages in between, as well as the more dangerous locations of collective memory, map out a journey in time through significant spaces and events.

174

That's the place where you first met someone and that's the place where you fell out of love, and that's the place where your money got stolen and that's the place where you ran for a taxi and it wasn't raining, and there's a building you slept inside, once perhaps, or many times, and isn't this a street you used to live on, and weren't you always the person staring out of the car window, watching the world like the movies, and weren't you always the one who'd travelled a long way through the day and through the night.

(Forced Entertainment, *Nights in this City*, 1995, unpublished)

In her paintings of the mid-1980s, Skelton depicted the archaeology of an imagined past, present and future. Since then, she has moved away from her previous use of myth and symbol towards a visual language of signs which is at once more direct and coded. In a series of large-scale works produced in 1989 she began to uncover layers of personal memory which, like archaeological remains, lie embedded in individual psychic history. Acting as the keys to memory, Skelton drew on the signs and physical traces of houses and flats she had once lived in to explore her own past, an archaeology of the self, in which 'the groundplans of remembered dwellings form the framework which represents events and moments associated with that particular time and space ... relationships to place, intimate recollections and memories' (Skelton 1989, unpaginated). Such memories are at once precise and yet selective; they recall sensations of smell, touch and sound which trigger recollection, but re-order them within patterns of meaning which belong to the present.

In a three-part work entitled *Fear of the Father*, 1989, Skelton explored the complex tensions of family life and its unspoken emotional legacy (Plate 42). The groundplan of her family home as a teenager in Leeds provides the framing image for all three panels. It functions both as a denotative sign for the semi-detached house in which she lived and as a concrete trace of memory. Skelton uses a visual language that is both iconic and indexical, encoding a personal system of signs that refer not only to events but to the painful and passionate associations they hold. Shorthand notations, scored as repeated marks on the paint surface, spell out the title of each piece. In a literal sense, these signs can be read, but they are also only fully legible in the context of the artist's own life – the reference is to the explosion of anger and fear triggered off by her father's discovery of a secret diary written in shorthand. The paintings employ a dual vocabulary of drawn sign and colour, a combination of control and sensuousness in which the colours and texture of the paint sometimes works across what the denoted signs tell us. Often intense and saturated, the colour of the painted surface functions crucially in Skelton's paintings as a invocation of remembered emotion. All three panels are painted

in a violent magenta, but in the central panel, *Ambivalence towards the Mother*, the area of the kitchen is a lighter hue and the groundplan appears to float within a blue space creating a shimmering field around itself.

This use of sign and colour in painting has parallels with Julia Kristeva's account of the operation of the symbolic and the semiotic in women's writing. Kristeva suggests that the semiotic is charged with emotion that overwhelms the signifier, 'an emotional force which does not signify as such but which remains latent in the phonic invocation or in the gesture of writing' (Kristeva 1987: 113). While all meaning is founded on a relation between the semiotic (pre-linguistic) and the symbolic (language), the unstable, polymorphous field of the semiotic disturbs signifying logic. Like memory, the semiotic cannot be contained within a given order and disrupts continuous narrative, for 'memory is a fragmented, scrappy, mixed-up state, overlaid by subsequent emotions – and by the emotion of recalling emotion' (Rusbridger 1994).[17] The maternal home, from which the mother's body is absent, is the source of such mixed-up emotions involved in remembering. And, as Laura Mulvey reminds us, the lost memory of the mother's body is similar to other metaphors of a buried past or a lost history, not only for an individual, but in the rhetoric of an oppressed race or sex:

> It cannot be easy to move from oppression and its mythologies to resistance in history: a detour through a no-man's land or threshold area of counter-myth and symbolisation is necessary ... the metaphors and emblems which belong to desire rather than to reason.
>
> (Mulvey 1989: 167)

Although the patterns which Skelton uncovers are uniquely hers, they also resemble our own; houses which we might once have lived in, emotions which could have been ours. The home provides comfort and consolation but also constriction. For women this may be experienced literally within the space of the house and metaphorically within the confines of femininity. The ambivalent feeling of containment and, conversely, of breaking through boundaries is a recurring theme of the series. Implying both confinement and potential freedom, the groundplan becomes a metaphor for the artist's own positioning and for the contradictory feelings we might have about a past which still entraps us.

This conflict between restriction and resistance, inertia and agency, is explored in recent work by Skelton which throws up complex questions about feminine passivity and its relationship to what Grosz has called a 'collective narrative based on a paradoxical passivity *and* strength' (Grosz 1990: 80). Skelton's work has begun to investigate a different politics of location linked to the Jewish diaspora. In *As Private as the Law*, 1991, and *The X Mark of Dora Newman*, 1991–4, she goes beyond

the marking-out of feminine space within the boundaries of rooms and houses and enters into the interior of the body itself (Plates 43 and 44). In forty-eight small square painted panels that depict twenty-four images of paired chromosomes, Skelton represents the fundamental markers of our genetic identity. Depending on how the panels are arranged, the pattern of paired chromosomes can be read as calligraphic marks in an unknown script or else pairs of footprints, traces of black on yellow and yellow on black as though someone had walked barefoot through paint. At close quarters, the shapes are less regular and appear more obscure yet curiously energetic, like the mobile bodies of dancers. This dual sense of the purposeful marking and the accidental trace of the living body is evoked in the title *As Private as the Law*, which can be understood both in terms of the natural 'laws' of biology and of the Jewish Torah, the Word or Scripture.

Chromosomes offer the genetic blueprint of individual identity, the unique and inescapable pattern of ourselves which determine sex, body shape, hair colour, and future health or disease. Current preoccupations with genetic fingerprinting, the discovery that some diseases can be genetically identified and, more controversially, the claim that certain social and sexual subjects are genetically determined – the so-called 'homosexual' gene – recall eugenic debates that prevailed in prewar Europe. Eugenic arguments about the purity of the race dominated social theory and practice in the period from the 1880s to the Second World War, the period of Jewish persecution and migration in Europe.[18]

But if the laws of genetics frame our physical bodies, law is also a social construct which regulates human relationships and differences. Skelton's installation reminds us that identities are formed through histories of place and displacement, racial and economic persecution, cultural tradition and community. It moves simultaneously from within the body out into the geographical spaces of exile and deportation traced through the history of her Jewish great-grandparents who, having left the Ukraine in the 1870s at the beginning of a wave of Jewish emigration from Russia, arrived in Hull, the main British port of entry for migrants from northern Europe. Behind each pair of painted black on yellow chromosomes, shadowy photographic transfers of the last remnant of the old Jewish district of Myton in Hull appear, together with images of Drancy, the transit camp outside Paris which was used for Jewish deportations to German concentration camps. These spatial and temporal dichotomies are central to Skelton's exploration of identities which fragment, coincide and return through memory. Just as her early work dealt with a palimpsest of the archaeological and the modern, so this work deals with the pre-histories of identity, a dual inheritance which is marked out within the biological body through genetic sequence, and in the social body through a history of exile. In a real sense, the work shows identity to be both given *and*

Plate 43 Pam Skelton, *As Private as the Law*, 1991 (detail), oil on canvas, photograph.

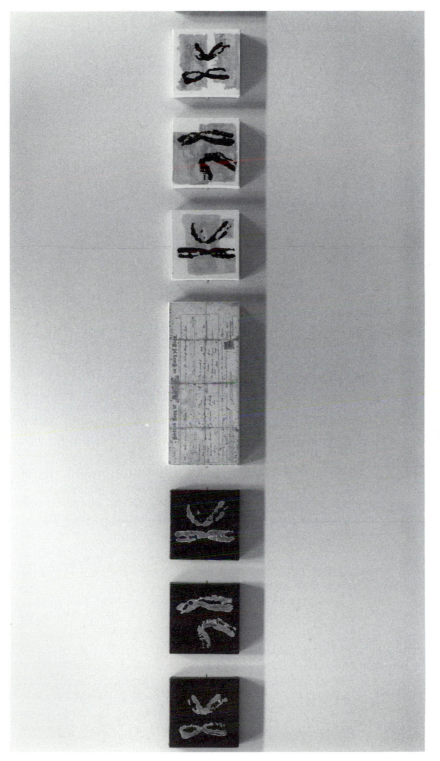

Plate 44 Pam Skelton, *The X Mark of Dora Newman*, 1991–4 (detail), acrylic on canvas, photograph.

shaped by history in 'practices that allow both for the construction of identity (subjectivity and history) to be "seen" and simultaneously offer a re-working, a reconstruction of the places (spaces) we have inherited and occupied' (Borsa 1990: 33).

The central image of *The X Mark of Dora Newman* is the mark that Dora Newman used instead of a signature on her daughter's birth certificate in 1886. Without any direct memory or image of her great-grandmother, who died long before she was born, Skelton uses a device which is both uniquely personal – the individual trace of her hand, and abstract – X also stands for the female chromosome – to invoke the presence and absence of her name in history. In this female lineage, the granddaughter reproduces the mark of her great-grandmother's hand as a sign of visibility where no image survives. The work explores the relations between memory and history, reflecting on the anonymity of fragmented lives and seeking to give some configuration to the past through explorations in the present. Remembering becomes a form of power which not only recalls events but gives to them shape and meaning. There are clear parallels here with the process of naming the victims and speaking out as the survivors of the collective obliteration of the Holocaust. Such self-representation is crucial to any oppressed or marginal group as a necessary transformation from passivity to resistance in the process of becoming subjects in history.[19]

In *Dangerous Places*, 1994, Pam Skelton has shifted her exploration from personal and family memories to sites of collective memory – and of collective amnesia. In a journey undertaken in the summer of 1993, she visited Poland, Lithuania and the Ukraine, and what had begun in 1990 as a personal quest to retrace the route of her great-grandparents' exile became a broader investigation of the sites of Jewish habitation and destruction in eastern Europe. From Warsaw to Chernobyl (Black Wormwood) to Vilnius, she went in search of the 'dangerous places' that were marked as much by forgetting as by memories. Walking through the quiet streets of a suburb of Warsaw, 'the ghetto is not so far away, for, although we cannot see it, the physical and visible line which separates the past from the present is here only as thick as concrete' (Skelton 1994: 2).

Ponar, 1994, a seven-channel video installation, documents a chance meeting with a survivor of the Holocaust in a forest outside Vilnius in Lithuania. On an over-lifesize video screen, we watch Itzak Dogan as he describes in unemotional words a story of horror and survival when he together with eighty other Jewish people, were kept in a circular pit in the ground after the liquidation of the Vilnius ghetto in September 1943. As he speaks, standing in an idyllic forest clearing, birds sing and a butterfly lands on his sleeve: 'The day before my arrival here the Germans killed all my family. The place was covered with snow. I walked a few metres

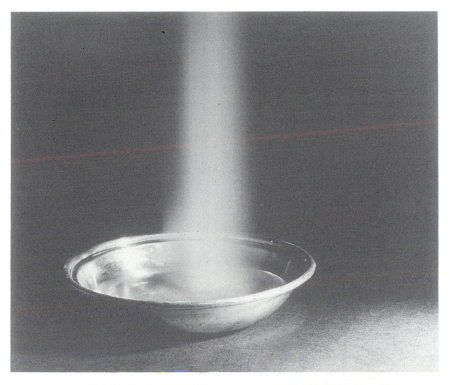

Plate 45 Lily Markiewicz, *Places to Remember II*, 1994 (detail).

on this side and I felt that the earth was trembling. After some time I stood by the grave of my family, this is the place.'[20] As his words are translated into English on the screen, we experience a similar sense of dislocation between present and past experience, between the here–now and the there–then which cannot be bridged through a video screen. On other video monitors set in wooden pillars like forest trees, flickering images of a fire burning, a German shepherd dog, derelict buildings, soldiers and unknown machines, offer more immediate yet transitory signs of the past. The installation asks how we can imagine what took place in a site such as Ponar and what our relationship can be to it today. The work of memory is to be the active witness to a lost or repressed past, for as Walter Benjamin has commented, 'To articulate the past historically does not mean to recognise it "the way it really was". It means to seize hold of a memory as it flashes up in a moment of danger' (Gilroy 1993: 187).

181

DIVIDED PASSIONS

By resisting the ever-present temptation to construct identity in terms of exclusion, and recognising that identities comprise a multiplicity of elements, and that they are dependent and interdependent, we can 'convert the antagonism of identity into the agonism of difference', as William Connolly puts it, and thus stop the potential for violence that exists in every construction of an 'us' and 'them'. Only if people's allegiances are multiplied and their loyalties pluralized will it be possible to create a truly 'agonistic pluralism'. Because where identities are multiplied, passions are divided.

(Mouffe 1994: 111)

In *Places to Remember II*, 1994, Lily Markiewicz also questions how memory functions in relation to sites of collective memory, and in the construction of identity, including the physical body. A white-walled room is empty but for two photographs on opposite walls, one in the form of a triptych showing a woman's hands with grains of sand trickling from her fingers into the palm of her other hand. The structure alludes to the relation between Christian culture and Jewish tradition, a single photograph repeated twice on either side of the main image suggests that this is both a triptych and a diptych. On the other wall there is a photograph of a shining bowl into which fall grains of sand against the light, while on a soundtrack the artist's voice quietly meditates on place, time, presence and inheritance (Plate 45). She asks what relation places and memories have to her own identity formed across subject positions which are now dispersed and unfixed. As a daughter, as a German and as a Jew living in London how can she, she asks, be expected to know: 'For there are places that remember, it is their job not mine. But when I am ready for forgetting, will I be?' (Markiewicz 1992). In deceptively simple and evocative images her installation invites the audience to meditate with her on the ways in which identities are constructed through memory, language, and culture and by (dis)placement as much as by territory or nationality.[21]

For Markiewicz 'home' is non-existent, a place only in memory, not a physical reality: 'But tell me, how does one pronounce a hyphen, or listen to the promise of a land? Home–land, this country penned in in words' (Markiewicz 1992, unpaginated). Markiewicz reminds us that for many people 'identity' could never be taken for granted historically. The break-up of the Enlightenment subject is being imagined and lived in other ways at the end of the twentieth century. On the one hand, new information technologies appear to offer the potential for an endless play with image and identity through the computer screen. In the domain of cyberspace, of virtual reality and 'virtual communities', fixity of individual identity dissolves into fragments of digital representation which short-cut

time *and* space. On the other hand, we are witnessing the vicious fragmentation of peoples into smaller and smaller ethnic, regional and religious groupings – Serb, Croat or Bosnian, Hutu or Tutsi, Russian or Chechen – in renewed fundamentalisms of national and racial identity. Such dual possibilities are not mutually exclusive, nor indeed are they disconnected. As Gayatri Spivak has pointed out, the postmodern form of neocolonialism symbolized by the microchip is predicated on new patterns of domination and subordination in which poor countries provide cheap, usually female, casual labour in high-tech work for multinational companies.[22]

Both kinds of fragmentation represent a reconfiguration of identities which poses a challenge to traditional liberal philosophies of the individual. Chantal Mouffe argues that in place of such essentialist concepts, we should consider identity as a continuing process of 'permanent hybrid-isation and nomadisation' (Mouffe 1994: 110). If we are to escape the antagonisms of cultural identity founded on territory and nation, then ideas of place and (dis)locatedness characteristic of the hybrid, the nomad and the exile may be more useful. For Elizabeth Grosz this is a position which is both 'perilous and enabling . . . all social marginals, all exiles are splayed between these two poles or extremes – one a tendency towards death, the other a positive movement towards self-production, critical resistance and transformative struggle' (Grosz 1990: 77). Perhaps what is hardest to bear and most difficult to articulate is the exile's sense of guilt at having survived. In this respect Leslie Hakim-Dowek's work, which deals with her own exile from Beirut, is an important testimony both to the lost dead and to the beginning of a process of grieving and resistance for those who have to bear their memories.

The abuse of nature and of women's bodies and the destruction brought about by war are among the most powerful themes in contemporary culture. In her series of paintings, *Poèmes Visuels* and *Semences*, 1991–2 Hakim-Dowek mobilizes these motifs in images whose deceptive delicacy and small scale belies their serious intent (Plate 46). While celebrating the beauty and fertility of nature, the paintings make links between a history of control of women's bodies and the abuse of the natural environment. Formally, the two are connected through the imagery of shells, flowers or ears of corn, sometimes literally embedded in the canvas. Words and phrases in French scored into the densely textured yet fragile layers of paint and wax allude to the pollution and degradation of the environment, while the organic textures of the painted surface suggest a living skin. The method of multiple layering of paint over wax creates a spatial ambiguity which has a quality of the unresolved, a refusal to ascribe any fixed and finite meaning to the body. As in her earlier series, *Lost Flora*, 1989, the fragility of nature evoked in these paintings also refers to the artist's own experiences of the war in Lebanon.

Plate 46 Leslie Hakim-Dowek, *Poème Visuel II: Calices*, 1991–2 (detail), oil, wax and petals on canvas, 94cm × 72.5cm.

The return to Beirut in 1993 after a long absence prompted Hakim-Dowek to find ways of dealing directly with the memories which in earlier paintings she had only been able to address through symbols. This new work recorded a series of literal and metaphorical displacements of time and location. In the form of a photo-text installation, *Journey*, registers the distances travelled between present experience and memory, between the country which is now her home, Britain, and her land of birth, Lebanon. The change from the personally expressive medium of painting to the use of photography with its connotations of documentary record gave Hakim-Dowek the 'certain distance' she needed to explore such charged memories. The shift from her mother tongue, French, in the paintings to the use of English, the language of her exile, suggests another kind of dislocation taking place. Exile here stands as an emblem of the estranged self, divided by distance and by language. Like Itzak Dogan, who returns to a place which exists only through memory, constructing a passage between the here–now and the there–then can only take place in *translation*.

Ten colour photographs made during Hakim-Dowek's visit are juxtaposed with nine written texts which interweave the record of her return with memories of childhood. The photographs and texts together describe a topography of yearning and loss, made visible in the empty shells of buildings gaping with holes, trees growing up through cracked tarmac streets in a broken cityscape (Plate 47). But these images of destruction are different from those made familiar in countless news photos from Beirut to Sarajevo. They describe a landscape of loss reconstituted in memory, the necessity for the artist to remember the tangible details of her homeland as talismans of her own identity. This was a journey in the present which is also one towards a rediscovery and reclaiming of the past. Both the memory of the child she was and images of contemporary life in Beirut fuse together in an evocation of both what has been lost and is still desired. Hakim-Dowek writes of how memories of Lebanon had been locked within her; the fear of forgetting was the fear of losing her own self. But, the paradox is that memory reconstitutes a past that no longer exists. The text refuses nostalgia and speaks instead of alienation:

> It is strange that, after so many years, nothing feels familiar. I could be walking down the street or driving and when I look up, I could be overcome by a feeling of total estrangement. I sometimes have the impression I arrived here a few days ago to visit a foreign land.

> (Hakim-Dowek, *Journey*, Text II, 1994)

A topography of desire is created in which the juxtaposition of past and present refuses to connect in an imaginary coherence of the self.

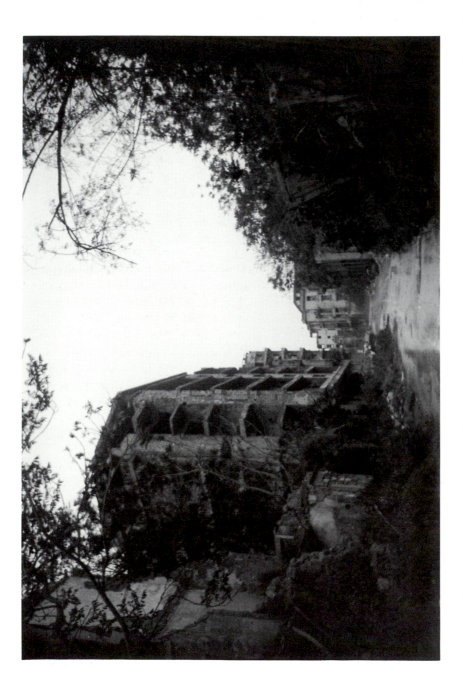

Plate 47 Leslie Hakim-Dowek, *Journey*, 1994 (detail), photo-text series, ten photographs 60cm × 50cm, nine texts 50cm × 40cm.

Six of the photographs document domestic interiors in the type of family building characteristic of the old quarter of Beirut (Plate 48). These rooms are empty of people but filled with traces of human presence and the mundane details of daily life; crumpled tissues on a mirrored dresser, a chequered tablecloth, the statue of the Virgin in an illuminated lamp, a woman's photograph. The tight framing of these interiors, enclosed and enveloped with curtains that veil the windows from the outside world, suggests a child's sense of protected space that offers a fragile defence of familiarity against unknown horrors, real and imagined.[23] But we are unable to accept these as zones of safety. They cannot function as places of intimacy or security because we are forced to read them against the texts which speak of destruction and the terrors of childhood. There can be no return to a pre-Oedipal haven of imagined safety. At one point, the narrative of return breaks down into a torn curtain of nightmare:

> There were no witches or fairies here. Like a vast forest ablaze, B. burned and burned. Buildings crumbled and voices turned to felt. The glass shattered, hair became limp with rage and bones were crushed. In fires and explosions, leaden bodies were clutched together. In children's ribcages lay dead butterflies full of misery.
>
> (Hakim-Dowek, *Journey*, Text VI, 1994)

Hakim-Dowek identifies the loss of her childhood with the death of a family servant who looked after her as a child, and it is this 'mother' whose absent presence haunts the empty rooms in the photographs. But, the line of red and green saucepans on a kitchen wall, a vivid patterned rug or a single pink flower in a vase, can also be read as testimony of women's resistance, the necessity of continuing to hold on to the texture and detail of everyday life within a terrifying and fractured reality.[24]

While Hakim-Dowek's paintings carry a symbolic resonance which calls upon cultural ideas of female nature, fertility and destruction, her photo-text series is more precisely located in time and place. Its power derives from this particularity and because it also speaks from a position of displacement which has become a common experience as whole peoples are driven into exile across the world. Their account of that experience and its effects lies silenced as the news media moves on to yet another assignment, leaving no representation of an enduring condition of loss.

The particular sense of loss which permeates Hakim-Dowek's photo-text series is also the subject of a video work by Mona Hatoum in which distance, memory and identity are explicitly connected to the maternal body. In *Measures of Distance*, 1988, estrangement from the maternal body and the mother-land are mapped across lines of desire encoded visually in Arabic script from the letters written by the mother to the daughter

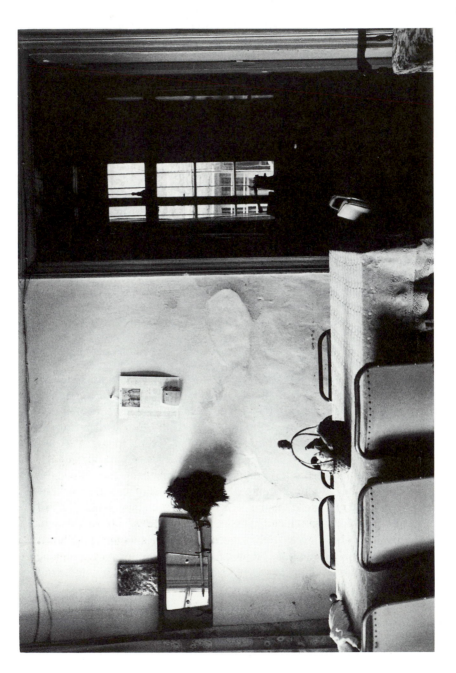

Plate 48 Leslie Hakim-Dowek, *Journey*, 1994 (detail), photo-text series, ten photographs 60cm × 50cm, nine texts 50cm × 40cm.

Plate 49 Mona Hatoum, *Measures of Distance*, 1988 (detail), colour video, fifteen minutes.

in exile (Plates 49 and 50). Hatoum sets up a series of connections between the female body, subjective identity and the ethnocentric gaze but, whereas in early work she used her body in performance as a metaphor for structures of racial and sexual oppression, here the artist's own body is absent from the representation.[25] Originally presented in 1986 in a performance version, *Mind The Gap*, the work is based on photographs and tapes made in 1981 of her mother in their family home in Beirut. In the video, the images of her mother washing herself in a shower are overlaid on the screen by Arabic script, while on the soundtrack extracts from the letters written by mother to daughter and translated into English are heard over conversations in Arabic. These multi-layered images, texts and fragments of 'mother tongue', as well as the sadness of the speaking voice, suggest a broken yet continuing dialogue between mother and daughter over distance and time. The daughter's recognition of her mother's sexuality and her exile from her mother's body/land are evoked with great formal beauty and precision. A sense of intimacy and distance is signified in the content of the letters and by their inscription like a veil between the viewer and the images of the mother's body which flicker on the screen. The lines of script form a permeable barrier, like barbed wire, between the subject and her audience, a distancing device made all the more

189

Plate 50 Mona Hatoum, *Measures of Distance*, 1988 (detail),
colour video.

powerful for non-Arabic speakers who literally cannot read the script.
But the written word also becomes the 'life-line', an umbilical cord that
connects daughter to mother. As the video ends, the screen fades to black
while the daughter's voice continues to read letters describing the bombing
of the main post office in Beirut, cutting off all communication. The
medium of video allows for a layering of sound, image and word to make
up a complex narrative which interweaves private and public, individual
and collective experience.

Edward Said has described his own exile from Palestine as a 'kind of
doubleness' in which:

> instead of looking at an experience as a single unitary thing, it's
> always got at least two aspects: the aspect of the person who is
> looking at it and has always seen it, looking at it now and seeing
> it now, and then as you are looking at it now you can remember
> what it would have been like to look at something similar in that
> other place from which you came.
>
> (Said 1988: 48)

The fluidity of viewing position which Said describes as the condition
of exile acknowledges the necessity for negotiation between culturally

different viewpoints. The power of *Measures of Distance* is that it poses this question of the relation between the viewer's position (us) and others (them) directly. For how are we, as spectators, implicated in such texts?

THE POETICS OF THE 'OTHER WOMAN'

And, like the marks on this paper now fixed and tied to this space – external to the whiteness of this sheet, the essence of its space – would I too be identified by my outline, or my character, or your reading?

<div align="right">(Markiewicz 1992, unpaginated)</div>

In the series of installations Mona Hatoum has made since the late 1980s, the body of the performer (artist or other) is no longer present. As Desa Philippi suggests, these works 'measure the absent human body ... the installations figure this absence' (Philippi 1993: 10). As we have seen, Barthes' critique of the author raised the problem of how precisely an authorial subject is figured in the text: 'Writing is that neutral composite, oblique space where our subject slips away, the negative where all identity is lost, starting with *the very identity of the body writing*' (Barthes 1977a: 142, my emphasis). Women might be expected to have a vested interest in the disappearance of this 'writing body' since, following the classic Cartesian mind–body split of the rational Enlightenment subject ('I think, therefore I am'), masculinity has been identified with mind, rationality and culture, whereas femininity is aligned with the body, emotion and nature. Yet Barthes' solution to the problem of the body in the text seems equally unsatisfactory, positing an aesthetics of the self which is *disembodied* and without specific identity or location.

Against this disembodied, neutral space of the text, the artists whose work I have discussed here offer a more complex and nuanced set of relations between embodiment and subjectivity. Each appears to have moved along a trajectory from use of the first person – narrative or speech, performance or self-portrait – towards exploring the construction of the subject within a wider frame. The move from representation of the body directly in painting, video and performance to installations produced for specific sites or contexts implies a shift towards a different set of temporal and spatial relations between artist and her audience. But this opposition is itself too simple: in both Mona Hatoum's and Pam Skelton's earlier work, for example, location, distance and time are always present, defining the self in terms of loss or lack expressed as memory. Equally, in Hakim-Dowek's phototext series, the first person narrative is split between present experience and memory of the past and we can only read her absence within the photographic spaces she opens up. In Lily Markiewicz's

<div align="center">191</div>

installation and in Mona Hatoum's video, the artist's voice is used to set up a direct relation which embraces the listener/spectator within her experiences, while resisting any literal depiction. Location and time therefore become ever-present as a means to narrate the self, even if the narrator herself, is almost by definition, absent. Although the artist's presence is only referenced indirectly by association or allusion, all these works insist on the need to situate the practices of making art in relation to a practice of viewing which is also positioned socially and symbolically.

For Barthes the reader, like the author, is disembodied – albeit linguistically gendered as male: 'without history, biography, psychology; he is simply that *someone* who holds together in a single field all the traces by which the written field is constituted' (Barthes 1977: 148). In this definition the reader has neither social location nor agency, 'he' is merely the passive destination of the text. A similar problem exists with the traditional terms, 'viewer' and 'spectator', used to describe a relation to the visual field. Both terms imply a passive relationship, a disembodied I (eye), that disguises any active role for the viewer in making the meaning of the work. Nor does it describe accurately the kind of involvement demanded of participants in the kind of work that I have described. In the installations by Sanderson, Skelton, Markiewicz, Hakim-Dowek and Hatoum, the performer's body is replaced by the body of the viewer.[26] As *we* move, we are necessarily embodied as spectators, we become part of the space of the installation, activating and occupying it with our presence. Rather than inscribing a reader in the text this offers a series of viewing positions in which the viewer may move to locate (or dislocate) herself. At the same time 'I' am forced to negotiate between the positions offered to me by the installations and my own situated self. The work interrogates my position as 'mere' spectator – it positions me. For how do I who am neither Asian, Jew, nor Arab, stand in relation to this work?

In discussing Mona Hatoum's installations, Desa Philippi suggests that, 'frequently the viewer is addressed in ways that demand a position: as a witness, as a woman, as a participant in a performance; even as an observer one cannot remain neutral' (Philippi 1990: 71). Philippi's suggestion that the work calls upon us to witness and participate parallels Paul Gilroy's proposal that we need other subject positions than those offered to us as either the active perpetrators or the passive victims of oppression, a split that he argues has been authenticated within anti-racist politics. Instead Gilroy proposes the position of 'active witness', the committed observer rather than passive spectator, who is enabled both to reflect upon and to act within the world.[27] Like the Women in Black in Serbia, our position as *witnesses* can challenge the interpretation of events and give them new meanings. What is the pleasure in this for viewers? One kind of pleasure is linked to the recognition of identity as well as, or across, difference.

And, with identity goes agency, the ability to act within and upon our own narratives in history and culture.

Elizabeth Grosz asks whether it is possible '*to think the otherness of the other* without assuming the other is merely a version of the same? In what terms, from what positions, with what characteristics is this otherness to be understood and addressed?' (Grosz 1990: 80). She suggests that the question of the relation between subject and other is an ethical one. But, it is also a question of aesthetics and of politics; of how I explore my own relation to 'a poetics of identity that engages with the "other woman"' (Miller 1986: 110).

One implication is that the answer to the question of artistic subjectivity lies in the creation of a place 'in between'. As Keith Piper has suggested, this means occupying a space where the artist can make work that both comes out of his or her own particularity and can be read by others within their different social subjectivities and cultural locations.[28]

The question of how to represent the body has become an interrogation of identity, marginality, power and difference: the body in history. Themes of identity have been explored in such practices through the relation of personal to historical memory, through journeys, both real and metaphorical, and through the representation of self from the point of view of those displaced from the 'centre' by gender and race. This kind of work engages with spectators who themselves occupy a variety of subjective spaces; an inter-subjectivity which enables identifications and differences between women and men and between races and cultures to be recognized. It also asks how we – as women, as feminists, as post-colonial subjects – might journey towards the articulation of our own desires.

NOTES

INTRODUCTION

1 A case in point would be Mary Kelly, whose work on the feminine and maternal body, in *Interim* and *Post Partum Document*, has been an invaluable resource for feminist practice and theory over the last decade. Historically, Frida Kahlo is an artist whose use of her own body has been very well examined in feminist critical writing.

2 In 'Women's Time' (1979), Julia Kristeva outlines two 'generations' of feminism, the first roughly from the time of women's suffrage up to 1968 (the struggle for equality) and the second post-1968 (the recognition of difference). She also imagines a third generation yet to come when binary sexual difference will be dissolved. See J. Kristeva (1986a) 'Women's Time'.

3 Even more than most, Chapter 3 was written across and because of other feminist accounts and, since I lay no claim to being a suffrage historian, I am grateful to previous researchers as well as to those who have helped me in the course of my own researches. I am particularly grateful to Alison Oram for her helpful suggestions and contacts at the Fawcett Library and National Museum of Labour History, Manchester.

4 See Tamar Garb, 'The Forbidden Gaze: Women Artists and the Male Nude in Late Nineteenth Century France' (1993: 33–42) and the catalogue *Profession Ohne Tradition: 125 Jahre Verein der Berliner Künstlerinnen* (1992) for an account of women artists' training at the turn of the century.

1 AN INTIMATE DISTANCE

1 See R. Betterton, 'How Do Women Look? The Female Nude in the Work of Suzanne Valadon' (1985) for a more detailed discussion of Valadon's representation of the female body.

2 See E. Fox Keller, *Reflections on Gender and Science* (1985).

3 These issues often produced stormy confrontations at women's art conferences and within art colleges in the mid-1980s, and work by women and men was attacked – sometimes physically – for its 'exploitation' of women's bodies.

4 This position was articulated most cogently by Laura Mulvey in 'Film, Feminism, and the Avantgarde' (1989). These complex shifts are described in detail in relation to feminist art practice by Rozsika Parker and Griselda Pollock in *Framing Feminism* (1987: 3–78).

5 Curiously in the version of *Post Partum Document* published in book form, Mary Kelly's text is prefaced by a photograph showing her seated with her

infant son on her lap for all the world like a traditional mother and child, whether as an intentional irony or due to the publisher's insistence is not clear.

6 See J. Berger, *Ways of Seeing* (1972), L. Nochlin, 'Why Have There Been No Great Women Artists?' (1973), R. Brooks, 'Woman Visible, Woman Invisible' (1977), G. Pollock, 'What's Wrong with Images of Women?' (1977), and, for an analysis of literature on the nude, L. Nead, *The Female Nude: Art, Obscenity and Sexuality* (1992).

7 The psychoanalytic implications of Mulvey's idea of transvestism are developed by M. Doane, 'Film and Masquerade – Theorising the Female Spectator' (1982) and 'Masquerade Reconsidered: Further Thoughts on the Female Spectator' (1988–9). Other accounts of female spectatorship in film and television can be found in L. Gamman and M. Marshment (eds), *The Female Gaze: Women as Viewers of Popular Culture* (1988), and D. Pribam (ed.), *Female Spectators. Looking at Film and Television* (1988). Lorraine Gamman and Merja Makinen offer a critical view of the fetishism of the female body in L. Gamman and M. Makinen, *Female Fetishism: A New Look* (1994).

8 See L. Faderman, *Surpassing the Love of Men* (1981) and L. Bland, *Banishing the Beast* (1995: 290–6).

9 See M. Jay, *Downcast Eyes: The Denigration of Vision in Twentieth Century French Thought* (1994: 435–56) for a useful discussion of Barthes' theory of the visual.

10 See T. Moi, *Textual/Sexual Politics* (1985: 127–49) for a discussion of the value and problems of Irigaray's use of the 'speculum'.

11 See, for example, M. Daly, *Gyn/Ecology: The Metaethics of Radical Feminism* (1978), S. Griffin, *Woman and Nature* (1978) and A. Rich, *Of Woman Born: Motherhood as Experience and Institution* (1976). Examples of their influence can be seen in the women's peace and ecology movements of the 1980s. See M. McNeil, 'Being Reasonable Feminists' (1987: 40–8) for a discussion of this.

12 See J. Butler, *Gender Trouble: Feminism and the Subversion of Identity* (1990).

13 See S. Bordo, 'Reading the Slender Body' (1990) and L. Jordanova, *Sexual Visions* (1989) on the 'evolutionary' forms of the body.

14 The term 'imaginary' here is used in the Lacanian psychoanalytic sense as that which the human infant (mis)recognizes as an imagined bodily unity during the mirror stage.

15 In a witty rewriting of the 'The Judgement of Paris', Rachel Bowlby warns against the elevation of the 'three goddesses' of French feminism (Cixous, Kristeva and Irigaray), arguing that they should not be taken as 'single authorial figures, to be defended or accused or explained as if they were offering, or failing to offer, universal blueprints' (Bowlby 1992: 129). As more of their work becomes available in translation, it is certainly more possible to take or leave aspects of their ideas.

16 This distinction between language as a system which sets limits on what can be thought and language as spoken is implicit in the different usage of *langue* and *langage* in French, but is not so easily made in English.

17 See L. Nead, *Myths of Sexuality* (1988: 110–37) for a similar discussion of the correspondences between nineteenth-century moral panics over prostitution and twentieth-century responses to AIDS, and J. Bristow, *Sexual Sameness* (1992). In their essay 'Panic Sex in America', A. and M. Kroker suggest that the moral panic over the body, sexuality and infection in late twentieth-century America is a displacement of anxieties about the body politic on to the pathologized sexual body. Just as in the 1950s McCarthyism attempted to cleanse the political system, in the 1980s a form of 'body McCarthyism' has made the 'secreting, leaking body' the target of state control (Kroker 1988: 11).

18 For discussion of the work of photographers on lesbian sexuality including Della Grace see T. Boffin, and J. Frazer (eds), *Stolen Glances: Lesbians Take Photographs* (1991), R. Lewis, 'Dis-Graceful images: Della Grace and Lesbian Sado-masochism' (1994), and of the 'sex performer', Annie Sprinkle, see P. Church Gibson and R. Gibson (eds), *Dirty Looks: Women, Pornography, Power* (1993).

2 MOTHER FIGURES

1 This is a substantially revised version of an essay, 'Figuring the Maternal: The Female Nude in the Work of German Women Artists at the Turn of the Century', which appeared in the catalogue *Profession Ohne Tradition: 125 Jahres Verein der Berliner Künstlerinnen* (1992). The original version was written in the months immediately before and after the birth of my daughter when I was experiencing my own identity crisis as a 'mother figure'.

2 The development of secularized forms of the Madonna and Child in eighteenth- and nineteenth-century art is discussed by Carol Duncan in 'Happy Mothers and Other New Ideas in Eighteenth Century French Art' in N. Broude and M. Garrard (eds), *Feminism and Art History* (1982: 201–19), and by Tamar Garb 'Renoir and the Natural Woman' (1985: 5–15).

3 The combination of the nude or semi-nude female body and the figure of the mother was not entirely new. In the nineteenth century a number of artists used the bare-breasted mother suckling her babies to represent the Republic or Charity, a political allegory of the female body which had its roots in classical and Christian iconographic traditions. Marina Warner discusses its symbolic significance in *Monuments and Maidens: The Allegory of the Female Form* (1985: 281–6).

4 Both artists studied at the Drawing and Painting School of the Berlin Association of Women Artists, Kollwitz attending in 1885 and 1886 and Modersohn-Becker between 1896 and 1898. Kollwitz returned to the School at the invitation of its director, Margarete Honerbach, to teach drawing and graphics in 1898. Although she may have overlapped briefly with Modersohn-Becker's period as a student, no contact between them is recorded. See Betterton (1992: 89–103).

5 Lucy R. Lippard suggests that Kollwitz had little in common with Modersohn-Becker 'except sex and occasional subject matter', in R. Hinz (ed.), *Käthe Kollwitz: Graphics, Posters, Drawings* (1981: vii). See also Alessandra Comini 'Gender or Genius? The Women Artists of German Expressionism' in M. Broude and M. Garrard (eds), *Feminism and Art History*, (1982: 271–91). For a recent overview of the critical reception of Kollwitz's work in America between 1900 and 1960, see Jean Owens Schaefer 'The Kollwitz Konnection' (1995: 10–16).

6 See Gillian Perry 'Primitivism and the "Modern"' in C. Harrison, F. Frascina and G. Perry, *Primitivism, Cubism, Abstraction. The Early Twentieth Century* (1993: 34–45).

7 This relationship is exemplified in Gustave Courbet's *The Painter's Studio*, 1855. In Courbet's painting, the nude model is replaced on the canvas by a landscape. Linda Nochlin discusses the gender relationships represented in which 'women and nature are interchangeable as objects of (male) artistic desire – and domination' (Nochlin, 'Courbet's Real Allegory: Rereading "The Painter's Studio"' in S. Faunce and L. Nochlin (eds), *Courbet Reconsidered* (1988: 32).

8 In a recent monograph of Lovis Corinth, Charlotte Berend's pose is described as: 'protected by his arms, but also shielding him, her gesture is at once suppliant and supportive' (H. Uhr, *Lovis Corinth*, 1990: 140). Lynda Nead offers a similar description of a painting of husband and wife by George Elgar Hicks, *Women's Mission: Companion of Manhood*, 1863, commenting: 'Norms of femininity and masculinity are constructed in this image.' L. Nead, *Myths of Sexuality. Representations of Women in Victorian Britain* (1988: 13).

9 Charlotte Berend has given her own account of the relationship:

> 'When I think back to how I always managed to carry on painting in spite of pregnancy, household duties, cooking, acting as model, much illness, looking after Corinth, being careful with money in the early years, in spite of giving strength to Corinth and the children at all times throughout life, an inner voice would always however call out: "Don't give up! Be mindful of your energy, think of yourself!" C. Berend-Corinth, 'My Life with Lovis Corinth' (1958), extracts in R. Berger, *"Und ich sehe nichts, nichts als die Malerie": Autobiographische Texte von Künstlerinnen des 18.–20. Jahrhunderts* (1989: 281)

A revealing comment in Lovis Corinth's version of their marriage refers to Berend as 'A guardian angel in human form: that is my wife', quoted in C. Berend-Corinth, *Charlotte Berend-Corinth: Eine Austellung zum 100 Geburtstag der Künstlerin Malerei und Graphik*, Erlangen (1980: 5). The translation of both these passages is by J. Brooks.

10 An extensive analysis of the gendered identity of the artist and the production of the nude is now available in feminist critical writing. For recent examples, see L. Nead, *The Female Nude: Art, Obscenity and Sexuality* (1992) and T. Garb, *Sisters of the Brush: Women's Artistic Culture in Late Nineteenth Century Paris* (1994) and 'The Forbidden Gaze: Women Artists and the Male Nude' in K. Adler and M. Pointon (eds), *The Body Imaged: The Human Form and Visual Culture Since the Renaissance* (1993: 33–42).

11 For an interesting analysis of the construction of the artist's public identity in male self-portraiture of the same period, see Irit Rogoff, 'The Anxious Artist – Ideological Mobilisations of the Self in German Modernism' in I. Rogoff (ed.), *The Divided Heritage: Themes and Problems in German Modernism* (1991).

12 Scheffler's comments are quoted in S. Behr, *Women Expressionists* (1988: 8).

13 For a further discussion of attitudes to female creativity among German feminists, see Kay Goodman, 'Motherhood and Work 1895–1905' in R.E. Joeres and M.J. Maynes (eds), *German Women in the Eighteenth and Nineteenth Centuries: A Social and Literary History* (1986: 110–27).

14 Jane Gallop places this idea in the context of a discussion of the opening and closing passages of Adrienne Rich, *Of Woman Born: Motherhood as Experience and Institution* (1976), in which a real-life incident of a mother's decapitation of her child is described.

15 In the final etched version of the print renamed *The Downtrodden*, 1900, the self-portrait and female nudes were removed and replaced by a proletarian family group. For a detailed account of the development of the motif, see E. Prelinger, *Käthe Kollwitz* (1992: 26–30).

16 For a useful discussion of this idea, see R. Braidotti, 'Body Images and the Pornography of Representation' (1991: 148–50).

17 For example, the poet, Rainer Maria Rilke left her out of his monograph on Worpswede painters published in 1903 and she received no professional

recognition as a painter before her second public exhibition held in November 1906 at the Bremen Kunsthalle (Modersohn-Becker 1980: 298 and fn. 26).

18　Linda Nochlin has suggested that the image was 'probably created when she was looking forward to motherhood', a view which collapses the reading of the work, inaccurately as it happens, into biography (A. Sutherland Harris and L. Nochlin, *Women Artists: 1550–1950* (1978: 67).

19　Martha Kearns describes a *Self Portrait* (1892) by Kollwitz in which the artist shows herself pregnant with her first son, Hans, which suggests some similarities with Modersohn-Becker's work: 'she stands nearly full-length before us, her right hand by her side, her left hand lying gently across her breasts; she gazes out dreamily, preoccupied with a distant image. Unlike her self portraits, this one conveys a light, drifting mood' (M. Kearns, *Käthe Kollwitz*, 1976: 64). I have been unable to identify this image.

20　I have used this translation of the passage in preference to that which appears in 'Motherhood According to Giovanni Bellini' in J. Kristeva, *Desire in Language* (1980: 238).

21　Shulamith Behr also makes this connection in *Women Expressionists* (1988: 18). Examples of this type of pregnant Madonna can be found in the work of Renaissance painters such as Piero della Francesca and Jan Van Eyck.

22　For a fuller discussion of these issues, see F. Gordon 'Reproductive Rights: The Early Twentieth Century European Debate' (1992: 387–99). Tamar Garb discusses Renoir's representation of maternity in the context of debates about motherhood in the French Third Republic in T. Garb, 'Renoir and the Natural Woman' (1985: 5–15). Anna Davin examined similar debates in Britain before the First World War about population, race and motherhood in 'Imperialism and Motherhood' (1978: 9–66).

23　Bachofen's ideas were variously taken up in Engels's *The Origins of the Family, Private Property and the State* (1884), Frazer's *The Golden Bough* (1890), and Freud's *Totem and Taboo* (1912). His theory of unregulated sexuality in the first stage of matriarchal society was attacked by Heinrich Schurtz in *Alterclassen und Mannerbunde* (1902). Schurtz argued that monogamous marriage was characteristic even of the earliest societies, a revealing critique in the context of contemporary debates on the responsibilities of motherhood within marriage.

24　The American feminist, Katherine Anthony, characterized the women's movement in Britain and the United States as 'Votes For Women' whereas in Germany and Scandinavia it was *Mutterschutz* (Protection for Mothers). See Kay Goodman 'Motherhood and Work 1895–1905' in R.E. Joeres and M.J. Maynes, (eds), *German Women in the Eighteenth and Nineteenth Centuries: A Social and Literary History* (1986: 10–127).

25　For a sympathetic discussion of Key's theories, see Cheri Register 'Motherhood at the Center: Ellen Key's Social Vision' (1982: 599–610) and Jeffery Weeks *Sex, Politics and Society: the Regulation of Sexuality since 1800* (1981: 126–8). A more critical view is offered by Sheila Jeffreys, who argues that the exaltation of motherhood in Key's work and that of her English follower, Havelock Ellis, influenced the developing Nazi ideal of women's destiny in Germany of the 1920s and 1930s (S. Jeffreys, *The Spinster and Her Enemies: Feminism and Sexuality 1880–1930*, 1985: 136).

26　The complex relationship between modernist and anti-modernist ideologies and their links to primitivism are very well explored in Jill Lloyd's essay 'Emil Nolde's "Ethnographic" Still Lifes: Primitivism, Tradition and Modernity', in Susan Hiller (ed.), *The Myth of Primitivism* (1991). See also G. Perry, *Primitivism and the 'Modern'* (1993: 34–45).

27 Modersohn-Becker described her deep sense of loss on Clara Westhoff's marriage to the poet, Rainer Maria Rilke, fearing that Westhoff's independent identity as a sculptor would be suppressed. This seems to have been intensified by her loneliness in her own marriage by 1902. On leaving her marriage, Becker also rejected responsibility for her stepdaughter, Elspeth, which suggests that she did not wholly subscribe to maternalistic ideology.

28 This brief summary does not exhaust the range of German feminist arguments about women's maternal role and female sexuality in the 1900s, but it does suggest the strength of maternalistic arguments within socialist and feminist positions. Karen Honeycutt ascribes the lack of radicalism to the predominance of married working-class women within the SPD women's organizations, in 'Socialism and Feminism in Imperial Germany' (1979: 38).

29 H. Stoecker (ed.), *Petitionem des Deutschen Bundes für Mutterschutz, 1905–1916* (Berlin 1916), reprinted in Riemer and Fout (eds), *European Women: A Documentary History, 1789–1945* (1983: 171).

30 The play by Ida Strauss is described in K. Goodman (1986: 124). Kollwitz gives her own moving account of the plight of a Frau Pankopf who suffered violence from her sick and depressive husband and the death of their child as well as having to support six remaining children alone, in her diary of September 1909. (K. Kollwitz, *The Diaries and Letters of Käthe Kollwitz*, 1955: 51–2).

31 Elizabeth Prelinger has noted that Kollwitz's frequently combined social realism with symbolism, an approach which she derived from the theories of Max Klinger (1857–1920). Klinger was an influential figure in German artistic circles at the turn of the century. Kollwitz read Klinger's *Malerei und Zeichnung* (1885) as a student, a turning-point in her decision to commit herself entirely to graphic media. His series of etchings *Dramen*, 1883, with their highly dramatized social realism, influenced Kollwitz's early attempt at a graphic cycle based on Zola's *Germinal* as did his symbolist graphics cycles such as *Ein Leben* (1884). Modersohn-Becker also mentions reading a Knackfuss monograph of Klinger while she was in Paris in 1900 (Modersohn-Becker 1980: 120).

32 For an accessible discussion of these ideas see J. Kristeva, 'A Question of Subjectivity: Interview with Susan Sellars' (1986b: 20).

33 A. Miller, *The Untouched Key: Tracing Childhood Trauma in Creativity and Destructiveness* (trans. H. and G. Hannum) (1990: 19–35). My thanks to Andrea Duncan for pointing out this reference to me.

34 Kollwitz describes her drawing for the image thus: 'When he was seven years old and I was doing the etching *Mother with Dead Child*, I drew myself in the mirror while holding him in my arm. The pose was quite a strain and I let out a groan' (Kollwitz, *The Diaries and Letters of Käthe Kollwitz*, 1955: 164).

35 Although Mary is usually shown holding the adult Christ, some versions of the Pietà, for example by Giovanni Bellini, show Christ as a child in a pose which prefigures his death, a conception which Kollwitz's image echoes.

36 For a discussion of the mother figure as monster in *Alien*, see Barbara Creed, 'Horror and the Monstrous-Feminine: An Imaginary Abjection', in *The Monstrous Feminine: Film, Feminism, Psychoanalysis* (1993) and also Lynda K. Bundzen, 'Monstrous Mothers: Medusa, Grendel and now Alien' (1987: 11–17).

37 Angela Moorjani suggests that, '(A) Kleinian reading of Kollwitz's image, on the other hand, suggests the resurfacing of the phantasmatic oral mother devouring her child' (A. Moorjani, *The Aesthetics of Loss and Lessness*, (1992: 111).

38 For example, Gwen John's sexually explicit correspondence with August Rodin and Edith Wharton's *Love Diary*, 1908. I am grateful to Mara Witzling and Judy Simons for calling my attention to these writings in a session of the 'Woman, Image, Text' conference, Sheffield Hallam University, November 1993.

3 'A PERFECT WOMAN'

1 William Wordsworth, *Poems of the Imagination* (Composed 1804, published 1807). I am grateful to Frances Dann for pointing out the source of these lines to me.

2 See Warner, *Joan of Arc: The Image of Female Heroism* (1983). In late nineteenth-century revivals of the cult of Joan of Arc, she was variously claimed as child of nature, Catholic saint and French patriot. Marina Warner notes that numerous statues were set up and three new journals were dedicated to Joan in the 1890s and her cult became subject to intensifying claims by right and left, both monarchists and republicans, both the Catholic church and the French state. She was mobilized in support of each side in the Dreyfus case between 1894 and 1899. *Votes for Women* had informed its readers of Joan's forthcoming beatification on 16 April 1909. Warner only makes a brief mention of suffrage claims to Joan in her book.

3 See Gertrude Colmore's biography *The Life of Emily Davison* (1913) in A. Morley and L. Stanley, *The Life and Death of Emily Wilding Davison* (1988). Liz Stanley argues that the model of martyrdom which derived from Joan of Arc was used to structure Colmore's account of Davison's life and death. The continual evocation of Joan by suffrage militants requires a separate study in itself.

4 Women were excluded from halls where political meetings were being held after early WSPU attempts to disrupt meetings. A moving account of the effects of this lack of a political voice for women is also given in Sylvia Pankhurst's autobiography. On the East London Federation deputation to Prime Minister Asquith on 20 June 1914, a Mrs Payne described how her 'mentally deficient' daughter had been taken into Poplar Workhouse: 'When I got there next morning they had put her in a padded room. I asked the doctor why she was there. He told me I had no voice, I was not to ask the why or the wherefore – only the father had that right' (Pankhurst 1977: 573– 4).

5 The WSPU was inventive in its militant acts which had public or private property as their main target. These included sending pepper-filled envelopes to MPs opposed to suffrage, breaking windows with stones wrapped in WSPU slogans and stuffing home-made 'bombs' of ink or sulphur into letterboxes, as well as less violent actions such as hiding in the House of Commons and refusing payment of taxes. These actions were not confined to the London leadership alone, for example, suffrage militants also fired letterboxes in Sheffield (*Sheffield Women's History Walk*, 1982).

6 The main suffrage organizations before the First World War were the National Union of Women's Suffrage Societies (NUWSS), formed in 1897 from a number of constitutional groups under the leadership of Millicent Fawcett, the Women's Social and Political Union (WSPU) founded by Mrs Pankhurst in Manchester in 1903, the Women's Freedom League (WFL) which split from the WSPU in 1907, and the East London Federation of Suffragettes (ELFS) led by Sylvia Pankhurst from 1914.

7 See Rolley, 'Fashion, Femininity and the Fight for the Vote' (1990: 47–71) for a fascinating and detailed analysis of suffrage dress codes. Rolley argues that

'tailor-mades' had become fashionable garments by 1912 and fitted the WSPU's shift to a more modern and youthful image. This is in contrast to the position only fifteen years before when a Punch cartoon 'The Three Dis-Graces' satirized women who wore tailored garments for aping men (Walkley, *The Ghost in the Looking Glass: The Victorian Seamstress*, 1981) See also Vicinus, *Independent Women: Work and Community for Single Women* (1985: 263–4) and Wilson, *Adorned in Dreams: Fashion and Modernity* (1985) for a useful discussion of the relationship between dress reform and radical politics. Rozsika Parker makes a similar analysis of the conflicting meanings of embroidery as a medium of political representation in suffrage banners in R. Parker, *The Subversive Stitch: Embroidery and the Making of the Feminine* (1984: 197–201).

8 The semiotics of headgear are complicated here. It is not clear whether this is a 'tam-o'-shanter' or 'billycock' referred to by Rolley as suffrage wear (Rolley 1990: 57, 62) or even a reference to a French revolutionary cap worn by figures of Liberty. It is certainly not the fashionable picture-hat beloved by Mrs Pankhurst.

9 See Warner, *Joan of Arc: The Image of Female Heroism* (1983: 229–33) and *Monuments and Maidens: The Allegory of the Female Form* (1985: 241–66). Other militant suffrage images included Caroline Watts's design for the Artists Suffrage League poster, 'The Bugler Girl', 1908, of which the *Manchester Guardian* wrote, 'Some people objected that the Amazon was too "militant"' (17 July 1908). Edgar Wind discussed the iconography of the white horse as a Platonic symbol of sensuous passion or libido in Titian's *Sacred and Profane Love*, in *Pagan Mysteries of the Renaissance* (1980: 141–51).

10 Liz Stanley discounts this view of the militant feminists' desire for martyrdom based on her detailed analysis of Emily Wilding Davison's life and friendships. See Morley and Stanley, *The Life and Death of Emily Wilding Davison* (1988: 163–5).

11 It is clear from the suffrage campaigner's own accounts of forcible feeding that they held the Asquith Government rather than individual prison governors or warders to be primarily responsible for their treatment. The role of doctors in the process was more problematic. While some doctors publicly opposed force-feeding on moral grounds, others carried it out without compunction.

12 Laura Mulvey has described the classic tropes of melodrama in 1950s Hollywood film in terms of a contradiction between sexuality and convention, between woman's independence and her place within the home, and between repression and expression. This might indeed function as an apt description of the tensions within feminism in the early part of the twentieth century. See Mulvey, 'Notes on Sirk and Melodrama' (1989: 39–46).

13 For a very full and informative account of different artists' organizations and designers who worked for the suffrage campaigns, see Tickner, *The Spectacle of Women: Imagery of the Suffrage Campaign 1907–14* (1987: 13–52). The Suffrage Atelier was the most radical of these artistic and political groups and had links with the Women's Freedom League.

14 There are a number of examples of such anti-suffrage postcards in the Museum of London Suffrage Archive.

15 First-hand accounts of prison experiences and force-feeding appeared regularly in the suffrage press: 'The Hunger and Thirst Strike and Its Effects' by Sylvia Pankhurst, took up three full pages in *The Women's Dreadnought* of 4 April 1914. A number of leading suffrage figures also wrote auto-

biographical accounts including Emmeline Pethick-Lawrence, Christabel, Sylvia and Emmeline Pankhurst, Constance Lytton and Emily Davison. The Museum of London Suffrage Archive has a large collection of prison memorabilia.

16 Ellman's account of the infant–mother relationship which, while powerful, seems descriptively inaccurate:

> Our first experience of eating is force-feeding: as infants, we were fed by others and ravished by the food they thrust into our jaws. We eat therefore to avenge ourselves against this rape inflicted at the very dawn of life.
>
> (Ellman 1993: 35–6)

Force-feeding, like rape, replaces an act of love with the assertion of power. If rape is a sexual relationship transgressed by the violent exercise of power, so in force-feeding, the mutuality of the infant–mother relationship is 'parodied' by a violent act.

17 Maud Ellman suggests that certain parallels can be drawn between religious abstinence, the political hunger strike and anorexia, in which each 'belong to an economy of sacrifice, and ... are founded on the dream of a miraculous transfiguration, whereby the immolation of the flesh will be rewarded by its resurrection' (Ellman 1993: 14).

18 Pankhurst describes the case of Grace Roe, a young Irish hunger striker, who complained repeatedly of being drugged while in prison and was herself counter-charged with attempting to obtain an emetic drug to induce vomiting after forced feeding (Pankhurst 1977: 556–61).

19 Pankhurst takes this objectification one stage further by describing how she visualized food presented to her during her hunger strike: 'The varied colours diverted my eye in the drabness of the cell, but I had no more inclination to eat the still life groups on my table than if they had been a painting or a vase of flowers' (Pankhurst 1977: 442).

20 Ann Morley and Liz Stanley argue that militant feminism derived from ethical and political commitment sustained over many years rather than any hysterical outbreaks. The reading of militant feminism as a female psychological disorder has been reproduced by some modern biographers, for example, Patricia Romero, *E. Sylvia Pankhurst: Portrait of a Radical* (1987). See Dodd, *A Sylvia Pankhurst Reader* (1993: 2–3) for an excellent analysis of this tendency.

21 An undated London Life postcard 'Arrest of a Militant Suffragette' gives some insight into popular representations of suffrage arrests with the caption:

> Hustle Them In and Bundle Them In
> Scoop Up The shrieking Mob.
> Who Says that 'Justice' is Going to Win
> When the 'Law' Takes up the Job?

See also Pankhurst, *The Suffragette Movement: An Intimate Account of Persons and Ideals* (1977: 556–7) and Morley and Stanley (1988: 22–3; 43–8) for graphic accounts of violent arrest and treatment in prison. Visual iconography of prison was much less dramatic and tended towards static representation. First-hand accounts of women being arrested suggest they were frequently subject to sexual abuse, a source of both shame and anger. A striking photograph of women heckling Lloyd George at Wrexham Eisteddfod on 11 September 1911

shows one woman being arrested with hair down, coat unbuttoned and head raised high, a joyous expression on her face (Museum of London). It bears a strong resemblance to photographs of women arrested in peace protests at Greenham Common in the early 1980s.

22 Morley and Stanley suggest that this may also have been the view privately held of Davison by the WSPU leadership (Morley and Stanley 1988: 147–55). They give a detailed description of Emily Davison's death and funeral and analyse its representation by contemporaries and subsequent historians.

23 See Tickner, *The Spectacle of Women: Imagery of the Suffrage Campaign 1907–14* (1987: 167–74) for a useful discussion of the use of stereotypes to characterize suffrage supporters and the relation of these to nineteenth-century concepts of phrenology as well as to theories of eugenics. The suffrage movement also drew on eugenic arguments to legitimize middle-class women's claim to the vote as against that of criminals and the insane.

24 His public demonstrations at La Salpêtrière had become famous by the 1880s and attracted an international audience, including the young Sigmund Freud between October 1885 and February 1886. Charcot's influence on the study of hysteria and its relationship to feminism is discussed by Showalter (1987: 145–64) and Heath (1982: 33–49). Charcot's studies of hysteria were an important starting-point for Freud's investigations of the hysteric patient undertaken in the 1890s with Josef Breuer. Freud and Breuer shifted the focus of their own analysis from visible symptoms to 'the talking cure'. Stephen Heath suggests that the shift from the visibility of the patient in Charcot's work to Freud's 'talking cure' was the founding moment of psychoanalysis.

25 For example, Sir Almroth Wright's letter to *The Times*, 'On Militant Hysteria', 28 March 1912, in which he linked the woman's movement with a mental disorder based on female physiology, a view from which prominent women anti-suffragists like Mrs Humphrey Ward, disassociated themselves. For further discussion of medical concepts of hysteria, see Tickner, *The Spectacle of Women: Imagery of the Suffrage Campaign 1907–14* (1987: 192–205).

26 For discussion of the *femme fatale* type in art, see Bade, *Femme Fatale* (1979), Dikstra, *Idols of Perversity: Fantasies of Feminine Evil in Fin de Siècle Culture* (1986), Schubert, 'Women and Symbolism: Imagery and Theory' (1980) and Showalter, *Sexual Anarchy: Gender and Culture at the Fin de Siècle* (1991: 144–68).

27 This association was compounded by suffrage actions which appeared to endorse the representation of feminism as anti-sex and anti-pleasure. The attack by Mary Richardson on the 'Rokeby Venus' by Velasquez in the National Gallery two months before the appearance of the *Daily Mirror* text was the most notorious of such actions. See Nead, *The Female Nude: Art, Obscenity and Sexuality* (1992: 34–43). Nead describes how the picture was represented as the 'Nation's Venus' having been bought by the National Art Collections Fund in 1906. Richardson's attack was thus on 'a certain kind of femininity and its position in the formation of a national cultural heritage' (Nead 1992: 36).

28 See the discussion of similar issues for women artists of the period in Germany in Chapter 2.

29 Olive Schreiner was then in London following the successful publication of her novel *The Story of an African Farm* in 1883 and was being treated for a nervous breakdown. Schreiner had 'an intense but unrequited passion' (Walkowitz 1992: 140) for Karl Pearson and left the Club in 1886. She belonged to a radical circle of socialist women which included Annie Besant and Eleanor

Marx who, as well as discussing new sexual politics, tried to live them out in their own relationships. For a fuller account of Schreiner's politics and writing, see First and Scott, *Olive Schreiner* (1980). For an account of New Women in fiction, see Showalter, *Sexual Anarchy: Gender and Culture at the Fin de Siècle* (1991: 38–58) and *Daughters of Decadence: Women Writers of the Fin de Siècle* (1993).

30 See Bland, *Banishing the Beast: English Feminism and Sexual Morality 1885–1914* (1995: 3–47)

31 See Jane Marcus (1980), 'Introduction' to *The Convert*. Elizabeth Robins also published *The Convert* in the form of a short play, *Votes for Women*, published in 1907 by Mills & Boon Ltd (sic).

32 The *Freewoman* journal provided a brief focus for debate about sexual issues, including contraception, sexual pleasure and lesbianism immediately before the First World War. Contributions and correspondence were received from Teresa Billington Greig, Stella Browne, and male radicals including Havelock Ellis, H.G. Wells and Edward Carpenter.

33 Minna Simmons's poem 'Friendship', written after the death of Eva Slawson in 1916, sums up their relationship:

> For seven short years there was given to me a love,
> A Woman too, she was my life, and soul, words fail
> And desolation fills me. Life itself seems nought
> And it is night forever more without her.
> (Thompson 1987: 307)

See also Stanley (1992) 'Romantic Friendship? Some Issues in Researching Lesbian History and Biography'.

34 That this was a real dilemma is evident from Sylvia Pankhurst's long and close relationship with the ILP leader, Keir Hardie, during the period of her militant suffrage activity up until 1912. While there is some debate as to the exact status of their relationship, it certainly could not be publicly acknowledged as an affair, not least for fear that the loss of her reputation would endanger the Cause even after Keir Hardie died in 1915. For an account of his personal importance to Pankhurst, see Charlesworth-Cunliffe 'Sylvia Pankhurst as an Art Student' (1992: 11–12). Kathryn Dodd suggests that Pankhurst's failure to mention her long affair with Keir Hardie in her autobiographical account, *The Suffragette Movement* (1931), was part of the discourse of the 'public' woman within suffrage writing rather than any deliberate desire to conceal the truth. See Dodd (1994: 3). Pankhurst's independence in sexual matters is apparent from her later refusal to marry a second partner, Silvio Corio, on the birth of their son in 1927, when she was forty-five.

35 The East London Federation articulated a different concept of suffrage politics based on mass organization, alliances with the labour movement and social and sexual reform. Federation projects in the East End included the setting up of mother-and-infant clinics and welfare centres, play nurseries, a cost-price restaurant and a toy factory which employed women workers.

36 See Val Williams, *Women Photographers: The Other Observers, 1900 to the Present* (1986), for a discussion of Norah Smyth's significance as a documentary photographer. See John Tagg, *The Burden of Representation* (1988) on nineteenth-century photography of the poor.

37 For a discussion of socialist iconography see Hobsbawm, 'Man and Woman in Socialist Iconography' (1978) and Alexander, Davin and Hostettler, '*Labouring Women: A Reply to Eric Hobsbawm*' (1979). See also Tickner, *The*

Spectacle of Women: Imagery of the Suffrage Campaign 1907–14 (1987: 30–42)
on suffrage iconography and its sources in socialist iconography. On the
construction of class and gender difference in nineteenth-century representa-
tions of working class women, see Griselda Pollock, '"With My Own Eyes":
Fetishism, the Labouring Body and the Colour of its Sex' (1994: 342–82).
Kathryn Dodd argues that Pankhurst's early journalistic writing, a series of
essays for *Votes for Women* on the lives of labouring women, is also marked
by class separation and difference. See Dodd, *A Sylvia Pankhurst Reader*
(1993: 8–11).

38 See Chapter 2 for a discussion of Käthe Kollwitz's iconography of the mother
and child. See Jackie Duckworth, 'Sylvia Pankhurst as an Artist' (1992: 36–57),
for a detailed account of her paintings.

39 Joan of Arc became the symbol for the extreme right wing Action Française
group founded in 1899. According to Charles Maurras, leader of Action
Française, she stood for:

> The [national] Heritage Maintained
> And the Fatherland restored
> By the Monarchy restored.
> (Warner 1983: 257)

In the 1995 French Presidential elections, the extreme right-wing candidate,
Jean-Marie Le Pen, used the image of Joan of Arc in his election rallies.

40 For a discussion of the significance of 'white slavery' in feminist politics before
the First World War, see Bland, *Banishing the Beast: English Feminism and
Sexual Morality 1885–1915* (1995: 297–304). See also Gordon and Dubois,
'Seeking Ecstasy on the Battlefield: Danger and Pleasure in Nineteenth
Century Feminist Thought' (1983 13: 42–56) and Walkowitz, 'Male Vice and
Female Virtues: Feminism and the Politics of Prostitution in Nineteenth
Century Britain' (1984) on the contradictions in nineteenth-century feminism
over issues of moral purity. In many ways, Billington Greig is representative
of the other strand within suffrage politics between 1903 and 1914. An early
WSPU organizer, among the first suffragettes to be sent to Holloway jail in
1906, and founder of the Women's Freedom League, she was also active in
ILP politics and a writer on feminism, socialism and pacifism in *The Freewoman*
and other journals. See McPhee and Fitzgerald (eds), *The Non-Violent Militant:
Selected Writings of Teresa Billington-Greig* (1987).

41 The photograph reminds me of one of my mother taken c.1914 when she was
two which shows her dressed up in just such fancy clothes, a plump child with
long fair hair in ribboned corkscrew curls. That photograph is a conventional
studio portrait of a respectable working class family in Fulham stiffly dressed
up in Sunday best. Although not an active feminist, my mother and her gener-
ation's political and personal commitments were born, like this child's, out of
the achievements of the suffrage movement.

4 BODIES IN THE WORK

1 A shortened version of this chapter first appeared in *Issues in Art, Architecture
and Design* (1995, 4, 1). It was originally based on an catalogue essay for the
exhibition, *(Dis)Parities*, 1992, Sheffield City Art Galleries.

2 It is clear that while there was a history of feminist painting through the 1970s
and 1980s and a number of key exhibitions were held in Britain – *Women's*

Images of Men (1980), *Pandora's Box* (1984), *The Thin Black Line* (1985), and *Along the Lines of Resistance* (1989) – these explicitly addressed the politics of representation. While all the exhibitions included painting, it was primarily figurative and focused on political issues with an explicit feminist content. For an overview of these debates see R. Parker and G. Pollock (eds), *Framing Feminism: Art and the Women's Movement* (1987).

3 For a discussion of the issue of representation and abstract art, see D. Batchelor, 'Abstraction, Modernism, Representation' (1991).

4 See also C. Duncan, 'The Aesthetics of Power in Modern Erotic Art' (1977), L. Nochlin, *Women, Art and Power and Other Essays* (1989: 1–36), and G. Pollock, 'Painting, Feminism, History' (1992a).

5 L. Gamman and M. Makinen, *Female Fetishism: A New Look* (1994).

6 An alternative reading would be to suggest that the pleasure and unease evoked by the painting could be viewed as homoerotic. Natkin, the male artist, here occupies the 'feminine' position, his work penetrated by the male critic. Fuller's relief in identifying himself as subject can thus be explained: to continue the sexual metaphor, it was masturbation all the time.

7 Following Lacan, Kristeva takes the point of transition to be the child's awareness of sexed subjectivity, marked by entry into language. It is thus *symbolic* rather than biological systems which are crucial to the construction of the gendered subject.

8 David Batchelor argues that Chave treats abstract art as 'cryptically iconic' and misunderstands the relation between abstraction and representation (Batchelor 1991: 49). See also A. Chave, *Mark Rothko: Subjects in Abstraction* (1989) and R. Fortnum, 'Minimal Maidens' (1994: 26–7).

9 Mary Kelly identifies a similar 'pathology of masculinity' using the rhetoric of minimalism as a form of parody to 'undo a situation of mastery' in her installation *Gloria Patria*, 1992 (Kelly 1992, unpaginated).

10 The phrase 'A Womb with a View' is taken from the caption to a review of O'Keeffe's 1993 exhibition by Sue Hubbard in *New Statesman and Society*, 16 April 1993: 32–3. Although the review was broadly sympathetic to O'Keeffe's work, the caption typifies the connection made in all the reviews between her work and her body.

11 One consistent feature of the media coverage was the way in which it dwelt on the sensational aspects of O'Keeffe's biography and her ambiguous sexual identity. References to O'Keeffe's relationship to Alfred Stieglitz, to her bisexuality or to the sexual interpretations of her paintings appeared in every review of the exhibition. See also A. Chave, 'O'Keeffe and the Masculine Gaze' (1990).

12 Thus, for example, many critics cited the fact of the widespread reproduction of O'Keeffe's work in the form of posters and greetings cards as an index of the inferior quality of her painting – a point, incidentally, which is rarely made about Matisse. Criticism on the grounds that the exhibition did not show the best of O'Keeffe's work was perhaps more justified.

13 Greenberg himself dismissed O'Keeffe in precisely the same terms as 'pseudo-modern art ... little more than tinted photography', *The Nation*, n.d., quoted by Hilton Kramer, *Sunday Telegraph*, 4 April 1993.

14 In the double page spread 'Georgia's Girls' in *Vogue*, April 1993, the painting *Black Iris II*, 1926, is paired with a Stieglitz photograph. This was one of several 'lifestyle' features on O'Keeffe as a model for famous and wealthy women. In this respect, like Frida Kahlo before her, O'Keeffe has been recuperated from a figure of feminist interest to the latest style and fashion

icon. On the making of the Kahlo cult, see O. Baddeley, 'Her Dress Hangs Here: De-Frocking the Kahlo Cult' (1991) and J. Borsa, 'Frida Kahlo: Marginalisation and the Critical Female Subject' (1990).

15 In the growing literature on women and modernism in the visual arts, feminist critics have begun to identify the various ways in which gender has been crucial to the construction of modernity. See W. Chadwick, *Women, Art and Society*, (1990), G. Pollock, 'Modernity and the Spaces of Femininity' (1988) and J. Wolff, 'The Invisible *Flaneuse*: Women and the Literature of Modernity' and 'Feminism and Modernism' (1990).

16 In this guise, the 'rediscovery' of painting was primarily associated with the 1980 exhibition, *A New Spirit in Painting*, at the Royal Academy, London, which excluded any contemporary women artists.

17 It is clear in this essay that Irigaray is addressing painting as part of a therapeutic practice. However, her comments on the links between colour and sound, for example, in the 'colour of phonemes', are remarkably similar to Wassily Kandinsky's attempt to theorize colour and sound correspondences in non-representational painting in his 1911 essay, *Concerning the Spiritual in Art*.

18 For critical views of Irigaray's relationship to contemporary art practice by women, see M. Whitford, 'Women with Attitude' (1994) and Hilary Robinson's interesting response, *Women's Art Magazine*, 61 (1994: 20). For a useful discussion of Irigaray's ideas in relation to painting, see C. Battersby, 'Just Jamming: Irigaray, Painting and Psychoanalysis' (1995).

19 See T. Moi, *Textual/Sexual Politics: Feminist Literary Theory* (1985) and L. Hutcheon, *The Politics of Postmodernism* (1989).

20 For useful discussions of Cindy Sherman's work, see P. Phelan, *Unmarked: The Politics of Performance* (1993), J. Williamson, 'A Piece of the Action: Images of "Woman" in the Photography of Cindy Sherman' (1983), L. Mulvey, 'A Phantasmagoria of the Female Body: The Work of Cindy Sherman' (1991) and R. Krauss, *Cindy Sherman 1975–1993* (1993).

21 Anna Chave suggests other terms which could be used are 'pregnant, nourishing, pleasurable' (Chave 1990a: 55).

5 LIFE AND A.R.T.

1 This chapter was first given as a paper at the Centre for Women's Studies, University of Lancaster. Its title is taken from a television programme on new reproductive technologies, *Life and ART* (Channel 4, 1993). I am using the term 'assisted' reproductive technologies here to cover a whole range of practices from high-tech medical intervention such as *in vitro* fertilization (IVF), egg donation, gamete intra-fallopian transfer (GIFT), and the genetic manipulation of embryos, to low- or no-tech forms of assisted conception such as artificial insemination by donor (AID), or surrogacy. I make some distinctions between them in relation to the level of medical intervention involved, but stress that they all are 'assisted' in the sense that they involve someone else other than a biological mother and father in the process of conception.

2 See Winship, *Inside Women's Magazines* (1987: 70–1) for an analysis of the structure and function of such 'triumph over tragedy' stories in women's magazines.

3 This is in spite of the fact that almost nine out of ten treatment cycles fail to result in a birth. The technique of IVF requires the prescription of drugs to increase ovulation, then removing of a number of the eggs produced from a

woman's ovaries by surgical means. These are mixed or in some cases injected with male sperm in a petri dish and then re-inserted into the womb. Success rates per treatment cycle for 1985–8 were between a 9.9% to 12.9% pregnancy rate and a 8.6% to 10.1% live birth rate. Figures quoted are from the Interim Licensing Authority, Fifth Report, 1990 (Morgan and Lee 1991: 15–16).

4 Michelle Stanworth gives a useful overview of various feminist positions on reproductive technology. For 'nature versus technology' arguments, see Corea, *The Mother Machine: Reproductive Technologies from Artificial Insemination to Artificial Wombs* (1985), Corea, Duelli Klein *et al.*, *Man-Made Women: How New Reproductive Technologies Affect Women* (1985) and Spallone and Steinberg, *Made to Order: The Myth of Reproductive and Genetic Progress* (1987).

5 For analyses of this issue from various perspectives within cultural theory, including literature and film, see Bowlby, 'Frankenstein's Woman-to-be: Choice and the New Reproductive Technologies' (1993), Braidotti, 'Body Images and the Pornography of Representation' (1991), Franklin, Lury and Stacey, *Off-Centre: Feminism and Cultural Studies* (1991), Jacobus, 'In Parenthesis: Immaculate Conception and Feminine Desire' (1990) and Kuhn, *Alien Zone: Cultural Theory and Contemporary Science Fiction Cinema* (1990).

6 For a valuable exploration of these issues, see Maureen McNeil 'New Reproductive Technologies: Dreams and Broken Promises' (1994: 483–506).

7 The majority of gynaecologists involved in reproductive technology are men, a fact which probably is reflective of its high-tech status within medicine. Nelly Oudshoorn argues that gynaecology is part of an institutional process of Othering in which women are the objects and men the subjects of investigations of the female body (Nelly Oudshoorn, paper given at the 'The Future of Nature' *BLOCK* conference, London: Tate Gallery, 1994).

8 Since beginning my research early in 1994, there has been a shift towards greater discussion in the media of women's experiences of infertility treatment, including its failures, for example in the series *Labours of Eve* (BBC2, 1995). But, however sympathetically handled, this still took the form of a personal narrative in which one woman was encouraged to re-live her, often traumatic, experience each week. There has still been no systematic research on the long-term risks, side effects or benefits of IVF, for example, possible links between drugs used in infertility treatment and ovarian cancer, despite the fact that it has been used on women for sixteen years.

9 As well as various medical and legal experts, initial membership of the Human Fertilisation and Embryo Authority included Liz Forgan, Director of Programmes at Channel 4, Rabbi Julia Neuberger and the actress, Penelope Keith. See Morgan and Lee, *Blackstone's Guide to the Human Fertilisation and Embryology Act 1990* (1991), for full membership and a detailed analysis of the ethical and legal debates surrounding the 1990 Act.

10 Jackie Stacey discusses Clause 28 and its relationship to familial ideology in the 1980s in Stacey, 'Promoting Normality: Section 28 and the Regulation of Sexuality' (1991).

11 The Warnock Committee argued that:

> To judge from the evidence, many believe that the interests of the child dictate that it should be born into a home where there is a loving, stable, heterosexual relationship and that, therefore, the deliberate creation of a child for a woman who is not a partner in such a relationship is morally wrong.
>
> (Warnock 1984: para. 2.11)

12 For example, Sheffield Health Authority imposed a restriction on IVF treatment under the NHS to couples under thirty-five, a decision which was tested and upheld in the High Court in October 1994.

13 It is clear that many doctors are opposed to giving fertility treatment to single women. Ian Cooke, a member of HFEA, and Professor of Obstetrics and Gynaecology at the University of Sheffield Jessop Hospital for Women, has stated that it is the doctor's right under the legislation to decide whether parents are capable of taking care of a child, and that this might exclude single and older mothers (over 35). 'Social workers might say it is better to put a child into a lesbian couple than into a single woman, because you are bringing up a child in a sharing relationship' (sic) (Professor Ian Cooke, lecture given at Sheffield Hallam University, June 1994).

14 See Jacobus, 'In Parenthesis: Immaculate Conception and Feminine Desire' (1990) for useful discussion of the wider implications of the 'Baby M' case in relation to definitions of motherhood.

15 See McNeil and Litt, 'More Medicalising of Mothers: Foetal Alcohol Syndrome in the USA and Related Developments' (1992) and Stanworth, 'Reproductive Technologies and the Deconstruction of Motherhood' (1987) for accounts of the legal treatment of women during pregnancy in the United States, and McClean, 'Reproductive Medicine' (1992) in Britain.

16 See Franklin, 'Fetal Fascinations: New Dimensions to the Medical-scientific Construction of Fetal Personhood' (1991), Hartouni, 'Fetal Exposures: Abortion Politics and the Optics of Allusion' (1992), Jacobus, 'In Parenthesis: Immaculate Conception and Feminine Desire' (1990), Petchesky, 'Foetal Images: The Power of Visual Culture in the Politics of Reproduction' (1991), Stabile, 'Shooting the Mother: Fetal Photography and the Politics of Disappearance' (1992) and Zimmerman, 'Fetal Tissue: Reproductive Rights and Amateur Activist Video' (1993) on the use of fetal imagery in abortion campaigns.

17 See Petchesky, 'Foetal Images: The Power of Visual Culture in the Politics of Reproduction' (1991: 57–80), for a detailed deconstruction of the video. In the United States, abortion has assumed political centrality for feminists because of a decade of legal assaults on Roe v. Wade as well as increasing physical violence on women and on staff at abortion clinics.

18 Evelyn Fox Keller has recently argued that the micromanipulation of embryos creates a different gaze in which 'seeing' and 'touching' are interdependent (E. Fox Keller, paper given at the 'Future of Nature' *BLOCK* conference, London: Tate Gallery, 1994). For a useful discussion of the wider role of visual technologies in the representation of the female body, see the special issues of *Camera Obscura* (1992), nos. 28 and 29.

19 Jacques Cohen, Associate Professor of Embryology, Obstetrics and Gynaecology, speaking on *Life and ART*, Channel 4, 1993.

20 Since 1991, Benetton campaigns have featured increasingly controversial images of race, dying people with AIDS, and soldiers in Bosnia. In 1995, Benetton franchisees in Germany sued the Italian firm for losses incurred as result, they argued, of such contentious advertising. For Benetton's use of racial imagery, see D.A. Bailey and S. Boyce, 'Exploring the Benetton Look' (1990) and L. Back and V. Quaade, 'Dream Utopias, Nightmare Realities: Imaging Race and Culture within the World of Benetton Advertising' (1993).

21 For a more detailed discussion of the concept of abjection in the work of Mary Douglas and Julia Kristeva, see Chapter 6.

22 These fears have been explored by Rosalind Coward who has suggested that the use of aborted fetal tissue to create new genetic material offers a double threat to human reproduction, and Karl Figlio who has suggested that it raises fears of a Frankenstein monster made up of dead body parts (R. Coward and K. Figlio, papers given at the 'Future of Nature' *BLOCK* conference, London: Tate Gallery, 1994).

23 In cases of surrogacy, the genetic mother may be a different person from the birth mother or the birth mother from the social mother. This would be the case where the genetic parent's sperm and egg are mixed outside and inserted into the womb of the surrogate mother and the child is then brought up by the woman who has paid for it. Until recently the 'social mother' had to go through formal adoption process to obtain legal rights of custody.

24 It is significant that the definition of 'father' required nine subsections of the 1990 Act. See Smart, ' "There is of Course the Distinction Dictated by Nature": Law and the Problem of Paternity' (1987) on the previous legal status of fatherhood in relation to reproductive technologies before the Act.

25 For example, Sandy already has two adopted children. When they 'steal' their father's car, the other two women friends go to rescue them from the police station.

26 This phrase was used by the artist, Deborah Law, in conversation with me about her work.

27 *Reclaiming the Madonna: Artists as Mothers* was the title of an exhibition first shown at the Usher Gallery, Lincoln in 1993 and subsequently exhibited by the Museum of Women's Art in London in 1994, together with a symposium on 'Motherhood and Creativity'. The work included was mainly based on personal experience, and only one artist, Julie Held, explored the subject of infertility.

28 The exhibition and accompanying catalogue for *IN VITRO: de les mitologies de la fertilitat als limits de la ciencia*, Barcelona, 1992, were produced by KrTU (Creation and Culture, Research, Technology, Universal). An international symposium which accompanied the exhibition in Barcelona included scientists, doctors, sociologists, historians and artists as speakers, ranging from Professor Robert Edwards, Director of the Bourn Hall Clinic, to the feminist writer, Marina Warner. On a more modest level, the *BLOCK* conference 'The Future of Nature' held at the Tate Gallery, London, in November 1994 explored connections and confrontations between culture and nature. At the time of writing, an exhibition of contemporary art on the theme of fertility to be curated by Deborah Law and Sandra Peaty is planned for 1996 in London.

29 Rebecca Horn's installations, shown in a retrospective at the Tate Gallery and the Serpentine Gallery in London in 1994 have a similar quality of life interacting with technology to create new cyborg forms which expose the body's fragility and vulnerability as, for example, in *The Peacock Machine*, 1982, and *77 Branches of Destiny*, 1992.

30 For an interesting discussion of the relations between creativity and reproduction, see O'Brian, *The Politics of Reproduction* (1981: 116–39).

6 BODY HORROR?
FOOD (AND SEX AND DEATH) IN WOMEN'S ART

1 Early versions of this chapter were given as papers in the 'Women and Culture' seminar series at the Royal College of Art in 1993, and MA Women's Studies seminar at Loughborough University in 1995. My thanks to Penny Sparke and Celia Kitzinger for giving me the opportunity to present the ideas.

2 Marina Warner has demonstrated how, in early Christian writing, female physical beauty was seen merely as a container for the corruption within. Medieval clerics frequently railed against the bestial materiality of the female body: 'The beauty of women is only skin-deep. If men could only see what is beneath the flesh and penetrate below the surface with eyes like the Boeotian lynx, they would be nauseated just to look at women, for all this feminine charm is nothing but phlegm, blood, humours, gall' (Abbot Odo of Cluny, 10th century, quoted in Warner 1985: 251). In secularized form, a similar misogyny can be traced into the modern period, for example, in Jonathan Swift's poem 'The Lady's Dressing Room' (1730), where a lover itemizes the detritus of his mistress's chamber in order to expose feminine beauty as cosmetic artifice. Swift builds up a vicious litany of bodily wastes before the lover finally discovers the horrid truth that his 'Celia shits'. I am grateful to Judy Simons for pointing out this reference to me.

3 *Death Becomes Her*, director Robert Zemeckis, 1992. The film was marketed on its special effects with trailers showing a sensational sequence of Meryl Streep with her body reassembled back to front. In UK video stores, *Death Becomes Her* is classified as a comedy rather than horror film.

4 This oscillation between control and release is clearly not unique to women, but the use of food as opposed to alcohol is still clearly gendered.

5 A series of exhibitions in Britain in the mid-1990s have addressed the body. These include *Bad Girls*, London 1994, *Rites of Passage: Art for the End of the Century*, London 1995, and *Fetishism*, Brighton 1995, as well as individual retrospectives on Kiki Smith, Rebecca Horn and Helen Chadwick.

6 Fascination with a deadly 'killer' disease that apparently consumed human flesh within hours became the focus of extensive media panic in Britain in 1994. The coverage of what turned out to be a common bug (streptococcus) drew on a repertoire of representations from horror film around the invasion of the body. The shift to body horror in science-fiction films of the 1980s is discussed by B. Creed, *The Monstrous Feminine: Film, Feminism, Psychoanalysis* (1993), E.A. Kaplan, *Motherhood and Representation: The Mother in Popular Culture and Melodrama* (1992), A. Kuhn (ed.), *Alien Zone: Cultural Theory and Contemporary Science Fiction Cinema* (1990) and E. Showalter, *Sexual Anarchy: Gender and Culture at the Fin de Siècle* (1991).

7 Other feminist critics such as Linda Bundtzen have argued that the monster in *Alien* is 'a primal mother defined solely by her devouring jaws and her prolific egg production' (Bundtzen 1987: 12), while some readings have identified the monster as representative of phallic male power. See J. Kavannagh, 'Son of a Bitch: Feminism, Humanism and Science in *Alien*' (1980). All critics of *Alien* have noted that it is full of recurrent images of birth from the emergence or re-birth of the spaceship crew to the famous sequence of the violent birth of the alien from Kane's stomach.

8 See L. Nead, *The Female Nude: Art, Obscenity and Sexuality* (1992). Conversely, the representation of the 'obscene' body in pornography breaks through the

boundary which separates the viewer from the viewed in order that he be sexually aroused and moved.

9 Lucy Lippard's often quoted comment on women's body art of the 1970s still seems apposite here: 'A woman using her own face and body has a right to do what she will with them, but it is a subtle abyss that separates men's use of women for sexual titillation from women's use of women to expose that insult' (Lippard, *From The Center: Feminist Essays on Women's Art*, 1976: 125).

10 Sherman's mutilated and reassembled bodies have been likened to Hans Bellmer's Surrealist doll constructions of the 1930s. Bellmer's work has attracted equally ambivalent readings. For example, while Luce Irigaray argues that women's bodies are subjected to violent scopic and sadistic drives in his work, (1994: 12), Hal Foster has argued that Bellmer's work is a critique of the armoured body of fascism (Foster 1991). Rosalind Krauss discusses Sherman's work in relation to Bellmer in *Cindy Sherman* (1993: 202–12).

11 Damien Hirst's 'dead animals' are clearly abject in this sense, but are already commodified within the mainstream of postmodernism and shown in international venues from the Whitney Museum, New York, to the Saatchi Gallery, London, and the Venice Biennale. They have, ironically, been subject to transgressive acts by others. When Mark Bridger poured ink over Damien Hirst's pickled sheep in the Serpentine Gallery in 1994, he was prosecuted and received a two-year conditional discharge.

12 See Whitney Chadwick, *Women Artists and the Surrealist Movement* (1985: 103–40). Chadwick does not entirely escape this tendency herself; while acknowledging that the (male) Surrealist conception of the erotic was revolutionary, she discusses women's uses of the erotic in terms of their own sexual liberation.

13 Common to these was the artist's use of her own body and the attempt, by transforming, deforming or manipulating it, to challenge prevailing cultural representations of women, for example, Hannah Wilke's *S.O.S.* (Scarification Object Series), 1974, in which she attached pieces of chewed gum in vaginal shapes to her face and nude body. On early feminist body art, see Lucy Lippard, 'The Pains and Pleasures of Women's Body Art' (in Lippard 1976), Lisa Tickner, 'The Body Politic: Female Sexuality and Women Artists since 1970' (in Tickner 1978) and Leslie C. Jones 'Transgressive Femininity: Art and Gender in the Sixties and Seventies' (1993).

14 See Mary Russo, 'Female Grotesques: Carnival and Theory' (1986) and Peter Stallybrass and Allon White, *The Poetics and Politics of Transgression* (1986: 171–91).

15 See Hal Foster, '*Armor Fou*' (1991) for a discussion of Lacan's theory of the 'body-in-pieces' (*corps morcelé*) in the context of Surrealist art. Susan Buck Morss discusses Lacan's ideas in relation to a theory of modernity and fascism in 'Aesthetics and Anaesthetics: Walter Benjamin's Artwork Essay Reconsidered' (1992).

16 In the laws of dietary prohibition outlined in Leviticus, these are defined in relation to the rules of Creation in which animals were separated according to their element as fish, fowl, or four-legged beasts. Any creature which transgressed these rules could not be eaten, 'Thus, anything in the water which has not wings or scales is unclean' (Leviticus xi). As well as these dietary prohibitions, other taboos concerned childbirth, skin diseases, stained garments, leprosy and issues and secretions from the human body.

17 As an anthropologist, Douglas insisted on the need to specify these differ-
ences. She was particularly resistant to what she saw as a reductionism in
psychoanalytic interpretations of ethnographic material which read primitive
societies as representative of an infant state of pre-individuation and anal-
eroticism. See Douglas (1991: 115–18). Douglas's own position can at times
be criticized conversely for functionalism, for example, in her discussion of
caste pollution in Indian society.

18 The fetish object both *substitutes* for the thing which is missing and *commem-
orates* in its absence. See Laura Mulvey, 'Some Thoughts on Theories of
Fetishism in the Context of Contemporary Culture' (1993).

19 During the period of breastfeeding my daughter I was possessed by the thought
that her body grew out of mine. In commonsense terms this is obvious from
the constant injunctions from midwives and babycare manuals to be careful
to eat 'for the baby', but at an existential level it is profoundly affecting.

20 See S. Orbach, *Fat Is a Feminist Issue* (1981), K. Chernin, *The Hungry Self:
Women, Eating and Identity* (1986), and N. Wolff, *The Beauty Myth* (1990:
146–88) for further references.

21 It is still overwhelmingly young women who suffer from eating disorders
although anorexia amongst boys is now recognised. There are an estimated
140,000 anorexics and bulimics in Britain according to the Eating Disorders
Association, with 5–6,000 new cases each year.

22 This work bears parallels with Jo Spence's 1984 phototherapy work about the
emotional roots of eating patterns, in which Spence photographed herself pour-
ing white sugar over her head and licking it from her hands. See Spence, *Putting
Myself in the Picture: A Political, Personal and Photographic Autobiography*
(1986: 182).

23 Alison Lurie makes the same analogy in *The War Between the Tates*: 'Women
age like apples she had once read. Most, fallen under the tree ungathered,
gradually soften and bulge and grow brown and rotten.'

24 In Nicolas Poussin's late painting *Spring* or *The Earthly Paradise*, 1660–4,
Adam and Eve are shown as young and innocent, in contrast to the more
usual depiction of Eve as a sensual and mature woman in northern Renaissance
art. For a useful discussion of the representation of women as the causal
link between lust and death, see E. Lawton Smith, 'Women and the
Moral Argument of Lucas van Leyden's *Dance around the Golden Calf*'
(1992). She quotes the late fifteenth-century manual for witch-hunters, the
Malleus Maleficarum, which described Eve as 'more bitter than death. . . .
Because that is natural and destroys only the body; but the sin that arose
from woman [lust] destroys the soul by depriving it of grace' (Lawton Smith
1992: 302).

25 As Christine Battersby comments, Kristeva still sees women's writing as a
fetish substitute for the phallus, a compensation for lack of identity experi-
enced during the maternal relationship (C. Battersby 1995: 130).

26 Gamman and Makinen make a distinction between what they call 'the com-
modity fetishism of the erotic', in which the female body is eroticized as the
object of the gaze, and orthodox sexual fetishism where the fetish object sub-
stitutes for the sexual act. Laura Mulvey argues that the two 'reinforce each
other through topographies and displacements linking the erotic spectacle of
the feminine to the eroticised spectacle of the commodity' (Mulvey 1993: 19).

27 'When a woman ventures out in those regions it is usually to gratify, in very
maternal fashion, the desire for the abject that ensures the life (that is the
sexual life) of the man whose symbolic authority she accepts' (Kristeva 1982:

54). It is such passages which tend to stick in the throat of any feminist reader of Kristeva.

28 The video and photographic installation *Sounding the Depths*, 1992, made in collaboration by Pauline Cummins and Louise Walsh, very powerfully evokes this relation between orality and the desiring, speechless body. In their images, the naked female body dissolves into an enormous gaping mouth which opens to show tongue, throat and teeth as though the body itself were trying to deliver its pain and pleasure. On the soundtrack, inarticulate vocalization and laughter suggest a mixture of physical sensations which cannot be spoken in words. Sarah Pucill's film *Milk and Glass*, 1993, explores a similar territory of abjection.

29 Gamman and Makinen point out that much of the research on anorexia and bulimia has focused on college students, that is, a stage in life when an individual is separated from her parental authority and home, possibly for the first time, and expected to take on responsibility for herself. As they suggest, this seems to activate regression to an earlier phase of orality, often in epidemic proportions. It may also explain class differences, in that bulimia appears to be a phenomenon associated with middle-class femininity, although this could also reflect the skewing of the research by the selection of students as a data base.

30 In Britain consumption of chocolate rose in the 1980s from 8.7 oz per person per week in 1984 to 9.2 oz in 1988 – a frightening 95 per cent of the British population now eat chocolate at least once a day. Allison James quotes these figures from the Confectionery Keynote Report, 1990, in 'The Good, the Bad and the Delicious: The Role of Confectionery in British Society' (1990: 672). Unfortunately, no statistics by gender are given. Gamman and Makinen quote the finding that chocolate contains phenylethylamine, a chemical apparently produced by the body in a sexual 'high' (Gamman and Makinen 1993: 143).

31 Margaret Atwood uses food as a metaphor for the body in a number of her short stories, for example, 'Spring Song of the Frogs' (1983). I am grateful to Jill Le Bihan for examples from Atwood and other references to food in women's writing.

32 Sartre offers an extended analysis of the issues of identity, self and other, in relation to the body and to sexual desire in *Being and Nothingness: An Essay on Phenomenological Ontology* (1943), especially Part 3, chapters 1 and 2.

33 In an earlier installation by Chadwick, *Of Mutability*, 1987, which also addressed female desire, a bound figure of Cornucopia appears: 'gagging with pleasure. She's bursting out of the basket and fruit is bursting out of her' (Chadwick 1987). The artist's own body is broken into parts, each separately photocopied and re-assembled whose boundaries are spilling over. In this allegory of the senses, female sexuality is represented as both sado-masochistic and excessive.

34 'Many of my women patients who suffer from disturbances of eating, *globus hystericus*, constriction of the throat and vomiting, have indulged energetically in sucking during their childhood' (Freud 1977: 99).

7 IDENTITIES, MEMORIES, DESIRES

1 See Susan J. Hekman, *Gender and Knowledge: Elements of a Postmodern Feminism* (1990: 62–104) for a useful summary of these debates.

2 See Stuart Hall, 'Minimal Selves' (1987) for a discussion of centre, periphery and marginality. Gilane Tawardros and Pennina Barnett address Hall's ideas in the context of discussing art practices by women in P. Barnett, 'Routes to Roots' (1944: 18–20) and G. Tawardros, 'The Sphinx Contemplating Napoleon: Black Women Artists in Britain' (1995: 25–30).

3 Rajeswari Sunder Rajan defines postcoloniality as 'a condition that describes a specific historical identity, politics and method' (R. Sunder Rajan, *Real and Imagined Women: Gender, Culture and Postcolonialism*, 1993: 5). The main focus for discussion of postcolonial art practices in Britain has been the journal *Third Text* (1987–). Here I have tended to use the awkward but descriptively accurate phrase 'postcolonial feminist art practice' to refer to the work of a range of artists.

4 The collective term diaspora was used originally to refer to the dispersed Jews after the Babylonian captivity and then, by extension, to all Jews living outside Israel in the modern period. Within postcolonial writing it refers to the forced migration of African peoples under slavery or, more broadly, with reference to the general displacement of peoples as a result of colonialism in the Middle East, Africa, Indian sub-continent and Far East. I am using the term here in all three senses. Paul Gilroy offers a critical view of the concept of diaspora in *The Black Atlantic: Modernity and Double Consciousness* (1993: 187–223).

5 The name of the artist, Mary Ann Francis, did not appear. She was then at Central St Martins as a student on the part-time BA (Hons) in Fine Art and Critical Studies.

6 This statement is taken from a photocopied collection of pamphlets and statements by women in Serbia, translated from Serbo-Croat. The 'Women In Black' are a small group who began to demonstrate against the war in former Yugoslavia on 9 October 1991 and have since held weekly vigils each Wednesday in Belgrade. They took their name from a similar protest by Palestinian women and have established links between women's groups in Serbia, Croatia and Bosnia, as well as with international solidarity movements across the world, publishing pamphlets against Serbian militarism, ethnic cleansing, and the use of rape as a weapon of war. (This translation is mine from an Italian original.)

7 See, for example, Sandra Kemp and Paolo Bono (eds), *The Lonely Mirror: Italian Perspectives on Feminist Theory* (1993).

8 See Lubaina Himid, 'Mapping: A Decade of Black Women Artists' (1990).

9 The American writer, Alice Walker, appears as the Muse, Phalia, holding a bouquet of flowers in a pose which echoes that of the black servant in Manet's *Olympia*, 1863. Sander Gilman discusses the significance of the black woman, Laure, in Manet's *Olympia* in 'Black Bodies, White Bodies' (1986) as does Griselda Pollock in *Avant Garde Gambits 1888–1893: Gender and the Colour of Art History* (1992). Elsewhere in her work, for example, in *Hysteria*, 1993, Maud Sulter has explored the historical suppression of black women as creators through the figure of a successful black woman artist working in Rome in the nineteenth century, who disappears.

10 Matthew Arnold's famous definition of culture from *Culture and Anarchy* was written at the time of the 1867 Reform Act. Arnold intended culture to be a defence against the anarchy of bourgeois capitalism and working-class revolt. In a 'weak' form, Said's cultural nationalism might be seen in the British Prime Minister John Major's defence of core English values in terms of cricket on the village green, warm beer and old maids cycling to church on Sunday mornings.

11 This can be seen in the case of Northern Ireland where cultural definitions of Catholicism and Protestantism are used to bolster Nationalist and Unionist identities.

12 Since Edward Said's formative analysis in *Orientalism* (1978), there have been a number of more detailed studies of gender and Orientalism in art. See L. Nochlin, 'The Imaginary Orient' (1983), S. Graham Brown, *Images of Women: The Portrayal of Women in Photography of the Middle East* (1988), R. Kabbani, *Europe's Myths of Orient* (1986), J. de Groot, 'Sex and Race: The Construction of Language and Image in the 19th Century' (1989), C. Tawardros, 'Foreign Bodies: Art History and the Discourse of 19th Century Orientalist Art' (1988) and R. Lewis 'Only Women Should Go to Turkey' (1993).

13 Rajeswari Sunder Rajan cites criticism of Spivak's assumption of the intellectual's self-assigned role '"to give the subaltern a voice within history" ... speaking "for" (other) women' (Sunder Rajan, *Real and Imagined Women: Gender, Culture and Postcolonialism* 1993: 4). Desa Philippi and Anna Howells make a similar argument about the American artist, Nancy Spero. See D. Philippi and A. Howells, 'Dark Continents Explored by Women' (1991: 238–60). Sunder Rajan is also critical, from a feminist position, of attempts to reclaim aspects of 'traditional' culture, such as sati (the widow burnt on a husband's funeral pyre) which were themselves often partly a consequence of colonialism.

14 *These Colours Run* was the title of a touring exhibition of Lesley Sanderson's work organized by the independent curator, Eddy Chambers, who has been responsible for curating a number of group shows of black and Asian artists since the mid-1980s. It was co-funded by the Institute of International Visual Arts (INIVA) in London, whose aim is to promote the work of artists, academics and curators from a plurality of cultures and cultural perspectives. A similar interest in hybridity can be seen in other cultural spheres, for example, in the dance work of Shobana Jeyasingh.

15 I am thinking here particularly of the kind of feminist writing, film-making and art practices that cross the boundaries of fiction, autobiography and history, and in which the object of search is often the daughter's psychic and social relation to her mother. Examples of such writing include Kim Chernin, *In My Mother's House* (1985) Carolyn Steedman, *Landscape For a Good Woman* (1986), and Michèle Roberts *Daughters of the House* (1992). A number of film-makers have also explored similar themes, for example, Margarethe von Trotta in *The German Sisters*, and Helma Sanders Brahms in *Germany Pale Mother* both from the early 1980s. Examples within feminist art practice include May Stevens's 'history' series from the late 1970s, *Ordinary/ Extraordinary* in which she juxtaposed the lives of her own mother and Rosa Luxembourg, and Marie Yates's *The Only Woman*, 1985, which examines the tensions and conflicts of the family album, a theme also explored in different ways by Jo Spence in her phototherapy collaborations with Rosy Martin in the mid-1980s.

16 For a brief summary and useful critique of Foucault's concept of self-representation, see L. McNay, 'Problems of the Self in Foucault's Ethics of Self' (1992).

17 The quotation is from Alan Rusbridger's obituary for Dennis Potter in the *Guardian*, (8 June 1994). The exploration of memory and identity as fragmented and partly fictional is, of course, not unique to feminist practice. Dennis Potter's television plays used a blend of narrative, memory, fantasy and music to explore the representation of masculine subjectivity and desire.

18 Eugenic theories have gained a disturbing new lease of life in some contemporary versions of sociobiology, for example, Richard Hernstein and Charles Murray, *The Bell Curve* (1993).

19 Edward Said describes a similar process of becoming an historical subject, although from an opposed viewpoint, that for him was precipitated at the moment during the Arab–Israeli war in 1967 when he realized what it meant to be a Palestinian, an identity which, he suggests, is still in the process of formation (Said 1988: 43).

20 Itzak Dogan from the soundtrack of *Ponar*. Pam Skelton describes how 'breathing' and 'trembling' are the words used by witnesses of the pit massacres in eastern Europe to describe what they saw as many victims were shot and buried while still alive.

21 The installations *Ponar* by Pam Skelton and *Places to Remember II* by Lily Markiewicz were shown at the Imperial War Museum in London as part of a series of fiftieth anniversary commemorative exhibitions held in Britain in 1995 under the title *After Auschwitz*. Arthur Miller's 1994 play *Broken Glass*, which was premiered at the Long Wharf Theatre in New Haven, Connecticut and in Britain at the National Theatre in London, also explores the fracturing of Jewish identities in response to the events of Kristallnacht in 1938.

22 Gayatri Spivak cited in N. Miller, 'Changing the Subject' (1986: 107–8).

23 This can be compared, within a very different context, with Pam Skelton's evocation of houses which recall both pleasures and pains of remembered experience. Desa Philippi makes a similar comment about Mona Hatoum's video *Changing Parts*, 1984, in which a bathroom in her parent's house in Beirut are represented: 'In its careful *mise-en-scène* of detail, the video literally stages the process whereby these images come to function as metaphoric, as tokens of memory premised on what fuels the desire for them, the scene of struggle, separation and loss' (Philippi 1990: 75).

24 Edward Said describes the significance of Beirut as the last of the places of his childhood to which he can no longer return.

> In that respect Beirut represents a kind of nostalgia, for that period of intellectual, political and personal development which is really utterly closed, shut off in a way that is so sad. It is not as if it happened and it was over. The news from Beirut as we hear it – since my mother still lives in Beirut – is that of a city that is sort of chopping itself and bleeding to death.
>
> (Said 1988: 47)

25 For a useful discussion of the politics of Mona Hatoum's early performance work, see Guy Brett, 'A Hatoum Chronology' (1993).

26 I would want to make a distinction here between the embodiment of the engaged participant in this work and the 'active reader' inscribed formally within modernist art practices from Cubist collage to avant-garde film-making in the 1970s.

27 Paul Gilroy speaking in a seminar at Nottingham Trent University on 'The Black Atlantic: Politics and Exile' (24 June 1994). A parallel can be made with the Northern Irish artist Willy Doherty's video installation *The Only Good One Is a Dead One*, 1993, a finalist for the 1994 Turner Prize. Doherty breaks down the division between victim and perpetrator of terrorist crime by assigning them both the same narrative identity. The 'viewer' is forced to adopt a position between two video screens set at right angles to each other.

28 Keith Piper speaking during a seminar at the Site Gallery, Sheffield, (1 June 1995.) on an exhibition of his installation work *Long Journey/New Frontiers*, 1995, and Vong Phaophanit's *From Light*, 1995.

WORKS CITED

Adams, T. (1993) 'From Primal Scream to Primal Scene', *Women's Art Magazine*, 54: 14–15.

Agulhon, M. (1981) *Marianne Into Battle: Republican Imagery and Symbolism in France 1789–1880*, Cambridge: Cambridge University Press.

Arditti, R., Duelli-Klein, R. and Minden, S. (eds) (1984) *Test Tube Women: What Future for Motherhood?*, London: Pandora Press.

Arnold, M. (1981) *Culture and Anarchy*, Cambridge: Cambridge University Press.

Atwood, M. (1979) *The Edible Woman*, London: Virago.

Bachofen, J. (1967) *Myth, Religion and Mother Right* (trans. R. Manheim), Princeton and London: Princeton University Press.

Back, L. and Quaade, V. (1993) 'Dream Utopias, Nightmare Realities: Imaging Race and Culture within the World of Benetton Advertising', *Third Text*, 22: 65–80.

Baddeley, O. (1991) 'Her Dress Hangs Here: De-Frocking the Kahlo Cult', *Oxford Art Journal*, 14, 1: 10–17.

Bade, P. (1979) *Femme Fatale*, London: Ash and Grant.

Bailey, D.A. and Boyce, S. (1990) 'Exploring the Benetton Look' in *Black Markets: Images of Black People in Advertising Packaging in Britain*, Manchester: Cornerhouse.

Barnett, P. (1994) 'Routes to Roots', *Women's Art Magazine*, 57: 18–20.

Barrett, M. (1992) 'Words and Things' in M. Barrett and A. Phillips (eds) *Destabilising Theory: Contemporary Feminist Debates*, Cambridge: Polity Press.

Barrett, M. and Phillips, A. (1992) (eds) *Destabilising Theory: Contemporary Feminist Debates*, Cambridge: Polity Press.

Barthes, R. (1977a) 'The Death of the Author' and 'The Grain of the Voice' in *Image, Music, Text*, London: Fontana.

— (1977b) *Roland Barthes*, New York: Hill and Wang.

Batchelor, D. (1991) 'Abstraction, Modernism, Representation' in A. Benjamin, and P. Osborne (eds) *Thinking Art: Beyond Traditional Aesthetics*, London: Institute of Contemporary Arts.

Battersby, C. (1989) *Gender and Genius: Towards a Feminist Aesthetics*, London: Women's Press.

— (1995) 'Just Jamming: Irigaray, Painting and Psychoanalysis' in K. Deepwell (ed.) *New Feminist Art Criticism*, Manchester and New York: Manchester University Press.

Beckett, J. (1994) 'Dis/Placements' in Lesley Sanderson: *These Colours Run*, Wrexham: Library Art Centre and London: INIVA.

Behr, S. (1988) *Women Expressionists*, London, Phaidon.

Ben Levi, J., Houser, C., Jones, L.C. and Taylor, S. (1993) *Abject Art: Repulsion and Desire in American Art*, New York: Whitney Museum of American Art.

Berend-Corinth, C. (1980) *Charlotte Berend-Corinth: Eine Austellung zum 100 Geburtstag der Künstlerin Malerei und Graphik*, Erlangen.

— (1989) 'My Life with Lovis Corinth' in R. Berger (ed.) *'Und ich sehe nichts, nichts als die Malerie: Autobiographische Texte von Künstlerinnen des 18.–20. Jahrhunderts*, Fischer Taschenbuch Verlag.

Berger, J. (1972) *Ways of Seeing*, London: BBC and Penguin.

Betterton, R. (1985) 'How Do Women Look? The Female Nude in the Work of Suzanne Valadon', *Feminist Review*, 19: 3–24.

— (1992a) *(Dis)Parities*, Sheffield: Sheffield City Art Galleries.

— (1992b) 'Figuring the Maternal: The Female Nude in the Work of German Women Artists at the Turn of the Century' in Berlinische Galerie, *Profession Ohne Tradition: 125 Jahre Verein der Berliner Künstlerinnen*, Berlin: Kupfergraben Verlag.

Bland, L. (1983) 'Purity, Motherhood, Pleasure or Threat?: Definitions of Female Sexuality 1900–1970s' in S. Cartledge and J. Ryan (eds) *Sex and Love: New Thoughts on Old Contradictions*, London: Women's Press.

— (1986) 'Marriage Laid Bare: Middle Class Women and Marital Sex c. 1880–1914' in J. Lewis (ed.) *Labour and Love*, Oxford: Blackwell.

— (1995) *Banishing the Beast: English Feminism and Sexual Morality 1885–1915*, Harmondsworth: Penguin.

Boffin, T. and Frazer, J. (eds) (1991) *Stolen Glances: Lesbians Take Photographs*, London: Pandora Press.

Bordo, S. (1990) 'Reading the Slender Body' in M. Jacobus, E. Fox Keller and S. Shuttleworth (eds) *Body/Politics: Women and the Discourses of Science*, New York and London: Routledge.

Borsa, J. (1990) 'Frida Kahlo: Marginalisation and the Critical Female Subject' *Third Text*, 12: 21–40.

Bowlby, R. (1992) *Still Crazy after All These Years*, London and New York: Routledge.

— (1993) 'Frankenstein's Woman-to-be: Choice and the New Reproductive Technologies' in *Shopping With Freud*, London and New York: Routledge.

Braidotti, R. (1991) 'Body Images and the Pornography of Representation', *Journal of Gender Studies*, 1, 2: 148–50.

Breslin, J.E.B. (1993) 'Out of the Body: Mark Rothko's Paintings' in K. Adler and M. Pointon (eds) *The Body Imaged: the Human Form and Visual Culture since the Renaissance*, Cambridge: Cambridge University Press.

Brett, G. (1993) 'A Hatoum Chronology' in *Mona Hatoum*, Bristol: Arnolfini Gallery.

Bristow, J. (1992) *Sexual Sameness*, London: Routledge.

Brooks, R. (1977) 'Woman Visible, Woman Invisible', *Studio International*, 193, 987, March.

Buck-Morss, S. (1993) 'Aesthetics and Anaesthetics: Walter Benjamin's Artwork Essay Reconsidered', *New Formations*, 20: 123–43.

Buhler Lynes, B. (1993) 'The Language of Criticism', *Women's Art Magazine*, 51: 4–19.

Bullock, I. and Pankhurst, R. (1992) (eds) *Sylvia Pankhurst: From Artist to Anti-Fascist*, Basingstoke and London: Macmillan.

Bundtzen, L.K. (1987) 'Monstrous Mothers: Medusa, Grendel and Now Alien', *Film Quarterly*, Spring: 11–17.

Butler, J. (1990) *Gender Trouble: Feminism and the Subversion of Identity*, London and New York: Routledge.

Chadwick, H. (undated) *Enfleshings*, New York: Aperture Books.

Chadwick, W. (1985) *Women Artists and the Surrealist Movement*, London: Thames and Hudson.

— (1990) *Women, Art and Society*, London: Thames and Hudson.

Charlesworth-Cunliffe, H. (1992) 'Sylvia Pankhurst as an Art Student' in I. Bullock and R. Pankhurst (eds) *Sylvia Pankhurst. from Artist to Anti-Fascist*, Basingstoke and London: Macmillan.

Chave, A.C. (1989) *Mark Rothko: Subjects in Abstraction*, Cambridge, Massachusetts: Harvard University Press.

— (1990a) 'Minimalism and the Rhetoric of Power', *Arts Magazine*, January: 44–61.

— (1990b) 'O'Keeffe and the Masculine Gaze', *Art in America*, 78: 115–25, 177, 179.

Chernin, K. (1985) *In My Mother's House*, London: Women's Press.

— (1986) *The Hungry Self: Women, Eating and Identity*, London: Virago.

Church Gibson, P. and Gibson, R. (eds) (1993) *Dirty Looks: Women, Pornography, Power*, London: British Film Institute.

Comand, N. (1994) *Repulsive Attractions: Abjection in Contemporary Art*, unpublished dissertation.

Comini, A. (1982) 'Gender or Genius? The Women Artists of German Expressionism' in M. Broude and M. Garrard (eds) *Feminism and Art History*, New York: Harper and Row.

Corea, G. (1985) *The Mother Machine: Reproductive Technologies from Artificial Insemination to Artificial Wombs*, London: Women's Press.

Corea, G., Duelli Klein, R. *et al.* (1985) *Man-Made Women: How New Reproductive Technologies Affect Women*, London: Hutchinson.

Creed, B. (1986) 'Horror and the Monstrous-Feminine: An Imaginary Abjection', *Screen*, 27: 1.

— (1990) 'Gynesis, Postmodernism and the Science Fiction Horror Film' in A. Kuhn (ed.) *Alien Zone: Cultural Theory and Contemporary Science Fiction Cinema*, London: Verso.

— (1993) *The Monstrous Feminine: Film, Feminism, Psychoanalysis*, London and New York: Routledge.

Croft, S. and Macdonald, C. (1994) 'Performing Postures', *Women's Art Magazine*, 57: 9–12.

Daly, M. (1978) *Gyn/Ecology: The Metaethics of Radical Feminism*, Boston: Beacon Press.

Davin, A. (1978) 'Imperialism and Motherhood', *History Workshop Journal*, 5: 9–66.

de Groot, J. (1989) 'Sex and Race: The Construction of Language and Image in the 19th Century' in S. Mendus and J. Rendall (eds) *Sexuality and Subordination*, London: Routledge.

de Lauretis, T. (1984) *Alice Doesn't: Feminisim, Semiotics, Cinema*, Bloomington: Indiana University Press.

— (ed.) (1986) *Feminist Studies/Critical Studies*, Basingstoke and London: Macmillan.

Deepwell, K. (1987) 'In Defence of the Indefensible: Feminism, Painting and Postmodernism', *Feminist Art News*, 2, 4: 9–12.

— (1994) 'Paint Stripping', *Women's Art Magazine*, 58: 14–16.

— (ed.) (1995) *New Feminist Art Criticism*, Manchester and New York: Manchester University Press.

Diane-Radycki, J. (1982) 'The Life of Lady Art Students: Changing Art Education at the Turn of the Century', *Art Journal*, Spring: 9–13.

Dikstra, B. (1986) *Idols of Perversity: Fantasies of Feminine Evil in Fin de Siècle Culture*, Oxford and New York: Oxford University Press.

Dimbleby, J. (1985) *Sweet Desserts*, London: J. Sainsbury plc.

Doane, M.A. (1982) 'Film and Masquerade: Theorising the Female Spectator', *Screen*, 23: 3-4, September–October.

— (1988–9) 'Masquerade Reconsidered: Further Thoughts on the Female Spectator', *Discourse*, II.

— (1990) 'Technophilia: Technology, Representation and the Feminine' in M. Jacobus, E. Fox Keller, and S. Shuttleworth (eds) *Body/Politics: Women and the Discourses of Science*, New York and London: Routledge.

Dodd, K. (ed.) (1994) *A Sylvia Pankhurst Reader*, Manchester and New York: Manchester University Press.

Douglas, M. (1991) *Purity and Danger: An Analysis of the Concepts of Pollution and Taboo*, London and New York: Routledge.

Duckworth, J. (1992) 'Sylvia Pankhurst as an Artist' in I. Bullock and R. Pankhurst (eds) *Sylvia Pankhurst: From Artist to Anti-Fascist,* Basingstoke and London: Macmillan.

Duncan, C. (1977) 'The Esthetics of Power in Modern Erotic Art', *Heresies* 1: 46–50.

— (1982) 'Happy Mothers and Other New Ideas in Eighteenth Century French Art' in N. Broude and M. Garrard (eds) *Feminism and Art History*, New York: Harper and Row.

Ellman, M. (1993) *The Hunger Artists: Starving, Writing and Imprisonment*, London: Virago.

Faderman, L. (1981) *Surpassing the Love of Men*, London: Junction Books.

First, R. and Scott, A. (1980) *Olive Schreiner* New York: Schocken Books.

Fortnum, R. (1993) *ContrA DictioN*, Winchester: Winchester School of Art.

— (1994) 'Minimal Maidens', *Women's Art Magazine*, 61: 26–7.

Fortnum, R. and Houghton, G. (1989) 'Women and Contemporary Painting: Re-presenting Non-representation', *Women Artists Slide Library Journal*, 28: 4–10.

Foster, H. (1991) '*Armor Fou*', *October*, 56: 65–97.

Foucault, M. (1977) 'What Is an Author?' in D. Bouchard (ed.) *Language, Counter-memory, Practice*, Ithaca: Cornell University Press.

— (1984) 'What is Enlightenment?' in P. Rabinow (ed.) *The Foucault Reader*, Harmondsworth: Peregrine.

Fox Keller, E. (1985) *Reflections on Gender and Science*, New Haven: Yale University Press.

Franklin, S. (1991) 'Fetal Fascinations: New Dimensions to the Medical-Scientific Construction of Fetal Personhood' in S. Franklin, C. Lury, and J. Stacey (eds) *Off-Centre: Feminism and Cultural Studies*, London and New York: Harper Collins.

Franklin, S., Lury, C. and Stacey, J. (eds) (1991) *Off-Centre: Feminism and Cultural Studies*, London and New York: HarperCollins.

Freud, S. (1977) *On Sexuality: Three Essays on the Theory of Sexuality and Other Works*, Harmondsworth: Penguin Books.

Fuller, P. (1980) 'Abstraction and "The Potential Space"', in *Art and Psycho-analysis*, London: Writers and Readers.

Fuseli, H. (1971) 'Aphorisms in Art', in L. Eitner, (ed.) *Neoclassicism and Romanticism 1750–1850: Sources and Documents*, vol. 1, London: Prentice Hall International.

Gallop, J. (1988) *Thinking through the Body*, New York: Columbia University Press.

Gamman, L. and Makinen, M. (1994) *Female Fetishism: A New Look*, London: Lawrence & Wishart.

Gamman, L. and Marshment, M. (eds) (1988) *The Female Gaze: Women as Viewers of Popular Culture*, London: Women's Press.

Garb, T. (1985) 'Renoir and the Natural Woman', *Oxford Art Journal*, 8, 2: 5–15.

— (1993) 'The Forbidden Gaze: Women Artists and the Male Nude in Late Nineteenth Century France' in K. Adler and M. Pointon (eds) *The Body Imaged: The Human Form and Visual Culture Since the Renaissance*, Cambridge: Cambridge University Press.

— (1994) *Sisters of the Brush: Women's Artistic Culture in Late Nineteenth Century Paris*, New Haven and London: Yale University Press.

Gatens, M. (1992) 'Bodies, Power and Difference' in M. Barrett and A. Phillips (eds) *Destabilising Theory: Contemporary Feminist Debates*, Cambridge: Polity Press.

Gilman, S. (1986) 'Black Bodies, White Bodies: Towards an Iconography of Female Sexuality in Late Nineteenth Century Art, Medicine and Literature' in H. L. Gates (ed.) *Race, Writing and Difference*, Chicago: Chicago University Press.

Gilroy, P. (1990) 'Art of Darkness: Black Art and the Problems of Belonging to England', *Third Text*, 10: 45–52.

— (1993) *The Black Atlantic: Modernity and Double Conciousness*, London and New York: Verso.

Goodman, K. (1986) 'Motherhood and Work 1895–1905' in R.E. Joeres and M.J. Maynes (eds) *German Women in the Eighteenth and Nineteenth Centuries: A Social and Literary History*, Bloomington: University of Indiana Press.

Gordon, F. (1992) 'Reproductive Rights: The Early Twentieth Century European Debate', *Gender and History*, 4, 3: 387–99.

Gordon, L. and Dubois, E. (1983) 'Seeking Ecstasy on the Battlefield: Danger and Pleasure in Nineteenth Century Feminist Thought', *Feminist Review*, 13: 42–56.

Graham Brown, S. (1988) *Images of Women: The Portrayal of Women in Photography of the Middle East*, London: Quartet Books.

Greenberg, C. (1973) 'Avant-Garde and Kitsch' in C. Greenberg, *Art and Culture: Critical Essays*, London: Thames & Hudson.

Griffin, S. (1978) *Woman and Nature: The Roaring Inside Her*, New York: Harper & Row.

Gross, E. (1986) 'Philosophy, Subjectivity and the Body: Kristeva and Irigaray' in C. Pateman and E. Gross (eds) *Feminist Challenges: Social and Political Theory*, Sydney, London, Boston: Allen and Unwin.

Grosz, E. (1987) 'Notes towards a Corporeal Feminism', *Australian Feminist Studies*, 5: 1–16.

— (1990) 'Judaism and Exile: The Ethics of Otherness', *New Formations*, 12: 77–88.

Hall, S. (1987) 'Minimal Selves' in *Identity: The Real Me*, ICA Documents 6, London: Institute of Contemporary Arts.

Haraway, D. (1987) 'Contested Bodies' in M. McNeil (ed.) *Gender and Expertise*, London: Free Association Books.

— (1990) 'Investment Strategies for the Evolving Portfolio of Primate Females' in M. Jacobus, E. Fox Keller, and S. Shuttleworth (eds) *Body/Politics: Women and the Discourses of Science*, New York and London: Routledge.

— (1991) *Simians, Cyborgs and Women: The Reinvention of Nature*, London: Free Association Books.

WORKS CITED

Harrison, C., Frascina, F. and Perry, G. (1993) *Primitivism, Cubism, Abstraction: The Early Twentieth Century*, New Haven and London: Yale University Press.

Hartouni, V. (1992) 'Fetal Exposures: Abortion Politics and the Optics of Allusion', *Camera Obscura*, 29: 131–51.

Heath, S. (1982) *The Sexual Fix*, London and Basingstoke: Macmillan.

Hekman, S.J. (1990) *Gender and Knowledge: Elements of a Postmodern Feminism*, Cambridge: Polity Press.

Himid, L. (1988) 'Fragments', *Feminist Art News*, 2, 8: 8–9

— (1990) 'Mapping: A Decade of Black Women Artists' in M. Sulter (ed.) *Passion: Discourses on Blackwomen's Creativity*, London: Urban Fox Press.

Hinz, R. (ed.) (1981) *Käthe Kollwitz: Graphics, Posters, Drawings*, London: Writers & Readers.

Honeycutt, K. (1979) 'Socialism and Feminism in Imperial Germany', *Signs* 5, 1: 33–45.

Hutcheon, L. (1989) *The Politics of Postmodernism*, New York and London: Routledge.

Huyssen, A. (1986) 'Mass Culture as Woman: Modernism's Other' in *After the Great Divide: Modernism, Mass Culture and Postmodernism*, London: Macmillan.

— (1990) 'Mapping the Postmodern' in L. Nicolson (ed.) *Feminism/Postmodernism*, London and New York: Routledge.

Irigaray, L. (1985a) *Speculum of the Other Woman* (trans. G.C. Gill) Ithaca, New York: Cornell University Press.

— (1985b) *This Sex Which Is Not One* (trans. C. Porter), Ithaca, New York: Cornell University Press.

— (1991) 'The Bodily Encounter with the Mother' in M. Whitford (ed.) *The Irigaray Reader*, Oxford: Blackwell.

— (1993) 'Flesh Colours' in *Sexes and Genealogies*, New York: Columbia University Press.

— (1994) 'A Natal Lacuna', *Women's Art Magazine*, 58: 11–13.

Jacobus, M. (1990) 'In Parenthesis: Immaculate Conception and Feminine Desire' in M. Jacobus, E. Fox Keller and S. Shuttleworth (eds) *Body/Politics: Women and the Discourses of Science*, New York and London: Routledge.

Jacobus, M., Fox Keller, E. and Shuttleworth, S. (eds) (1990) *Body/Politics: Women and the Discourses of Science*, New York and London: Routledge.

Jay, M. (1994) *Downcast Eyes: The Denigration of Vision in Twentieth Century French Thought*, Berkeley, Los Angeles, London: University of California Press.

James, A. (1990) 'The Good, the Bad and the Delicious: The Role of Confectionery in British Society', *Sociological Review*, 38, 4: 666–88.

Jeffreys, S. (1985) *The Spinster and Her Enemies: Feminism and Sexuality 1880–1930*, London: Pandora Press.

Jones, L. (1993) 'Transgressive Femininity: Art and Gender in the Sixties and Seventies' in Ben Levi, J., Houser, C., Jones, L.C. and Taylor, S., *Abject Art: Repulsion and Desire in American Art*, New York: Whitney Museum of American Art.

Jordanova, L. (1989) *Sexual Visions: Images of Science and Medicine Between the Eighteenth and Twentieth Centuries*, London: Harvester Wheatsheaf.

Kabbani, R. (1986) *Europe's Myths of Orient*, London: Pandora Press.

Kaneda, S. (1991) 'Painting and Its Others', *Arts Magazine*, Summer: 58–64.

Kaplan, E.A. (1992) *Motherhood and Representation: The Mother in Popular Culture and Melodrama*, London and New York: Routledge.

Kavanagh, J. (1980) '"Son of a Bitch": Feminism, Humanism and Science in *Alien*', *October*, 13: 90–100.

Kearns, M. (1976) *Käthe Kollwitz*, New York: Feminist Press.

Kelly, M. (1981) 'Re-Viewing Modernist Criticism', *Screen* 22, 3: 41–62.

— (1985) *Post Partum Document*, London: Routledge & Kegan Paul.

— (1992) *Gloria Patria*, New York: Cornell University.

Kemp, S. and Bono, P. (eds) (1993) *The Lonely Mirror: Italian Perspectives on Feminist Theory*, London and New York: Routledge.

Key, E. (1983) 'The Renaissance of Motherhood' in E.S. Riemer and J.C. Fout (eds) *European Women: A Documentary History, 1789–1945*, Brighton: Harvester Press.

Kingsley Kent, S. (1990) *Sex and Suffrage in Britain 1860–1914*, London: Routledge.

Klinger, L. (1991) 'Where's the Artist? Feminist Practice and Poststructural Theories of Authorship', *Art Journal*, 50, 2: 39–46.

Kollwitz, K. (1955) *The Diaries and Letters of Käthe Kollwitz*, Chicago: Henry Regnery.

Krauss, R. (1993) *Cindy Sherman 1975–1993*, New York: Rizzoli.

Kristeva, J. (1980) 'Motherhood According to Giovanni Bellini' in *Desire in Language*, Oxford: Basil Blackwell.

— (1981) 'The Maternal Body' *m/f*, 5/6: 158–9.

— (1982) *Powers of Horror: An Essay on Abjection*, New York: Columbia University Press.

— (1986a) 'Stabat Mater' and 'Women's Time' in T. Moi (ed.) *The Kristeva Reader*, Oxford: Basil Blackwell.

— (1986b) 'A Question of Subjectivity: Interview with Susan Sellars', *Women's Review*, 12: 19–21.

— (1987) 'Talking about Polylogue' in T. Moi (ed.) *French Feminist Thought*, Oxford: Basil Blackwell.

Kroker, A and Kroker, M. (1988) (eds) *Body Invaders: Sexuality and the Postmodern Condition*, London and Basingstoke: Macmillan.

KrTU (1992) *In Vitro: A Debat*, Barcelona: KrTU.

— (1992) *IN VITRO: de les mitologies de la fertilitat als limits de la ciencia*, Barcelona: KrTU.

Kuhn, A. (1985) *The Power of the Image: Essays on Representation and Sexuality*, London: Routledge & Kegan Paul.

— (ed.) (1990) *Alien Zone: Cultural Theory and Contemporary Science Fiction Cinema*, London: Verso.

Lawton Smith, E. (1992) 'Women and the Moral Argument of Lucas van Leyden's *Dance Around the Golden Calf*', Art History, 15, 3: 296–316.

Lee, R. (1987) 'Resisting Amnesia: Feminism, Painting and Postmodernism', *Feminist Review*, 26: 5–29.

Levi, P. (1985) *The Periodic Table*, London: Michael Joseph.

Lewis, R. (1993) '"Only Women Should Go to Turkey": Henrietta Brown and Women's "Orientalism"', *Third Text*, 22: 53–64.

— (1994) 'Dis-Graceful Images: Della Grace and Lesbian Sado-Masochism', *Feminist Review*, 46: 76–91.

Lincolnshire County Council (1993) *Reclaiming the Madonna: Artists as Mothers*, Lincoln: Lincolnshire County Council.

Lippard, L. (1976) *From The Center: Feminist Essays on Women's Art*, New York: Dutton.

— (1980) 'Issue and Taboo', in ICA, *Issue: Social Strategies by Women Artists*, London: Institute of Contemporary Arts.

— (1993) 'In the Flesh: Looking Back and Talking Back', *Women's Art Magazine*, 54: 4–9.

Lloyd, J. (1991) 'Emil Nolde's "Ethnographic" Still Lifes: Primitivism, Tradition and Modernity', in S. Hiller (ed.) *The Myth of Primitivism*, London and New York: Routledge.

Lytton, C. (1988) *Prisons and Prisoners: The Stirring Testimony of a Suffragette*, London: Virago.

Mackenzie, M. (1975) *Shoulder to Shoulder*, Harmondsworth: Penguin.

McClean, S. (1992) 'Reproductive Medicine' in C. Dyer (ed.) *Doctors, Patients and the Law*, Oxford: Blackwell Scientific Publications.

McNay, L. (1992) 'Problems of the Self in Foucault's Ethics of Self', *Third Text*, 19: 3–8.

McNeil, M. (1987) 'Being Reasonable Feminists' in M. McNeil (ed.) *Gender and Expertise*, London: Free Association Books.

— (1994) 'New Reproductive Technologies: Dreams and Broken Promises', *Science as Culture*, 3, 4, 17: 483–506.

McNeil, M. and Litt, J. (1992) 'More Medicalising of Mothers: Foetal Alcohol Syndrome in the USA and Related Developments', in S. Platt, S. Scott, H. Thomas, G. Williams (eds) *Private Risks and Public Dangers*, Aldershot: Avebury Press.

McPhee, C. and Fitzgerald, A. (1987) (eds) *The Non-Violent Militant: Selected Writings of Teresa Billington-Greig*, London and New York: Routledge & Kegan Paul.

McRobbie, A. (1991) 'Women and the Arts into the 1990s', *Alba*, April/May: 4–12.

— (1992) 'Room to Move', *(Dis)parities*, Sheffield: Sheffield City Art Galleries.

Manion, E. (1988) 'The Ms-Managed Womb' in A. Kroker and M. Kroker (eds) *Body Invaders*, London and Basingstoke: Macmillan.

Marcus, J. (ed.) (1987) *Suffrage and the Pankhursts*, London: Routledge & Kegan Paul.

Markiewicz, L. (1992) *The Price of Words*, London: Book Works.

— (1993) '(Trans)Formations – (Re)Locations', unpublished paper.

Miller, A. (1990) *The Untouched Key: Tracing Childhood Trauma in Creativity and Destructiveness*, London: Virago.

Miller, N. (1986) 'Changing the Subject: Authorship, Writing and the Reader' in T. de Lauretis (ed.) *Feminist Studies/Critical Studies*, Basingstoke and London: Macmillan.

Modersohn-Becker, P. (1980) *The Letters and Journals of Paula Modersohn-Becker*, Metuchen, New Jersey and London: Scarecrow Press.

Moi, T. (1985) *Textual/Sexual Politics: Feminist Literary Theory*, London and New York: Methuen.

— (ed.) (1987) *French Feminist Thought: A Reader*, Oxford: Blackwell.

Moorjani, A. (1992) *The Aesthetics of Loss and Lessness*, Basingstoke and London: Macmillan.

Morgan, D. and Lee, R.G. (1991) *Blackstone's Guide to the Human Fertilisation and Embryology Act 1990*, London: Blackstone Press.

Morgan, J. (1990) 'Maud Sulter' in Tate Gallery Liverpool, *New North: New Art from the North of Britain*, Liverpool: Tate Gallery.

Morley, A. and Stanley, L. (1988) *The Life and Death of Emily Wilding Davison*, London: Women's Press.

Morris, M. (1988) *The Pirate's Fiancée: Feminism, Reading, Postmodernism*, London and New York: Verso.

Mouffe, C. (1994) 'For a Politics of Nomadic Identity' in G. Robertson *et al.* (eds) *Traveller's Tales: Narratives of Home and Displacement*, London and New York: Routledge.

Mulvey, L. (1989) 'Changes: Thoughts on Myth, Narrative and Historical Experience' and 'Notes on Sirk and Melodrama' in L. Mulvey, *Visual and Other Pleasures*, Basingstoke and London: Macmillan.

— (1991) 'A Phantasmagoria of the Female Body: The Work of Cindy Sherman', *New Left Review*, 188: 136–50.

— (1993) 'Some Thoughts on Theories of Fetishism in the Context of Contemporary Culture', *October*, 65: 3–20.

Mulvey, L. and Wollen, P. (1982) *Frida Kahlo and Tina Modotti*, London: Whitechapel Art Gallery.

Nead, L. (1988) *Myths of Sexuality: Representations of Women in Victorian Britain*, Oxford: Basil Blackwell.

— (1992) *The Female Nude: Art, Obscenity and Sexuality*, London and New York: Routledge.

Nesbitt, M. (1987) 'What Was an Author?', *Yale French Studies*, 73: 229–57.

Nochlin, L (1973) Why Have There Been No Great Women Artists?' in E. Baker and T. Hess (eds) *Art and Sexual Politics*, New York; Collier Books.

— (1983) 'The Imaginary Orient', *Art in America*, May: 118–31, 187–91.

— (1988) 'Courbet's Real Allegory: Rereading "The Painter's Studio"' in S. Faunce and L. Nochlin (eds) *Courbet Reconsidered*, New York: Brooklyn Museum.

— (1989) *Women, Art and Power and Other Essays*, London: Thames & Hudson.

Oakley, A. (1972) *Sex, Gender and Society*, London: Temple Smith.

O'Brian, M. (1981) *The Politics of Reproduction*, Boston and London: Routledge & Kegan Paul.

Orbach, S. (1981) *Fat Is a Feminist Issue*, London: Hamlyn.

Oudshoorn, N. (1994) *Beyond the Natural Body: An Archaeology of Sex Hormones*, London and New York: Routledge.

Owens, C. (1984) 'The Medusa Effect or the Spectacular Ruse', *Art in America*, January: 97–106.

Pankhurst, C. (1987) *Unshackled: The Story of How We Won the Vote*, London: Cresset Library.

Pankhurst, S. (1977) *The Suffragette Movement: An Intimate Account of Persons and Ideals*, London: Virago.

Parker, R. (1984) *The Subversive Stitch: Embroidery and the Making of the Feminine*, London: Women's Press.

Parker, R. and Pollock, G. (eds) (1987) *Framing Feminism. Art and the Women's Movement*, London: Pandora Press.

Perry, G. (1979) *Paula Modersohn-Becker*, London: Women's Press.

Petchesky, R.P. (1987) 'Foetal Images: The Power of Visual Culture in the Politics of Reproduction' in M. Stanworth (ed.) *Reproductive Technologies: Gender, Motherhood and Medicine*, Cambridge: Polity Press.

Phelan, P. (1993) *Unmarked: The Politics of Performance*, London and New York: Routledge.

Philippi, D. (1990) 'The Witness Beside Herself', *Third Text*, 12: 71–80.

— (1993) 'Do Not Touch' in *Mona Hatoum*, Bristol: Arnolfini Gallery.

Philippi, D. and Howells, A. (1991) 'Dark Continents Explored by Women' in S. Hiller (ed.) *The Myth of Primitivism*, London and New York: Routledge.

Pollock, G. (1977) 'What's Wrong with Images of Women?', *Screen Education*, 24.

— (1988) 'Modernity and the Spaces of Femininity' in *Vision and Difference: Femininity, Feminism and Histories of Art*, London and New York: Routledge.

— (1992a) Painting, Feminism, History' in M. Barratt and A. Phillips (eds) *Destabilising Theory*, Cambridge: Polity Press.

— (1992b) *Avant Garde Gambits 1888–1893: Gender and the Colour of Art History*, London: Thames & Hudson.

Prelinger, E. (1992) *Käthe Kollwitz*, New Haven and London: Yale University Press.

Pribam, D. (ed.) (1988) *Female Spectators: Looking at Film and Television*, London: Verso.

Register, C. (1982) 'Motherhood at Center: Ellen Key's Social Vision', *Women's Studies International Forum*, 5, 6: 599–610.

Rich, A. (1976) *Of Woman Born: Motherhood as Experience and Institution*, New York: Norton.

Riemer, E.S. and Fout, J.C. (1983) (eds) *European Women: A Documentary History, 1789–1945*, Brighton: Harvester Press.

Roberts, M. (1992) *Daughters of the House,* London: Virago.

Robertson, G. *et al.* (1994) *Traveller's Tales: Narratives of Home and Displacement*, London and New York: Routledge.

Robins, E. (1980) *The Convert*, London: Women's Press.

Rogoff, I. (ed.) (1991) *The Divided Heritage: Themes and Problems in German Modernism*, Cambridge: Cambridge University Press.

Rolley, K. (1990) 'Fashion, Femininity and the Fight for the Vote', *Art History*, 13, 1: 47–71.

Romero, P. (1987) *E. Sylvia Pankhurst: Portrait of a Radical*, New Haven and London: Yale University Press.

Rose, J. (1991) *The Haunting of Sylvia Plath*, London: Virago.

Rowbotham, S. and Weeks, J. (1977) *Socialism and the New Life: the Personal and Sexual Politics of Edward Carpenter and Havelock Ellis*, London: Pluto.

Rusbridger, A. (1994) Obituary for Dennis Potter, *Guardian*, 8 June 1994.

Russo, M. (1986) 'Female Grotesques: Carnival and Theory', in T. de Lauretis (ed.) *Feminist Studies/Critical Studies*, Bloomington: Indiana University Press.

Said, E. (1978) *Orientalism*, Harmondsworth: Penguin.

— (1983) *The World, The Text and the Critic*, Cambridge, Massachusetts: Harvard University Press.

— (1988) 'The Voice of a Palestinian Exile', *Third Text*, 3/4: 39–50.

— (1993) *Culture and Imperialism*, London: Vintage Books.

Sartre, J.P. (1943) *Being and Nothingness: An Essay on Phenomenological Ontology*, London: Methuen.

Scarry, E. (1985) *The Body in Pain: The Making and Unmaking of the World*, Oxford: Oxford University Press.

Schaefer, J.O. (1995) 'The Kollwitz Konnection', *Women's Art Magazine*, 62: 10–16.

Schreiner, O. (1993) 'The Buddhist Priest's Wife' in E. Showalter (ed.) *Daughters of Decadence: Women Writers of the Fin de Siècle*, London: Virago, 84–97.

Schubert, G. (1980) 'Women and Symbolism: Imagery and Theory', *Oxford Art Journal*, 3, 1: 29–34.

Showalter, E. (1986) (ed.) *The New Feminist Criticism: Essays on Women, Literature and Theory*, London: Virago.

— (1987) *The Female Malady: Women, Madness and English Culture, 1830–1980*, London: Virago.

— (1991) *Sexual Anarchy: Gender and Culture at the Fin de Siècle*, London: Bloomsbury.

— (1993) (ed.) *Daughters of Decadence: Women Writers of the Fin de Siècle*, London: Virago.

Skelton, P. (1989) *Groundplans*, Birmingham: Ikon Gallery.

— (1994) *Dangerous Places*, Lyon: Galerie l'Ollave.

— (1995) *Ponar*, London: Skelton-Forster.

Smart, C. (1987) ' "There is of Course the Distinction Dictated by Nature": Law and the Problem of Paternity' in M. Stanworth (ed.) *Reproductive Technologies: Gender, Motherhood and Medicine*, Cambridge: Polity Press.

Smith Rosenberg, C. (1985) *Disorderly Conduct: Visions of Gender in Nineteenth Century America*, New York: Alfred Knopf.

South Bank Centre (1990) *The British Art Show 1990*, London: South Bank Centre.

Spallone, P. and Lynn Steinberg, D. (eds) (1987) *Made to Order: The Myth of Reproductive and Genetic Progress*, Oxford: Pergamon Press.

Spence, J. (1986) *Putting Myself in the Picture: A Political, Personal and Photographic Autobiography*, London: Camden Press.

Spender, D. and Hayman, C. (eds) (1985) *How The Vote Was Won and Other Suffrage Plays*, London and New York: Methuen.

Spivak, G. (1989) 'Who Claims Alterity?' in C. Harrison and P. Wood (eds) *Art in Theory 1900–1990*, Oxford: Blackwell.

— (1991) 'Asked to Talk about Myself . . . ', *Third Text*, 15: 9–18.

Stabile, C. (1992) 'Shooting the Mother: Fetal Photography and the Politics of Disappearance', *Camera Obscura*, 28: 179–207.

Stacey, J. (1991) 'Promoting Normality: Section 28 and the Regulation of Sexuality' in S. Franklin, C. Lurie and J. Stacey (eds) *Off-Centre: Feminism and Cultural Studies*, London and New York: HarperCollins.

Stallybrass, P. and White, A. (1986) *The Poetics and Politics of Transgression*, London: Methuen.

Stanley, L. (1992) 'Romantic Friendship? Some Issues in Researching Lesbian History and Biography', *Women's History Review*, 1, 2.

Stanworth, M. (1987), 'Reproductive Technologies and the Deconstruction of Motherhood' in M. Stanworth (ed.) *Reproductive Technologies: Gender, Motherhood and Medicine*, Cambridge: Polity Press.

Steedman, C. (1986) *Landscape for a Good Woman*, London: Virago.

Sunder Rajan, R. (1993) *Real and Imagined Women: Gender, Culture and Postcolonialism*, London and New York: Routledge.

Sutherland Harris, A. and Nochlin, L. (1978) *Women Artists: 1550–1950*, Los Angeles: County Museum of Art, New York: Alfred A. Knopf.

Tagg, J. (1988) *The Burden of Representation*, Basingstoke and London: Macmillan.

Tawardros, C. (1988) 'Foreign Bodies: Art History and the Discourse of 19th Century Orientalist Art', *Third Text*, 3/4 Spring–Summer.

Tawardros, G. (1989) 'Beyond the Boundary: The Work of Three Black Women Artists in Britain', *Third Text*, 8/9: 121–50.

— (1991) 'Black Women in Britain: A Personal and Intellectual Journey', *Third Text*, 15: 71–6.

— (1993) 'Sutapa Biswas: Remembrance of Things Past and Present', *Third Text*, 22: 47–52.

— (1995) 'The Sphinx Contemplating Napoleon: Black Women artists in Britain' in K. Deepwell (ed.) *New Feminist Art Criticism*, Manchester and New York: Manchester University Press.

Thompson, T. (ed.) (1987) *Dear Girl: The Diaries and Letters of Two Working Women 1897–1917*, London: Women's Press.

Tickner, L. (1978) 'The Body Politic: Female Sexuality and Women Artists since 1970', *Art History* 1, 2,: 236–51, reprinted in R. Betterton (ed.) (1987) *Looking On: Images of Femininity in the Visual Arts and Media*, London: Pandora Press.

229

— (1980) 'Pankhurst, Modersohn-Becker and the Obstacle Race', *Block*, 2: 32–7.

— (1987) *The Spectacle of Women: Imagery of the Suffrage Campaign 1907–14*, London: Chatto & Windus.

Uhr, H. (1990) *Lovis Corinth*, Berkeley and Los Angeles: University of California Press.

Vicinus, M. (1985) *Independent Women: Work and Community for Single Women*, London: Virago.

Walkley, C. (1981) *The Ghost in the Looking Glass: The Victorian Seamstress*, London: Peter Owen.

Walkowitz, J. (1984) 'Male Vice and Female Virtues: Feminism and the Politics of Prostitution in Nineteenth Century Britain' in A. Snitow *et al.*, *Desire: The Politics of Sexuality*, London: Virago.

— (1992) *City of Dreadful Delight: Narratives of Sexual Danger in Late Victorian London*, London: Virago.

Wandor, M. (1972) *The Body Politic: Writings from the Women's Liberation Movement in Britain 1969–72*, London: Stage 1.

Warner, M. (1983) *Joan of Arc: The Image of Female Heroism*, Harmondsworth: Penguin.

— (1985) *Monuments and Maidens: The Allegory of the Female Form*, London: Weidenfeld & Nicolson.

Warnock, M. (1984) *Report of the Committee of Inquiry into Human Fertilisation and Embryology*, London: HMSO.

Weeks, J. (1981) *Sex, Politics and Society: The Regulation of Sexuality since 1800*, London: Longman.

Whitford, M. (1991a) *Luce Irigaray: Philosophy in the Feminine*, London and New York: Routledge.

— (1991b) *The Irigaray Reader*, Oxford: Blackwell.

Williams, V. (1986) *Women Photographers: The Other Observers 1900 to the Present*, London: Virago.

Williamson, J. (1983) 'A Piece of the Action: Images of "Woman" in the Photography of Cindy Sherman', *Screen*, 24, 6: 102–16.

Wilson, E. (1985) *Adorned in Dreams: Fashion and Modernity*, London: Virago.

Wind, E. (1980) *Pagan Mysteries of the Renaissance*, Oxford: Oxford University Press.

Winship, J. (1985) ' "A Girl Needs to Get Street-Wise": Magazines for the 1980s', *Feminist Review*, 21: 25–46.

— (1987) *Inside Women's Magazines*, London: Pandora Press.

Wolff, J. (1990) 'The Invisible *Flâneuse*: Women and the Literature of Modernity' and 'Feminism and Modernism', in J. Wolff, *Feminine Sentences: Essays on Women and Culture*, Cambridge: Polity Press.

— (1995) 'The Artist, the Critic, and the Academic: Feminism's Problematic Relationship with "Theory"' in K. Deepwell (ed.) *New Feminist Art Criticism*, Manchester and New York: Manchester University Press.

Wolff, N. (1990) *The Beauty Myth*, London: Chatto & Windus.

Zajovic, S. (ed.) (1993) *Women for Peace Anthology*, Belgrade: Women in Black.

Zimmerman, P. (1993) 'Fetal Tissue: Reproductive Rights and Amateur Activist Video', *Afterimage*, Summer.

NAME INDEX

Page references in italics refer to illustrations

SUBJECT INDEX

Page references in italics refer to illustrations

SUBJECT INDEX

Vanitas (Sterbak) 141
Verein der Berliner Künstlerinnen 3, 23, 24
victims 60–1
viewing 80–1, 104, 192
Vilnius 180
Virgin Mary 20, 32–4, 42, 123, 149
virginal maternal 33
virginity 52, 54
visibility 62
Vogue 90
vomiting 151
Votes for Women 52, *53*, 56

Waiting 121, *122*, 123
War (Kollwitz) 39
Warnock Committee 111
warriors 52, 54, 74
Weavers, The (Hauptmann) 23
Weavers' Rebellion, A (Kollwitz) 42
'White Slave Traffic' Bill 75
Whitney Museum 136
Woman under Socialism (Bebel) 35

Woman with Dead Child (Kollwitz) 20, 22, 42–3
women, as artists 28, 83–4
Women in Black 163, 164, 192
Women's Coronation Procession 48, *49*
Women's Dreadnought, The 73, 75, 77
Women's Freedom League 72
'Women's Misused Energy' (Key) 36
Women's Social and Political Union (WSPU) 48, 50, 52, 75; bodily control 64, 65; class 73–4; divisions 72, 73; hunger strikers 56
workshops 104
Worpswede 24, 29, 30, 35, 37
Wounds of Difference (Fortnum) 100
Wrangler Jeans 114, 115, 116, 117
writing 173

X Mark of Dora Newman, The (Skelton) 176–7, *179*, 180

Yugoslavia 163

Zabat (Sulter) 165–6